Raw Histories

MATERIALIZING CULTURE
· ·

Series Editors: Paul Gilroy, Michael Herzfeld and Daniel Miller

Barbara Bender, *Stonehenge: Making Space*

Gen Doy, *Materializing Art History*

Laura Rival (ed.), *The Social Life of Trees: Anthropological Perspectives on Tree Symbolism*

Victor Buchli, *An Archaeology of Socialism*

Marius Kwint, Christopher Breward and Jeremy Aynsley (eds), *Material Memories: Design and Evocation*

Penny Van Esterik, *Materializing Thailand*

Michael Bull, *Sounding Out the City: Personal Stereos and the Management of Everyday Life*

Anne Massey, *Hollywood Beyond the Screen: Design and Material Culture*

Judy Attfield, *Wild Things*

Daniel Miller (ed.), *Car Cultures*

Raw Histories

Photographs, Anthropology and Museums

Elizabeth Edwards

Oxford • New York

First published in 2001 by
Berg
Editorial offices:
150 Cowley Road, Oxford, OX4 1JJ, UK
838 Broadway, Third Floor, New York, NY 10003-4812, USA

Berg is the imprint of Oxford International Publishers Ltd.

Library of Congress Cataloging-in-Publication Data

A catalogue record for this book is available from the Library of
Congress.

British Library Cataloguing-in-Publication Data

A catalogue record for this book is available from the British Library.

ISBN 1 85973 492 8 (Cloth)
 1 85973 497 9 (Paper)

Typeset by JS Typesetting, Wellingborough, Northamptonshire.
Printed in the United Kingdom by Biddles Ltd, Guildford and
King's Lynn.

For Simon and Issy and for Roslyn

Contents

Acknowledgements

Many colleagues, friends and students have kindly read, discussed, encouraged, offered constructive criticism and consoled with cups of coffee as *Raw Histories* slowly emerged: Josh Bell, Alison Brown, Linda Clover, Jeremy Coote, Chris Dorsett, Paula Fleming, Gill Grant, Clare Harris, Janice Hart, Gwyneira Isaac, Julia Knight, Patti Langton, Philip Lankester, Hélène La Rue, Owen Logan, Antonia Lovelace, Fiona Maddocks, Howard Morphy, Chris Morton, Alison Nordström, Mike O'Hanlon, Lynn Parker, Alison Petch, Jude Philp, Chris Pinney, Jorma Puranen, Russell Roberts, Joanna Sassoon, Virginia-Lee Webb, Elizabeth Williams and Chris Wright. In particular Chris Gosden, Anita Herle, Laura Peers, Roslyn Poignant, Simon Schaffer and Joan Schwartz have been supportive way beyond the call of duty, and soothed my various crises regardless of their own pressures. I thank them all. I hope they will call in the debt one day. I also thank the anonymous readers for the encouraging and constructive comments.

I am also grateful to the librarians, archivists and curators who have eased my way, especially Anne Barrett at Imperial College London while I worked on the Huxley material. Also Godfrey Waller in Cambridge, Chris Wright and Beverley Emory at the Royal Anthropological Institute, and Harry Persaud at the Museum of Mankind. Thanks also to staff at the Public Record Office, The Library of the Foreign and Commonwealth Office, British Museum Archives, Borough of Camden Local History Library, and especially the wonderful Book Reserve staff of the Upper Reading Room of the Bodleian Library, Oxford.

I am grateful to the Hulme Fund, University of Oxford, who supported my research on Huxley's project, and the University of Cambridge and the Sub-Faculty of Anthropology, University of Oxford who supported my work on the Torres Strait. My home institution, the Pitt Rivers Museum, University of Oxford has been unfailingly supportive. They have also kindly allowed me to reproduce many photographs from their

collections here, and thanks must go to Malcolm Osman who did so much of the photographic work. I should also like to thank Owen Logan, Jorma Puranen, Elizabeth Williams, the Royal Anthropological Institute, Cambridge University Museum of Archaeology and Anthropology, and the Library of the Foreign and Commonwealth Office for permission to reproduce their photographs.

I am grateful to the Keeper of the University Archives for permission to quote from the Marett–Jenness correspondence in the Committee for Anthropology Papers, and the Curators of the Bodleian Library for permission to quote from the Acland Papers. Special thanks must go to Michael Young, who has been so generous with his data on Goodenough Island that the second part of Chapter 6 should by rights be billed as a collaborative project. Chapter 6, 'Visualising History' was first published in *Canberra Anthropology* 17(1) 1994. I am grateful to the editors for permission to republish it here. Earlier and very substantially different versions of Chapter 5 'Time and Space on the Quarter Deck' appeared as 'Visuality and History' in C. Blanton (ed.), *Picturing Paradise: Colonial Photography in Samoa 1875–1925* (Daytona Beach, FL: SEMP 1995) and as 'Visualität und Geschichte' in J. Engelhard and P. Mesenhöller (eds), *Bilder aus dem Paradies* (Marburg: Jonas Verlag, 1995).

I am indebted to Kathryn Earle and the team at Berg for their support, encouragement and patience throughout and to David Phelps for coping with my literary eccentricities.

Finally the forbearance of my family, Simon and Issy, has been saintly throughout. They have long been looking forward to my emergence from my study and to a house free of my trail of notes to myself.

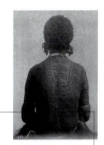

List of Figures

one

Introduction: Observations from the Coal-Face

Perhaps the first thing that reached me about photography was the *punctum*, the inexplicable point of incisive clarity, although in those days I had not yet put a name to it. In my case it was the carefully tied knots in the lashings on a bamboo palisade erected around the canoe house at Makira in the Solomon Islands. The photograph was taken by one George Smith, for C. F. Wood on his yachting cruise of the Pacific in 1873. There was a sense of presence – of fingers that had tied those knots in other times – that filled the whole image and gave it meaning. This first recognition was a strangely prescient metaphor for the threads wrapped around, entangling photographs and making histories.

Over the years many theorists and writers on photography, such as Siegfried Kracauer, Walter Benjamin, Roland Barthes, John Tagg, and John Berger, and historians such as Greg Dening, Carlo Ginzburg, and Hayden White, to name but a few, have left an indelible mark. However, my primary interests have also come from another direction, from many years working as a curator of photographs within an anthropological museum and teaching critical history and theory of still photography within visual anthropology to students in anthropology, history, art history, contemporary arts practice and museum studies. During the hours, days and months spent in many places, working with photographs, looking at photographs, talking about photographs, thinking about photographs and thinking about their relationship with history, I have talked to people looking for 'history'. This history has been both the actuality of evidential inscription, and their own particular 'realities'. They are looking for their own history or someone else's history, for the history of their discipline, or confronting the nature of their colonial past, both the colonised and the colonisers;

1

people looking for their ancestors, people making, re-making or even imagining histories. Such experiences are of eradicable subjectivity. Photography here cannot be reduced to a totalising abstract practice, but instead comprises photographs, real visual objects engaged with in social space and real time. In such contexts, the analysis of photographs cannot be restricted only to sorting out structures of signification, but must take into account that signifying role of photography in relation to the whole nature of the object and its social biography.

The essays in this volume recollect not those experiences as such, but the need for historiographical contemplations on the relationship between photographs and the way in which pasts are made in both inscription and archiving. Photographs here are as much 'to think with' as they are empirical, evidential inscriptions. A concentration on content alone, ethnographic appearance – the obvious characteristics of a photograph – is easy, but will reveal only the obvious. Instead, one should concentrate on detail. It is more revealing, not merely in the detail of content but the whole performative quality of the image (Ginzburg 1983:82). Thus one moves beyond surface description, beyond originating context itself, beyond the homogenising rubrics of disciplinary action, or of overarching explanatory systems. In many ways the arguments here follow Geertz's methodological statement (1973:28), by using theory to make thick description more eloquent and to draw, or at least point to, larger conclusions from the smaller case-studies. These are developed to support broader assertions about the role of photographs in intersecting histories through engaging precisely and exactly with complex specifics. Similarly, the arguments draw on de Certeau's 'Recipe for Theory' by undertaking 'an ethnological isolation of some practices in the form of case studies, enabling focus on a distinct yet coherent corpus'. Such action dissolves unity, without denying the power of that unity, but allows, within it, that which was 'obscure, unspoken, culturally alien, to become the very element that throws light on the theory and upon which the discourse is founded' (1980 :190). Rather than starting from a series of observations and assumptions imposed on a body of material, the starting-point here is always with photographs themselves, the entangled histories and their significations, to look for an intelligible structure that will recognise both possible closures of meaning, and open spaces of articulation (Levi 1991:98), in an attempt at methodological exploration.

A detailed consideration of the many theoretical underpinnings that have been variously forged into tools is beyond the scope of this volume, although they resonate throughout the arguments, and in any

case they have been admirably dealt with and analysed by others. For instance, it is not intended to analyse in detail the relationship between photography and the forces of domination and repression, the operation of capillary power and asymmetries within colonial relationships that saturate many of the photographs discussed here. This is not to underestimate, diminish or overlook them; they too have been admirably dealt with elsewhere (for example Pinney 1997: Chapter 1; Sekula 1989; Green 1984, 1985; Lalvani 1996; Ryan 1997) and I take them as axiomatic. They will be accorded an active and foregrounded role in the argument as appropriate. Where they are silent, they are still very much present, informing and shaping the photographic practice explored in these essays. While proceeding from and building upon those elements, which have been the focus in much critical writing, I shall argue that photographs cannot simply be reduced to signifiers of social forces and relations, premised solely on models of alterity, nor to models of spectacle within a socio-political matrix, although they are indisputably active and potent, as both makers and sustainers within these discourses. The mechanisms of photographs are too complex. They are more ambiguously dynamic as they function in the real world, and within daily experience, not merely in some imagined or reified theoretical world. As Jenks has argued (1995:13–14) there is a space between theorised vision and its relations to the real world of everyday empirical experience. The close-up view, based firmly in ethnographies of photography, allows us to grasp what eludes the broader more comprehensive viewing, and vice versa (Ginzburg 1993:26–7). This echoes Kracauer's view that the micro-view (like the cinematic close-up) is capable of modifying more comprehensive views (Barnouw 1994:254).

Consequently the arguments explore *specific* photographic *experiences*: how photographs and their making actually operated in the fluid spaces of ideological and cultural meaning. These cannot always be encapsulated precisely through the mechanisms of reception theory, semiotics or post-colonial deconstruction, yet, at the same time, carry their mark. Perhaps, as Hoskins has suggested, it is because 'many of the "grand" narratives of science, progress and politics have lost their credibility', that 'little' narratives, situated in the particular experience of individuals, have resurfaced (1998:5). Photographs, those visual incisions through time and space, constitute such 'little narratives', yet at the same time are constituted by and are constitutive of the 'grand', or at least 'larger', narratives. Consequently the intention here is not to produce a grand theory of photography, ethnography and history as abstract practices, but to look at specific photographs and specific acts of photographic

involvement, collecting, displaying and intervening. These essays are small vertical samplings in a rich and varied field, which are nonetheless conceptually linked. From this I hope to suggest, following Geertz, the general within them, which might be extended to other bodies of material and to contribute to a broader understanding. Any one of the essays could serve as the basis of a book in itself.[1]

Museums and Archives

Underlying all the essays is an idea of 'The Museum' and 'The Archive'. Although there is a difference in focus, in practical terms, in the means by which they produce public statements, here, for the sake of argument, I slip between the two, for as far as photographs are concerned, they are closely related, often being inseparably linked sites of disciplinary regulation. The 'Archive' and 'The Museum' have become a privileged site of critique in recent years, especially in relation to ethnography (see for instance Bennett 1995; Coombes 1994; Ames 1992; Sekula 1989; Richards 1993; Bal 1996; and McQuire 1998). However, it is not only a place of disciplinary regulation and enclosure, although it is of course that in one register. It is also a place of potential, open to new historical frames of references where photographs can interrupt dominant narratives (Hartmann, Hayes and Silvester 1998: 2, 8–9; McQuire 1998:133–4). There is a fluidity, heterogeneity and even serendipity to both making photographs and their preservation in 'The Archive', for neither making nor preserving is a unified practice. It is important to move away from the reiteration of an almost predictable catalogue of stereotypes, which frequently exaggerate the homogeneity of archival action and which confuse consumption with production. Such over-determined models both reify 'The Archive' as an inactive space after the first act of appropriation, and at the same time, paradoxically, close precisely the space in which alternative voices might emerge, whilst doing nothing to displace or destabilise the power of 'The Archive'. I shall argue instead that within the archive and the museum there is a dense multidimensional fluidity of the discursive practices of photographs as linking objects between past and present, between visible and invisible and active in cross-cultural negotiation. Meanings come in and out of focus, double back on themselves, adhere silently. Indeed, as will be suggested in Chapter 8, in considering the role of photography in the ethnographic museum, photography has the potential for critique in precisely those spaces to whose representational practices it has contributed so forcefully in the past.

I want to consider particular roles of photographs in inscribing, constituting and suggesting pasts. Contained within this is the way in which photographs termed 'ethnographic' or 'anthropological' have been used to define cultures. But embedding this within history allows the photographs to perform on a broader stage in space and time, not necessarily confined to specific cultural pasts. Further, it intentionally blurs the canonical categories that designate photographs as 'ethnographic' or 'anthropological'. My basic question is: what kind of past is inscribed in photographs? What is the affective tone through which they project the past into the present? How can their apparently trivial incidental appearance of surface be meaningful in historical terms? How does one unlock the 'special heuristic potential' of the condensed evidence in photographs, representing, as they do, intersections? Egmond and Mason have recently described these intersections as 'cross roads of morphological chains, as the intersection of numerous contexts and actions, or at the nodal point where both contemporary and modern preoccupations reflect and enhance each other' (1999:249). Do photographs have their *own agency* within this? If there are *performative* qualities in photographs, where do they lie? In the thing itself? In its making? In its content? While one can only summarise the complex arguments here and amplify in the case-studies, suffice it to say that such strategies move us beyond the surface level evidence of appearance, so that 'if it can be recognised that histories are cultural projects, embodying interests and narrative styles, the preoccupation with the transcendent reality of archives and documents should give way to dispute about forms of argument and interpretation' (Thomas 1997:34).

Photographs are a major historical form for the late nineteenth and twentieth centuries, and arguably we have hardly started to grasp what they are about,[2] and how to deal with their rawness. Photographs are very literally raw histories in both senses of the word – the unprocessed and the painful. Their unprocessed quality, their randomness, their minute indexicality, are inherent to the medium itself. It has been suggested that anthropologists, and for that case historians, are worried by still photography because, lacking the constraining narratives of film, still images contain *too many meanings* (Pinney 1992:27). Photographs present a levelling of equivalence of information, with the trivial and the significant intertwined and shifting places. 'Photography is a vast disorder of objects . . . Photography is unclassifiable because there is no reason to *mark* this or that of its occurrences . . .' (Barthes 1984:6). It is also a function of the photograph's infinite recodability. They are ultimately uncontainable, there is an incompleteness and unknowability

of photographs. There is seldom a 'correct interpretation': one can say what a photograph is not, but not absolutely what it is. It was this unknowability, lack of absolute definition and completeness that, for Kracauer, placed photography with history as 'the last things before the last', in the 'anteroom' to understanding, which is found only in philosophy (1995a:191).

Yet the inclusive randomness of photographs as inscriptions, the heightening theatricality of their nature, and the mutability of their meaning, contain their own future, because of the near- infinite possibilities of new meanings to be absorbed. Their inclusiveness also has the potential to be unsettling. Photographs are painful, not only in their content matter sometimes (we can all think of such examples); but sometimes their truth-telling, their performance of histories, their reality has a painfulness – rawness. All the photographs discussed here, whether as exchanged objects, colonial documents or cross-cultural explorations, were intended to present some closure within a specific body of practice, but, as all these essays suggest, they present, instead, points of fracture, an opening out. Through the photograph's points of fracture, the rawness, we can begin to register the possibility of a history that is no longer founded on traditional models of experience and reference.

Before going on to outline further the theoretical concerns especially relevant to the arguments, I want to turn briefly to the essays them-selves. They address some of the themes I have found interesting within these concerns. In many ways they themselves are like snapshots, arranged in an album, of the dense possibilities that seem significant in that relationship between photography, ethnography and their analytical sisters, anthropology and history. The essays in the volume are arranged into three sections, 'Notes from the Archive', 'Historical Inscriptions' and 'Reworkings'. The balance and emphasis are not the same throughout, for there are many ways to explore photographs, and each section concerns itself with certain ways of thinking with photographs. Different theoretical stances, for example, cultural politics, post-colonial critique, identity and memory and differently premised historical narratives, which resonate within the essays variously, could just as well have been pulled into sharper focus in differently nuanced readings of the photographs. The first two essays are vertical samplings into 'The Archive'. The first looks at the mechanisms of collecting, while the second examines the relationship between photographs and objects in the collection of culture and the culture of collecting. My intention here is to point to the differentiated, and sometimes fortuitous,

nature of 'The Archive' as a series of micro-intentions, as much as a universalising desire. The second part of the book, 'Historical Inscript-ions', looks at the production of photographs within anthropology or at photographs absorbed into anthropology, and explores some of the theoretical and historiographical issues raised by these particular examples. Further, all have been subject to the poetics and politics of collecting discussed in Part I, changing meaning and value. These four essays also point to the complex and blurred discourses that constitute anthropological photographs within a system of visual equivalence (Poole 1997:133–4) that was a crucial enabling factor of "The Archive'. The two essays in the final section return to the museum to look at the potential role of photographs and photographic engagement as a site of self-reflexive critique within the public spaces of museum and contemporary arts practice. The final essay, on the work of the Finnish photographer and artist, Jorma Puranen, brings the key themes of this volume together, those of performance, social biography, mutability, recodability and the space for alternative histories.

The focus could have been different, but these were groups of photographs that, for me, had a particular resonance and density as nodal points. To a greater or lesser extent such an analysis could be undertaken on all photographs or groups of photographs; however, I have found these especially articulate and co-operative as 'photographs to think with'. Concern is not necessarily for a grounded reading, the decoding of the image to reveal a truth. The interest is not only with the surface of the image, but with its cultural depth as an inscription; that is, how photographic meaning is made in the precise intersections of ethnography, history and the past, both as a confrontation with the past and as an active and constituent part of the present.

Photographs and Histories

The deconstructive stresses of post-modern analysis have served to defamiliarise the past and the photograph through revealing its political, psychological and thus representational discursive practices and instrumental procedures. While such analyses concentrated on exposing the inadequacies (from myopia to fantasy) of colonial repre-sentations, they did not engage, on the whole, with how photographs might have operated within ideas of historically specific legitimation. Nonetheless, such analyses opened a critical space from which differ-ently figured interrogations might emerge. Before going on to discuss this potential in more detail, I want to consider briefly this relationship

between history and the nature of the photograph in theoretical terms, for it weaves itself through these essays. Such considerations should inform any serious attempt to use photographs as historical sources and form the basis of any critique of those sources and assumptions that we might have about them. If what follows is rather ambiguous and occasionally plain contradictory, this is to a large degree a reflection of the ambiguous nature of photographs themselves.

The starting-point must be the very nature of the photograph, for this is the site of its ambiguity, and in the essays that follow it becomes an interrogatory tool. In many ways a photograph denies history. A fragment of space and time, it defies diachronic connections, being dislocated from the flow of life from which it was extracted. While it is 'of' the past, it is also of the present in that the past is transported in apparent entirety to the present: in Barthes's famous phrase – the 'there-then' becomes the 'here-now' (1977:44). It is this insistent anteriority of photographs and their social action in the present that has exercised much thinking about photography; a point to which I shall return. The photograph contains and constrains within its own boundaries, fracturing the balance and natural flow of those processes that are the focus of historical, anthropological, or sociological study: 'a photograph preserves a moment of time and prevents it being effaced by the suppression of future moments' (Berger and Mohr 1989:89). Fragments come to stand for a whole, as an expression of an apparent essence, what it is 'to be' something. This aspect was especially marked in the way nineteenth-century anthropological photography, as the physical mapping of the body and of culture, carried moral value, a theme that emerges strongly in Chapter 6. In this context photographs become symbolic structures, reifying culturally-formed images as observed realities, rendering the latter as visible 'objects' in space (Fabian 1983:117). The signifying qualities of the photograph bridge the abyss between appearance and meaning. The physical subject, the referent, itself becomes indivisible from its symbolic or metaphorical meaning; the symbol becomes reality, and in this process the signifier and the signified collapse into each another (Barthes 1977:36–7). Yet these readings remain arbitrary. Specific to a discourse of consumption, meanings are not necessarily in the photographs themselves, but in their suggestive appearances within different contexts, as people and things decontextualized within them are transposed within the culture of viewing. Further photographs operate in both 'private' and 'public' or 'personal' and 'collective' functions. This is an important distinction, because the way in which photographs can be said to move from one

to the other has much to do with their reading as historical data. Images read as 'private' are those read in a context contiguous with the 'life' from which they are extracted: meaning and memory stay with them, as in family photographs for example. 'Public' photographs remove the image entirely from such a context, and meaning becomes free-floating, externally generated and read in terms of symbol and metaphor (Berger 1980:51–2).

Our expectation of photographs is grounded, nonetheless, in the way in which they are anchored to the real world, in that they are the product of light reflected off an object on to a sensitized film or plate, and thus chemically inscribed. In bald terms, the substantive relation-ship between the photograph and its referent is analogical; it offers us a beguiling realism that appears to deny the mediation of creation and interpretation to the extent that photography allows us to *believe* (Sontag 1979:9). Yet photographic inscription is not unmediated; the photograph is culturally circumscribed by ideas of what is significant or relevant at any given time, in any given context. Hence, as in any primary historical document, the inscription itself becomes the first act of interpretation. Yet it is in realism that our historical hopes are grounded. Photography brings the expectancy of the real, the truthful. The immediacy and intimacy offered by the photograph also suggest 'truth', for intimacy and truth are perceived as largely contingent on one another: this, after all, is a guiding tenet of field anthropology.

Thus we expect photographs to *tell,* but find them remarkably resistant, for, like history, they do not lend themselves to being dealt with in any definite way (Kracauer 1995a:191–2). As Barthes remarked 'if photography cannot be penetrated, it is because of its evidential power. In the image . . . the object yields itself wholly, and our vision of it is *certain'* (1984: 106, original emphasis). Yet photographs are no different from other historical sources in that they must be integrated with other ways of articulating the past. This necessity is often seen as a weakness – as if because of its *appearance,* the photograph should reveal a greater truth, the whole picture. This is because we are lured into a pattern of expectancy inappropriate to the true nature of a medium, which can be simultaneously fragmented, unarticulated, and resistant, yet challenging.

The relationship between photography and history has a substantial theoretical literature, especially in recent work on Benjamin, Kracauer and Barthes, which I can only briefly summarise here (Cadava 1997; Barnouw 1994; Shawcross 1997; and, for instance, Trachtenberg 1989; Lury 1998; McQuire 1998). The analogy between the photograph and

historiographical endeavour was clear to Kracauer. For him it both constituted a composite of fragmented, selective, exclusive, tentative, illustrative and suggestive relations, rather than a sustained and coherent argument (Barnouw 1994:206). While there may be different cultural expectations of what either historiography or photography can deliver, both are thus concerned with the partial nature of historical inscription and understanding, the ultimate unknowability in holistic terms, despite the appearance of knowability upon which photographic hopes are based. If neither can state ultimate truths, they can both reveal 'a peculiar openness to the visible world in ways that permit access to new and surprising aspects'(Barnouw 1994:238–9). Walter Benjamin famously conceived of history itself in the language of photography, and constantly employed photography as a metaphor and allegory for history and memory, which breaks down into images not stories. For Benjamin, the historian and the photographer had a similar task: 'to set in focus' both the fragment and the materiality of the past as manifestations of unique experience. His contemplation on this relationship was premised on desire and loss and ultimately as a death mask, the fleeting flash of memory that can only be grasped at the moment of its disappearance. Its redemption was the way that, like the photographs discussed in these essays, it reaches into the future (Cadava 1997:30; Leslie 1999; see also Steinberg 1996). Barthes was more intensely preoccupied with loss, which eventually focuses itself on the photograph of his mother. 'Ultimately what I am seeking in the photograph taken of me is Death' (1984:14–15), 'the anticipated essence of the Photograph could not in my mind be separated from pathos' (1984:21). The sense of loss was articulated through the surface tracing and fracture upon which photography insists so forcibly, and that has characterised modernity's symbiotic relationship with the medium (McQuire 1998). Such a view has resonances with the relationship between photography and salvage ethnography. Malinowski spoke of the disappearance of the ethnographic object at its moment of recognition: 'Ethnology is in the sadly ludicrous, not to say tragic, position. In that at the very moment when it begins to put its workshop in order . . . the material of study melts away with hopeless rapidity . . . die[ing] away under our very eyes' (1922:xv). As is discussed in Chapter 7, in relation to photographs from the 1898 Cambridge Torres Strait Expedition, much writing and practice of photography in anthropology in the late nineteenth and early twentieth centuries clusters around concerns with disappearance, presence and absence and the seen and the unseen.

However, to reduce photographs to ineffable nostalgia and pastness merely repeats oppositions of lost past and active present, links photographs to one past time only and restates the trope of the disappeared 'authentic' (Morris 1994:6–7). Within the contexts of re-engagement and re-cognition photographs have the cultural potential for being about not Barthesian loss, but instead regain, empowerment, renewal and contestation, a point to which I shall return. While in one register, there is loss, a cultural dispossession, increasingly archives and museums have become not places only of exclusion and disappearance, temples of cultural loss, but spaces of contested histories and contesting practices, negotiation, restatement and repossession (Simpson 1996; Ames 1992; Clifford 1997). Photographs are not excluded from these processes; indeed, because of their indexical insistence and the politics of their production, they become central to it, symbolic of the asymmetries of power (Harlan 1995:20).[3] While the theoretical and practical impetus has come from the wider issues of cultural politics of representation, identity and sovereignty, the effect has been the gradual opening of spaces for 'indigenous counter-narratives' (Douglas 1999b), fragmenting the authoritative and monolithic power of 'The Archive'.

As Green-Lewis (1996:14), Sekula (1989) and Tucker (1997) have argued from different perspectives, there has been a predominance of certain models of the vision world in the nineteenth century, namely the mirror with a memory or the Foucauldian panopticon. While they are not mutually exclusive, the first of these assumes a broadly uncritical acceptance of photographic truth, while the second has linked photography to the instrumental power of the state and its apparatus. This manifests itself as an ordering of knowledge that was itself premised on a privileging of vision in which photography was both constitutive and constituted. As Sekula and others have demonstrated, photographs functioned within certain discursive regimes of truth. Indeed, Tagg argues, along similar lines, that outside their historical specifications, the power of photographs is lost: 'photography has no identity. Its status as a technology varies in the power relations that invest it' (1988:63) Photography here, as an abstract ideological practice 'chameleon-like, adopts the ideological perspective of the institutions that employ it', in this it becomes legible only within certain currencies. This view, Brothers argues, is derived not only from the historically determined nature of vision (of which photography is constitutive in part) and the embodiment of scopic regimes, but also from a view from *histoire de mentalité* which has tended to attribute a common view to all members of a collective (1997:27–9). While both undoubtedly reflect

a certain range of photographic instrumentality in the nineteenth century, the dominance of these models, and the way they have been applied, has meant that certain photographs or clusters of photographs become signature images for a discipline or practice – in anthropology one might cite Lamprey's anthropometric method (see Figure 6.1). Such photographs have come to stand for a whole range of photographic practices, which cohered momentarily, and constantly shifting, around anthropology, without precise engagement with how such images became thinkable, meaningful and active (or not) within anthropology.

What were the specific requirements of 'evidence' within a given context at a given moment? How do these shift, even within the unifying 'archive'? Thematic analyses, such as the 'colonial gaze', while creating important interrogatory resonances throughout, cannot provide an appropriate language for dealing with the multiplicity of possibilities, histories and counter histories lodged within photographs. As the case-studies here suggest, even the most dense of colonial documents can spring leaks if we 'keep our theory close to the ground' (Geertz 1973:24) and interrogate not the sweep of abstractions but the distinctions and points of fracture in the image. While I do not depart from Tagg's identification of photographs with ideological perspectives of the institutional uses in which they are active, such a position fails, in its semiotic concern and the position of pure conventionality of the photograph, to move towards a consideration of inscription, the problematic of context, and the subjectivities of photographic effect, which are directly related to the medium. It is this that Barthes, in *Camera Lucida*, recognises as central to photographic meaning and the to relationship between the photograph and the past.

Nonetheless, paradoxically, Tagg's fundamental and tenable argument, that the meaning of photographs is vested in their contexts and instrumentality, holds the seeds for the re-engagement and subversion of images that the more over-determined aspects of his argument close off. Meanings are made through dynamic relations between photographs and culture that do not stop at the door of the archive. To be able to argue such a position is a measure of the opening of 'The Archive' itself as a cultural object, with its own social biography, a reconceptualisation that is framed through the fragmentation of institutional structures in the practical realisations of post-structuralist critiques. In these contexts photographs are about empowerment, repossession and a different and, perhaps, contesting articulation of history 'which are not bounded by the autonomous modernist subject but [which] refers to a general human capacity for active choice, self-representation and

deployment of strategies, always historicised in terms of circumstantial and structural possibilities and constraints' (Douglas 1999b:20–1). Images in the archive can literally become reindividualised, acquiring new status through new contextual links. As John Berger has stated – an idea that will resurface in a number of places in the following essays: 'If the past becomes an integral part of the processes of people making their own history, then all photographs will re-acquire a living context instead of being arrested moments' (1980:57). The social biographies of photographs as objects operate as a series of micro-engagements that threaten to destabilise the homogenising instrumental desires of meta-discourses. It is to social biography that I now wish to turn.

Social Biographies and Materiality

Ideas of social biography or cultural life have, in recent years, been used particularly pertinently in the analysis of material culture itself and the museum effect. The biographical persuasion in material culture studies 'can make salient what might otherwise remain obscure', for the 'cultural responses to such biographical details reveal a tangled mass of aesthetic, historical and even political judgements, and of convictions and values that shape our attitudes to objects' (Kopytoff 1986:67). Appadurai's now seminal volume (*The Social Life of Things* 1986), especially the essay by Kopytoff, has provided a classic model arguing that a thing, in our case a photograph, cannot be fully understood at one single point in its existence – for instance, perhaps, the inscription of the colonial gaze – but must be examined through the processes of its production, exchange, and consumption. Things have accumulative histories that draw their significances from intersecting elements in their histories. This takes on an added dimension in relation to photographs, as their infinite recodability of content is linked to shifting relations of the material object. What links these approaches, and the way in which meanings are transformed, is that objects enmeshed in this system are perceived as active in social relations, not merely passive and inert entities to which things happen and things are done (Gosden and Marshall 1999:169). Rather they constantly pick up new meanings, both reworking the relationship between signifier and signified, and in relation to the way photographs are used to create and sustain meanings in people's lives. In a similar vein, Thomas has written of cultural objects as 'socially and culturally salient entities, objects change in defiance of their material stability. The category to which a thing belongs, the emotion and judgement it prompts, and the narrative it

recalls are all historically refigured . . . something which effaces the intentions of the thing's producers' (1991:125).

In relation to photographs, such ideas take on particularly pertinent perspectives. All the photographs discussed in these essays might be described as having 'functional' origins. They were made for a reason, for an audience, to communicate information within a culture of realism and an expectation of objectivity (Schwartz 1995:47–8). But they are nonetheless objects created with a clear biographical intention: they are inextricably linked to the past, but they are also about the future – a moment, fixed and active in the present, specifically to communicate the past in the future. Such a desire is fundamental to the act of photography. As I shall suggest, photographs remain socially and historically active within these contexts; indeed, arguably they are more open to the generation of multiple performances and the making of multiple meanings. Concepts of social life and cultural biography have been used successfully with photographs, and linked to the latter's polysemous nature, lack of fixity and context-dependent modes of making meaning. Pinney's (1997) study of the social life of Indian photographs draws heavily on these ideas; his analysis demonstrates the importance of repeated and significant engagements with images, making social meanings over space and time. Kendall, Mathé and Ross Miller (1997), for instance, have considered the shifting social biography of a whole collection, that from the Jesup North Pacific Expedition of 1897, exploring how it was used in different scientific and museum contexts, making and adding meanings that accrued around not only individual images, but whole series of photographs. Consequently we have entangled layers of social biographies of individual photographs and groups of photographs, both 'organic' and synthetic collections that have active social lives beyond the bounds of the image itself. They are not dead in the stereotypical cultural graveyard of the museum and archive, but are active as objects and active as ideas in a new phase of their social biography. Both sites of activity are subject to the cultural processes by which things are not only produced materially but are culturally marked as being a certain kind of 'thing'.

Integral to social biography is the way in which the meaning of photographs, generated by viewers, depends on the context of their viewing, and their dependence on written or spoken 'text' to control semiotic energy and anchor meaning in relation to embodied subjectivities of the viewer. These are acts upon photographs, and result in shifts in its meaning and performance, over time and space, producing

'a culturally constructed entity endowed with culturally specific meanings and classified and reclassified into culturally constituted categories' (Kopytoff 1986:67). The way in which photographs become 'ethnographic' is part of this, as is demonstrated through the Samoa photographs discussed in Chapter 5. In this instance, records of political encounter became ethnographic by being absorbed into a specific value class, through the privileging of certain elements in content while suppressing those of inscription. Likewise with the photographs exchanged amongst anthropologists (Chapter 2), 'ethnographicness' resides in the absorption and consumption of images within specific discourses, rather than in the intention of the images at their inscription. They become culturally marked as a certain kind of 'thing' – an ethnographic photograph. They might accrue further cultural capital as ethnographic, both in the eyes of contemporaries and the historiographical density of their subsequent biography, by the fact that they were owned, for instance, by Tylor or Radcliffe-Brown. Even where there is greater congruity between the intention and the preservation of photographs, the biographical trajectory is still active. As I demonstrate with Diamond Jenness's photographs (Chapter 4), the social biography of the images, the way in which they are evaluated and engaged with, is as closely related to the shifts in disciplinary practice within anthropology as it is to the shifts in curatorial imperatives with which their archiving is entangled.

The model of social biography can be linked to that of the visual economy. Poole has defined this as the political, economic and social matrices in which photographs operate and which pattern their production, circulation, consumption and possession, encompassing both the modes of production and those individuals who use the images (1997:9–13). Crucial to this model are the material forms of photographs; the way images are viewed, their affective tone, the way their material forms engage subjectivities around the image. The forms in which photographs were circulated and the forms in which they entered the archive follow their function, in that a cultural expectancy brings together appropriate forms of the photographic object and cultural function. The concentration on images alone has failed to give sufficient consideration to photographs as material objects; indeed, it has been necessary to suppress consciousness of what a photograph is, in material terms, in order to see what it is 'of' in image terms. What things are made of and how they are materially presented relates directly to their social, economic and political discourses and their function as documents.[4] For instance '. . . the choice of ambrotype over paper print

implies a desire for uniqueness, the use of platinum over silver gelatin intimates an awareness of status; the use of gold toning a desire for permanence' (Schwartz 1995:58). Similarly Miller has argued more broadly that 'Through dwelling on the more mundane sensual and material qualities of the object, we are able to unpick the more subtle connections with cultural lives and values that are objectified through these forms, in part because of the qualities they possess' (1998:8–9). In this much, photographs do not differ from other classes of things enmeshed in everyday life. As Pinney has demonstrated in his discussion of Indian photographic practices, the materiality of photographs and interventions on their surface to extend photographic inscription and meaning is formative in the production and use of photographs as socially salient objects (1997:153–5). Such a position can, I would argue, be extended to photographs in many other ways, including historical photographs, for social interactions involving people and objects create meaning. Thus the material forms in which photographs are arranged, how they are printed and viewed, as albums, lantern slides, or mounted prints, is integral to their phenomenological engagement, structuring visual knowledge as well as those related human actions in modes of viewing.

Materiality is significant in almost every chapter, for at one level it is materiality, the physical nature of the photograph, that allows the representational quality of photographs to function. One has only to contrast the act of viewing photographs with the act of viewing film to comprehend the importance of materiality. It was, for instance the reproducibility of the material forms of photographs that made it possible for them to constitute an active exchange system (Chapter 2). Material forms allow us to see different accounts of fieldwork (Chapter 4) and finally material form defines the art installations in a northern landscape (Chapter 9).

Photographs as Performance

Like social biography, the context and metaphors of performance bring to the fore a number of issues that have resonated throughout this Introduction thus far. I want to explore briefly the ways in which photographs could be thought to have performative qualities, both literally and metaphorically. It is an idea that recurs through all the essays and is intimated through the idea of social biography, which positions 'things' as active rather than passive in making meanings. Performance becomes a useful tool through which to explore this

activity of images. The potential of the idea is a historiographical liberation if, as a heuristic device, we accord photographs a certain agency in the making of history, allowing them to become social actors, impressing, articulating and constructing fields of social actions in ways that would not have occurred if they did not exist (Gell 1998). Both Gell and Holly (1996) have argued that objects have a form of agency in that they are active in social relations. Holly, extending Baxendall's notion of the period eye, has used Lacanian and post-structuralist theory to reconsider the relations between objecthood and the subjectivity of the viewer. She argues that the active agency of the object, in terms of rhetorical patterns of meaning, is embodied in the object in a way that shapes responses to it (Holly 1996:81). Such an argument can certainly be extended to photographs. Like the social saliency of the material object, active agency implies a level of performance, projection and engagement on the part of the object. In the idea of performance, and its more overt and formal manifestation, theatricality, is implied a presentation that constitutes a performative or persuasive act directed toward a conscious behold (Fried 1980).

By theatricality I do not mean the embedded formal qualities of drama as a genre, so much as a representation, heightening, containment and projection. It can be argued that theatricality is linked to photography, and in two senses. First, is the intensity of presentational form – the fragment of experience, reality, happening (whatever you want to call it) contained through framing, and second, the heightening of sign worlds that results from this intensity. Peacock has defined performance as a condensed, distilled and concentrated life – an occasion when energies are intensely focused (1990:208). Like performance or theatre, photographs focus seeing and attention in a certain way. Just as performances are set apart as non-ordinary activities, so photographs are apart, separated from the flow of life; they are of other times and other places. Performances, like photographs, embody meaning through signifying properties, and are deliberate, conscious efforts to represent, to say something about something. In Schechner's analysis of the nature of performance (1990:44), the sign itself is performative in that it constitutes one or more bits of meaning that are related and projected into larger frames of performance, 'scenes' that are sequences of signs embodying narrative. Such a model allows us to link the mutability of the photograph's signs with their historical contexts, in that larger frames of performance, the cultural stage on which the drama of the photograph is played out, are composed of the smaller, on to which it in turn deports meanings in a mutually sustaining relationship.

The nature of the photographic medium itself carries an intensity that is constituted by the nexus of the historical moment and the concentration of the photograph as an inscription. This concentration or containment has a heightening effect on the subject-matter. As singular events are presented as discrete displays, they are forced into visibility, focusing attention, giving separate prominence to the unnoticed and, more important, creating energy at the edge. Furthermore, photographs might be said to 'perform' the mutability of their signifying structures as they are projected into different spaces. Photographs have a performativity, an affective tone, a relationship with the viewer, a phenomenology, not of content as such, but as active social objects. As I have suggested through the idea of social biography, performativity is more than passive images being read in different contexts. Although that is obviously part of the equation, the heuristic device of performativity makes it possible to see images as active, as the past is projected actively into the present by the nature of the photograph itself and the act of looking at a photograph. One is reminded here of Mitchell's question 'what do pictures really want?' (1996:79). This is not a collapse into personification and fetishism of the photograph, but rather it clears a space to allow for an excess, or an extension, beyond the semiotic, to an appeal to the photograph, whose powers and possibilities emerge in the intersubjective encounter. Perhaps, as is suggested in different ways in the discussion of Acland's Samoa photographs (Chapter 5) and the photographs that were sent to the Colonial Office in response to Huxley's instructions (Chapter 6), performativity or theatre is more intense at moments of encounter across systems of power and value. Such a heuristic device highlights points of fracture. Significantly, the Soviet film-maker, Sergei Eisenstein, perceived similar boundaries between photography and film as between theatre and film (Kracauer 1980:256). Closing the triangle surely aligns photography with theatre.[5]

Frame is central to the idea of performativity or theatricality. It has become, of course, one of the central tropes of post-modern thinking, pointing to the multiple layering of constructedness of texts. While this gives the concept particular resonance in this discussion, concern with frame and its metaphorical density has always been active within the discourse of photography, for it is intrinsic to the medium. The frame was one of the five characteristics of the photograph defined by John Szarkowski in his famous catalogue for *The Photographer's Eye* at the Museum of Modern Art in New York: 'The central act of photography is the act of choosing and eliminating, it forces a concentration

on the picture's edge, the line that separates "in" from "out" and on the shapes created by it' (1966:9). While this statement was intended as a modernist restatement of photographic purity and essence, it has wider resonances if we allow ourselves to move outwards from this characteristic of the photograph, rather than inward to a concentration on essence, and to consider the relationship of form and the making of historical meaning. I am not arguing that the medium is the message, but that cultural assumptions and expectancy both limit thinking about photography and put too great a stress on its indexicality. Like Barthes, I would like to reintegrate ontology into the rhetoric of the medium – insert the sense of magic, of theatre and even of alchemy, for history too embraces such subjectivities (Shawcross 1997:44). The photograph awakens a desire to know that which it cannot show. It was this that was at the base of both Benjamin's and Barthes's photographic desire. Perhaps it is an ultimate unknowability that is at the centre of the photograph's historical challenge, for we are faced with the limits of our own understanding in the face of the 'endlessness' to which photographs refer and that Kracauer saw as one of his four affinities of photography (1980:263–5).[6]

In the way in which it contains and constrains, frame heightens and produces a fracture that makes us intensely aware of what lies beyond. Thus there is a dialectic between boundary and endlessness; framed, constrained, edged yet uncontainable. The boundary of the photograph and the openness of its contexts are at the root of its historical uncontainability in terms of meaning. Derrida's argument would seem pertinent here. While apparently naturalised, frames are essentially constructed and fragile. Framing and constraint impose artificially on a discourse constantly threatened with overflowing (1987:70). As I argue in Chapter 6, this is so even of the most overtly oppressive of photographic practices, such as anthropometric photography, where the humanising marks of culture – the arrangement of hair, the cultural marking of the body such as cicatrices – pierce the objectifying image and allow the possibility of subject experience (see Figure 6.1). Indeed, it is perhaps the tensions between the intense objectified presentation of subject and an awareness of 'beyond' that is part of the power of such photographs.

Theatre also confronts the viewer, opening a space for reflection, argument and the possibility of understanding. For Dening 'Theatricality is deep in every action ... the theatricality always present, is intense when the moment being experienced is full of ambivalences' (1996:109). As we have seen, photography is full of such ambivalences,

especially in cultural translation. Performance constructs a social reality in which it is possible to experience symbolic meaning (Hughes-Freeland 1998:15). Through the heightening nature of the medium and the theatricality within the photograph and its inscription, points of fracture become apparent. The incidental detail can give a compelling clarity, through which counter narratives might be articulated. The performance thus extends the possibilities of authorship of history through the interaction with precisely those points of fracture.

Three different forms of performativity and their relation to history and photography might be said to emerge in these essays. First is the performance of the image through the spatial dynamic of its framing; the way in which this projects its subject-matter into another space becomes very clear in different ways in the discussion of photographs of ethnographic objects (Chapter 3) and in the photographic installations of Jorma Puranen (Chapter 9). Second is the performance of making photographs. This is most clearly articulated in the political rituals of power that constitute the making of Acland's photographs of Samoan chiefly claimants, Mauga Manuma and Mauga Lei, discussed in Chapter 5. Here power relations are acted out spatially in the act of photographing, but the resulting photographs contain their own counter-narrative. Finally there is the theatre or performance within the frame. Performance within the image is in its most concentrated form in re-enactment. A photographic statement of reality constructed outside 'real time' experience, it becomes doubly mimetic, as I discuss in Chapter 7 in relation to Haddon's photograph of the 'Death of Kwoiam'. These categories are not mutually exclusive, but rather integrally interconnected in the performance of history. Photography is like ritual or theatre because it is between reality, a physical world, and imagination, dealing not only with a world of facts, but the world of possibilities (Hughes-Freeland 1998). Ultimately, there is a moment of theatricality in any representation, the space created by the consciousness of the representer, making a statement about something in which the viewer participates in the creative process of representing (Dening 1994:458).

Performance nonetheless implies certain genres as well as certain expectancies of both performance and genre. It is to these I wish to turn finally, because much thinking on performance of historical forms has come out of the study of oral histories, and there is a sense in which there are parallels between orality and visuality in history that might be used to heuristic effect. For the sake of argument this connection might be made more concrete by drawing on a model of genre and

expectancy from oral history, especially that articulated by Elizabeth
Tonkin (1992). While integrally related to performance, it is not a model
that can necessarily be downloaded to photographs exactly; but the
shape is useful to think with in relation to photographs. Genre and
expectancy will resonate through many of the essays, and emerge as
central in the discussion of photography in the ethnographic museum
(Chapter 8). Genres – visual dialects of style, form, intentions, uses,
rhetorical strategies – carry an expectation and assumption of the
appropriateness of performance. As in the case of the photograph
representing the death of Kwoiam (Chapter 7), looking at the construct-
edness of photographs in these terms can sometimes lead us straight
back to the originating centre (Holly 1996:185). Expectancy of the
medium might be glossed here as how we expect photographs, with
their beguiling realism, to tell us about the past in given performative
or interpretative spaces and with their various audiences. The 'horizon
of expectation' determines the use of images in relation to the answers
they are expected to give and the questions that can be asked of them
(Holly 1996:198). Further, orality itself, from which my model is drawn,
penetrates all levels of historical relationships with photographs, not
simply in terms of a verbal description of content, but the way in which
the visual imprints itself and is absorbed, 'played back orally, "narrativ-
ising" the past where no one speaks but events [or photographs] are
seen to tell themselves' (H. White 1980:7). These connections with
the models of oral history are, of course, historically specific, and
constitutive elements of the social life of photographs.

* * *

There is another performative link to the oral: people talk about
photographs, with photographs and to photographs. As Bakhtin has
argued 'The text as such never appears as a dead thing . . . We always
arrive in the final analysis, at the human voice, which is to say, we
come up against the human being' (1981:152–3). 7 There is a corner
of me that recognises that, having sat with people stunned into moist-
eyed silence by the photographic appearance of their ancestor or,
alternatively, forcibly voicing the iniquity of the colonial past, that
theoretical concerns may appear tangential. Nevertheless, the questions
must be asked, if only to illuminate the points of fracture that can
dissolve categories and translate visual images into real-life experience
of a past. The definitions of cultures, to which photographs have so
forcefully contributed, might at some level, for some images, emerge as

just part of their biography. The present act of recognition, rearticulation, and refiguration that these essays represent, is part of the ongoing entanglement of the photographic object in multiple histories and thus multiple trajectories.

I have only been able to summarise here the wide range of perspectives that permeate the volume and cause the essays to cohere. These will, severally, emerge more strongly at moments when their theoretical intervention is pertinent to a set of questions. I recognise that these are no more than partial and provisional readings of the photographs, for that is the nature of photographs. They have a rawness, uncontainability, resistance and ultimately unknowability, despite their clamorous claims to the contrary. By their very nature photographs are sites of multiple, contested and contesting histories. Rather, I hope to suggest ways in which the beleaguered historian or anthropologist, from any cultural space, can open a space in which some of those histories – those of the subjects, the institutional structures, the colonised and the colonisers – might become visible. For it is precisely the alternative readings and counter-narratives that are opened up by the paradoxical constraint and liberation within photographs,

Notes

1. Chapters 2 and 3 are first fruits of a much larger research project on the collection and dissemination of 'ethnographic' images in nineteenth-century Great Britain.

2. Notable and satisfying exceptions here are Poole (1997), Brothers (1997) and Hartmann, Hayes and Silvester (1998). In the recent *Companion Guide to Historiography* (ed. M. Bentley, London: Routledge, 1997) of over 1000 pages, 'photography', 'images' or 'visual' are conspicuously absent from the index. Similarly Gaynor Kavanagh's *Bibliography for History, History Curatorship and Museums* (Aldershot: Scolar Press, 1996) contains a mere 16 entries on film, video and photography. However, with the digital fracturing of the link between photography and its referent, when the indexicality of the photographic image can no longer be assumed as its evidential bedrock, theoretically informed historiographical engagement would seem more pressing than ever.

3. Many museums are developing increasingly nuanced practices of consultation, restitution, ethical curatorship and restricted access in relation to

photograph collections, especially in North America, Australia and New Zealand, where indigenous communities are an active part of a museum's constituency (see for example Holman 1996).

4. It is precisely this historical information embedded in the photograph as an object that is being lost in the eagerness of archivists, managers and funders to embrace copying technology, whether analogue or digital. For a cogent analysis of these issues see Sassoon (1998) and also Schwartz (1995).

5. Barthes also likened photography to theatre as sharing 'a singular immediacy' (1984:31–2); but whereas he related this relationship back to stillness and death, one could argue the opposite in the performative model.

6. The others being 'an outspoken affinity with unstaged reality, fortuitousness and indeterminacy'. In stating that the picture is bound by the plate, but that the subject from which it was extracted went off in three dimensions, Szarkowski himself points in this direction; but he does not explore it.

7. Hoskins (1998) and Cruikshank (1995), for example, have explored objects in this relation.

Part I

Notes from the Archive

two

Exchanging Photographs, Making Archives

The Shape of Collecting

It is quite clear to anyone with a comparative knowledge of photograph collections that the flow of images between scholars and other interested parties, in the nineteenth and early twentieth centuries, was constant and significant. In this chapter I want to explore the exchange and collecting of photographs within the interpretative community that constituted the anthropology of that period. In becoming socially salient objects, enmeshed within a visual economy that reflected complex and wide-reaching scientific and social networks, a wide variety of images was given anthropological authority. As Phillips and Steiner have argued in relation to objects, authority 'lies not in the property of the object itself, but in the very process of collection, which inscribes, at the moment of acquisition, the character and qualities that are associated with the object in both individual and collective memories' (1999:19). Objects, of course, also flowed through the networks; however, photographs were perhaps more plentiful; they were more easily exchanged, slipped into letters or pocket books, yet they leave fewer traces. Although I am concentrating here on the situation within British anthropology, similar exercises might be undertaken in relation to other national traditions in, for instance, Germany or France, with, one suspects, similar results, while yet simultaneously reflecting the particular characteristics of the organisation of science in any given national state and/or colonial power. Nonetheless, at another level those traditions overlapped through networks of collection and exchange amongst individual scholars that were truly international, in terms of both the subject-matter and the international world of scholarship and science.

These issues are of more than simply antiquarian interest. As Appadurai has argued 'We have to follow things themselves, for their meanings are inscribed in their forms, their uses, their trajectory. It is only through the analysis of these trajectories that we can interpret the human transactions and calculations that enliven things' (1986:5). Transactions and calculations are essential to understanding the archive. In a related way , historians such as Dening (1988:26) have considered the texting of history through the modes of its preservation, a view that relates to the social biography of archival materials and one that was prefigured in the work of earlier historiographers, as exemplified by Marc Bloch's comment, 'The migration of manuscripts is, in itself, an extremely interesting study . . . The progress of a literary work through libraries, the execution of its copies, and the care or negligence of librarians or copyist, fully correspond to the vicissitudes and interplay of the cultural main streams of real life' (1954:77). In this vein recent interest in both the history of collections and the deconstruction of photographic images has meant that, as I have suggested, photographs have ceased simply to be photographs 'of' things and become, rather, historically specific statements about them, with their own social biography – in other words, cultural objects in their own right.

The focus on the content of the image at the expense of historio-graphical interrogation of the record has meant a partial invisibility of, or a blindness to, some of the other histories such photographs have to tell, for 'micro-techniques are part of the construction of discourse – not merely its content' (Green-Lewis 1996:190). At a meta-level photographs were part of a new field of 'serially produced objects', which produced a new and homogeneous terrain of consumption and circulation in which the observer was lodged (Crary 1990:13; Tagg 1988), for the practices of seeing, collection and consumption constitute a technology of regulation as defined by Foucault. In more confined and specific contexts, they were part of the representational machine by which the construction and circulation of images worked within the trade routes of colonialism. Understanding the archive requires not only a conceptualisation of the ideological meta-levels and a critical engagement with the content of images themselves. It requires the exploration of the structuring of forms of accession, the processes of collecting and description, contexts of collecting and use and the range of social practices associated with them at a historically specific level, if we are to understand the histories embedded within the homogenised disciplinary archive: 'we often need to consider circuits, not simple place' (Clifford 1997:37). Such a position is also necessary if we are to

understand the micro-exchanges that make up 'the archive', where 'the anthropological archive' emerges as an accumulation of micro-relation-ships in which objects are involved. It resonates throughout with Tagg's model of the currency of photography whereby '. . . items produced by a certain elaborate mode of production and distributed, circulated and consumed within a given set of social relations: pieces of paper that changed hands, found a use, a meaning and a value, in certain social rituals' (1988:164). Without an understanding of these mechanisms, photographs cannot be fully used as evidence, a theme that will resonate through later chapters.

Exchange networks became possible through the availability of cheap photographic prints. The Great Exhibition of 1851 had been a starting-point for a massive rise in photographic awareness as it 'horizontally spread out to cover almost every conceivable form of human endeavour and vertically established itself through the various strata of nineteenth century society' (Hamber 1996:1). The increasing ease of photographic technology from about the 1860s onwards meant an explosion in the circulation of anthropological photographs. As Crary has argued in relation to the reshaping of vision in the nineteenth century, at an abstract level photography was a crucial component of a new cultural economy of value and exchange. Within this, photography reshaped 'the entire territory on which signs and images, each effectively severed from a referent, circulate and proliferate' (1990:13). This was essential for the development of collections, which are now perceived as the homogenised 'anthropological archive', which has become a privileged site of critique in recent years (for example Sekula 1987, 1989; Green 1984).[1] Studying the way in which exchange systems operated within the intellectual and social networks of late-nineteenth-century anthro-pology suggests not only the archive as palimpsest, but also a much more nuanced and indeed serendipitous development of the 'anthro-pological archive' that was not necessarily based on a directly causal realisation of the 'thesaurus of culture' or an undifferentiated appro-priative desire. While this latter model may work at a discursive meta-level and created the cultural preconditions for such activity, close consideration shows how 'the archive' breaks down into smaller, more differentiated and complex acts of anthropological intention in the production, evaluation and flow of images as items of data within anthropological circles. After all, collections require a human centre. In this characterisation, it has more in common with that aspect of Foucault's archive that 'differentiates discourses in their multiple existences and specifies them in their own duration' – discourses that

are 'composed together in accordance with multiple relations' (1989: 149).

The study of collection and exchange thus contributes to the understanding of the visual culture that sustained nineteenth-century anthropology. Exchange, or rather here acts of reciprocity, is, as all anthropologists know, central to the identity and cohesion of social groups, linking participants in a chain of gifts and obligations (Kopytoff 1986:69). Consequently exchange was as much a facet of disciplinary sociability as scientific pragmatic. The circulation of photographs formed a common ground that linked anthropologist to anthropologist; they operated as objects that fixed moments within relationships. Additionally, such a study also points to shifts in both observational rhetoric and institutional paradigms. Further studies of collections' history in relation to anthropological photographs will, in the fullness of time, reveal the nuances, ambiguities and points of fracture of that particular trajectory. Ultimately, what did anthropologists actually *see*? One cannot hope to answer so large a question fully, but rather to point in the direction of future research by concentrating on exchange roles.

The focus here is the way in which images were made, collected and exchanged by individual scholars who authored collections of photographs according to their interests and networks. Although the exchanges that concern me were informal, they either operated within, or overlapped with, institutions that were part of what Richards has described as an 'archive [which] took the form not of a specific institution but of an ideological construction for projecting the epistemological extension of Britain into and beyond its Empire' (1993:19). While the museum and the archive are understood as representing a detached mastery over objects – the detemporalised end-product of collecting – collecting itself is perhaps more private, reflecting smaller obsessions and intentions (Thomas 1994b:116). Nevertheless, individual collections, cohering around private interests, become intimately related to the development of larger collections – such as that at the Pitt Rivers Museum, University of Oxford or the University of Cambridge Museum of Archaeology and Anthropology. As individual scholars donated or bequeathed their collections to the central archive, they became absorbed within specific institutional agendas of description, function and usage.

I shall draw for the most part on examples from three important figures in late nineteenth- and early twentieth-century British anthropology, Edward Burnett Tylor, who held the first teaching post in

anthropology in a British university when he was appointed at Oxford in 1884 as a condition of the Pitt Rivers gift to the University; Henry Balfour, first curator of the Pitt Rivers Museum; and Alfred Cort Haddon, closely connected with the Museum of Archaeology and Anthropology and, from 1900, lecturer in anthropology at the University of Cambridge. While they are far from being alone in such activities, they are nonetheless exemplary in the way that photographs flowed ceaselessly around their networks, making meanings about culture. In the case of Tylor and Haddon, in particular, they were involved in generating wider-reaching theories on humanity, culture and origins, in which the visual played an important role. Although I can only give a few examples in support of my thesis in a single essay, they should be understood to be indicative of broader patterns. Even at this stage in our understanding of the collecting of photographs, what is striking is the scale and intensity of exchange activities.

The collecting and exchange of images might be seen as an extension of the eighteenth- and early nineteenth-century antiquary's portfolio of engravings of, for instance, classical sculpture or vases. There was, of course, also an established tradition of exchanging photographic images. Amongst early enthusiasts in photography in the 1840s and 1850s, this had been concerned with the technical and aesthetic development of the medium. However, by the 1860s the amateur period of photography was loosing its experimental impetus, and exchange and collection were merging with subject or document collecting (Sieberling and Blore 1986). Collecting clubs, what Pearce has described as 'peer collecting', were active in a wide range of subject areas such as archaeology and natural history, and they developed an immense and complex network, encompassing a broad range in collecting activity (1995:230–1). However, more importantly, the exchange system also belonged to a developing scientific discourse that linked the profession-alisation of knowledge to the flow of information, the sharing of data and the maintenance of scientific 'social' networks of the emergent anthropological discipline through reciprocity and exchange (Kuklick 1991:27). Within this, certain forms of vision emerged as privileged, in that they met several criteria of, for example, production and use, which were established by an emerging consensus of authorities within the discipline (Tucker 1997:381; Daston and Galison 1992).

Assumptions about the analogical nature of photography in nineteenth-century anthropology have, by now, been well documented (see for example Green-Lewis 1996 and references therein). Photographs closed the space between the site of observation on the colonial periphery

and the site of metropolitan interpretation. The indexical nature of the medium, the inscription through the action of reflected light on sensitised emulsion on glass, film or paper, created 'immutable mobiles' through which information could be transferred in uncorrupted form to another interpretative space (Latour 1986). They created a form of 'virtual witness' – 'what I saw, you too will see' – attesting to the truth value of observation (Shapin and Schaffer 1985:30), functioning as a way of amassing raw data in analogical or metonymic form and re presenting material for interpretation in visual form.

Considerable attention has been given to the learned societies in the development of anthropology and the collection of anthropological knowledge through the *Notes and Queries* publications, the first edition of which came out in 1874 (for example Urry 1993; Poignant 1992a; Stocking 1987:258–61). However, as Stocking has pointed out, there was 'a previously unappreciated form . . . what may be called "epistolary ethnography"' (1995:16). Many anthropologists of Tylor's generation, and indeed later, were in postal contact with missionaries, colonial officers and others with anthropological interests who were capable of competent observation. They answered queries, and supplied inform-ation, and in return Tylor and others would shepherd their papers into print in the *Anthropological Journal* or similar specialist journals. Flowing through this vast network, very often unremarked, were photographs. Photographs were displayed, swapped, collected, taken for collectors locally, and were active participants in the making of meanings around culture. There were perhaps two overlapping 'trade routes' through which photographs moved. One must distinguish between them because they have since become conflated in the culture of archiving. First were the centralised projects of photographic collection focused on the learned and scientific institutions, and second, those reference collections of individual scholars that have since been deposited in larger institutional archive collections. While their histories have somewhat different foci, they were premised identically on the immut-able mobile and the promise of virtual witness.

In Britain, the collecting activities of the Anthropological Institute were paradigmatic of the centralising collections made by learned institutions and, later, by museums and universities, which formed the various sites of 'archival confinement of total knowledge' (Richards 1993:11). From the early 1870s onwards, the Institute not only initiated projects in conjunction with the British Association for the Advance-ment of Science (hereafter B.A.A.S.), but also regularly received gifts of photographs "of anthropological interest' from other learned societies

and individual scholars. Photographs were regularly shown at meetings: for instance, in 1881, Richard Buchta's African photographs were shown (Anthropological Institute 1882:74); in 1886, Prince Roland Bonaparte showed his portfolio of portraits of Sami people ;[2] photographs from Niger were displayed in 1887 (Anthropological Institute 1887:23) and in 1889 H. O. Forbes's photographs from his 1887–1888 expedition to the Owen Stanley Range, New Guinea, were exhibited (Anthropological Institute 1889:241). There were institutional exchanges: for instance, F. Hayden, of the United States Geological Survey, presented the Anthropological Institute (Anthropological Institute 1878:2) with an album of some 600 photographs of Native American peoples in 1877, and the Bureau of American Ethnology presented the newly formed Pitt Rivers Museum with a substantial collection of objects and some ninety photographs in 1886 as an act of scientific reciprocity.[3] Such exchanges were, however, never formalised within ethnography in the way they were in fine and decorative arts and antiquities;[4] yet the impetus was similarly grounded. Many of the object photographs I discuss in the next chapter moved through these exchange networks. Clearly one of the objectives of W. T. Brigham, the director of the Bernice P. Bishop Museum in Honolulu, on his tours of American and European Museums in 1896 and 1912, was to establish networks through which he could exchange photographs of comparative material culture, mutually enhancing museum collections: 'The time may come when all important museums will photograph their collections on scale, bearing the museum number, for exchange with other museums in the same line and using the same method' (1913:265). A history of the Anthropological Institute collection is beyond the scope of this essay, and in any case has been admirably addressed by Roslyn Poignant (1992a). Suffice it to say that the shape of that collection today reflects the shifts in anthropological thinking over the years; its inclusions and exclusions define the fluctuating boundaries of the discipline. Yet it is an eclectic and inclusive collection, against which one can position the shape of the collections of individual anthropologists and the way those collections reflect the extent of their specific interests.

An Interpretative Community

Given that the boundaries of the anthropological discipline were fluid at this date, and that practitioners were not necessarily university-trained or of scientific eminence, it was consistent with the organisation of science that the institutional bases of the subject, the Anthropological

Institute and the B.A.A.S., were outside the university system. Even if a large number of their officers and membership came from within it, both were still forums in which it was appropriate for anthropological knowledge to be made and exchanged outside the academy in a reciprocal relationship (Kuklick 1991:44–5). Notices and reports of meetings of the Anthropological Institute and other learned societies were published in widely read newspapers and journals such as *The Athenaeum*. Photographs, the confirmation of observation, operated within this broadly based anthropological awareness. Consequently, learned papers elicited photographs from a wide range of sources, and these entered the scientific exchange system. For example, Balfour's copies of his article offprints were interleaved with written and especially visual responses to his papers from a very wide range of correspondents with anthropological interests. For instance, his paper on frictional firemaking of 1914 attracted, amongst others, a letter from F. W. Barton, a colonial administrator with serious collecting and photographic interests, describing firemaking in the Owen Stanley Range in New Guinea: 'If you like I can send you photographs of the men making fire in a standing position & also one showing the ratten round their waists and their peculiar petticoats"(Figure 2.1).[5] Earlier, when Thomas Huxley was facilitating a photographic survey of the races of the British Empire through the Colonial Office in London (see Chapter 6) he received unsolicited 'ethnographic' photographs from Formosa, purchased in China, from a Mr W. A. Pye, who had heard of the project through a relation in the Colonial Office.[6] Tylor's paper on ancient games (1879) similarly elicited a considerable correspondence with related photographs. However, amongst scientists themselves, the exchange of photographs appears to operate at a more intimate level of social connection than that other scientific exchange ritual that emerged in the nineteenth century, and is still avidly pursued, the exchange of offprints.[7]

Despite, or perhaps because of, the ubiquity of photography by the late nineteenth century, there is relatively little commentary on it, on specific images or practices, when compared with the huge body of material now extant in anthropological photograph collections or archives. The instructions given on photography in, for instance, the 3rd edition (1899) of *Notes and Queries on Anthropology,* the first edition to carry a substantial section on photography, provide a *post-factum* statement of photographic expectation rather than setting new agendas for photography. However, there is no clue to the way the trade routes

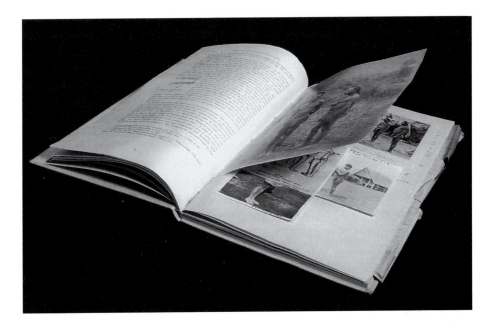

Figure 2.1 Photographs sent to Balfour, interleaved in his copy of his paper on firemaking. (Courtesy of the Balfour Library, Pitt Rivers Museum, University of Oxford.)

operated within this; rather, the circulation of images is naturalised within the relations between the 'man on the spot' and the interpreting anthropologists of the metropolitan centres. Much of the evidence is in the dissemination patterns of images themselves and in museum documentation of these images. However, a combination of the status of photograph collections within anthropological institutions and museums and the way they have had their contexts destroyed through archiving means that coverage is often uneven and varies in its density. There is some substantiating material in manuscript collections and a certain amount of evidence in the acknowledgements in the published record. However, these do not necessarily reveal the precise status of photographs within the implied relationship. The piecing together of small fragments of evidence nonetheless has a massing effect and gives

an impression of the very substantial level and range of activity in photographic exchange. Some examples from the vast array of possibilities will serve as representative samples:

W. Gowland, who had previously sent Tylor photographs from Japan and China, wrote to him on 14 April 1894:

A friend of mine has undertaken to procure photographs of groups of wooden figures in the temple at Canton representing the tortures of the Buddhist hades and I hope to receive them some time.[8]

Horatio Hale to Tylor, 12 November 1896:

I send you a copy [of a photograph of wampum belts]. It is the last I possess, and I must request you be kindly prepared to return it if I should write for it. Otherwise please keep it with the other documents I send.[9]

F. W. Elworthy [Folklorist] to A. C. Haddon, 21 October 1897:

If you care for them I can send you the original photos. From which these prints were done, as I do not want them any more . . . You kindly said you could send me photos. or slides of corn maidens from Cambridge.[10]

Walter Baldwin Spencer to James Frazer, 12 July 1897:

By the last mail I sent a few photos, to give some idea of what the ceremonies are like which are described in 'Nature' of June 10.[11]

A. M. Fillodean [Sacred Heart Mission, Glastonbury] to Haddon, 12 November 1902:

I brought back a certain number of photographs [from New Guinea] as they may be agreeable to you I forward some of them. Be so kind as to accept them in remembrance of one who was delighted with your so learned conversation in New Guinea.[12]

Exchanged images formed a serendipitous massing of discrete pieces of data for use in a comparative method. In January 1890 A. C. Lyall sent Tylor two copies of a photograph of '2 natives playing Pachiri [a board game]' taken at Multra, North-West India, commenting 'I think you wished to compare the Indian Pachiri players with ancient Mexican or Peruvian drawings.'[13] The reality effect of photography, amassed through the accumulation of images, stressed the comparative qualities of accounts. This was further accentuated through the nature of

photography itself, which created isolatable units for examination.

Haddon was particularly interested in the role of the visual in ethnography. He gave lectures on photography and folklore,[14] and was a keen photographer and active in the exchange of images. There is a particularly interesting correspondence with Otto Finsch, the German zoologist and ethnologist, on the subject of Melanesian photographs, for it indicates not only the exchange of photographs in developing an ethnographic baseline for a region, but also the declining evidential value of certain forms of anthropological photography in the late nineteenth century. In a letter dated 24 May 1893 Finsch writes:

> I send you a rough list which of course only shows the location. But I can give to each Photo a full description on all particulars and these informations [sic] balance the imperfections of many plates. As a whole the collection, never published, reference a lot of interesting types and would be very valuable to the knowledge of Races of men, and for Anthropological and Ethnological Science in general. But according to my experience Science does care very little on such material and its scientific value and so it becomes a useless thing and a source of constant harm to the poor creator regarding to the many costs, not to mention the amount of time and trouble. [original English][15]

A number of interesting points emerge from this passage, substantiating more piecemeal evidence. First is the idea that photographs were integral to other forms of anthropological data and that data emerge from a balanced confluence of different representational forms; here, caption and image. Second, it suggests the shifting truth values accorded to certain kinds of images, where 'types', which had dominated much of the anthropological visual discourse in the 1870s and 1880s, were beginning to give way to the truth values of observation through the 'no-style style' of photography of unmediated realism and naturalism. I shall return to this issue of shifting truth values in the relationship between photography and anthropology at the end of this chapter.[16]

While the personal and the institutional existed simultaneously, complementarily, and to an extent overlapped, for much of the late nineteenth century, by the early twentieth century this pattern of photographic use was beginning to give way to a valuation of photographic evidence that privileged the residue of individual field experience over the collected portfolios of photographic evidence. This shift exactly mirrors the development of the primacy of individual fieldwork over

the serendipitous collection of examples of isolated phenomena for the purposes of comparative study. However, Patrick Wolfe's recent claim (1999:151–2) that the development of the relationship between anthropology and photography shifts from collecting to observation is too disingenuous, for it overlooks the function of photographs within certain parameters of scientific knowledge-making in the late nineteenth century. Collection, in effect, constituted observation by the 'virtual', where objects and photographs were perceived as having inherent scientific validity in the structure of data. However, as I have already suggested, there was not necessarily a naive acceptance or objectivity attached to photographs, in that meaningful representations in late-nineteenth-century anthropological science did not happen automatically but were made through group massing of certain forms of images that flowed through the exchange networks. The authority of the photographic document was often conferred or confirmed by the reputation, reliability or power of the person or persons concurring in the formation of the photograph (Schwartz:1995:45). This emerges strongly in a correspondence between Balfour and Spencer soon after the latter's return from fieldwork in central Australia with the 1896 Horn Expedition. Balfour was anxious to get a set of photographs: 'It was very kind of Horn to promise you Anthrop. Photos. But they don't belong to him but to Gillen who handed them over on the distinct understanding that copies were not to be given away without permission. However we can let you have some much better ones.'[17] In the interim Balfour approached Gillen, keen to get the photographs, but clearly to no avail. On 23 September 1898 he wrote to Spencer:

> I wrote to Gillen some time ago asking him if he could very kindly let me have photographs of his natives especially such that deal with arts, customs etc. I have not heard from him & I dare say he is far too busy to attend to 'begging letters' . . . Photos. I find are so important an adjunct to a Museum that I try to beg all I can for as series I am making for the Museum. My funds don't allow of my buying many in the open market, & the trade ones are apt to be unsatisfactory & made up.[18]

Significant are, first, the implication of the privileging of the record of the man of science on the spot; second, a specific assessment of the 'truth value' of different kinds of images; third, the prevalence of copying and exchange; fourth, the interpenetration of personal and institutional interests in the building of collections; and finally, perhaps,

this correspondence's hints at the shifting of the photographic from the centralised endeavour to the production of material specific to a body of fieldwork.

If there were tensions between personal and institutional collections, they were resolved through copying and exchange. Photographs as reproducible forms, were perceived as pieces of information to move through different spaces in the way that Latour has argued. The vast number of copy negatives of photographs and series of multiple prints dating from the early part of the twentieth century in collections such as that of the Pitt Rivers Museum would point to this, as would the numerous references to borrowing and copying photographs in the correspondence of anthropologists. For instance, Frank Gillen, writing in 1895 to Spencer, his collaborator in the Central Australian fieldwork, was anxious that their rival E. C. Stirling did not have access to some of their photographs to make copies: 'He is to take charge of . . . the plates and take any lantern slides he wishes from them as none of these plates are of any importance it does not matter a twopenny d—m if he takes slides of the lot. The negatives in your possession are not to be used for this purpose until after publication' (Mulvaney, Petch and Morphy 1997:82).

What is significant in this exchange system, beyond the consolidation of relationships and the consolidation of data in the interpretative community, is that the material in circulation was active in the making of meanings about cultures. The flow of exchange photographs was longest-lived in material culture studies, where analogical and metonymic functions of photography continued to provide isolated units of comparative material. For instance, some of the 1898 Torres Strait Expedition's field photographs entered the exchange system on their return home. Haddon sent Balfour a full set on pottery-making in the Papuan Gulf, apparently relatively soon after the return of the Expedition. These were still active in making meanings within the Museum in the 1930s, when they were integrated into a typological series on ceramic technology. The two series, those from the village of Hanuabada and those made in a colonial officer's compound, were conflated to make meaning, arranged on a card carefully captioned with the narrative of pottery-making. This mirrors, visually, the process of ethnographic production where multiple happenings are conflated to make a generalised statement of cultural behaviour. Absorbed into the museum's representational systems,[19] they were shown with objects in the museum's display, active in the economy of truth in the museum's

public spaces, and thus were launched on yet another trajectory of institutional meaning. The activity of collected images has not ceased: the meanings they generated, and still generate, fluctuate in application and intensity, but remain enmeshed in performances and 'trade routes'.

Although much of the material under discussion might be described as 'amateur' in that it was made by anthropologists themselves or their friends, commercially produced images also functioned within exchange networks.[20] As is well acknowledged, anthropologists also absorbed commercially produced material into their collections. If commercially produced images can be said to have an ethnographic intention through the broadly racialised discourses of colonial photographic practice, their absorption into the scientific gave them authority. The dominance of the analogical value of subject-matter over photographic style allowed a slippage between both contexts of production and photographic aesthetics. It would seem that anthropologists had a knowledge of commercial photographers working in the ethnographic genre. For example, many anthropologists with an interest in Melanesia owned photographs by the L.M.S. missionary the Revd. W. G. Lawes, as well as photographs from Lindt's *Picturesque New Guinea*, which were available as a bound volume or as loose prints. Both Balfour and Haddon, for instance, collected Thomas Andrew's studio portraits of Samoan men and women, which became absorbed into the discourse of type within anthropological evaluation, despite the fact that they were produced for a tourist market in exotica.

What is significant is the way in which the dominant noise of the content suppressed differences in photographic style and intention through a privileging of content over form in producing meaning. Realism, in and of itself, is not photographic, but part of a much broader discursive formation, one manifestation of which was precisely a desire for greater pictorial accuracy. This was, of course, a historically specific evaluation that was linked to what was available. However Geertz's argument, in a different context, seems pertinent here: representations 'must be cast in terms of the interpretations to which persons of a particular denomination subject their experiences, because that is what they profess to be descriptions of, they are anthropological because it is in fact, anthropologists who profess them' (1973:15). Therefore it was important that the Berliner Gesellschaft für Anthropologie gave anthropological credibility to an ethnographic atlas produced by the Hamburg photographer Carl Dammann that comprised copies of a mixture of commercially and scientifically produced material in a

variety of formats (Theye 1994/5). Tylor, caught between photographic realism and scientific method, was able in 1876 to praise it as 'one of the most important contributions to the science of man' (1876:184) and used a number of the photographs as the basis of engravings in his *Anthropology* of 1881.

Commercial dissemination did not necessarily mean the image was produced within an uncomplicated commercial environment. Perhaps the most widely disseminated example of work of this category is that of Revd. W. G. Lawes.[21] He took up photography in the early 1870s and by the late 1880s was selling his photographs through Henry King in Sydney, who published a catalogue listing of the photographs divided into several sections. One of these comprises largely views of villages and canoes, while a further distinct category comprises almost entirely portraits of scientific reference. We are fortunate that copies of these lists survive in the collections of both Tylor and Haddon. There is a clear confluence of interests in the way that both anthropologists selected images from both the 'General' and 'Anthropological' sections. Their interest was in the appearance of pristine culture; significantly, choices from the 'Mission' section are absent. Haddon's comments survive, and it is clear, from the list in which he gave negative numbers and commented on the images, that he valued photographs that show clear 'physical type' and tattoo patterns, followed by those that display elements of material culture to the camera; in a couple of instances he actually noted that the subjects were wearing European clothing. In *Decorative Art of British New Guinea,* he exhorted other anthropologists to acquire the photographs: 'The Rev. W. G. Lawes, of Port Moresby, has taken a large number of most excellent photographs illustrating Papuan ethnology, and he has generously deposited the negatives with Mr. H. King, Georgestreet [*sic*], Sydney N.S.Wales, in order that anthropologists might have the opportunity of purchasing authentic photographs' (1894:275).

Such examples abound. Balfour bought a whole set of ethnographic photographs from the German Trappist Mission at Marianhill, Natal, in 1896. The same set was bought by, for instance, Küppers-Loosen, a Cologne businessman with strong geographic and ethnographic interests whose collection now forms the historical core of the photograph collection at the Rautenstrauch-Joest Museum.[22] Other photographers who were extensively collected as data in the late nineteenth century were, for example, Beattie, Martin (who advertised 'Special Type Collections of Ethnological and Anthropological Subjects Selected for

Students, Societies or Museums'),[23] Dufty, Kerry[24] and Tattershall in the Pacific and Australia, Middlebrook, Caney, and Lloyd in Southern Africa, and Zangeki from North Africa.[25] Such commercial material, following Tagg, found meaning and value within the rituals of anthropology. One manifestation of this flow of information and images is that there is a very substantial overlap between photographic collections across Europe and to an extent through North America and Australia. The evaluation of photographic collections often tends to stress the rare and the different, premised on the content of the image and singularity. However, the overlaps and duplications between and within collections are equally significant. What were the images that many anthropologists had and used? From this perspective it is possible to point to certain images that were deemed 'of interest' and in demand, even if this was due in part to aggressive marketing by photographers. Such images successfully performed as anthropological according to historically specific ideas of evidential veracity in disciplinary terms. In this register, overlap and duplication, often created through the networks of exchange, are measures of that success.

Looking at Photographs

Looking at other anthropologists' collections was clearly part of the exchange system. Photographs in these terms were truly 'social objects'. Images did not exist merely as in the context of abstract and ideological discourse. They were looked at, copied from, discussed, and existed in bodily relation with the viewer in social time and space. Henry Cole, the key figure in the development of photography and its collection at the South Kensington Museum (later the Victoria and Albert Museum) is known to have made a habit of examining photographic reproductions of art with friends (Hamber 1996:407; A. Thomas 1997:81). It is not unreasonable to think that anthropologists did the same. A few examples must suffice. The Revd William Turner had access to Lawes's photographs and others during his time in New Guinea; these he used as engravings in his paper 'Ethnology of Motu', published in the *Anthropological Journal* (1878:473). Haddon's papers include sketches of photographs by H. O. Forbes and others that can be identified as being by Josiah Martin in Fiji and Thomas Andrew in Samoa, both dating from the 1890s (Figure 2.2). Possibly he saw them in Oxford, for Balfour acquired a series in the 1890s through his cousin Graham Balfour, who was part of Robert Louis Stevenson's set in Samoa. Spencer wrote to Balfour that he is sorting out the photographs left behind by

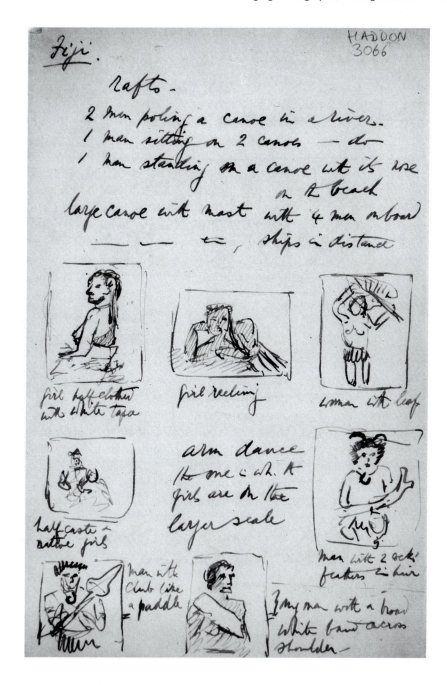

Figure 2.2 Looking at photographs: drawings by Haddon of photographs from Fiji. (Courtesy of the Cambridge University Museum of Archaeology and Anthropology Haddon Papers Env. 3066.)

Haddon and Balfour after the 1914 B.A.A.S. meeting in Australia; the implication is that they were working with them together.

It is clear from the references and acknowledgements in published sources, from scribbled addresses and from photographers' prospectuses that the knowledge of reliable sources of commercial material in the ethnographic genre was part of the flow of information within the scientific exchange system. Indeed the desire for photographs can be traced through the historical copy negatives of commercial images. They must have been seen and made in collections of other anthropological photographs, even if we have lost the precise 'trade route'. Furthermore, as I have suggested, endorsement by this interpretative community enhanced claims to the scientific status of images, as the trade routes and the provenance of photographs were a critical part of their discourse. As Poole has argued 'When we consider such social uses of photographic objects and commodities, it becomes clear that the value of images is not limited to the worth they accrue as representations seen (or consumed) by individual viewers. Instead images also accrue value through the social processes of accumulation, possession, circulation and exchange' (1997:11). Thus the symbolic value in the relationships between individuals was, at one level, as important as the scientific content of the images. The following example serves to illustrate the interconnectedness of the networks. Haddon, as we have seen, extolled the virtues of Lawes's photographs in *Decorative Arts*; addresses were perhaps passed around – there is a tiny scrap of card in Haddon's papers, torn from a programme card of the Belfast Natural History and Field Club, on which is scribbled the address of Henry King, the Sydney photographer. A member of that club was the Belfast photographer R. W. Welch, who produced a substantial series on Irish folklife and knew Haddon well;[26] and the latter recommended Welch's photographs to Balfour, who acquired a series for the Pitt Rivers Museum in 1906.

Lantern slides formed a crucial element of the exchange system, constituting a key way in which images were viewed, both formally and informally, in anthropology and more widely. Through lantern slides photographs left the study and became active performers in the dissemination of anthropological meaning. A vast amount of work remains to be done on lantern slides themselves; however, through them one can track the movement of some of these images into wider anthropological discourses. Turned into lantern slides, photographs impressed specific figurations of a cultural reality on students and audiences at scientific meetings. Further, like published photographs working with text, they had an 'affective tone' in the wider culture of

representation within anthropology. For instance, throughout his life Haddon gave public lectures, and it was through them that not only photographs from his own fieldwork, especially those of a more 'primitivist' appearance, but also material from the exchange networks was disseminated. He had lantern slides of some of Otto Finsch's photographs, for instance, and commercial photographs such as those by Welch, the Belfast photographer. It would appear that Seligmann used photographs of *dubu* platforms given to him by A. C. English, Government Officer of Rigo District, British New Guinea as lantern slides to illustrate his paper on the subject at the Dover B.A.A.S. meeting in September 1899. Tylor had some of the photographs from the Bureau of American Ethnology gift of 1886 made into lantern slides by Henry Taunt of Oxford, a leading local photographic firm. Haddon borrowed photographs from the missionary ethnographer Dauncey to make lantern slides in 1900,[27] and Beatrice Blackwood in Oxford was borrowing photographs from Haddon, and vice versa, to make slides as late as the 1930s, to give just a few examples.[28] Indeed, it would appear that, with copying, the making of lantern slides was one of the main reasons for the loan (as opposed to the exchange) of photographs within this general network of exchange and reciprocity.

However, it would appear that the act of showing lantern slides was also part of the general exchange and flow of anthropological data – almost an act of scientific courtesy. The reciprocal nature of this is very clear in the case of David Ballantine, the customs officer from Port Moresby. When members of the Torres Strait Expedition visited the Gulf region they were entertained on a number of occasions by lantern slide shows of material of local interest; for instance Ballantine showed local lantern slides to the expedition members after dinner one evening: 'In the evening Ballantine gave them [the Papuan people] a lantern show in the boat house – interspersed with phonograph songs and tunes by Ray. I think they did not take to the latter – but the pictures were thoroughly appreciated by them.' When Ballantine was due to return to England on leave, Haddon wrote to his wife from Port Moresby:

B[allantine] has a lot of N.G. Lantern slides. Speak to Ridgeway[29] ab[ou]t him & see if the Camb[ridge] Ant[hropological] Soc[iety] w[oul]d like a show – This could be arranged when B writes to you . . . Please show B all my lantern slides & especially the Folk-lore ones wh[ich] you can easily explain to him . . . & ask R[idgeway] to show B the anth[ropological] slides.[30]

Earlier when MacGregor, Governor of British New Guinea, gave a lecture at the Royal Geographical Society in 1895 it was Haddon who prepared, and perhaps lent, some of the lantern slides, for he was thanked for the 'great trouble he has taken in preparing the photographs . . . several of which – I believe as many as twelve – he prepared this very day' (MacGregor 1897:100).[31]

At one level, the lantern slide shows can be seen as an extension of the replication and virtual witnessing that was central to the exchange networks themselves. They also shifted anthropological images, whatever their origin, into a performative space in a way that became increasingly significant in the making and reproduction of anthropological meaning with the rise of university-based anthropological teaching in the early years of the twentieth century.

Shifting Interests

If, by the First World War, there was a shift in the valuation of photographic material within British anthropology, how did this manifest itself within the exchange of images along the networks involved in the making of anthropological knowledge? As the focus of anthropological activity, at least in its theoretical character, moved towards the university departments rather than the museums and learned societies, the idea of photographs as a centralised resource began to decline. If the exchange of images was constituted by the cultural expectancy of photographic truth value and analogical veracity, along with the free flow of information amongst the anthropologically minded, the gradual decline in the flow of images, solicited or unsolicited, along 'trade routes' as currency of information can be written in terms of a professionalising and increasingly exclusive disciplinary self-definition in British anthropology. Related to this is a shift in the idea of valid data and a shift in the power to authenticate. Isolated pieces of information, both in terms of observation and photographic expression, and a massing effect of comparative data that had informed definitions of culture premised on the positioning of data within an evolutionary, or at least progressivist, model gave way to an increasingly integrated model of social structure for which the photograph was perceived as a less satisfactory mode of recording and expression. Furthermore, as depth rather than surface became the perceived goal of the anthropologist, the realist insistence of photography appeared increasingly irrelevant to the concerns of modern, functionalist anthropology.

As photographs moved from being a process to a product of fieldwork, so they moved from a 'public' sphere' to a private one. This was not in terms of a private collection in the way that Tylor or Haddon had developed it, but the relation of a body of photography to a specific fieldwork endeavour, private like field notes, rather than a shared resource, with sets of images with deposited key institutions. As I have suggested, this may be at the root of Gillen's reluctance to circulate his photographs. This shift from 'public' to 'private' changed radically the role of photography in the making of generalised meanings, outside the published record and the lecture theatre.

At the same time the changes in the truth value of anthropological observation, shifting towards the individual fieldworker making extended and concentrated observation in the field, made photographs produced in such contexts increasingly desirable within those institutions that were becoming more marginalised in intellectual terms. This is illustrated by Balfour's anxiety to acquire photographs from Spencer and Gillen's work in central Australia, which I quoted above. As Finsch's letter to Haddon suggests, there is the shift away from the mapping of physical types alone towards a more culturally articulated form of field photography. Balfour's privileging of scientific men in the field over other forms of image-making points to a shift away from the more fluid slippages between photographic dialects that had characterised the earlier period.

In the twentieth century, within the ethos of individual fieldwork in the British school, photographs remained in the private domain, being specific to particular fieldwork endeavours. Despite its visualist metaphors, in an anthropology premised on observation embodied in the fieldworker and not the camera, the immutable mobiles that moved raw data around the anthropological networks ceased to have the same relevance. As photographic material ceased to have such a central role in the collective making of anthropological knowledge, its exchange value declined. The photographs of fieldworkers of the classic mid-twentieth-century British fieldwork period were not, on the whole, widely circulated, nor did anthropologists, especially those working outside the interests of material culture, collect from other sources; this for instance, is in part the reason why Jenness's photographs, discussed in Chapter 4, were treated as 'collection-specific'. In another example, Malinowski's collection of photographs contains very little that does not belong directly to his own work, and much of that which is present was taken by his friend and photographic collaborator, Billy Hancock (Young 1998:17–18). Such photographs as Malinowski's, or

later Evans-Pritchard's, remained largely within the private domain of individual research and publication until they had outlived their usefulness for their originator and were archived, thus becoming 'public domain' or centralised resource. Here again the archiving of the collections of Malinowski at the London School of Economics and Evans-Pritchard at the Pitt Rivers Museum are typical of this trend. Once in the archive, however, they assume aspects of equivalence through homogenising discourses of precisely those institutional practices that absorb the earlier material with which I have been concerned.

Thus one can argue that the rejection of nineteenth-century ways of acquiring photographs occurred not merely because of what they 'showed' (or did not 'show'), but that the process of producing photographs was integrally linked to shifting evaluations of the nature of the production of evidence and changing modes in the transmission of that information. The exchange of images relates to larger questions of the production of anthropological knowledge in the late nineteenth century at which I have only been able to hint in this chapter. If reality constructions are a mosaic formed by fitting together observations according to their content, the shape of recording, selection and dissemination is crucial. Of course, relics of the past are cultural artefacts of the moments that produce them, but they are cultural artefacts of *all* the moments that give them permanence (Dening 1996:43). If we accept that this is so of anthropological photographs, then their collections history, that is the way they were collected, the meanings attributed to content, how they were used and the contemporary status of the photograph's creators and owners, become important. These constituent parts of the social biography of photographs and their life histories in interpretative communities of anthropology are crucial to the history of the photographs and their role in the history of anthropology. This essay can claim only to be introductory to such a vast field; however, I hope I have highlighted an area for future research that will enable us to have a better understanding of the role of photographs in late nineteenth- and early twentieth-century anthropology, built on solid ethnographies of photographic collections rather than solely on assumptions about the nature of the archive. While the latter may work as 'the imagined form of a utopian state' (Richards 1993:11) of knowledge, they do little to offer an ethnographic explanation of the social and cultural flow in which photographs were entangled. The 'presence or absence in the depth of the archive ... are due to human causes which by no means elude analysis. The problems posed by their

transmission ... are most intimately connected with the life of the past' (Bloch 1954:71). Looking at the trade routes or networks through which photographs moved perhaps suggests some ways in which they might be used to understand the processes through which meanings were made in anthropology in the emergent years of modern practice.

Notes

1. From within anthropology itself there has been the exhibition *Impossible Science of Being*, curated by Chris Pinney, Roslyn Poignant and Chris Wright of the Royal Anthropological Institute at the Photographers Gallery, London 1996.

2. See Chapter 9.

3. The US Geological Survey had an ethnological function that was constituted as the Bureau for American Ethnology in 1878.

4. An international agreement on the exchange of reproductions of fine art was made at the International Exhibition in Paris in 1867. This included casts and electrotypes as well as photographs (Hamber 1996:407).

5. Barton to Balfour, 1 December 1914. Interleaved in Balfour's bound copy of 'Frictional Fire-Making' (reprint from *Journal of the Anthropological Institute* 44). PRM.Balfour Library.

6. ICL.HP Vol.XV.

7. The 'social' elements are also represented in exchanges, for example, in a scientific letter to Tylor (May 1888) A. W. Howitt enclosed three family photographs of an Easter picnic party (PRM.TP Box 12).

8. PRM. TP Box 12.

9. Ibid.

10. CUL. HP Envelope 2010.

11. PRM.SP Box 5.1. The reference is to Spencer and Gillen 'The Engwura' (1897) *Nature* 56:136–9.

12. CUL.HP, Envelope 3066. Haddon had visited the Sacred Heart Mission at Yule Island, Papuan Gulf, whilst on the Cambridge Torres Strait Expedition.

13. PRM.PC C1.18.28. Related Documents File.

14. One such lecture is summarised in *Folklore* (Haddon 1895).

15. CUL.HP Envelope 4.

16. CUL.HP Envelope 1053.

17. PRM.SP Box IV.

18. Ibid. It appears that Balfour only ever got limited access to Spencer's and Gillen's photographs in unpublished form. While he undoubtedly saw

them in Australia in 1914, none seem to be in Balfour's own collection. The series in the Pitt Rivers Museum was donated by Spencer's daughter in 1932, a couple of years after her father's death.

19. PRM.PC.C1.12.6–8. Balfour also received a set of photographs of the tattooing process (PRM. PC.C.12.17).

20. Many anthropologists of the period, for example Spencer and Haddon, were highly competent photographic technicians, capable of undertaking complex darkroom work.

21. For a discussion of Lawes as a missionary photographer see Webb (1997:17–19). Lawes photographs can be found, for instance, in collections in London, Oxford, Cambridge, Cologne, Harvard and Sydney.

22. For a brief history of the collection in Cologne see Engelhard and Wolf (1991).

23. Josiah Martin, *Selected Catalogue of New Zealand Scenery,* advertising pamphlet *c.*1890 (PRM.PC. AL.55 Related Documents File)

24. A set of Kerry's lantern slides of Aboriginal rituals and social life has recently been identified at the Pitt Rivers Museum as belonging to Radcliffe Brown. The slides are accompanied by Kerry's catalogue list marked up in Radcliffe Brown's hand. Presumably these images of pristine culture were used to illustrate lectures on the social organisation of Australian tribes.

25. Overall one sees the massing of anthropological value around certain bodies of images. An important related study would explore the significances of the *overlaps* and *duplications* between collections of anthropological or ethnographic photographs, rather than the singularities of collections.

26. Welch was also active within anthropology. He was closely involved with trying to collect data, including photographs, for the B.A.A.S. Ethnographic Survey of the British Isles in the 1890s. He was also one of the commercial photographers to record his photographs in a register of material 'of anthropological interest' that was run for a few years by the Anthropological Institute in the late 1890s, organised by J. L. Myres at Christ Church College, Oxford.

27. CUL.HP Envelope 2010.

28. CUL.HP, 1898 Diary 141. Sidney Ray was a London schoolmaster and expert on Melanesian languages who went as the linguist on the Torres Strait Expedition. I have explored lantern slides in this cross-cultural relation elsewhere (Edwards 1998, 2000a). Chapter 7 in this volume considers other aspects of the Expedition.

29. William Ridgeway, Disney Professor of Archaeology at the University of Cambridge. He had strong anthropological interests as well.

30. Letter to Fanny Haddon 28.6.1898, CUL.HP Envelope 12.

31. I thank Josh Bell for this reference.

three

Photographing Objects

The Overlooked

It is no coincidence that photographs of material culture, with their confirmation of surface appearance, had the longest currency in the exchange of images. However, photographs of ethnographic objects,[1] at that stage of their social biography when they are labelled 'museum specimens,' has drawn little interest or analysis compared with the politics and poetics of museum practice or ethnography more generally.[2] Their repetitive, functional nature and very ubiquity makes photographs of objects appear transparent in the extreme, lacking the immediate aesthetic or ideological compulsions of other photographic expressions of cultural alterity. However, as in any photograph, optical precision cannot guarantee objectivity, nor can the content be conflated with the meaning (Schwartz 1995:44). My concern in this chapter recalls Bryson's apposite phrase 'looking at the overlooked', which he used of still life painting (1990). Its aim is, first, a preliminary exploration of the ways in which collected objects were represented photographically in the second half of the nineteenth century. Second, I shall point to some of the theoretical concerns that present themselves in the representational and stylistic devices that were applied to a wide range of objects and that cohered, with rhetorical force, in this overlooked corner of photographic practice. Photographing objects was (and still is) integral and crucial to the apparatus through which ethnographic and museological knowledge was made, generating discourse around objects; yet it is one naturalised within museum curatorial practices.[3]

The clear visual description of objects was one of the earliest applications of photography, creating not only representations of objects from glasses to fossils, but also displaying both their ordering and the precision of the medium's documenting capabilities (Schaaf 1998).[4] Photographs of ethnographic objects were later in coming and worked with photographs of peoples and cultural activities, in a representational

51

matrix that substantiated relations of knowledge and power. Further, such photographs clearly articulate the universalising, encyclopaedic archival desire that extended collections of objects through the indexical and metonymic nature of photography, at the same time prefiguring the expansion of experience through photographic reproductions in the comparative juxtapositions of Malraux's 'Museum Without Walls' (1949:18–19).

Although there is a superficial stylistic coherence in many of these photographs, a closer consideration suggests a somewhat more complex and ambiguous situation. Slippages emerge between photographic dialects and other visual forms in which objects were enmeshed. The power of the photographs was not simply in the nature of the objects themselves but dependent on the rhetoric of their photographic performance. This reflects not only informational rhetorics but also disciplinary and institutional rhetorics (Wollen 1995:10). Consequently, my central argument is that the actual way objects are photographed is integral to their influence, as images, in affecting the perception not only of the object itself, but also of the cultures in which they originated. The reduction of three-dimensional objects to 'inscriptions on paper, result[ed] in the simplification of the symbolic and conceptual management of objects which stabilised meanings of objects in both institutional and, by implication, public spaces and well as within the interpretative community' (Jenkins 1994:244). As I suggested in the last chapter, the photographic representation of objects must, however, be seen as part of the rapid industrialisation of image production that transformed the entire visual economy and that produced that 'new and homogeneous theatre of consumption and circulation' (Crary 1990:13). The pictorial census made possible not just the circulation of racial images, but associated material cultures through the print-capitalism of books of all sorts, illustrated journals as diverse as the *Journal of the Anthropological Institute, Archaeological Journal, The Reliquary and Illustrated Archaeologist,* missionary magazines and a wide range of popular anthropologies (Ivins 1953:94; Tagg 1988:56). By the late nineteenth century there was in circulation a massive range of illustrations of ethnographic objects, represented not within their cultural contexts, but as specimens that could be invested with meaning. An especially fine example is Ratzel's *The History of Mankind* (1896) (*Völkerkunde* 1894). It includes engravings from photographs and colour-lithographs of massive regional assemblages by G. Mützel, encompassing all the visual styles of representing ethnographic objects that I am discussing in this chapter.[5]

Photographs extended the effective circulation of cultural objects. Malraux's claim for art history that it was 'the history of that which can be photographed' (1949:32) is in many ways applicable to ethnographic objects, for photography enabled the study of objects over space and time. There have been a number of excellent studies of making and collecting photographs within the fine and decorative arts, for instance at the South Kensington Museum (now the Victoria and Albert Museum) and Le Cabinet des Estampes at the Bibliothèque Nationale in Paris (for example Hamber 1996; McCauley 1994:265–300; Haworth-Booth and McCauley 1998) . These studies offer a number of insights against which to position photographed ethnographic objects. However, while they shared some basic premises, namely the creation of 'immutable mobiles', exactly repeatable pictorial statements for the dissemination of data, the debates around the quality and moral value of the photographs are somewhat different. Those around the photographic reproduction of works of art were figured through questions of aesthetics and taste and the relationship of photography, with its replication of external forms, to the spiritual and inner experience that was, in the dominant Kantian tradition, a defining characteristic of the art work (Freitag 1979/80; Fawcett 1986). This is exemplified by Roger Fenton's photographs of classical statuary made for the British Museum in the mid-1850s. The subject-matter was perceived to demand a photographic style that not only inventoried and recorded the object itself (the intention of Fenton's photographs) but created the aura of cultural value around those objects (Lloyd 1988). In contrast, photographs from cultures outside those perceived as having major historical traditions of their own, such as India and Japan, were placed firmly within the discourses of science.[6] This embraced not only ethnographic material but other groupings of material culture perceived as being outside accepted canons of aesthetic discourse, for instance excavated archaeological finds (Piggott 1978:22). Such photographs were seen as being 'matter-bound' and, through their apparent visual directness, expectations of the objective claims of the medium were brought into full play to produce 'facts about which there is no question' (Read 1899:87).

This is not to say that these two spheres of artefact photographs were totally separate. Anthropologists certainly used some of the massive commercial output of photographs of classical and Western art objects. Images of objects of classical antiquity, from statuary to medical equipment, for instance, were collected and absorbed into the comparative interpretative discourses of the nineteenth-century anthropology. The

Swiss-American physical anthropologist, Louis Agassiz, included three stereocards of classical and neo-classical statues into his albums of physical types from Manaos made in 1865 (Isaac 1997:7–8). The stereo-cards correspond, in terms of a crude visual correlation, with his Brazilian images, which directly precede them. In the contexts of polygenist theories of human origin, these photographs of statuary partake in a scientific discourse of the separate, creating the racial standard, and by implication a cultural and moral standard, against which the images of Brazilian people could be read. This album exemplifies the way in which two linked sets of moral values enmesh the photographs; first, the indexical nature of the photograph, which provided non-interventionist rendering of objects as statements; and secondly the moral values attributed to the content of the photographs.

Photographing Ethnographic Collections

Museums were slow to harness photography to their ethnographic collections. Although photography early developed an important role in the fine and decorative arts, its development in museum ethno-graphic collections appears to be very much more piecemeal, despite efforts by Franks at the British Museum (to whom I shall return) (Caygill and Cherry 1997:106 (n.87),147). Following his extensive tour of European and American museums looking at ethnographic material, especially from Polynesia, in 1896, W. T. Brigham, reported that 'very few museums had a system of photography; indeed the Museum für Völkerkunde at Berlin, where the accomplished Dr. von Luschan is a skilled photographer, was the only one prepared to exchange photo-graphs of its contents' (1898:66). It would appear that while photographs were made on demand for interested scholars, there was little systematic photographing and exchange or building of collections of photographic reproductions in institutional terms such as was found at the South Kensington Museum. In his report to the Museums Association meeting in Dublin in 1894, F. A. Bather of the British Museum wrote admiringly of the Australian Museum: 'The value of [a photographer] in a museum of any size is enormous. Whether it be in the preparation of photo-graphs for the better display of specimens . . . Or in the ready transmission of information concerning a specimen to a specialist or inquirer in a distant place, or in the reproduction of illustrations to catalogues and scientific memoirs published under the auspices of the museum' (1894:215).[7] Bather's comments are interesting because not only does he link photography to museum display, an intersection to which I

shall return, but he hints at the reasons behind the eclectic and hybrid representation of objects in museum contexts: 'Constantly employed in the photography of scientific objects, he acquires the cunning of a specialist, very different from the crude attempts of the ordinary photographer one so often has to employ . . . Needless to say that the expense is far less than incurred by employing an outside photographer, while the amount of work done is absolutely greater.' While photographic manuals of the period are full of advice on framing, lighting and composition in general, and the photographic and scientific publications were concerned with specialist applications, especially microscopy, there is little comment on the photography of objects. Although there were photographic firms that specialised in museum work,[8] outside the demands of art photography and the laboratory, photographing objects seems to have been an assumed skill within photographic practice.[9]

Whatever the specific means of making and acquiring photographs, like the art institutions studied by Hamber and McCauley, ethnographic institutions and individual scholars nonetheless used photographs to extend collections of objects beyond their limitations of size and their sometimes serendipitous nature and, in this, moved towards the universal cultural thesaurus. Photographs of objects were integral to these attempts to order the world's diversity, as in Malraux's 'Museum Without Walls', where 'picture, fresco, miniature and stained glass, all fall into line . . . all have become colour plates' (1949:50). As many commentators have noted, scientific forms of conceptualisation, and the equivalences they produced, became a dominant visualising cultural force of the nineteenth century. Photographs and evidential value were complex historical outcomes emanating from these specific social practices and, in their turn, creating certain ways of seeing.[10]

In what Snyder has described as a 'rhetoric of substitution', the photograph functioned as an imprint of object operating in a rhetoric of transparency and truth. This was a central concept in the production of photographs of ethnographic objects (1998:30). Museums 'relied upon the mimetic function of photography to replace actual specimens and a metonymic acceptance of the fragmented state of the object [or culture] as it was represented in the Museum' (Rosen 1997:386). For instance, C. P. Stevens of the Blackmore Museum, Salisbury, wrote in the late 1860s 'Our museum is set apart for pre-historic archaeology, and for weapons, and so on, in use by modern savages, as illustrating the collection, and photographs of rare forms of clubs, spears, ornaments, tools and weapons &c. are useful and valuable to us. We also collect

photographs of the aborigines of various countries, and for this nothing is equal to photography, because artistic licence is impossible' (quoted in Henderson 1868:38). Similarly Rudler suggests the interchangeability of models and photographs within a rhetoric of substitution 'Models of dwellings, boats etc. may sometimes be procured but in their absence the objects must be represented pictorially' (1897:60). In his paper on 'Anthropological Uses of the Camera', presented to the Anthropological Institute in 1893, Everard im Thurn lamented the incomprehensibility of objects 'in heaps or even bundles, in museum cases'. Anticipating Malraux, he went as far as to argue that 'a good series of photographs showing each of the possessions of a primitive folk, and its use, would be far more instructive and far more interesting than any collection of the articles themselves' (1893:193,197). Underlying such remarks as these was the fluid relationship between the object itself and its indexical trace, the photograph, in establishing the truth values around objects.

The slippage between the object and its image is articulated in other ways. In a series of large albumen prints of Ecuadoran archaeological specimens, made by F. Whymper in 1878–9 and which belonged to Tylor,[11] the labelled objects are arrayed symmetrically in the frame. The photographs have faded, probably relatively soon after the prints were made, and the writing on each label has been meticulously overwritten in soft pencil, as if it were attached to the object itself. Many object photographs bear the traces of such usage, adding to the image as a functional object and blurring the boundaries between the photograph and its referent. There are a wide range of surface interventions extending the purely visual and mimetic qualities of the image; for instance, pieces of paper stuck to the surface like labels on objects, containing measurements or documentation of the object, in a series of photographs of Inuit bone carving, probably made by or for R. Darbishire in the 1890s, or the many photographs with numbers added in manuscript to their surface in order to caption them.[12] The use of object photographs as 'working objects', selecting phenomena through which concepts are formed (Maynard 1997:31; Daston and Galison 1992:85), becomes clear in the case of Haddon's collection of photographs of shields from the Papuan Gulf. The photographs were written on, coloured and overpainted, tracings were made, photographs were cut in half and the background was standardised with blank-out pen (Figure 3.1).[13] Clearly this was more than merely looking at photographs as illustrations. These photographs were active tools in making, literally constructing, anthropological meaning through material intervention

with the surface. In these examples, the writing disrupts the picture plane, forcing attention on to the surface of the image and marking simultaneously their representational and metonymic roles. Here the original object is not diminished through its reproduction in the way that Benjamin argues in his famous essay; rather it is enhanced in scientific terms, as the object, through its reproduction, is able to perform in different related disciplinary micro-discourses – classification, comparison, identification – that add to its density.

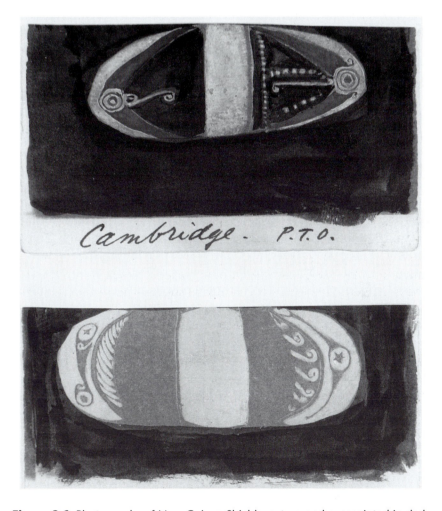

Figure 3.1 Photographs of New Guinea Shields, cut up and overpainted in dark grey, white and red watercolour by A. C. Haddon. (Courtesy of the Cambridge University Museum of Archaeology and Anthropology Haddon Papers Env 2024.)

If one defines style as a set of particular attributes observable in a set of objects or images, then photographs of ethnographic objects refer to pre-photographic forms of graphic representations of objects, such as scientific drawing and engraving and the arrangement of cabinets of curiosities. It is to these hybrid and eclectic representational strategies that I now wish to turn, for they are crucial to the discourse around objects and their photographic inscription. These strategies came not from the aesthetic debates of the arts, but from the constructed modes of objectivity in the medical and natural sciences and their moral implications. This is not merely because of the subject-matter itself. Many of the practitioners of the emerging discipline of anthropology had a scientific background, often in the natural sciences or medicine, conditioning the ideas of visual truth that they brought to the establishment of the parameters of visual representation.

Often the lack of apparent photographic engagement marks such photographs out. The favoured museum style suppressed interpretation or explanation of the object; yet, as we shall see, the subjective noise around photographing objects is often deafening. The moral value of photographs was premised precisely on the self-restraint and intellectual asceticism that removed subjective desires and human agency through mechanical and automatic inscription through which objects could demonstrate themselves (Daston and Galison 1992:120–2). Through 'techniques for the management of attention, for imposing homogeneity' (Rosen 1997:381) they created a set of relations that organised visual space in order to create specific ways of looking at objects. This created a 'point of view' that constituted objects as scientific specimens. Poole has suggested the importance of a 'system of equivalence' in relation to visual economy (1997:133–4), grounded in photographic realism, standardising formats, sizes and, most importantly for our purposes, style, so as to create a system of representation in which the most dissimilar objects could be transformed into equivalent, and hence comparable objects, both within the frame and between frames. The loss of the object's materiality through photographic reproduction was part of this rhetoric of equivalence (Malraux 1949:37, 50). The naturalistic surroundings for material culture, such as were widely found in popular representations, for instance photographs showing objects arrayed around the body as cultural markers, form a clear contrast to the scientific texts, where the object is pure, clear and ordered (Rosen 1997:383). Objects were isolated in front of camera, either singly or in groups, arranged for maximum visibility. Photographed against a contrasting background in even light, as much of the object's physical

form as possible is projected to the viewer. Dramatic uses of light and shade were avoided; rather, light was used to give uniformity to a series, emphasising certain significant features: form, texture, material or decoration, for instance.[14] Sometimes the background, that is the context of the subject of the photograph and the conditions of its own photographic representation, such as background shadow, was removed through manipulation of the negative in order to create the correct form for viewing the object as pure specimen, unencumbered by any form of cultural context, including institutional context. In the extreme form of this style ethnographic objects appear as floating objects, removed from both time and perspectival space. This is often accentuated by a focal length that flattens perspective, reducing the representation of the object to a form of photographic drawing. In a style derived from archaeological drawing, the photographic illustrations in General Pitt Rivers's *Art from Benin* (1900) show the same object from different aspects in one frame, making the object visible in different perspectival planes simultaneously. A different version of the visual rhetorics of comparison can be seen clearly in von Luschan's *Beiträge zur Völkerkunde,* where New Ireland carvings are reproduced as a mosaic of floating objects of exactly the same size (von Luschan1896:pl.47) (Figure 3.2). In presenting a precisely comparable visual correlation they demonstrate, as Sekula has argued 'The capacity of the archive to reduce all possible sights to a single code of equivalence ... grounded in the metrical accuracy of the camera' (1989:352). If photographs in an archive operate as an organising device, the frame thus acts similarly. This double framing accentuates the system of equivalence, as a vast array of hetero-geneous objects were reduced to a perfect intellectual similitude (Crimp 1993:54).

The links with scientific illustration and engraving are clear, both in the stylistic conventions that massed data within the frame, and in the moral values ascribed to such representations. The formal present-ation of objects arrayed within one frame both caused them to cohere within a taxonomic structure and gave a comparative impulse through juxtaposition. While photographs were expected to give a more complete rendering of the visible, they were guided by a conventional depiction and composition that operated within this established rhetoric, object-ivity giving a stylistic and intellectual coherence between drawings and objects (Blum 1993:265–75; Rudwick 1996:267–9; Stafford 1994:230–8). Such scientific conventions can be traced back through the encyclo-paedias of the eighteenth century and the herbal and medical texts of the seventeenth century and earlier, where framing devices isolated

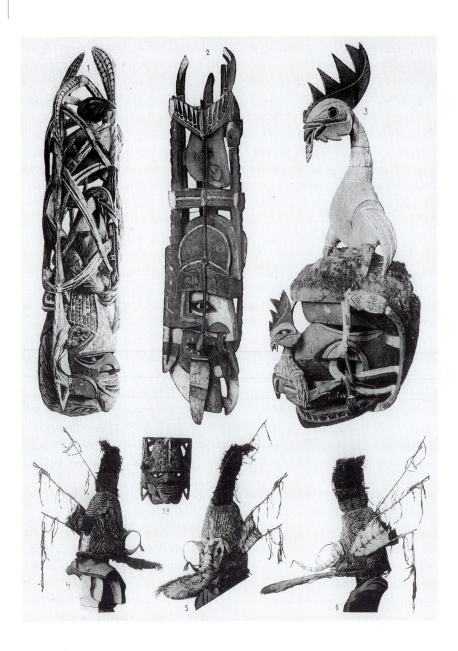

Figure 3.2 A mosaic of floating objects: New Ireland carvings, *c.*1890. *Beiträge zur Völkerkunde* Photographs by F. von Luschan? (Courtesy of the Balfour Library, Pitt Rivers Museum, University of Oxford.)

phenomena from a mass of competing phenomena, controlling the viewing distance through 'edited and compressed displays of nature's antiquities' (Stafford 1994:230). These conventions had already been employed extensively in the representation of ethnographic objects in the pre-photographic period. As Thomas has discussed in relation to engravings on Polynesian objects from accounts of Captain Cook's voyages, the styles of representation came from the spaces that objects were made to occupy. The juxtaposition of objects and the moral and aesthetic values implicated operate within the contexts of extreme objectification, 'abstracted from human use and purposes: the very possibility of displaying "weapons and ornaments" in a single assemblage indicates the extent to which the things imaged were decontextualised, their uses made irrelevant' (N. Thomas1994a:118–19). The arrangement of objects within the frame 'privileged investigative vision [which] is implied by the analogies with the depiction of natural specimens' (N,Thomas1991:136–7). Equally one can identify these strands in the presentation of archaeological knowledge, such as James Douglas's *Nenia Britannica* (1793), which pioneered systematic illustration of excavated antiquities (Piggott 1978:52). The authority of these representations followed the precept of truth to nature articulated through attempts to render 'what truly is', a rendering often obtained through the *camera obscura* (Daston and Galison 1992:84). The biological sciences abound with widely read examples of the visualisation of thinking, for instance the work of Linnaeus and his followers, Cuvier or Haeckel. By the mid-nineteenth century the taxonomic rhetorics of scientific engraving had become clearly articulated in the massing of certain morphological forms within the frame as a single composition, assembled on a single printing surface. Representations of objects similarly amassed thus assumed a clear rhetorical meaning within taxonomic and comparative debates.

However, as in medical, zoological or botanical illustration, there were tensions between objectivity and the aesthetic in images of ethnographic objects. Within the carefully arranged arrays of visibility, strong aesthetic compulsions were at work, disrupting a taxonomic agenda. Arrangements mirror broadly the search for pattern in the natural sciences which was expressed photographically, especially through microscopy; but the arrangement sought was one in which individual objects became part of a larger aesthetic and moral design (A. Thomas 1997:98–103). Symmetrical arrangements, carrying the eye into the centre of the image, are common; larger objects often provide an inner frame within the photographic frame, and, within this, smaller objects

are arrayed in patterns drawing on size and form. While obviously there were practical constraints on the way certain kinds of objects could be photographed, especially the very large or objects like spears, which invite massing and a strong linear patterning, most photographs present arrangements that are confluences of scientific visibility and aesthetic arrangement. For instance in photographs of Peruvian Moche pottery (possibly at a dealer's), from Jorge Alexander of Lima, about fifteen objects were grouped in one frame. The overall stress is on outline form. However, a central bowl is tilted forward to show decorative motifs inside and is placed centrally above a large vase; the other objects are arranged around symmetrically, revealing tensions between the aesthetic and taxonomic. The power of conventional repetition is clear in a series of simple photographs of spears from the Pacific in the Tufnell collection. The spears, with the tips pointing to the top of the frame, as is usual, are ranged across the frame vertically in large regular groups. However, one image was made with the spear tips pointing down to the bottom of the frame. This stylistic aberration was corrected in the 1930s, when the photograph was mounted upside-down in order to accord with the conventions for representing spears.[15]

An even more marked example of conflated and confused taxonomies is a photograph of face jugs from the Peruvian Moche pottery series.[16] These were photographed in profile, which not only displays the salient morphological points of the objects themselves, but carried a resonance and visual reference to physical anthropology. One can argue that styles of photographic representation of objects in ethnography are closely related to those of race, gender and the anthropologicized body. Like photographs of objects, anthropometric images and those absorbing the visual rhetorics of such practices, such as those I discuss in Chapters 6 and 9, are presented in a shallow picture plane with even lighting eliminating shadows, to allow full, and sometimes mathematicised, somatic mapping of the body under scrutiny. Photographs of objects arguably operate within a visual and intellectual continuum with such photographs. What is significant here, and in the Agassiz album, is the way in which photographs of objects are, in different ways, active in racial discourses through the system of equivalence. The precise placing of the Peruvian objects within the photographic frame conflates the cultural and the racial. The conjectural historical processes of evolutionary thinking informed a reading of the objects that absorbed such apparent physiological data into a racial taxonomy.[17]

Displayed Objects

The museum display has resonated through much of the argument so far, and it is to this key relationship in photographs of ethnographic objects that I now wish to turn, for a seamless stylistic coherence between engraving, display and photograph emerges (Stafford 1994:278–9). It is especially pertinent in that both photographic and display forms work to transform objects and construct meanings through their presentation as visual spectacles. W. H. Flower's comment on the prerequisite visibility of museum displays could equally apply to photographs: '[The] isolation of each object from its neighbours, the provision of suitable background and above all . . . A position in which it can be readily and distinctly seen' (1996[1893]:33). If both photographs and museum displays emerge from the rhetorics of scientific visibility and the spatial construction of knowledge, displays and photographs also merge.[18] Jenkins has argued that museum displays were set up as if they were photographs, flattened, framed, glass-covered, to be viewed and interpreted according to internal narratives created and performing in relation to bodies of cultural knowledge. Like photographs, museum displays were set up for maximum visibility; both could be comprehended at a glance (1994:246). In museum displays themselves objects were carefully arranged in aesthetically controlled formations, symmetrical groupings of abstract patterning and configurations of size and shape. These frames produced a series of typological or cultural narratives. However, conversely one can argue equally that the arrangement of visual information on the photographic plate was set up like a museum display, linked at the same time to presentational forms of taxonomic engraving and drawing, in an apparently symbiotic relationship, framing and objectivity being closely connected. Photographers used frame as an important semiotic indicator to construct a visual field and to give internal coherence to a diverse array (Rosen 1997:381). The slippage between photograph and display case actually reinforces the taxonomic structures of viewing collected objects, in creating a 'correct' field of viewing.

The point is forcefully made by the framing of photographs of museum displays themselves Notable examples are Josiah Martin's photographs of displays of Polynesian, Melanesian and South-east Asian material at the Auckland Museum in the 1890s (Figure 3.3). Here in the direct frontal recording of the case, the edges are co-terminous with the frame of the photograph; only the case heading remains as a label for the photograph. The divisions of the case itself, the shelves vertically

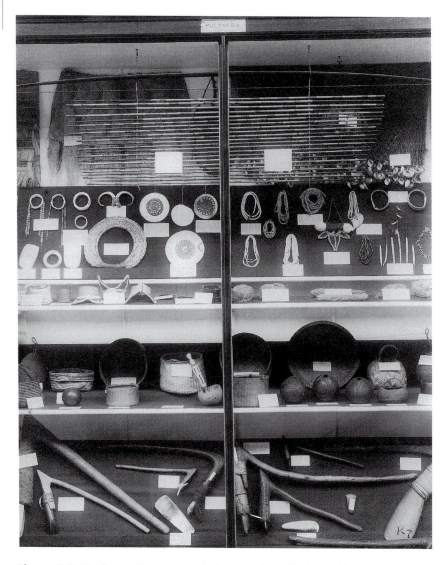

Figure 3.3 Displays at the Auckland Museum, New Zealand. Albumen print
c.1890. Photograph by Josiah Martin. (Courtesy of Pitt Rivers Museum, University
of Oxford, PRM C1.11.20c.)

bisected, form smaller framings of objects. The result is almost like a
series of smaller photographs, frames within frames each containing
and concentrating objects that are projected into visual space, the
juxtapositions of the framings simultaneously constituting a form of
narrative. Commenting on these cases in 1894 Bather stresses the clear

visibility of the objects: 'Each article is placed in a position that will allow it to be readily seen' (1894:210–11). In a photograph of a case showing the evolution of the bow at the Pitt Rivers Museum of *c*.1900 the edge of the case is just visible, forming a black line around the image, an inner frame reminiscent of a untrimmed photograph where the uncoated part of the glass negative prints black. Here again we have a slippage between museum display and photograph. The objects, supported by a map, text and photograph, are arranged in an evolutionary narrative for maximum visibility and thus comprehension (Coombes 1994:146). What emerges is a seamless visual continuum between photograph and museum display in which the narrative is equally legible in both forms, in a double rhetoric of substitution.

However, as was suggested in Chapter 2, despite the imposed discourse of homogeneity of the archive, as argued by Sekula and Crimp, many sorts of photographs were absorbed into the flow of images that created ethnographic meaning. Deviations from the standards of object representation did not necessarily undermine faith in the authority of the image; however, this is not to argue a naive acceptance, but rather, fluid concepts of evidential value (Tucker 1997:381). The evidential power of the photograph vested in the trace and the absorption of ethnographic objects into conventional iconography was not limited to the scientific or its aesthetic dimension. There are strong links to still-life painting and its photographic derivatives. The 'attentive looking' demanded of still-life painting has a direct descendant in photography. Like still-life painting, photographs of objects, even in a scientific register, demand an attentive looking as the basic access to knowledge and understanding. The characteristics of photographs that are part of their beguiling reality effect and that relate seeing, knowing and picturing – fragmentary, arbitrary framing, and yet immediacy – are likewise part of 'the mapping impulse' of Dutch art in the seventeenth century, what Alpers terms 'an art of description' (1989:43–4). These too related to wider issues of systematic ordering (Rowell 1997) and carry an aura of authenticity of subject-matter, naturalism and unmediated realism. In still-life painting, objects are opened up, exposed. The play of light on the surface distinguishes materiality and multiple surfaces, creating a feast for the attentive eye and simultaneously creating concrete knowledge. Through these rhetorical devices, poetic and moralising elements intrude into scientific modes of photographing ethnographic objects. For instance, many of Martin's photographs of Maori carving simultaneously delight in the textures and craftsmanship and signify cultural difference and the rhetorics of

the 'primitive' (see Figure 3.4). Such photographs embody the struggle in history of photography between 'two different imperatives: beautification which comes from the fine arts, and truth-telling, which is measured not only by a notion of value-free truth, a legacy from the sciences, but by a moralized ideal of truth-telling' (Sontag 1973:87).

Another recurrent compositional convention that moves seamlessly between museum and photograph in an interpenetration of visual rhetorics is that of the 'trophy'. The concept of 'trophy' was not unusual as a collective noun in relation to photographs of collected material culture, for examples Lawes (see Chapter 2) included two photographs entitled 'Trophy of Curios' in his list of photographs of New Guinea.[19] By the late nineteenth century, the 'trophy' referred to conventions of display, especially of arms and armour; however it has its origins in statements of power, not only in terms of the spoils of war and conquest from the classical period on, but also as a decorative form of storing weapons in the sixteenth and seventeenth centuries.[20] Such conventions, which operated in public spaces of both museums and exhibitions, were also transferred to the colonial domestic space. Writing of the display of Fijian objects in Government House, Levuka, Fiji, which was photographed for commercial sale by W. A. Dufty, Lady Gordon, wife of the Governor, stated that 'such beautiful and artistic patterns can be made with clubs, spears, bowls, arrows, axes, paddles, etc.' (quoted in N. Thomas 1991:174).

In museum displays of material culture, trophy-style arrays existed alongside the clear symmetries of scientific visibility. Indeed, it was the lack of the latter that prompted Brigham's comment on the trophy displays at the Museé de Marine, Paris: 'Here everything is without scientific arrangement, and the rich treasures scattered here and there, sometimes arranged in rosettes on the ceiling where they cannot be studied, as trophies on the walls where military, domestic and musical instruments are grouped together for effect, and equally useless to the student' (1898:37). However, photographs of early displays at, for instance, the Musée de Trocadero, Paris, the Horniman Museum, London or Pitt Rivers Museum suggest the blurred edges between the conventions of science and those of the trophy. This is equally manifest in photographs, which operated within the registers of both scientific and colonial discourses of the aesthetic and the exotic in the visual projection of ethnographic objects. It is significant that trophy photographs often, but not exclusively, represent weapons. Not only does this suggest some stylistic differentiation between classes of objects; it also draws an ideological significance from the framing devices of the trophy. This

stylistic device is not necessarily determined by the spatial demands of the objects in front of the camera. For instance, short knives, such as those from the Gabon River photographed by Stephen Thompson for the British Museum in 1872, could be photographed in any number of styles or formations. Rather the choice of the trophy as the compositional form invites a more complex reading as a colonial document of containment and appropriation.

For 'the trophy' also signifies, as Coombes has argued (1994:12–13), formal and metaphorical links in intention and meaning between the photography of arrays of objects and hunting photography. Sontag's well-known analogy between hunting and photography can be seen at work (1973:14–15). It is more than a simple visual correlation and the shock of dismemberment that links, for instance, an 1876 photograph by Guy Dawnay of stuffed lions' heads, displayed to the camera on a blackboard easel (Ryan, 1997:113), and General Robley's photograph of shelves of tattooed Maori heads.[21] What is significant is the naturalisation and depoliticisation of the Maori image within ethnographic discourses. The existence of the referent, the tattooed Maori heads, becomes paramount not in terms of the colonial encounters they imply, but in the Museum without walls, contained within and reduced to a comparative concern with tattoo. Both are also inflected through the traditions of still-life painting (*nature morte* would be more proper here) and emerge as indexical signs of past moments, the dead but once alive, of danger contained.[22]

It is with trophies that the links with still-life painting re-emerge, with the stress on formal presentation and rich texture. J. W. Lindt's *Picturesque New Guinea* series from Sir Peter Scratchley's expedition of 1885 includes two trophy photographs, arrays of weapons and other implements. In 'New Guinea Trophy: Weapons and Implements' the objects – clubs, a gourd in a string bag and feather and shell bead ornaments – are grouped around a central point in a strong triangular composition, falling cascades of still life, reminiscent of seventeenth- and eighteenth-century studies of game or fruit (Lindt 1887). While indexically photographs of ethnographic objects, they are affective rather than descriptive, studies in texture that simultaneously accentuate the strangeness of the objects and domesticate them through the compositional forms.

The salvage agendas in material culture, related to popular ideas of cultural disappearance, are especially clear in a photograph produced in the 1880s (but sold long after that) by Josiah Martin, 'The Old Order Changeth'. This widely disseminated photograph[23] shows a collection

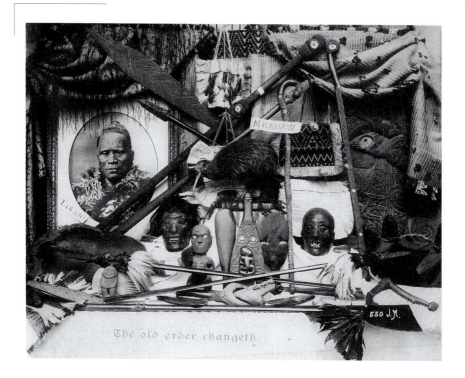

Figure 3.4 Trophy photograph 'The Old Order Changeth'. Albumen print
c. 1885. Photograph by Josiah Martin. (Courtesy Pitt Rivers Museum, University
of Oxford, PRM.)

of Maori material culture arranged in a decontextualising and aesthetic-
ising array around a photographic portrait of Tamhio (Figure 3.4). The
arrangement of objects here shows craftsmanship and aesthetic qualities
(even if in registers of the exotic) and relates us immediately back to
the representational devices of still-life painting. Such photographs of
objects demonstrate a slippage of photographic dialects between the
inscription of science, which dominates the representation of objects
within the museum and collecting contexts, and the arts of description.
Here the visual dialects of still-life painting and photography are
transposed to the nostalgic registers of the supposedly dying race, as if
here 'real life' and 'still life' stand in opposition to one another. Whereas
'lived experience is a flow of the immediate, unpredictable and undiffer-
entiated' on which are imposed hierarchical patterns of perception and
understanding, still life is ordered, structured and articulated within
specific semantic codes, becoming a parade of cultural signifiers (Rowell
1997:16). Consequently it was intellectually possible to absorb such

images into the anthropological archive through the combined registers of photographic indexicality and salvage ethnography. Such reductive photographs express an essentialised totality of a culture, here 'Maoridom', expressed through material culture, but linked visually with the indigenous, producing body within one frame.

Although many of the photographs I have been discussing were professionally produced, in that they were produced for interested parties by professional photographers, overall the commercial production of photographs of ethnographic objects for the popular market was very much more limited. The massive popular antiquarian and amateur art-historical demand for images does not appear to have extended to representations of ethnographic objects. Outside the specialist interest of the comparative methodologies of anthropology and the museum, the collection impulse was for indigenous peoples themselves, represented as 'native types', or for natural wonders, rather than man-made objects.[24] It would appear significant that many of those that were made drew heavily on the trophy form, both literally and metaphorically. In a photograph of about 1875 by O. Mollita entitled 'Naga Trophies'[25] a Naga man is seated on the ground, centre frame, the caption immediately beneath him, with objects of his culture arrayed around him. The colonial message, through the play on the word 'trophy' and the taxonomic references of the placing of objects within the frame is unmistakable: 'Naga trophies' comprise the people in the pacification of the north-eastern border of the Indian Empire and the material culture absorbed into a comparative discourse of scientific taxonomy. The photograph totalises culture through the massing of fragments within one frame, both body and object held up for inspection. However, such photographs, made for commercial and popular sale, nonetheless become absorbed into scientific collections of photographs as legible representations of objects through the indexicality of the image and the privileging of content over style. Further, such photographs not only were absorbed into the discourses of meaning around objects in museum collections but spoke to the urgency of the salvage paradigm around the collection of objects.

Thompson and the British Museum

In the light of my consideration of the visual rhetorics photographically enmeshing ethnographic objects, I want to look at the earliest institutional photography of ethnographic objects in Britain. This was as part of the substantial portfolio of objects from the British Museum

made by Stephen Thompson in 1872, which included some 150 photographs of ethnographic objects. Despite the efforts of A. W. Franks, the energetic and brilliant curator responsible for the ethnographic collections at this period (King 1997:137–40), the British Museum was slow to address the photographic demand systematically, unlike the active photographic agendas at the South Kensington Museum, where demand outstripped an impressive supply (Hamber 1996:385). The inclusion of ethnographic objects in the project is significant on a number of counts. At this period the British Museum was beginning to consolidate its ethnographic collections around a major donation of 1865 from Henry Christy, whose collecting activities had influenced the young Tylor (King 1997:137–40). The majority of the objects in Thompson's project were drawn from this high-profile collection and were selected for it by Franks himself.[26] Probably an equally significant influence was the funding of the project. This came from Charles Harrison, a wealthy London solicitor with archaeological and anthropological interests (Hamber 1996:385), who had been elected to the Ethnological Society in 1869, a period when Franks was on the Council of the Society and then that of the newly formed Anthropological Institute. It was Harrison who wrote the introduction to the catalogue of the photographs, which were published by W. A. Mansell, the photographers and print dealers who had premises only a few streets from the British Museum.

The ethnographic photographs appear in Part One 'Pre-Historic and Ethnographical Series' and include material from Africa, Asia, island south-east Asia, Oceania and North America; there is also a substantial series on Meso-American archaeology. The portfolios follow a chronological progression, which ends with medieval art and the seals of the sovereign corporations: however, this is transformed into an evolutionary statement by the placing of the ethnographic photographs at the beginning of the series, immediately after prehistoric remains. That this, and its moral implications, is the intended reading of the photographs is clear from Harrison's introduction: 'It is almost superfluous to allude to the important position which national and other collections occupy, in supplying evidences of man's advancement, from the lowest stage of his history, the conditions of social life, of belief, of science, from the earliest to the latest epoch' (1872:ix). Indeed, a reviewer in *The Athenaeum* described the introduction to the photographs as an admirable basis for a series of lectures on ethnology (1872:309).

The photographs demonstrate stylistic eclecticism: science, still life, trophies. While many objects are isolated and arranged for maximum

visibility, other representations are less certain. For instance, in a group of pots from the Rif Coast, Morocco (No.49) the overlapping positions of the objects and the clear highlights co-exist in the frame with a stress on form, but not to the extent that the painted decoration of the pots is illegible in the image. Even more marked is a photograph of Mexican terracotta vessels (No.115). In this photograph there is a strong sense of form within a group of objects as the contrasts of highlight and shadow, the slightly high camera angle and the rhythm of ellipses formed across the frame by the shadows link one object to

Figure 3.5 Solomon Island clubs from the British Museum collection. Albumen print 1872. Photograph by Stephen Thompson. (Courtesy of the Royal Anthropological Institute B115.)

the next. On the other hand, weapons are presented as trophies in one frame, like Thompson's photograph of those from the Gabon River (No.44) or the Solomon Islands (No.64) (Figure 3.5). The sheer volume of objects in these frames resonates with violence and savagery; yet it is a violence contained within both aesthetic conventions and the photographic frame. As I suggested earlier, the formal arrangement has a signifying function within moral and colonial discourses around objects. The *Athenaeum* reviewer articulates an evaluation of culture in describing photographs of 'intolerable' Peruvian masks as 'Monstrosities . . . rightly classed with what is called prehistoric . . . ethnographical is the true title of specimens of this sort because their production has little to do with chronology but depends on the status of the races which delight in them' (1872:311). An Easter Island carving constitutes 'the primeval condition of art: as regards design they are naught . . . They are ruder than anything we know . . . in merit they are much below the charming decorations of paddles and spears from the Pacific and Africa' (1872:310).

It is not clear how wide a dissemination the ethnographic photo-graphs had. As I have suggested, unlike photographs of classical and Western art objects, photographic prints of ethnographic objects as science do not appear to have been widely distributed.[27] Their avail-ability was made clear to visitors. Harrison was given permission to place a catalogue of photographs in the hall of the Museum and the relevant portfolio in each department (Hamber 1996:386). The avail-ability of the photographs was seen, with a strangely modern ring, as democratising access to the collections: 'Photography will be found to be the best and cheapest means of placing such collections before the public particularly if the present publication should initiate a mutual system of exchange of photographs taken from the National and Local Museums of Europe and America' (Harrison 1872:xliii).[28] However, even individual prints were still quite expensive, which is likely to have limited the ethnographic material to a small and specialist circulation. The photographs were sold as a whole set, as separate divisions of forty-five prints each, (the ethnographic material was in the first division), or as individual prints, priced at 2s. each, one guinea a dozen or eight guineas for 100.[29] The range of material forms – mounted, unmounted, album, or portfolio – in which it might be possible to consume such photographs suggests the generation of other sets of understandings around the objects, in that the photographs invited a potential range of embodied acts of looking and prescribed to some extent the conditions of viewing. The portfolios, such as those of the set at the Museum of

Mankind Library, in pale blue/grey card decorated with letterpress title and little vignettes of indeterminate Italian Renaissance style, with half morocco binding mounted on matching grey card, each with Mansell's blind stamp, suggests both preciousness and seriousness.

Parallel to the photographs of assemblages of objects were, of course, images of single objects. These are present in the 1872 set by Thompson, but appear to be dictated by the size of the object, such as the Easter Island figure, rather than the specific desire to isolate an object for examination as such. While such images had always been made, they became increasingly prevalent by the late 1890s. Photographs of single objects were increasingly used in Museum catalogues, for instance photographs, possibly by D. McBeth, that were used to illustrate the 1910 British Museum *Handbook to the Ethnographic Collections*. Likewise, Brigham's reports to the Bishop Museum represent objects as single specimens for examination. This shift in the imaging of objects perhaps points to a move away from a purely taxonomic and comparative interest to a greater concentration on the meaning of specific objects integrated with other forms of text. The photographs of objects in the 1910 British Museum handbook were used in an illustrative capacity linked to text explanations of the cultural role of the specific object. Also, there was an increasing use of photographs, replacing drawing, in museum practices to create second-order meanings around specific objects within the documentation and management of collections. In this context, there was an emphasis on the precise description of a single object rather than on its performance within a taxonomic array. This is clear in the historical object photographs at the Pitt Rivers Museum, typical of a British institution at this date, where Balfour's technician, A. Robinson (also a fine scientific illustrator who made many drawings for display cases in the museum), increasingly made functional record photographs of individual objects for internal museum use, rather than in response to requests for exchanges and for use by external scholars. These were, however, still in the scientific mode, the object isolated, with even lighting placed against a plain, usually light background at a sufficient distance to obliterate shadows. The object of unmediated observation floated within its own space, the photographic frame.

Commodities

Another form in which ethnographic object photographs circulated were those available from dealers. It is to these that I want to turn now,

for they draw their visual references from two forms, that of the scientific photograph and that of display in mail order catalogues, conflating science and desire. As Coombes has pointed out, the 1890s saw a substantial growth in the market for ethnographic objects, with the emergence of specialist dealers such as W. D. Webster and W. O. Oldham and auction houses such as Steven and Fenton & Co., who specialised in ethnographic sales, an emerging commodity field that shifted from 'curiosity shop' to 'scientific repository'. Major British museums such as the Pitt Rivers Museum and the Horniman Museum bought from these dealers for their collections (Coombes1994:158–9). Photography played a major role in the marketing of ethnographic objects through these sources. In 1896, for example, Webster started to issue photographically illustrated catalogues, in which large arrays of objects contained within one photographic frame were arranged, usually by geographical region, with each item numbered.[30] What is clear is that the catalogue listing follows the arrangement in the photographs rather than visa versa; consequently one could argue that the visual presentation of objects was definitive (Figure 3.6) While these photographs may have resonated with the scientific reference of the earlier period – for instance there is often little stylistic difference between Thompson's 1872 photographs of Borneo shields in the British Museum and those of Webster's catalogues some twenty-five years later – the performance of the styles had shifted from science to commodity. Each object was photographed straight and usually in even lighting, although lighting was also used to accentuate detail, such as carving, that might appeal to buyers. Like earlier 'scientific' photographs the objects float within the photographic frame, all background shadows having been obliterated. The aesthetic procedures of science, which focused attention on the object, are also used to magnify the importance of commodity elements, creating 'a vast collection of exchangeable artifacts displayed prominently for all to see' (Richards 1991:195). If such photographs resonate with the museum display, they also reflect the arrangement of the desirable in mail-order catalogues and indeed the advertisements of firms, such as William Potter of London, who sold exhibition stands and related hardware and whose advertisements were found in museum journals of the late nineteenth century.[31]

Yet there is a strong aesthetic dimension to the presentation of the objects, with symmetrical arrangements, for instance Plate 12 in catalogue 19 (April 1899) presents an Australian rainforest shield, elegantly surrounded by shields and parrying sticks from other areas in Australia. However, such aesthetic intervention does not go as far as

Figure 3.6 Pacific objects for sale. From gelatin half plate negative, *c.*1896.
Photograph by W. D. Webster (Courtesy of the Royal Anthropological Institute.)

the trophy style, for as we have seen, that would have limited the
desired visual engagement with the object. As Coombes has argued,
such developments had a considerable influence on the way ethno-
graphic meanings were made, implicating museums, and indeed their
displays, in the multiple values attached to ethnographic objects
through their saleroom activities (1994:158–9). Photographs extended

the range of this discursive activity. Webster, for instance sold 8½" × 6½" photographs from his catalogues of objects in his stock for one shilling each, and both Webster and Oldman advertised the availability of photographs in the pages of the *Museums Journal*. These photographs also entered museum collections, extending the latter metonymically. Sometimes they were acquired in relation to a purchase, for instance Brigham's print acquired from Webster in 1900 of a series of Purari Delta ornamented skulls;[32] others would appear to have been acquired or at least retained as comparative material within the apparatus of ethnographic meaning, for instance a photograph of lime spatulae from New Guinea that Balfour acquired from Webster for the Pitt Rivers Collection.[33] These photographs are interesting because they signal simultaneously scientific value and commodity desire. They demonstrate the mutability of meaning and the tensions between science and, here, commodity, embedded in the image. Meanwhile the compositional and stylistic forms of the photographs simultaneously gave scientific authority to the objects displayed in the photographic frame and rendered them desirable objects for serious collections.

Conclusion

All these forms that I have considered were narratives of possessing, knowing and studying objects and translated ethnographic classification into a photographic vocabulary that performed in the museum, my focus here. However, they are also used in the field, where these representational strategies are reproduced in collecting material culture, in the printed publication and popular literature. If photographs of ethnographic objects created scientific specimens, the mutability of photographic meaning and instability of categories meant that ultimately photographs performed within a fluid visual culture. Photographs such as those discussed here were part of the visual economy through which artists such as Picasso came to know African objects. As Ivins has argued, photography, in allowing new views, eventually 'changed Asiatic, African, Polynesian and Amerindian curiosities into works of art. It has brought about the reconsideration of the curious and the ambiguous notion of the masterpiece' (Ivins 1953:178). Such revaluations themselves brought about a shift in the imaging of ethnographic objects, for instance in Walker Evans's work on African Art for the Museum of Modern Art, New York, in the 1930s (Webb 2000) . But more importantly, the study of photographs of ethnographic objects also functions as a crucial part of the history of looking at those artefacts in Euro-American culture,

just as important as the actual museum displays. What informs these photographs of objects is a framework of cultural references, constituting a patrimony of knowledge that interacts with the image and determines the selection of codes through which the photographs are read. Photographs of objects reflect disciplinary agendas of looking at objects, yet they also projected ethnographic objects on a wide number of stages. Every bit as significant as other photographs that constitute the discourses of alterity, their power to affect the reading of objects, and thus cultures, is grounded in the complexities of their unstable, indeterminate and hybrid forms.

Notes

1. While I am using the term 'ethnographic objects' throughout, the cultural objects that are the subjects of the photographs are, of course, not intrinsically 'ethnographic' but made so through categories of Western discourse. Photographs are part of that discourse.

2. There is a massive and growing literature here. See for instance Clifford (1988, 1997) , Coombes (1994), Karp and Levine (1991), Bal (1996) and Barringer and Flynn (1998).

3. Contemporary practices are beyond the scope of this essay; suffice it to say that the modern museum object is defined by a series of documenting photographic practices: accession photographs, conservation photographs, X-ray and infra-red photographs revealing unseen depths of the object – procedures that often address the part, rather than the whole of the object. There is a sense in which the museum object becomes a sum of its photographs.

4. For instance Daguerre's *Arrangement of Fossil Shells* (1837–9) or Fox Talbot's *Articles of China* and *The Milliner's Shop*, *c.*1844.

5. At the Museums Association in 1897, Rudler actually advocated cutting up a copy of Ratzel's book to provide illustrations for museum displays (1897:59).

6. Colonial material, such as Indian and Chinese decorative arts, was absorbed into the fine and decorative arts agendas of the South Kensington Museum. See Barringer (1998).

7. A report on the new Horniman Museum in south London at the Museums Association Conference in Canterbury in 1900 especially mentioned the provision of photographic darkrooms.

8. For example around 1900 Henry Irving of Horley in Surrey advertised in the *Museum Journal* as a 'specialist in all kinds of photographic work in and for the museum'.

9. The situation changed with the rise of advertising photography in the early twentieth century.

10. It is unnecessary to restate here these arguments, drawing heavily on those of Foucault concerning surveillance, disciplinary control and visibility; they are well established – see for example, Tagg (1988); Lalvani (1996); and Sekula (1989). In a museum context, see Bennett (1995).

11. PRM.PC. C2.7.4.

12. PRM.PC. C2.5.13–14.

13. CUL.HP. Envelope 2024.

14. For instance, eliminating unwanted highlights with a light dusting of powdered clay.

15. PRM PC. C2.9.24. The collection is now in the Pitt Rivers Museum.

16. PRM.PC C2.7.15.

17. A series of photographs of Egyptian hieroglyphs was also read racially (Ruffer Collection, Pitt Rivers Museum).

18. A substantial literature on the history of museum display, too extensive to cite, has informed my argument here, especially Bennett (1995) and Coombes (1994).

19. Lawes list published by King of Sydney, images Nos 139 and 151 (see Chapter 2). These images and others, including pottery, stone clubs, earrings, shields and 'Fly River Curios', are listed under 'General' . This categorisation is not because the images were 'unscientific' but because those listed under 'Anthropology' are all concerned with a broad physical anthropology, portraits of local people in the style of scientific reference.

20. Trophies of Arms were found in armouries of great houses as an aesthetically pleasing way of storing arms and monitoring their condition for use. See for instance Parnell (1993:73–7). By the nineteenth century they had largely become romantic decorating devices in wealthy homes. Trophies of arms for domestic decoration were available from Bannerman's catalogue as late as the 1920s. My thanks to Philip Lankester of the Royal Armouries Museum for discussing trophies with me and for bringing this, and more, material to my attention.

21. PRM.PC B60.17b.

22. For a discussion of taxidermy in relation to photography, display and empire see Harraway (1989:26–58); and Ryan (1997:112–19).

23. I have seen prints in anthropological institutions, in travel albums and in the collection of a nineteenth-century folklorist.

24. Although, as Coombes has rightly argued, the compositional devices of the trophy are present in photographs of 'native types' (1994:13)

25. This title is integral to the image, written into the negative, PRM.PC AL62.1.2.1. The photograph was collected by an army officer with the Indian north-eastern boundary survey of 1875.

26. British Museum Central Archives CE 4/102 f.47.

27. Fenton refused to make any more photographs of natural history specimens for Richard Owen in the 1850s, arguing that they were not financially viable (Hamber 1996:383).

28. This was especially so because at that date the Christy Collection was not yet on view at the British Museum but at Christy's house on Victoria Street.

29. Advertisement in Mansell's catalogue.

30. The original plates for Webster's photographs are now at the Royal Anthropological Institute. Oldman's were also producing photographically illustrated catalogues by 1904.

31. In the early twentieth century, the department store was seen as the model for museum display in the Brooklyn Museum by Stuart Culin. See Bronner (1989:222–3).

32. Bishop Museum, Honolulu. Photograph Collection Folder: PNG Ethnic Culture.

33. The Museum's object accession registers suggest that he acquired the photograph but not the objects themselves.

Part II

Historical Inscriptions

f o u r

Visualising History: Diamond Jenness's Photographs of the D'Entrecasteaux Islands, Massim, 1911–1912

Some Fieldwork

The series of photographs that forms the focus of this chapter was the product of nine months' fieldwork in 1911–12 in the D'Entrecasteaux Islands, Massim, off the south-east coast of Papua New Guinea. The photographs were taken by a young Oxford anthropologist of New Zealand origin, Diamond Jenness, a student of R. R. Marett. Although not modern fieldwork in the post-Malinowskian mode, it was typical of the survey work that can be seen as the stirrings of the British fieldwork tradition in anthropology (Stocking 1983:83–4). Again I want to argue a form of social biography, namely the way in which different forms of truth value are attributed to photographs over time and space. It is precisely this that is at the crux of their value and interest in any historical assessment. In this the 'performance' of photographs as genres of historical expression mirrors the processual nature of history itself. Central to this is the consideration of the photographs as a site of intersecting histories, here those of anthropology and local Pacific histories in the D'Entrecasteaux Islands – intersecting because they share experiences and yet have their own trajectories, encompassing sameness and difference.

Jenness based his fieldwork on Goodenough Island, one of the principal islands of the D'Entrecasteaux group. His choice of site was dictated by the fact that his brother-in-law, the Revd Andrew Ballantyne, was in charge of the Methodist Mission station at Bwaidoga in the south-east corner of Goodenough Island. It was the first anthropological

endeavour of its kind to be supported by the University of Oxford. It drew strongly on the methods established by the Cambridge Torres Strait Expedition of 1898 (see Chapter 7). Indeed direct allusion was made to the latter during Marett and Jenness's fund-raising efforts in Oxford: 'such field work forms an integral part of [the Committee for Anthropology's] educational programme, . . . other Universities have brought much honour to themselves by equipping Anthropological Expeditions . . .'.[1] The fieldwork constituted a systematic survey of an area, encompassing social structure, genealogy, ritual and religion, physical anthropology, material culture, music (including sound recordings) and photography. In the course of the planning, Jenness went to Cambridge to visit Haddon, Rivers and Frazer, collecting fieldwork advice and methodological guidance: for instance, Rivers furnished him with a copy of his genealogical method. It was Haddon who guided Jenness in the field use of the mimetic technologies of photography and sound recording, both of which had been used extensively on the Torres Strait Expedition.[2] Indeed, Jenness was moved to write to Haddon 'I am beginning to feel that Cambridge as well as Oxford is sending me out, so much help have I received from it. You especially have helped me enormously, and I shall always be proud that a mere novice like myself has been thought worthy of assistance by such a veteran anthropologist.'[3]

Jenness's fieldwork, while fruitful in some ways, did not achieve everything he had hoped. This was not merely because of his inexperience, but because of a more general confusion resulting from a compound of anthropological method and prevailing local conditions. Jenness's arrival coincided with one of the periodic famines that afflict the Islands, a famine that did not ease until June 1912.[4] As a consequence he was faced with a society under extreme stress: normal social functions and behaviour, many of which revolved round the competitive production and consumption of staple foodstuffs, were dislocated in the fight for physical survival. Moreover, Jenness was severely disappointed by the quality of his data. He wrote to his supervisor Marett in Oxford: 'Sometimes I fear that I have not got into the real native life – it all seems too open and straight forward but I think I have. I can't think "native" tho' as I suppose one ought to, much as I try, Oxford scepticism is too much for me.'[5]

In the light of Stocking's comment in relation to early fieldwork, this remark would seem to suggest proto-participant observation. Similarly, both Jenness's student visit to Paris to meet members of the Année Sociologique (Richling 1989:775)[6] and his visit to Rivers and his interest in the latter's genealogical method suggest he was aware of the changing

shape of his discipline. However, there was a paradox in Jenness's position in the Islands. Although his relationship with the Mission gave him ready access to people and an interpreter in the person of Ballantyne, conversely it circumscribed his relationship with the Islanders and limited his perspective. This is not to say that he underwent no methodological shifts in the course of his fieldwork. Jenness seems slowly but surely to have operated more independently as Ballantyne became more preoccupied by mission business, and it is implied that he had acquired some local language skills: 'We are no longer having natives in for me to fire questions at ... I have been tramping far and near ... I have been touring round the island with a large party of natives – about 50 – who had made new canoes ... Living and sleeping with them the barriers appear to break down.'[7] Nevertheless the unsatisfactory conclusion of the fieldwork, both as Jenness perceived it and in terms of its immediate historical assessment,[8] would appear to exemplify that hiatus of method that pertained in anthropology between the collapsing evolutionary paradigms of the nineteenth century and the evolving sociological approach. Further, Jenness himself appears to have a somewhat ambiguous relationship with photographs, an uncertainty that was to become more marked in anthropology of the classic functionalist period. The photographs were clearly valued as part of the scientific endeavour. Yet in disseminating the record, Jenness appears to participate in this marginalising process himself. In writing from Canada to Marett on the arrangements for publishing the fieldwork monograph, *The Northern D'Entrecasteaux*, he says: 'In the selection of photographs to illustrate the text, some obviously had to accompany certain passages. But in many places almost any photograph would serve, since the only object was to use as many as possible without actually turning the report into an album.'[9] This suggests concerns that over-visualization in relation to textual truth might be construed as a weakness or at least inappropriate.

I have outlined this history because enmeshed in it is a collection of some 470 photographs that form part of the fieldwork corpus, which, in its entirety, also comprises material culture and sound recordings.[10] The field notes have not survived. The published volume, *The Northern D'Entrecasteaux*, which appeared in 1920 to polite but unenthusiastic reviews,[11] is a descriptive but somewhat uninspired monograph, devoid of the kind of sociological analysis towards which anthropology was rapidly moving in the years after the First World War.[12] Further, as I have suggested, the photographs are used illustratively, rather than analytically. They are not referred to in the text, as Malinowski's were

to be, but form an authenticating and visualised parallel and unspecified anchoring of the textual descriptions. Especially from the standpoint of his later work in the Arctic, Jenness seems to have been far from satisfied with both the fieldwork data and the book, being conscious of the changing shape of anthropology: 'I realize how much I had left undone in Papua . . . If only I had known how to set about fieldwork.'[13]

So the most substantive result of this little history played out at the periphery of the colonialised world is a collection of photographs in the form of five-inch by four-inch gelatin glass plate negatives. There is also a set of rather poor contact prints captioned by Jenness, and his personal album, which comprises the same pictures, but differently arranged and captioned and with some additional photographs of the mission.[14] The photographs had existed quietly in the Photograph Collections since they arrived in the Museum in 1913. Significantly, in the context of my discussion in Chapter 2, they do not appear to have been disseminated, but remained as part of a fieldwork-specific scientific record.[15] They do not seem to have been disturbed except in order to make, in the early 1930s, a set of prints showing various technologies for inclusion in a series of photographs typologically arranged to mirror the Museum's own typological classification and display of objects. Consequently the photographs' performances were restricted to the documentation of pottery or sago making, rather than being engaged with in terms of the history of D'Entrecasteaux and the people who live there.

However, here I want to consider these photographs in terms of the history within them and the histories around them: their historical refiguring.[16] Such an exercise requires a consideration of the relationship between photography and history, our expectations of this relationship and the social biography of these photographs as both images and objects. I have already discussed in Chapter 1 the way in which serious consideration of the nature of photography as a medium is necessary to the exploration of photographs as historical sources. In the contexts of Jenness's field photographs we see, very literally, different performances in shifting space, both in and outside the archive. Immutable inscription and mutable meanings in photographs are, of course, crucial to the processes of re-engagement. Yet at another level one is lured into a pattern of expectancy inappropriate to the true nature of the medium, which can be simultaneously fragmented, unarticulated, and resistant yet challenging. This ambiguity is, as has already been suggested, one of the reasons why photographs have been marginalised, despite their promise to deliver a mass of raw data. As was

pointed out in Chapter 1, still photographs contain too many mean-
ings, unconstrained by the narrative chains of signification that
characterise film. Nonetheless, we must note that this expectation of
photography is our cultural expectation. As Niessen has argued, people
have a peculiar faith that photographs will function in certain ways:
'This is an aspect of our own mythology about who we are in relation
to "the other". Photographs do not perpetrate this relationship but
are manipulated in its service and as such act as an extension of ethno-
graphic authority' (1991:429). The points I wish to develop in relation
to Jenness's photographs exemplify these issues.

Further, one has to consider the movement between memory and
history in the contexts of these photographs. There is a vast literature
on memory and history in relation to photography, much of it at an
abstract or metaphorical level, as I suggested in Chapter 1. What con-
cerns me here is a working out of some of these issues 'on the ground'
in a specific cultural environment. Here, genre, expectancy and perform-
ance become crucial to understanding of the way that these photographs
have been engaged with. It will have become clear from my discussion
so far that photographs can be read over two broad categories of history:
the forensic, constituted by the material stability of the content in terms
of 'reality', and the submerged, traced through refiguring histories that
gather around and enmesh images. The latter category comprises those
possibilities that the image *implies,* perhaps through absences within
the image, suggesting a historical counterpoint to the forensic. This is
where, as I hope to demonstrate, the nexus of photography and history
is potentially most revealing.

The forensic, here, is the status of Jenness's photographs as ethno-
graphic documents, describing or inscribing the lives and material
culture of the Islanders.[17] In terms of salvage ethnography, Jenness's
photographs record many things, such as house styles, graphic art, and
even sago-making techniques, which are nowadays rare or have dis-
appeared completely. Contemporary occurrences are often conscious
revivals and statements of identity and cultural renewal. Such consider-
ations are clearly important and have strong implications for the
forensic use of historical photographs, though a discussion of these is
beyond the scope of this chapter. Suffice it to say that one has only to
look at the work of, for instance, the Vanuatu Cultural Centre, which,
since 1977, has built up a collection of over 2,000 visual images, mostly
photographs, documenting the visual inscription of the islands (Huffman
1996), or the Ashiwi Awan Museum and heritage project at Zuni Pueblo,
New Mexico, where copies of some 3,000 photographs, mainly from

the National Anthropological Archives at the Smithsonian Institution in Washington, were gathered in a project in 1990 (Holman 1996:109). These are just two examples of an active virtual repatriation of heritage through photographs gathered from collections all over the world. They are amassing visual data that are slowly being absorbed into local indigenous cultural currencies, with a consequent assertion of indigenous control over them. Nevertheless, I am going to pick up some relevant points later in this chapter to pose theoretical questions about assumed universal equivalence in visual history.

For the most part Jenness's camera is focused on the everyday in a way that reflects Haddon's short instruction on appropriate subjects for ethnographic photography in the third edition of *Notes and Queries* (BAAS 1899:239–40): making pots, smoking, fishing, talking, grooming, inaugurating a new canoe, funerals. As such the very acts of description and forensic analysis become historically inscribed. There is a concentrated framing to many of Jenness's photographs, focusing attention on the processes of, for instance, gardening or pottery making.[18] From this material one can extrapolate, on a forensic or evidential level, information on land use, settlement pattern, spatial arrangements and the health of the population, all representing the minutiae of history and Malinowski's 'imponderabilia of actual life'. But even the forensic implies an enmeshing of the image with other systems, for as Clifford has argued 'the salvage paradigm . . . [is] . . . a relentless placement of others in present-becoming-past' (1986:44), a point I shall explore further in Chapter 7.

In the Archive

This leads me to what I believe is a more complex but ultimately rewarding issue. I want to argue here that it is not what a photograph is *of* in purely evidential terms that should primarily concern us, but the context in which it is embedded. We are concerned here with 'provocative contexts', those broader discourses in which the photographs and photography participate, suggesting and provoking rather than containing in terms of historical meaning (Tonkin 1992:89–90). Different contexts, or 'performances', will suggest, of course, different readings of the same set of photographs, a point to which I shall return in Chapter 5.[19] Jenness's own photographs demonstrate this lucidly, suggesting two possible but related directions for interrogation. First, the structuring of the ethnographic record as an exercise in anthropological historiography, and second, the relevance of such a photographic

record to the histories of the subjects, the Goodenough Islanders themselves. In this latter connection I am especially interested in the theoretical and methodological questions such an exercise raises rather than in any way attempting to 'tell their histories' through the mediation of the photographs. Within this structure we see the photographs shifting from what Friedman (1998) has characterised as communicative knowledge, which can be freely transferred, such as the surface appearance of the subject-matter in a photograph moving into the anthropological archive, to a conjunctive knowledge that requires context in the form of active social embeddedness. Obviously, one can argue that anthropological consumption also constitutes a form of social embeddedness; however, the model serves as an adequate heuristic device for distinguishing the different communicative roles of the photographs in the two spaces under consideration.

To take first the structuring of the anthropological record. The intention that directed these images created a specific form of anthropological gaze, as intention, meshed with the evidential, articulates a meaning to be communicated. However, inscription outlives intention by the very nature of the photograph, and thus we have the beginning of a refiguration, a reinterpretation. Although Jenness's work fell short of participant-observation fieldwork in the post-Malinowskian sense, a nascent observational model can be discerned both in Jenness's informal comments that I quoted above and, more insistently, through a close reading of the photographs. The snapshot style of photography, a genre of immediacy, predominates. There is a non-interventionist quality. Very few photographs are overtly set up with the exception of children's games or, in a very different context, physical anthropology.[20] There is seldom the tension of intrusion, and only occasionally bewilderment (Figure 4. 1). Indeed, the photographs might be seen to be closing the cultural distance, not creating or reifying it. They have an immediacy and a relaxed quality, inviting a direct human response that is rare in material of this kind from this early date. These photographs challenge the stereotype of pre-Malinowskian fieldwork as distanced and non-participatory. In fact, as documents the photographs are revealingly honest about the nature of the colonial encounter and anthropological entanglements with it: for instance, the activities of the mission station in feeding starving women and children. Such photographs suggest an understanding on the photographer's part of the historical processes in which he is implicated. Furthermore, the photographs reveal the encounter to have some parallels with a more modern fieldwork dilemma: that of intervention in the face of natural or political

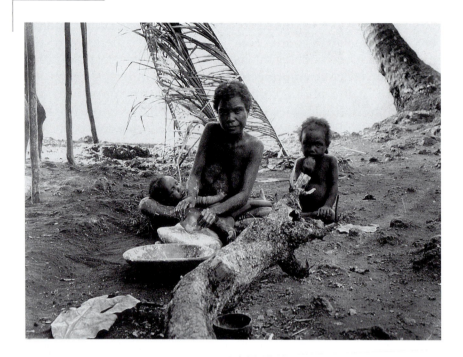

Figure 4.1 Making knife and watching the photographer. From gelatin quarter plate negative *c.*1912. (Courtesy of Pitt Rivers Museum, University of Oxford, PRM JS.309.)

catastrophe. Indeed on 11 April 1912 Jenness wrote to Marett 'many of the natives are sorely pressed and some of the children and old folks would certainly have died had we not fed them with our own rice and biscuits'.[21] While at one level this action is colonially circumscribed, it is clear from Jenness's letters that it was equally circumscribed by the humane.

Yet conversely, if one looks at both the structure of the 'scientific' contact prints Jenness made for the Museum and at the structure of his personal album, the post-factum making of the anthropological object in photographic terms is clear. There is an evident tension between personal impression and scientific expression. The album is arranged conventionally, in a grid of nine images to the page in serried ranks (Figure 4.2). The viewer is led in through a narrative of place and then through functionalist ethnographic categories. The locating landscape is followed by the establishing images of native 'types'; none of the subjects are named, and indeed many were taken at Samarai Hospital before Jenness actually arrived at Goodenough Island. These are followed

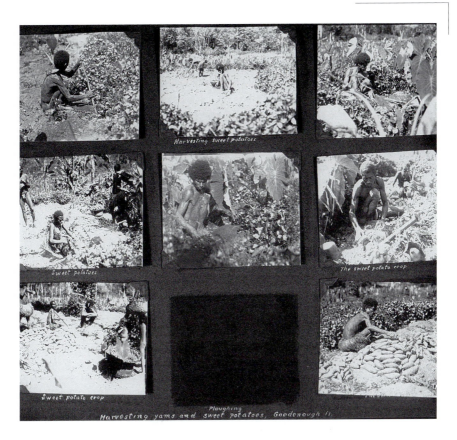

Figure 4.2 Page from Diamond Jenness's album of his fieldwork photographs. Gelatin silver prints on black card, *c.*1914. (Courtesy of Pitt Rivers Museum, University of Oxford, PRM AL74.33.)

by views of the mission station with Fijian and Samoan mission teachers, who are all named; then establishing shots of the local villages, and people in the villages; and then a survey of activities and technologies such as gardening and pottery making, concluding with funerals. The fieldwork tension is eventually released by a final page of farewell shots of Port Moresby. The arrangement suggests increasing penetration of the gaze in almost formalist terms; yet it is a private record, an arranged experience that, as memory, becomes the thing itself.

The making of the anthropological object is equally clear when one compares the album set with the 1913 contact prints that were made and captioned by Jenness for the Pitt Rivers Museum. Indeed, these preceded the plates into the collection, and numbered only 460 from

a total of some 520 plates.[22] The captioning is much more detailed, yet more distanced and less personal. Significantly, images that threaten the purity of the anthropological object, such as the photographs of mission teachers, do not appear in the 'scientific' series.[23] Further, whereas three separate funerals, occurring at Kabuna, Faiyavi and Waikiwali, occupy separate pages in the album, in the 'scientific' series they are more integrated, while in the reprinting for the Museum's 'typological' series in the 1930s they are actually conflated to establish a generalising visual narrative of funeral ritual, mirroring the construction of an atemporal 'typical behaviour' from discrete, unique incidents in written ethnographic text (Figure 4.3.). These examples are important because they underline the selective inscription not only in the making of the photographic record but also at its subsequent reproduction. Here context is refiguring, juxtaposing images in ways that suggest questions about the nature of anthropology and its history, questions that reach beyond the content of the images themselves. The photographs offer us evidence that clearly contradicts the view of

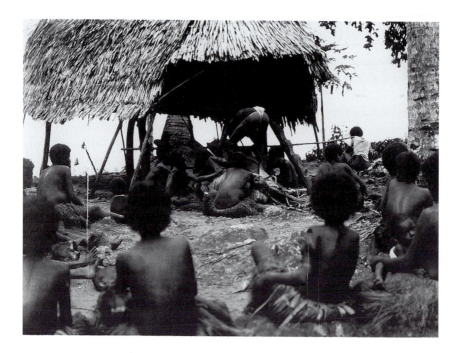

Figure 4.3 Funeral at Kabuna. From gelatin quarter plate negative, *c.*1912. (Courtesy of Pitt Rivers Museum, University of Oxford, PRM JS.395.)

pre-modern anthropology as non-participant, culturally distanced and objectifying at the moment of its inscription.[24] Rather, it is a later refiguring and institutionalisation that pushes this inscription towards a more structured, homogenised and stereotypical form, and the making of the anthropological object. Thus, I would argue, Jenness's photographs can actually be used as data to reassess the fieldwork relationship in the early modern period. The evidence in and around these images quite simply does not square with the more conventional, received histories of anthropology. In pointing to a greater complexity of individual motive and disciplinary intention, it accords with, for instance, the reading of the Torres Strait Expedition as operating within a complex set of ambiguous relations of interchange, agency and instrumentality between Islanders, colonial authorities, the mission and the scientists, some of which I discuss in Chapter 7 (Herle and Rouse 1998).

The Photographs in New Spaces

The other path of enquiry I wish to follow raises even more complex questions about history and photography, and encompasses questions of the visualisation of history, namely, the historical encounter itself, the experience of those involved as expressed photographically, and finally, the modern encounter with that expression as we try to make historical sense of it. This poses some interesting theoretical questions about photography like those that this re-engagement with Jenness's photographs has raised about history, memory and photography. Indeed, assumptions about this relationship are based in Western expectations of the relationship between photographs and memory: expectations and, consequently, uses and readings that prefigure approaches to photographs in certain ways. Inscriptions in photographs might not accord with a historical consciousness that is not necessarily defined around the same events or chronologies that inform the photographs. Further, assumptions around photographs as historical sources have been dominated by the Euro-American theoretical model, which has tended to 'universalise an interest in certain modes of historical narrative . . . a step taken in the name of democratising history . . . curiously affirms the generalised authority in certain ways of establishing a command of the past' (N. Thomas 1997:45–6). Such a position might thus obscure differently constituted relations between the photograph and the past.

Much of what I shall say is presented as a series of questions. I cannot begin to offer answers, for these would be meaningless generalisations,

given the culture-specific nature of any practical application. One can only point to the complexities of memory, identity and image in an essay concerned with drawing out the methodological complexities of cross-cultural readings of photographs as history. Indeed photography is increasingly recognised as important in the construction of multiple articulations of cultural identity and memory, as well as formal histories, of emergent nation-states. Further, it is important to realise the extent to which empowered narratives, linked to photographs, are experienced as real or true within a particular moment (Morris 1994:7). There are inside ways of responding to culturally specific actualities that work through photographs. Binney and Chaplin (1991), working with Tuhoe people at Urewera, New Zealand, found that photographs brought forward many associations, both painful and pleasurable, that were invisible in the European record but still active within individual and collective memory. The photographs represented a life-force that became totally absorbed within different modes of historical narrative. Similarly, Poignant noted of her work with people at Maningrida, Arnhem Land; 'the interpretation of photographs seemed no more than traditional oral modes of representing the past' (1996a:8). As I suggested in Chapter 1, orality penetrates all levels of historical relations with photographs, not simply in terms of verbalising content, but of the way the visual imprints itself, is absorbed and is played back orally (Poignant 1996a; H. White 1980; Barnouw 1994:207–8).[25] The history of Jenness's field photographs thus becomes a tool, for the relationship of Goodenough Islanders' own history to the photographs exemplifies many of the points I wish to make.

Jenness's photographs form a record of the Islanders at a difficult period in their own history, when they were confronted not only by immediate problems of physical survival in the face of famine, but also with the broader problems of involvement in a wider world. Coming under anthropological scrutiny was, of course, also part of that encounter, and indeed formed the dominant discourse for the performance of these photographs. The watershed perceived in Western histories of the area – the establishment of colonial rule – is mirrored in the indigenous periodisation. Both conceive of a new era in which the Mission (the main agent of institutionalised cultural change) is pivotal and that is differentiated in myth from a violent and savage past (Young 1977:130–2).[26] The latter is typified, for example, through the representations in oral-history-cum-myth of the reign of terror of Malaveyoyo, a Kalauna big-man who died some fifteen years before Jenness arrived at Bwaidoga (Young 1983:92–109).

These photographs provide the documentary substance for a definable moment of several intersecting histories: those of anthropology itself, colonial history, and the local Pacific history. Both temporally and conceptually, that moment is given prominence by virtue of being made visible through photography, though the static reality of photographs would appear diametrically opposed to the idea of myth as an expression of processual history. Working with Michael Young, who was able to undertake some fieldwork in 1992, it has been possible to consider some of the specifics articulated through Jenness's photographs. A number of lines have suggested themselves: layers of history that have gathered round the images but have yet to be properly articulated or interrogated. Again, as I suggested, if we are to re-engage or re-activate the histories submerged in photographs, we have to look at different 'performances', different linkages between what photography is and what is expected of it in any given context. The first stages of a photo-elicitation exercise were initiated by Young in the field when he took a small sample of photographs back to Goodenough Island. Though limited, it has already raised some theoretical issues that it is well to consider here. It mirrors, in relation to photography, the concerns raised by Friedman (1998), Munro (1994) and others about modes of knowing and the fundamental contradictions between local forms and their translation for wider audiences. For instance, the incompatibility of content and form, questions of authority, and locally motivated appropriations and refigurations, when knowledge formulated in an anthropological discourse becomes embedded in local social experience, and constituted as a conjunctive knowledge. All these resonate through possible readings of the photographs.

Most of the responses of modern Bwaidogans to Jenness's photo-graphs were at the forensic level. This itself is valuable in terms of extending the ethnographic baseline that the photographs themselves represent. For instance, Tomokivona (who knows Young well) was shown the picture of his paternal grandfather, also called Tomokivona. Confronted with the image he talked about the man, how the photo-graph seemed to catch him in a characteristic stance with his arms behind his back – just as Tomokivona remembered him.[27] He then begins to move in and out of the image itself, using it as a conduit of personal memory activated by the very specific circumstances of the photograph; this begins to move into what Collier would call 'projective interpretation', which he sees as the only way in which the camera record can be fully useful (1967:49): 'That coconut palm behind him I can remember. It used to be just there, where William's house is now . . .

The other tree in the picture is an afua tree . . . it fell down in a big wind . . . the waves came into the village. I think the photographer was standing just there, where Mataivu's house is now' (Tomokivona to Young 1992). And so on. In purely ethnographic terms, one begins to get an idea of the old layout of the village.

Yet while the realist nature of the photographic image suggests access to unmediated historical truth, the patterning is external to that of the subjects: fragments of their ancestors' experience deemed relevant and significant by 'us'. This is clearly, but inadvertently, articulated by Collier: 'questioning the native [with] the photograph can help *us* gather data and enhance *our* understanding' (1967:46, added emphasis). Between ethnographers' use of photographs and how their informants interpret them 'lie inconsistencies which shed light on our historical enterprise' (Niessen 1991:419). What happens in this space between is crucial, for at the same time 'the boundary becomes the place from which *something begins its presencing*' (Bhabha 1994:5 original emphasis). We have to ask: in what ways can history so inscribed be absorbed into the Islanders' own perception of their past, beyond a basic surface appearance? If 'photographs sharpen the memory' and give a 'gratifying sense of self expression', how was this circumscribed? (Collier 1967:48). Berger has argued: 'If the living take that past upon themselves, if the past becomes an integral part of the process of people making their own history, then all photographs would re-acquire a living context, they would continue to exist in time, instead of being arrested moments' (1980:57).

But even this is not unproblematic, for images return not only to the location of their creation but also to a different set of social relations. They are refigured. These inflect images returned to the private sphere, and the way in which photographs act as a conduit of memory, triggering remembrance, association. This kind of articulation of memory has been marginalised by some oral historians as 'reminiscence'; but here it would appear both active and relevant, for in this instance photography becomes an interface between history-as-lived and history-as-recorded. Memory is the site of social practices that make us, together with the other cognitive practices through which we understand society (Tonkin 1992:12). As I suggested in Chapter 1, it is necessary to apply to photography – 'visuality' – the same kind of critiques and analysis that have been applied to oral history – its genres, reproductions, performers and audiences – and not to concern ourselves solely with questions of empirical detail and veracity of content, a raw evidentiality that, as Barthes has argued, might paradoxically be the site of the

photograph's resistance (1984:106–7). Rather, our concern should be the social relations of photography's production, reproduction and consumption specifically as a mode of historical expression.

To return to my main argument, the shift of photographs from public to private consumption implies also a dilemma raised by the reality effect of photography. The shift emphasizes the appropriation of the subjects' history and the silence of their voices at the moment of inscription. Can one really sustain the assumption on our part that, because photography has a relevance that we, as interpreters, might value, the same will apply in societies whose visualisation of the past, whose verification and expression of historical event and the transmission of historical knowledge are quite different from and even incompatible with received Western notions of what is history? Beyond the technical determinants, are we dealing, in conceptual terms, with the same medium? Arguably, photographs superimpose a preconceived and alien model of seeing and articulating the past that is in direct contrast with other patterns of remembering (Connerton 1989:19). Is there a danger that photography's realist claims state categorically an appearance of the past that might, in historical reality, have more fluidity? In imposing itself on memory, it is not dissimilar to the way in which, as Goody argues (1987:268–70), visual components of language mediate internal models, feeding back into the structure of speech and perception. Obviously, alternative perceptions of the past will instigate different readings of images; but there is a tendency to universalise not only the authority of certain modes of historical narrative (N. Thomas 1997:46–9) but also assumptions of the qualitative expectation of photographs as natural conduits for memory based on a universalized notion of realism and visual inscription.

Consequently, we must distinguish here between photographs as a tool for our further inscription of histories and an absorption of photography into alternative histories themselves. In much writing there has been a slippage between the two, failing to distinguish the way in which our uses of photographs are socially conditioned. The role of photography itself as a medium is conspicuous here, with its seductive realism and its apparently unmediated access to the past. As Fabian has argued '. . . our diagrams [read photographs] are unquestionably artifacts of spacio-visual conventions whose function is to give "method" to the dissemination of knowledge in *our* society' (Fabian 1983:116, original emphasis). Similarly, this touches on a central anthropological problem, that, however much we might want to take other ways of consciousness seriously, we cannot assume in advance

that they will coincide with what *we* take to be a convincing account (Keane 1997). The visual communication debates on whether or not we 'see' the same thing and whether the iconicity, indexicality and Panofskian notions of the pre-iconic of photographs work cross-culturally – where does recognition lie? – seem beside the point in terms of such a heavily culturally constituted activity as the construction of history. Rather, as for instance Poignant's Maringrida work has shown, our questions should be framed in terms of the culture of telling the past. We return, in this, to genre, expectancy and performance.

Thus, as I have intimated, responses will be culture-specific within a global visual economy, depending not only on traditional indigenous modes for visualising history, and on the influences, absorptions and refigurings of globalised media outpourings of Western modes of imaging, but also on differing degrees of assimilation of the possibilities and politics of the power of photography. Even within this framework one cannot, of course, assume a homogeneous response: to do so would merely be another manifestation of the objectifying and reductionist anthropological construct. Rather, there emerge contrasting, and even ultimately competing, historical refigurations, creating (very literally in photography) plural frames of history. This, after all, is intrinsic to the nature of photography, part of the discourse of mutable meaning and infinite recodability.

This point is illustrated by the response of one Goodenough Islander, Lawrence Yaubihi, to Jenness's photographs. As a number of commentators have demonstrated (for instance Keesing 1989; Otto and Thomas 1997; Friedman 1998; Kech 1998), modern assertions of identity and cultural renewal in the Pacific involve, amongst other things, the internalisation of anthropological-come-ethno-historical notions of culture. We can detect subtle elements of this in Lawrence Yaubihi's comments. Yaubihi is a man of considerable political experience. He had been a government interpreter in the colonial days, then a village councillor and latterly an elected representative in the Milne Bay Provincial Government, in which he achieved the office of Speaker. He is also an amateur historian. He offered Young a detailed forensic, ethnographic reading of a photograph of Malauna people feasting on the beach at Lupwasa when Jenness travelled aboard a new Wagifan canoe. It was the detail that fascinated Yaubihi. 'It is good to see what they were wearing.' Exactly. Here we have images being re-appropriated as living history and what appears to be a rich and dense reading of them as historical data (which they are); but Yaubihi's data are evaluated as such because his expectation pattern of 'history' as a genre, and perhaps

photography too, accords more clearly with our own expectation patterns.

For other people, in contrast, the photographs acted as conduits for very differently inscribed memories. An example of this is provided by considering a photograph that intensely interested people in Bwaidoga. Their emphasis on place is significant. I have already alluded to this in connection with salvage ethnography offered by Tomokivona in his reading of the photograph of his grandfather: Wailesi's house was there, the photographer stood here. But the emphasis suggests another line of enquiry. Bwaidogans' reading of a photograph of fishing in Mud Bay (Figure 4.4) evoked commentaries by Tomokivona, Uledoma and Mataivu (all of whom belong to the same clan). Their reading of the photograph was cued by their reading of the landscape, or more specifically the land-use: they identified fishing grounds, rocks, gardens and land reverted to bush. Again one has a dense form of projective reading, revealing a level of visual fluency on the Bwaidoga men's own terms. This was more than merely a detailed local reading that shifted the significance of the photograph from its formal centre – the men

Figure 4.4 Wisps of smoke rising from the hillside beyond Mud Bay. From gelatin quarter plate negative, c.1912. (Courtesy of Pitt Rivers Museum, University of Oxford, PRM. JS.382.)

fishing[28] – to a totally different centre, the distant wisps of smoke, indicating gardening activity. It projected significant, emotionally invested attitudes on to the photographs and triggered history inscribed by other means than 'shown in the image'. Only through reference to these points did people enter the story. This is not merely a forensic description of what is in the photograph; rather it is an appropriation of the photograph to an established way of inscribing the past. This is what Goody, Tonkin and others have argued is the relationship between oralcy and literacy. The absorption of a medium of communication may extend consciousness but does not necessarily imply deep cognitive changes. What seems to have happened is that Tomokivona and his kinsmen initiated their own historical refiguration of the images, through them asserting their identity and associated control of the land, and hence of the means to produce food and therefore wealth and status. Memory, that interface between the individual and social identity, is expressed or inscribed in land, which in turn is inscribed in photography. Here we see the points of intersection of different ways of telling history.

We can go on to ask what kinds of images, beyond primary content recognition, might be recognisable images of the past and have historical density. Realism is a culture-bound judgement of likelihood. The problems this suggests for the nexus of photography and history are obvious. For instance, there is an assumption amongst anthropologists that photographs of specifically anthropological intent are more relevant to people's history, merely because anthropologists place high likelihood value on them. The anthropological photograph expresses a specific expectancy pattern of 'truth', a label of agreement between producer and recipient being well understood. But why not travel photography? Or even tourist photography? (Both of which, through the nature of the medium, capture ethnographic and historical incident at some level.) Whereas one must admit to a visual hierarchy of truth, arguably such photographs are different ways of seeing over the same ground, expressing different sets of relationships that will ultimately mesh in varying degrees in the articulation of historical experience. This is precisely why Jenness's five hundred photographs of the D'Entrecasteaux Islands lingered unheeded for nearly eighty years. They failed the judgement of anthropological likelihood. That judgement constituted a studied rejection of the photographs because the context of their creation was perceived as inadequate for producing anthropological or historical truths, a process that was demonstrated in Chapter 2 in the contexts of collecting photographs.

It goes without saying that cultural concepts of reality can be so vastly different that it may be difficult to establish points of contact at all. But this is precisely what photographs such as those of Jenness are: shared conduits of memory for different perspectives on the past. They are not the same pasts but they are, through sheer force of history, intersecting pasts. This is the locus of their historical power. Given that, as Tonkin argues (1992:51–2), expectancy patterns are dynamic and situational, photographs consumed in other contexts present the challenge of other ways of seeing. This is what re-engagement with images, probing their historical refigurations, is all about. Thus, one might argue against the position I have just outlined that photographs can in fact confirm reality – though not necessarily a forensic reality *per se*; rather they imply a reality of identity for those who have been marginalised not only from the inscription of history but from its interpretative process. An increasing body of work, from academic work to community projects, suggests the enormous potential of photography for opening alternative histories.[29] Photography can do this precisely because it invites also a subjective, internalised response, even a purely emotional response, that references different experiences and opens a space for their articulation. Although the inscription may be within the dominant way of telling, the space exists for recoding and absorption, as in the instance of the old lady from Banada who, having heard about Jenness's photographs, paddled across Mud Bay to see them. Like the responses, speaking to photographs, experienced by Binney and Chaplin (1991:432), she sat on her lineage's stone platform in the village, holding the photograph of a long-dead kinsman, and cried a soft mourning lament.[30] The photographs assumed a new meaning and a new phase of their social biography.

Conclusion

I have outlined a critical and perhaps contradictory stance, but I think it is one that needs to be articulated, for it challenges our assumptions about photography. The complex, sometimes resistant, yet rich responses to photography, and the implications for its relationship to 'history', that have been reported increasingly from the field cannot be explained away by an increasingly sophisticated and reflexive view of photography by fieldworkers. It is time to take a deeper look at the whole nature of visuality in history. Maybe we feel that photography can never itself inform in a relevant way because we are dealing with such different levels of history, one the 'myths we live by' and the other, the minutiae

of the ordinary. Are they compatible, does photography intersect different levels of history and suggest new perspectives? I believe it can inform, for, as is argued here, photography is capable of providing that link between the lived experience, moving between personal and collective inscription, that is the raw material of history and memory and wider, more general structures. Photographs make visible, at a metaphorical level, those whose disappearance was formerly a condition of traditional Western practice, a situation that has exercised writers from Fanon (1990) to Wolf (1982). As de Certeau argues, 'if the historiographer applies himself to the task of listening to what he can see or read, he discovers before him interlocutors, who even if they are not specialists, are themselves subject-producers of histories and partners in a shared discourse. From a subject object relationship, we pass to a plurality of authors and contracting parties' (1980:217). A hierarchy of knowledge is replaced by a mutual differentiation of subjects.

Visualised history, as it relates to photography, is not something intrinsically in the phenomena of the photograph; indeed, as we have seen, photographs actually deny or resist history through their temporal slippage. History itself starts (and this applies equally to other types of document) with the critical questioning that reactivates photographs and probes the multiple layers of meaning that constitute their historical refiguration. One starts with 'material stability', the evidential; but through the categorisations, judgements, emotions and narratives that photographs gather around them, we find that, echoing Tagg, that they are *of* history themselves. They are not only what they were, but what they have become. They are the stuff of many histories.

Epilogue – Another Stage in Social Biography

Since the publication of the paper in which this chapter originated in 1994, the photographs have entered a new social engagement. In 1997 the 16″ × 20″ prints that had been made for the exhibitions in Oxford and New York were given as a gift to the National Art Gallery and Museum of Papua New Guinea, and they now form part of the collections there. They were exhibited in 1998 for about three months, the opening being attended by many dignitaries, and I thank Soroi Marepo Eoe, Director of the National Museum, for his kind words on that occasion.[31] The photographs were valued both historically and aesthetically, for their powerful immediacy but also for their very direct discursive role in the articulation of social change, continuities and discontinuities. Significantly this gift was viewed locally as an act of both collaboration and

repatriation. It was the latter aspect that was stressed in the local press. This also constitutes another performance of the photographs as they move on to yet another trajectory. It is intended eventually, should funding and infrastructure allow, to exhibit the photographs at one of the schools in Goodenough Island, where the photographs will have more especial relevance, and also at other places in Milne Bay Province.

Notes

1. OUA.DC1/31.6.

2. OUA DC1/3/1/f.6. For advice on sound recording he went to Lilian Frazer, the formidable wife of Sir James Frazer, who had a particular interest in the subject. On her advice he bought a Home Edison machine. OUA DC1/3/1.f.57-58.

3. Jenness to Haddon 14 July 1911.CUL. HP Correspondence Envelope 24. I am grateful to Josh Bell who found this for me.

4. Serious drought, crop failure and famine were recorded in 1899–1901, 1911–1912 (when Jenness was there), 1946–1947 and 1957–1958 (Young 1971:3).

5. OUA DC1/2/4/f.lll.

6. I should also like to thank Stuart Jenness for talking to me about his father in ways that fleshed out the picture.

7. Jenness to Marett 26 July 1912, OUA DC1/3/1/ff.107–108.

8. Jenness was forced to give up the fieldwork a few months early through ill health. Ballantyne died of blackwater fever in 1915, leaving unpublished notes on language and 'folklore'.

9. OUA DC1/3/f.192.

10. Some other material, especially natural history specimens, was lost when the SS *Turakina,* which was shipping the collection to Britain, suffered a serious fire at Rio de Janeiro (OUA DC1/3/1.f.112).

11. For instance the review in *Man* (1921:187) by F. R. Barton, a colonial administrator and amateur ethnographer of southern Papua, concentrated on the descriptive elements of the text rather than methodological considerations. Interestingly, Barton was an ethnographic photographer of very different mould to Jenness (see Macintyre and MacKenzie 1992:158–64).

12. Publication of his fieldwork results was one of the two conditions of the financial support given to Jenness by the University of Oxford. The collection

of material culture for the Pitt Rivers Museum (under the direction of Henry Balfour), in which the photographs were included, was the other. £50 was given by the Common University Fund for this purpose.

13. Jenness to Marett 21 February 1919 OUA DC1/3/1/f.211. Jenness went on to become a distinguished scholar and curator of Inuit culture, arguing for the equitable treatment of the indigenous people of Canada's north (Lotz and Lotz 1971). He is still remembered with much affection in the region (Stuart Jenness, personal communication.).

14. The fieldwork album was donated to the Pitt Rivers Museum by Stuart Jenness in 1988.

15. It is also possible that, like the object collections, they were regarded as University property because of the way Jenness had been funded. This again points to the shift from photographs as a centralised resource in anthropology.

16. This exercise in re-engaging and reactivating became essential to an exhibition of the photographs that I curated in 1991–2 entitled 'Wamo: D'Entrecasteaux Islands, New Guinea 1911–12: photographs by Diamond Jenness' . It was shown at the Pitt Rivers Museum from November 1991 to May 1992, and the Metropolitan Museum of Art, New York, from November 1992 to May 1993 (see Edwards 1992) .

17. Jenness probably used a tripod camera. In a popular article describing his trip with the new canoes (1919:41) he mentions his camera strapped on the outrigger of a canoe, which suggests that it was quite large. It was probably the same camera that was lost in the wreck of the Stefansson Expedition ship *Karluk* in the Arctic in 1914.

18. This differs from the position argued by Young (1998:17–18) for Malinowski's photography in the neighbouring Trobriand Islands a few years later, that broad framing reflected Malinowski's interest in the contexts of social life rather than the detail. However Jenness takes as many broadly framed photographs as he does photographs of focused detail. The shape of Malinowski's photographic corpus might simply be a reflection of the absence of detail photographs rather than a conscious inclusiveness.

19. One is reminded of Ansel Adams's famous comment that a photographic negative is like a musical score, and every print a performance (Adams was an accomplished musician). The analogy could usefully be extended to the relationship between performance and audience.

20. These latter photographs were taken at Samarai Hospital, China Strait, before Jenness arrived in Goodenough Island. As far as one can extrapolate from the photographs, he took few 'physical anthropology' photographs once he arrived at Bwaidoga.

21. OUA DC1/2/4.f.100.

22. OUA DC1/3/1/f.212. The 460 are listed as a scientific result of fieldwork in a report sent back to Marett and the Committee for Anthropology in Oxford. About 470 survive in the collection.

23. The negatives of these photographs were deposited at the Museum with the rest of the collection but never printed until full cataloguing of the collection in 1983.

24. Such is the stereotypical view argued by Wright (1992).

25. This complex interplay is discussed in a wide range of work; for instance, Vansina (1985) , G. White (1991), Neumann (1992), Kech (1998) and Wassmann (1998).

26. Jenness comments that 'their memory reaches at best to a vague recollection of the days of their grandfathers' (Jenness to Marett, 11 April 1912, OUA DC1/3/1/f.101).

27. A relaxed characteristic pose surely suggestive of a relaxed climate of encounter.

28. Also the focus for its museum classification.

29. For instance Lippard (1992), Poignant (1992b, 1996a), Binney and Chaplin (1991), Rohde (1998).

30. Michael Young, personal communication.

31. This was facilitated by the generosity and good offices of the British Council (Visual Arts Department) and the British High Commission in Port Moresby, who supported transport and the local framing of the prints, and by Mark Busse, then Curator of Anthropology at the National Museum. I am most grateful to Andrew Moutu, University of Cambridge, formerly a curator at the National Art Gallery and Museum of Papua New Guinea for discussing this with me.

Time and Space on the Quarter Deck: Two Samoan Photographs by Captain W. Acland

The Contexts of Photographs

The focus of this chapter is on two photographs taken on a British gunboat anchored off Tutuila, Samoa (now American Samoa), by a Royal Naval officer, Captain W. A. D. Acland. To all intents and purposes they appear colonial documents, the product of certain power relations and with a clear closure of meaning. However, I hope to demonstrate how, through a deep contextual reading of intentions and moment of photographic inscription, an 'indigenous' counter-narrative' (Douglas 1999b) emerges from the silence imposed through the social biography of the photographs. Central to this current act of recognition is the use of the photograph's ambiguous relation with space and time as an interrogatory tool.

The photographs were taken on 18 November 1883. They have been in the Pitt Rivers Museum since 1886, when the negatives were donated by the photographer for their ethnographic or anthropological interest. The surviving set of multiple prints was made soon afterwards.[1] The 'ethnographicness' of these photographs was defined by the subject-matter, two different groups of Samoans on board a ship, their 'other-ness' determining the classification. This set the course of their trajectory as an anthropological document. Dening has argued that history is texted through the contexts of its preservation (1988:26). The archive not only preserves, it reifies, it frames and sets meanings; it also structures silences. However, this does not mean that meanings in the archive are necessarily static. In the last part of this chapter I

shall consider the institutional phase of the social biography of these photographs. But first I am considering how detailed teasing out of the photograph through 'theory close to the ground' can facilitate the emergence from one context to others. The recognition of another trajectory for the two photographs has allowed a fuller understanding and analysis, not in terms of ethnographic documents or even a closure or containment of meaning, but as a means of reaching out to broader discourses – the whole cultural theatre of which the photographs are part.

These concerns raise the question 'what is context?' It is necessary to problematise context so that we might understand its potentially active nature. Context is not merely a given, 'backdrops to set off the performance of images' (Tagg 1988:65). Informational or forensic value, fixed by content, anchors the photograph in a range of relationships of intention, audience and dissemination, and such context also embeds it in a series of signifying structures (Schwartz 1995). As has already been discussed, the meaning of photographs resides in the discursive practices that constitute them and that they themselves constitute (Tagg 1988:4–5), from relations of power that constitute the conditions of existence for these photographs to current readings of the image. Echoing Tagg's claim that photographs have no identity of their own (1988:63), Berger has argued that photographs 'do not in themselves preserve meaning . . . meaning is the result of understanding functions' (1980:55). However, ideas of contexts themselves are historically or culturally constituted. Consequently, context is also an active attribution of significance, not a property of the photograph itself, but an artefact of the questions under consideration. Their recognition is itself part of the analytical engagement with photographs, made possible in part through the specifics of the latter's social biography.

An over-determining definition of 'context', especially in relation to productive practices, would seem to obscure readings against the grain and obliterate the space for counter-narratives. The power of context in the silencing of the political discourse and local agency within these two photographs of Samoa becomes very evident if one creates a productivist closure for them as simply 'colonial documents'. The infinite recodability of photographs and their multiple layers and intersections themselves contain a point of fracture for such a model. Thinking with these photographs also suggest how contexts, attributions of predetermining significance, change over time and thus mediate our understanding of photographs, re-establishing different perspectives on the cultural stage on which the drama was played out.

For contexts have infinite expansiveness, blurring the edges of the object/document, subjecting it to other orbits and the possibility of alternative histories (Bryson 1992:21–3). These two photographs tell many stories. The paradox of photographs is that while they are intentional enunciations, whose very significance is grounded in their acts of representation, they are, at the same time random incisions that always carry that possibility of the arbitrary in 'what is being said'. They invite many orders of explanation and many lines of causality, which in their turn, point to the limits of understanding, the ultimate unknowability of the random, inclusive realism of photographs. They pose the question 'How can an event [the happening in these two photographs] that appears only in its disappearance leave something behind that opens history?' (Cadava1997:128).

Two figurations of context co-exist; what we might call the 'containing' or 'originating' (of who, what, why and when ?) and the 'dense context' – which, while not originating or linked to the reality effect of the photograph, emerges through the relations of the photograph. This itself is an act of discourse, 'an awareness that certain phenomena, persons or events accumulate layer upon layer of meaning, perhaps finding themselves at a cross-roads of morphological chains, at the intersection of numerous contexts and actions, or a nodal point where both contemporary and modern preoccupations reflect and enhance each other' (Egmond and Mason 1999:249). 'Containing' and 'dense' contexts exist in a dialogical relationship, playing out the drama of the images' creation and their various, subsequent performances (entanglements) as objects of and for interpretation. As such, context is creative, suggestive and provocative. It is this relationship that transfers its extending qualities on to the text (Bryson 1992:20).

Analysis along these lines might be seen as an exercise in 'thick description', articulating the shifting webs of significance that entangle photographs (Geertz 1973:26–7). A full exploration of a photograph's historical potential therefore should allow, on the one hand, for the institutional practices of observation and the enabling power relations translated through the photograph. On the other hand, recodability and indiscriminate inscription make it possible for them not simply to replicate the power relations of their production, but also to inscribe and present multiple spaces and multiple histories that have the potential to contest or subvert the ideological discourses of the image's creation. At the same time, extended discourse brings new contexts into play, which may constitute contradictions, and which must be embraced by a different explanatory system (Sahlins 1981: 5–6). These

contexts, I will argue, become recognised through the way space and time are manifested in the photographs.

Thinking through the contexts of the photographs also provokes and illuminates the creative theatricality of the event. Photography itself is integral to this process of articulation. Through the spatial and temporal fracture or fragmentation inherent in the photographs, the two photographs discussed here insert the impression of the specific moment into the historical consciousness by the very act of making it visible: 'the passing event, which exists only in its own moment of occurrence [is turned] into an account, which exists in its inscriptions and can be reconsulted' (Geertz 1973:19). What makes this event an event, indeed arguably in the modern world what makes any happening an event, is its technological reproducibility; a reproducibility that both gives it a specificity of space and time and paradoxically removes it from temporal and spatial determinants altogether (Cadava 1997:xxiii). Visibility endows the event with significance, and elevates that moment from the mass of undifferentiated past time. The event that forms the focus of the two photographs is thus restored, through its *photographic* visibility, to a process of historical engagement. In this sense the photograph is not really 'of' an event, but is the event. It makes the event, the history it shows being inseparable from the history it enacts (Trachtenberg 1989:xvi).

The Emergence of the Event

Polynesian islands of Samoa were subject, in the 1880s, to increasing instability, being the focus of rivalry between the Great Powers – Britain, Germany and the United States. Germany was pursuing a particularly aggressive colonial policy, based on the development of the plantation system, notably under the Deutschenhandels-und Plantagen-Gesellschaft, producing especially coconuts, which, when dried, were exported as copra for the German and Australian soap industries. Equally important was Samoa's strategic value as the last easterly landfall on the southern route between Australia and New Zealand and the western coast of the United States. The islands were lush and fertile, and well endowed with natural harbours. Consequently, they were desirable as a key coaling station and provisioning centre in an increasingly lucrative trade, based on the steamship routes across the Pacific. Although British policy was ambivalent – it preferred to concentrate its efforts further west – by 1889 war between the Great Powers threatened. The situation was diffused only by an auspiciously timed hurricane on 16 March 1889,

which destroyed the rival fleets, especially the German and American ships, which, rather than moving out to sea to ride the storm, had stayed in harbour, reluctant to give up their military positions. Indeed photographs of the wreck of the German SMS *Adler* became popular tourist souvenirs in the 1890s. The minor dispute of 1883 with which the two photographs under discussion are concerned slipped from historical significance following the turbulent events of 1888 and 1889.[2]

An unfolding of the social drama of this event forms the cultural stage that established the spatial and temporal discourses from which the photographs emerge.[3] On 21 October 1883, HMS *Miranda*, a Royal Navy sloop, under the command of Captain W. A. D. Acland, set sail from the Royal Navy's Australia Station based at Sydney.[4] She was to proceed to Fiji, where Acland was to investigate the case of John Rees, a British subject, who had allegedly murdered three people on Greenwich Island, Yap. She was then expected to cruise the islands until the end of the season unless the Acting High Commissioner for the Western Pacific, based at Suva in Fiji, required any particular action to be taken in the area under his jurisdiction. When HMS *Miranda* arrived in Fiji on 4 November, the Acting High Commissioner, Sir George William des Voeux, was of the opinion that for various reasons the Rees case could not be usefully pursued at that time, but requested that HMS *Miranda* sail straight for Samoa, where the activities of a Mr Hunt and a group of New Zealand adventurers were causing concern in the light of the recent failure of New Zealand to annex Samoa. To strengthen Captain Acland's own authority he was given the rank of Deputy-Commissioner for the Western Pacific.[5]

When Acland arrived in Samoa he received a request from King Malietoa Laupepa to act on his behalf, with the co-operation of the consuls of the other Great Powers, and to intervene in a local dispute that had been giving concern for some time. However, with no warship in Samoan waters, the Great Powers had not yet been in a position to respond to Malietoa Laupepa's concerns (Churchward 1887:337). The dispute concerned the entitlement and succession to the *mauga* title on Tutuila. Two rival claimants, between whom there had been tension for some time, had started fighting over this issue. This in itself was not unusual, nor was its eruption into violence; normally it would have been seen as an internal Samoan problem by the Great Powers.[6] However, what particularly concerned King Malietoa Laupepa was that while one claimant, Mauga Manuma, supported his party, the other, Mauga Lei, was of the opposition party, which supported the claims of Tamasese, creating a focus for more generalised opposition to Malietoa

Laupepa's kingship.[7] Thus not only did the situation threaten to escalate into a full-scale civil war, jeopardising Malietoa Laupepa's own position, but it also threatened to destabilise the careful consolidation of a central indigenous power, orchestrated and supported by the Great Powers to put in place a power structure to which they themselves could relate in dealings with the Samoan people. Any threat to this fragile and constructed *status quo* was clearly a threat to the interests of the Great Powers themselves.

Making it very clear that he was acting on the request of King Malietoa Laupepa and the three consuls of the Great Powers, and thereby in no way infringing the power and jurisdiction of the King, Acland set sail for Pago Pago, Tutuila on the evening of 16 November. He was accompanied by the British Consul, Mr W. B. Churchward, and two senior representatives of King Malietoa Laupepa, Seamane, Governor of Tuamasanga, the central district of Upolu, and Lawauti from Malietoa's native district of Faasaaleleanga, Savai'i, who was reputedly one of the finest orators in Samoa (Churchward 1887:340). The Revd Charles Phillips of the London Missionary Society agreed to act as interpreter. Phillips had lived in Samoa, based at Malua, Upolu, and in other areas of the Pacific for many years and had strong links with Malietoa Laupepa, who was a church teacher. Following HMS *Miranda* was the German dispatch ship *Hyäne*, which had just arrived in Samoa, carrying the German acting-consul, Dr Stuebel, for it was considered desirable for the Great Powers to present a united front in settling the dispute and, by implication, their united support for King Malietoa Laupepa.[8]

The intention of the mission was to put a stop to the fighting, which threatened to engulf the whole of Samoa, as had occurred in 1879 and in 1880, not to resolve the argument over the entitlement to the *mauga* title itself, which was purely an internal, Samoan affair. There had already been two battles, killing twelve people and injuring many others. Pago Pago, Mauga Lei's village, had been razed to the ground; only the church and the native teacher's house were still standing. A retaliatory attack on Mauga Manuma's village of Faga Togo had been partially successful. Preparations for more fighting were well advanced; Churchward reports that when the naval and consular parties went ashore at Pago Pago 'a lot of noble savages were scattered about the village, all carrying firearms, from the homely single-barrel shotgun to the seventeen-shot Winchester' (1887:342).

Letters were sent from Acland and the Consuls to both Mauga Lei and Mauga Manuma, requesting their attendance on HMS *Miranda* at,

respectively, 10:30 a.m. and 2 p.m. on 17 November so that the wishes of King Malietoa Laupepa and the Great Powers could be communicated. The Maugas duly attended. Mauga Lei's party argued their position for over two hours before acquiescing to Malietoa Laupepa's demands, and Mauga Manuma agreed almost immediately. He was, of course, one will remember, of the King's party. Both men signed an agreement before they left the ship to the effect that they would not fight. Fearing that neither party would adhere to the peace agreement, Acland recalled both parties on board HMS *Miranda* the following morning, 18 November at 10 a.m., for a formal act of recognition and reconciliation. Each party, with the chief, Mauga, at its head was seated, positioned at opposite sides on the quarter deck of HMS *Miranda*, the Great Gun between them (Churchward 1887:343–4). They were to make agreement formally and publicly, in front of the colonial powers, and to give up their firearms.

At this point, in keeping with the political theatre of the event, Acland took two photographs (Figures 5.1 and 5.2).

> The idea struck me that if I could get the fighting men on board, each chief on one side of the quarter deck and talk to them, we might be able to make them shake hands & rub noses & so make the promised peace a little more certain. The two photos show the scene on the Qr. deck during the palaver. The two chiefs in the middle surrounded by their followers.[9]

Photographs in/of Space and Time

The formal structure of these photographs is similar to that of many other ships' photographs. They are photographs of encounter. The 'natives' are seated on the deck in an organised group, wearing various exotic modes of attire. Conventionally, in such photographs, the subjects are surrounded by British, or French, or German, or American sailors, or labour recruiters or curious tourists.[10] Finally they are framed by the technical mastery embodied in the ship and the technical mastery of the photographic frame.

It is perhaps the apparently unmediated immediacy of surface description of Acland's photographs that holds us. As one looks into the face of Mauga Manuma and his supporters, for instance, one is faced with the reality of that encounter – 'this is how it was' – and the power of the photograph's authenticating qualities, of 'having-been-there', far exceeds the notion that the event is being represented to us (Barthes 1984:49). We can see how, having boarded the ship from

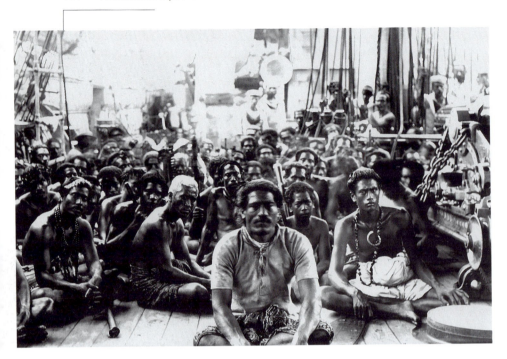

Figure 5.1 Mauga Manuma and supporters on the quarter deck of HMS *Miranda*, 18 November 1883. Albumen print. (Courtesy of Pitt Rivers Museum, University of Oxford, PRM. B36.10a.)

opposite sides, the rival claimants are seated either side of the Great Gun. We have the colonial view, not only through the instrumentality of the camera in embodying the photographer's view, but because together these images impress us with the whole scene, enclosed by the rigging of the ship and the frame of the photograph. The images overlap (see the sailor in the background with the slightly crooked hat). They suggest a kinetic, spatially embodied experience of the view – we can move our attention across the quarter deck from one group to the other and back again, just as Acland must have done, both diplomatically and photographically. We are presented with an authenticated past, drawn in the full detail of its nuanced surfaces, in a way that is uniquely photographic (Barthes 1977:44–5; 1984:89).

From the moment of inscription, however, the event begins to fragment into different discourses. For instance, Churchward, the British Consul, exoticises the event, placing it within the generalising, temporally distancing and exoticising tropes of the 'Pacific Paradise'. He writes, in line with his overall representation of Samoans as 'noble

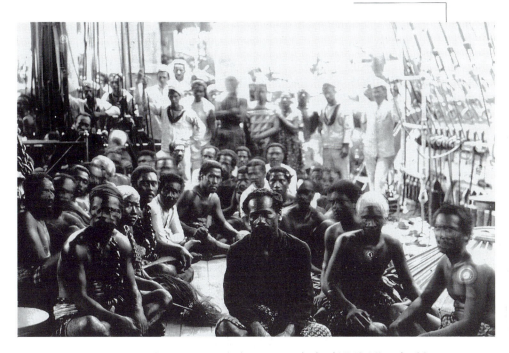

Figure 5.2 Mauga Lei and supporters on the quarter deck of HMS *Miranda*, 18 November 1883. Albumen print. (Courtesy of Pitt Rivers Museum, University of Oxford, PRM.B36.10b.)

savages': 'Not a scrap of European costume was to be seen upon them: their lava-lavas (waist-cloths), the only garment they wore, were of tappa [*sic*] (native cloth); their bodies were shining with oil and adorned with garlands of high-scented leaves and bright-hued flowers and berries' (1887:344). The photograph enables us to see the genesis of this trajectory with its exoticising stress on the sensual; ironically, it is a discourse that was (indeed still is) often couched precisely in visual terms, photography being one of the major media through which the vision of the soft primitivism of the Pacific, especially Polynesia, was constructed. Photographs by John Davis in the 1880s and Thomas Andrew in the 1890s, which received wide dissemination, resonate with the kind of imagery evoked in Churchward's description.[11] However, the photographic trace subverts Churchward's romanticised description, which effaced the 'scraps of European costume', the markers of the Samoans' colonial entanglements. Photography brings us back to the 'actuality', away from Churchward's constructed 'reality'. In the photographs we see the tapacloth, European clothing, trade cloth,[12] ornaments, clubs, body oil, the Orator's whisk and limed hair.

But is that all? Barthes's classic description of the conjunction of spatial immediacy and temporal anteriority inherent in the photograph – the 'there-then becoming here-now' (1984:44) – can perhaps be extended beyond mere anteriority and inscriptive power to shift the axis of reading. The photographs of the Mauga claimants on HMS *Miranda* require a reading integrating the two broad categories of the forensic and the submerged possibilities that the photographs imply, their dense contexts. It is often what they are not of, in forensic terms, that is suggestive of a counterpoint, in which are embedded the complexities of the moment. That 'thickness' of description that started with the cross-reading between the photographs, the Admiralty Office records and Churchward's aestheticising text begins to take shape as 'piled-up structures of influence and implication' (Geertz 1973:7) that constitute more than a density of linear narrative. These are the refiguring histories that gather round and enmesh images. It is within these intersections of photography and history that images are potentially at their most revealing. Photographs interrupt history and open up another possibility of history, one that spatialises time and temporalises space (Cadava 1997:61).

These photographs display very clearly Bakhtin's idea of the 'chronotope': that is, an intrinsic interconnectedness of temporal and spatial relationships that also acts as an organising centre of narrative 'the place where the knots of narrative are tied and untied' (Bakhtin 1981:84, 250). The photographs show, at the moment of temporal fracture, stillness, space and a set of relations within space. This is not merely the specifics of physical space – the side of the Great Gun and the rigging – but a cultural space that is itself grounded in temporality. There is a vast literature on space and time that cannot be summarised adequately here.[13] Equally, the consideration of the relationship between photography and time has developed an enormous literature, the most relevant of which I pointed to in Chapter 1. Rather than explore these relations in the abstract, what is more important to emphasise here is the way in which spatio-temporal models might be used to analyse photographs. In his concern with the relationship between time and social being, Gosden has argued that the spatial characteristics of social relations also imply temporal modes, deriving from the pattern of events. As such they represent a qualitative temporality about the experience of social relations and involvement with the real world, as much as quantitative slices of experienced time.

These are, of course, culture-specific, and link different ways of connecting different areas of social being and action. For space and time are not only abstract qualities in which social actions are embedded,

but rather dimensions created through the concrete operation of social forms (Gosden 1994:78–80). If differing social forms produce various types of time and space, then the colonial encounter held in these photographs contains heightened and concentrated intersecting spatial and temporal configurations, the social configurations inscribed through a medium itself deeply characterised by its relations to space and time. The photograph spatialises time through the stilling of experience in the frame; a static yet insistent inscription can be read as the antithesis of the experience itself (Sontag 1973:156). The concept of frozen moment, so frequently evoked in relation to historical photographs, imposes only one time, subordinating and negating others. But if we accept that space is temporally figured and that these photographs represent more than one spatiality, then they embody also more than one temporality. Indeed, through their very stillness they set ideas of time in motion – ideas of moment, experience, past and future. Temporal and spatial processes entangle the event and its images, and are thus integrally active in the production of meaning in those events and their inscription as photographs.

Further, time itself is literally made visible in the photograph of Mauga Lei and his supporters. Something happens beyond the frame and some of the men turn – one of them in the time taken to expose the photographic plate. Time, spatialised and spread out in the photographic frame becomes palpable, accentuating the concrete narrative through such photographic accidents. In this register it 'makes them take on flesh and causes the blood to flow in their veins. An event can be communicated, it becomes information . . . it is precisely the chronotope that provides the essential ground for *showing forth* [my emphasis] the representability of event . . . of human life and historical life that occurs within well delineated spatial areas' (Bahktin 1981:250). The two photographs taken on HMS *Miranda* exemplify the process of photographic incision in temporal process and the way in which photographs spatialise time. The action of the event unfolds as a temporal process: the frenzied temporal succession of violence and burning, of diplomatic and colonial negotiations, and of manoeuvring in physical space (referenced by imposed, structured time in imposed structured space – the Maugas were to be on the quarter deck of the ship at 10 o'clock in the morning). Experienced differently by the different actors, it ends in the stillness of the photograph.

Yet the photographs themselves, through the heightening and concentration of their stillness, allow more complex readings to emerge. A close consideration of the photographs in relation to the emergent contexts of their making suggests that we are dealing with three

interrelated spatial configurations, all of which have a temporal dimension in the way I have just outlined: the space of action, the space of containment, and the spaces of consumption. The space of action is the concrete setting that frames an event . This expresses itself photographically as the authenticating 'this is how it is'. While at one level a liminal space of cultural encounter,[14] it is transformed into metaphors through the mobilisation of political power (V. Turner 1974:17). The ship itself, as a space of action, was not neutral ground. It was a deeply cultured space, displaying an intensified fragment of the culture of colonial power. As a metaphor the ship becomes the space of containment. The two claimants to the Mauga title are seated on the quarter deck of HMS *Miranda*, a space that itself is heavily connotated culturally within the Royal Navy, and it is very likely that they had a sense of this hierarchical space. The quarter deck was a sacred or non-ordinary space reserved for officers, and within this the space was subject to invisible hierarchical mapping. It was also the site of such non-ordinary events as receptions, courts martial, and divine service; in the early days of the Royal Navy the crucifix or shrine was placed on the quarter deck, and acknowledged by those boarding the ship, who customarily looked towards the stern (the position of the quarter deck) and saluted.[15]

On this register of the space of containment, the photographs themselves become a metaphor of containment for the encounter of Mauga Lei, Mauga Manuma, Acland, the Consuls, and the representatives of King Malietoa. Each party's contained within its own frame, contained within the quarter deck of a Royal Navy ship, with the camera placed somewhere in the middle, as it must have been to take those particular photographs, moving from one side of the Great Gun to the other. The quarter deck of HMS *Miranda* becomes a point of intersection. Further, in line with Gosden's argument, the special relations of space are inflected by temporal modes through the patterning of events. This event projects itself into the temporal experience of both parties.[16] The groups, the two Maugas and the representatives of Malietoa and the Great Powers, share physical space but occupy very different cultural spaces. To the Powers the ship becomes a microcosm of their authority, floated into other authorities, whereas to the Maugas it was perhaps the site to which they have been removed from Tutuila, the site of their own contested powers. The *Miranda* also represents yet another dangerous intersection, the Great Powers and King Malietoa Laupepa. With the exception of a few naval seaman watching the proceedings from beyond the Maugas and their supporters, however, the Great

Powers appear in the photographs only through their metaphors, the ship and the existence of the photographs themselves. Acland does not position himself overtly within the photographs; rather, as I have suggested, his position as observer is implied through the subject relations of observation embedded within the photograph itself. The invisibility of the observer sits ambiguously with the act of witnessing, which is reinforced through the perspectival inscriptions of the photographic apparatus and the seeing eye embodied therein.

But what of the points of fracture to which I referred? It is to the Samoan presence that I now want to turn, for conflicting and very different cultural realities can leak out, even from heavily controlled and connotated texts. Despite being taken on a British gunboat, and recorded by a British naval officer with the world-view that that implies, these two photographs 'inadvertently register shadowy traces of local agency, relationships and settings' (Douglas 1998:70). There is a Samoan spatial articulation clearly at work that represents itself forcibly in both cultured spaces, the quarter deck and its trace in the photographic frame. Rather than being fractured by the spatial expressions of colonial power, Samoan social being asserts its own cultural cohesiveness and destabilises (perhaps subverts – but maybe that is too strong a claim) the totality of authoritative space and restores elements of Samoan agency.[17] This articulation of local agency constitutes a form of counter-narrative within the photograph. Pre-existing socio-political hierarchy in Samoa is expressed spatially through precise placing on formal occasions, such as village meetings (Holmes 1974). In these two photographs, the claimants to the chiefly title, the Maugas, are seated in the centre of their respective groups; over their right shoulders are their orators, 'talking chiefs' with limed hair[18] and carrying ceremonial flywhisks. Such men spoke for the chiefs and served as their chief advisers. They will have done so on this occasion, Churchward implies as much, but their voices, on behalf of the Maugas, are lost through translators and the official record (1887:343). Given that these crucial protagonists, the chiefly claimants and their orators, are in an ethnographically confirmed spatial arrangement and the other men are in broadly semicircular array around their respective Maugas (broadly mirroring the shape of a *fale*, a village meeting house, a shape, conveniently, not unlike that of half a quarter deck), it is not an unreasonable assumption that the rest of the entourage, or at least the senior men, express hierarchical and kinship relations. Further, although it is dangerous to read body language caught in a few moments of photographic exposure, especially cross-culturally, the Maugas in the

centre of their groups have an assertiveness and presence – Churchward records that 'the chiefs sat perfectly unmoved in stolid dignity' (1887:346). This is reproduced and reinforced through their central positioning within the photographic frame (we can see to the edges of their space): it suggests an easy authority within that space. Thus a Samoan statement of authority is reproduced, both spatially and through the bearing of the chiefs. It is moment of quiet theatre, as the performers project themselves to the representer, Acland, their first audience.

Consequently, it is possible to argue we have the performance of Samoan space, social being, in the heart of the colonial symbol – the gunboat. Importantly, there were those in the colonial party who could read this, even if Acland could not. Not only would it have been clear to the two senior Samoans with the colonial party, Seamane and Lawauti, but probably also to Phillips, the experienced LMS missionary. Churchward, as consul, must have been familiar with formal Samoan spatial dynamics, indeed he alludes to 'having experience in the result of the talking men's orations' (1887:346). But who is the tall Samoan with limed hair standing behind Mauga Lei's group? Lawauti the great orator? How did the colonial powers perform their space? Where were they standing? What were the kinaesthetics?[19] We do not know if Acland and the consuls were standing throughout the encounter, although we can presume that Acland was at some stage to take the photographs. In Polynesian terms standing in the presence of two such senior men would have been seen as a lack of respect, marking yet another spatial reproduction of colonial relations and further contesting spatialities.[20]

Such arrangements at least point to different experiences of the event inscribed spatially within the photograph. We can never fully know, but the photograph makes us aware of an expression of a specifically Samoan constituted presence, obscured through the insistent colonial appearance and the structure of archiving (a point to which I shall return at the end of this chapter). The ship is revealed as a hybrid zone, a dialogic space where differences are both preserved and reconstituted in relation to one another. In relation to the photographs, it becomes clear that they have the potential to break through the enclosed space of textual history.

One can extend the analysis by drawing together separate elements concerning both the nature of history and the nature of photography. Through their heightening containment of the frame, photographs confront the generalising nature of history, for the existence of the

photographic image returns the specificity of the historic moment and *forces* it to signify. The trace enables the event to maintain the potential for specific meaning, not merely to collapse into the enactment of the context. The visual incision, the specificity, remains. The photograph contains and constrains within its own boundaries, fracturing the balance, the natural flow of those processes that are the focus for both historical and anthropological study. It gives an intensity of moment that emphasises the theatricality of the event, precisely fracturing the processual and instituting the ambiguous imposition of both a precise temporality and an atemporality, a heightening process born of the spatial immediacy and temporal stillness that are uniquely inherent in the photographic medium. As Dening has argued 'The theatre of encounter [is] a play within a play – about power, world systems and reifications. Theatre is about making unreal metaphors real at home and abroad' (1994:452–3). It would seem that these photographs are doing exactly that in their representation of symbolic actions, the theatre of moment and intersections within it.

The act of photographing endowed the event with a permanence and theatricality that echoes, at an abstract level, the performance of the event itself. [21] This has major implications for the relation between photography and the past, for it heightens and projects. Here, the intensified fragment of the event held in the photograph mirrors the intensified fragment of cultural power embodied in the ship. Acland had intended the last meeting of the Maugas precisely as a performance of political authority. The ceremonial itself, expressing social relations in time and space, was an integral part of that authority articulated in the spectacle or visibility of the moment (Cannadine 1987:17–19). The photographs thus become both the very essence of that moment and a metaphor of that moment.[22] What is crucial is that the photographs allow us to access the event in multiple ways. Without them we would not sense the Samoan agency in all this; their presence would remain passive. We can begin to see the quality of the quotation that these photographs represent, as they suggest the possibility of transformation into experience (Berger and Mohr 1989:287–8). However, this has depended on an intervening act of restitution, the cutting away of the 'ethnographicness' that contained the meaning of these two photographs for so long. Yet, as I have suggested, we cannot know the whole of it. Despite the promise held out by the seductive realism of photographs one still faces the ultimate unknowability of the past. Although agency is, as Keane has argued, culturally and historically constituted, we must not overplay the claims for these two photographs. They can

only suggest a moment of reflexivity. We cannot know it all, even if there were a 'truth' of the situation. The argument forwarded here merely points to an alternative consciousness, experience beyond the colonial inscription that can be extrapolated from the photographs.

In the Archive

If this close reading between context and what is within the frame moves us closer to the experience of the event on the quarter deck of HMS *Miranda*, this has not always been accessible within those images. What is the social biography, that has both preserved and obscured the alternative histories within the image, between the act of inscription and my act of interpretation? As Fabian has argued, observing and gathering (collecting) are visual and spatial activities, spatial enactment of power relations, creating a detemporalisation that translates into cultural distance (1983:122). The social biography of these photographs also has temporal and spatial dimensions. The production of space, movement over distance, physical and metaphorical, constitutes a making of history (Gosden 1994:79), both the meaning of the photographs themselves and the histories made through the entanglements of their social biography. As objects, the photographic negatives literally passed from the sharp edge of the colonial periphery where they were inscribed to the metropolitan institutional centres of interpretation of which Oxford was quintessential. Multiple prints were made from the original inscriptions (the negatives), which enabled the images to perform in different discourses. In the archive, removed from a specific moment of experienced time, they slip from view through the generalising processes of archiving.

However, to understand this trajectory one must start by asking why Acland took the photographs. They do not constitute any part of the official record as inscribed, even as confirmation of a colonial job 'well done'. Taking the photographs is not even mentioned, except in the one letter to Smith that I quoted above. Yet the event–document relation explored above was intentional, deliberate and premeditated – it had to be, given the photographic technology available to Acland. It is clear from Acland's letters to his family that the photographs constitute a personal record, which was sent home to show 'how it was' and to amuse: 'We have been having a great sticking in all of your photographs. They are very much appreciated by all comers ...' .[23] Thus, the subject is converted into private property, to be circulated within a closed group.[24]

The photographs do not seem to have been circulated more widely, nor prints to have been given to friends or learned societies.[25] We do not even know if they were circulated on HMS *Miranda*, as would have been the case with 'official' photographs. However, by 1886 the photographs became embedded in another discourse, that of anthropology, which fixed their major trajectory for the next hundred years. They shifted from colonial encounter to anthropological document, which entailed a projection from the periphery of colonial action to the orderings of the imperial consumption. Such a relationship was one that constituted the notion of the imperial archive, in which the invisible interconnectedness of knowledge enabled these images to shift category. They were absorbed into institutional practices that come to constitute the conditions of the photographs' existence (Richards 1993:111–12; Tagg 1988:21). Acland had strong Oxford and scientific connections. His father was the distinguished royal physician and Professor of Medicine at the University of Oxford, Sir Henry Acland. A leading Oxford figure, well connected in political and artistic circles, Sir Henry was instrumental in the development of modern science and medical teaching at Oxford in the second half of the nineteenth century. He was largely responsible for establishing the Radcliffe Science Library, which is still the University's main science library. He also supported General Pitt Rivers over the gift of his ethnographic collections to Oxford and the establishment of the teaching of anthropology in a systematic way at the University. The Acland family had also given specimens of ethnographic objects to the University Museum (of Natural History), which were transferred to the Pitt Rivers Museum in 1886. Consequently the photographs moved along established trade routes of collection and institutional deposit. The preservation of the photographs in anthropological archives enabled another 'performance' of the photographs, where their relevance was dictated by the patterns of expectancy of a particular genre. That this process is both dynamic and situational is articulated through those of Acland's photographs that fulfilled the expectation that they would 'perform' anthropologically. The photographs, despite their originating context of colonial encounter and gunboat diplomacy, were perceived as anthropological or ethnographic by virtue of their subject-matter, the 'otherness' of the subject matter constituting it as an object of scientific interest.[26] Only those photographs showing Pacific Islanders or their material culture were printed for the Museum, while general views of the islands and life in the Royal Navy were excluded from the constructed ethnographic record.

The list of negatives that came to the Museum in 1886 notes twelve photographs of Samoa, but, of these, only six were printed. Those omitted, one can reasonably assume, were those perceived as having no visual information in anthropological or ethnographic terms, for instance, views of Apia Harbour. The photographs of Mauga Manuma and Mauga Lei were printed; indeed a multiple set was made. They appear to have existed as loose prints until c.1930–1, when one of each image was mounted on a large card and arranged as a series, filed under racial types, 'Samoa'. A shift in the transliteration of names, reflecting the spoken word, crept into their captioning – 'Maunga Lei' and 'Maunga Manuma'.[27] Those captions shifted in time, and became interpreted as place names in the documentation. Within in this archival structure the two photographs are juxtaposed with other photographs from a wide variety of sources, notably portrait types from commercial photographers operating in Samoa, especially those of Thomas Andrew, as well as miscellaneous images of Samoans, including anthropometric images, taken in Apia by Johann Stanislaus Kubery in c.1875 (Lederbogen 1995:44–6). The photographs arrayed in this context assume an equivalence of scientific weight and an equivalence of meaning premised on the surface appearance of objectified Samoan bodies and the markers of difference, themselves temporally and spatially inflected. Such juxtaposition made the reductive transformation of Mauga Lei and Mauga Manuma complete, enmeshed in the atemporal spaces of 'synchronic objects' premised on a perception of knowledge '. . . organised around objects or images of objects in spatial relation to each other' (Fabian 1983:113). Institutionalised, the subjects become essentialised and generalised as 'ethnographic types', just as their impression on the historic moment becomes generalised in Gilson's footnote in *Samoa 1830–1900*, reduced to a type event obscuring or effacing an earlier political and particular reading. This is not to say that the photographs became inactive in this space; merely that their social biography entangled them within anthropology's allochronistic discourses, including those of the museum, and that meanings generated were constituted through this grid. The encompassing geographical reality of Samoa itself, represented in views of the islands, was separated from its people and left in a dark box, an unprinted and thus inaccessible photograph. It was only through this research and re-engagement with the possibilities of the very dense images that both names and identities were restored to these subjects, and their presence in the historical moment articulated.

As I have suggested, this essay constitutes yet another performance or entanglement of the two photographs in yet another space (and indeed time). It is an obviously imaginative interpretative act of teasing out connections and signs in action, which 'effaces the intentions of the things' producers', yet is embedded from the moment of inscription and remains in that sense, as it should, a 'grounded' reading. Such a reading as I have suggested here moves vertically from one level to the next, suggesting meanings that elude a linear, unilateral investigation (Barthes 1977: 87). It also suggests a space for a sense of the cultural relativity of the event and responses to it. Through my concern with metaphor and entanglement and with the dialogue between surface and depth that a photograph embodies, I hope to have suggested the way in which the different levels, or poles of meaning, work. I hope further to have demonstrated how, like social drama, the subsidiary subject is really 'a depth world of prophetic, half-glimpsed images and the principal subject, the visible, fully known (or thought to be fully known) at the opposite pole to it, acquires new and surprising contours' (V. Turner 1974:51). Because the poles are active together, the unknown (the submerged histories and the metaphors of the intersection of histories and photography) is brought a little more into the light by the known. Extending context and moving beyond the instrumentality of the photograph opens a conceptual space in which we can see how silences have been made. I hope I have suggested how context does not merely demarcate a moment that is past. Such an approach conceals the contextuality of the present – our re-engagement; for, Bryson has argued, our own context of interrogation, an articulated concern with the relation between photography, ethnography and history, enables us to see different ones that continue to locate ourselves in the historiographical process (1992: 39–40).

I have consciously extended beyond the conventionally 'grounded' reading to suggest a range of resonance on visuality and history that must inform all more 'contained readings'. These two images assume a density that appears to 'condense a range of social forces and relations' (Daniels 1993:244–5). The heightening effect of stillness within the frame as the historical moment is performed for us opens up possibilities not for seeing what the picture is 'of' in forensic terms, but rather, and more significantly (for this is where I believe photographs are an unique form of history) can suggest the *experience* of the past. Kracauer, writing of the distinctions between painting and photography, encapsulates their historiographical need: 'In order for history to present itself, the

mere surface coherence of the photograph must be destroyed' (1995b:52). While photographs particularise, at the same time they resonate with that beyond themselves, they explain something of that world that made them possible in the first place. Bryson argues that 'blindness, not knowing, seeing, understanding, is often presented as a failure in the archive not in ourselves' (1992:39). If we do not explore the interrogatory potential of the medium itself and the intellectual possibilities of photographs, entangled as they are in their multiple histories and trajectories, we will surely, through privileging surface over depth, be blind to much of what photographs have to tell us.

Notes

1. There are some eighty Pacific photographs in the Acland collection at the Pitt Rivers Museum, Oxford. They are images of life in the Royal Navy, New Zealand, New Caledonia, Fiji, Samoa and Vanuatu (New Hebrides). They appear to result from both the 'Island Runs' of HMS *Miranda*, October 1883 to January 1884 and April to October 1884. Acland probably learned photography as a lieutenant at Greenwich Royal College, where various suitable technical skills were taught to young and rising officers. All Acland's photographs from the Pacific are competently and carefully produced; they are not first attempts. The dry gelatin whole plate negatives survive, but are in a very fragile condition. However there were clearly more, which have as yet not been located, if they survive, as there are some prints in an album, 'New Hebrides and other views' in the Mitchell Library, Sydney (ML Q988.6/N)) for which there are no negatives in Oxford. The prints in Oxford are on albumen papers made in 1886 when the collection was given to the Museum, and are recorded as having been made at 'The Oxford Museum', i.e what is now the University Museum of Natural History Museum.

2. It very literally becomes a footnote of history, for it is the case referred to by Gilson (1970:38,n.8) but used as a generalised 'type event'.

3. I use the term 'social drama' in Turner's processual sense of breach, crisis, redressive action, and reintegration, because it mirrors both the contexts and the social biography of the two photographs. (V. Turner 1974:37–42).

4. The numerous sources for this event in the papers of the Admiralty Office are most accessible in their printed collated form: PRO. ADM. 122/13 *Cruise of H.M.S. 'Miranda:' Fiji and Samoa October to November 1883*. Churchward states (1887: 338) that HMS *Miranda* brought as a passenger Sir Frederick Holmes,

late Commander-in-Chief of the army in India. However, it is not clear from any of the accounts if he was actively involved with the event which concerns us here.

5. This procedure was not uncommon during the classic period of British marine diplomacy in the Pacific.

6. The *mauga matai* title was being disputed between the *tama tane* and *tama fafine* kinship connections. For an explanation see Gilson (1970:35–9). Mauga Lei was the *tama fafine* claimant, being a son of the sister of the deceased *mauga* title-holder. Mauga Manuma was the *tama tane* claimant, being the son of the deceased Mauga and his testamentary heir (Churchward 1887: 336).

7. The kingship was itself fragile, being a colonial construct. Although Malietoa Laupepa was 'king', his rival Tamesese was appointed deputy king in 1881 and was supposed to alternate with Malietoa Laupepa as king (see Meleisea 1987:38). Traditional Samoan political leadership was based not on a central sovereign head but on a complex and greatly varying system of graded lineage chiefships comprising *ali'i*, chiefs of personal sanctity, and *tulafale*, 'talking chiefs', who acted for the *ali'i*, and *matai* household and lineage heads. For a brief introduction see Gilson (1970:19–23, 29–30) and Meleisea (1987:8–9).

8. PRO.ADM. 122/13.

9. Acland to W. Smith 28.1.1884 [and sending some photographs]; BOD.AP Ms. d55.f2v.

10. It would appear that in current readings there is also a 'colonial' expectation of these photographs through an intersection of style and context. A number of people to whom I have shown them have read the leaf garlands (markers of status) as chains of prisoners.

11. See Nordström (1991:272–84); Engelhard and Mesenhöller (1995) and Stephen (1993).

12. The Revd Phillips notes 'Manchester goods [cotton cloth] are now very largely superceeding [*sic*] native dress' (C. Phillips1890:11).

13. For useful discussions from different perspectives see, for instance, Fabian (1983); Bender and Wellbery (1991); Gosden (1994) and McQuire (1998) and the extensive references cited in these volumes. Also Kern (1983); Soja (1989); Lefebvre (1991 [1974]).

14. Tomas (1993:64) has argued that ships are liminal 'transcultural spaces'.

15. For instance, the commander walked on the leeward side, out of the wind, while other officers had to tolerate the prevailing winds. Many of these cultural customs had their origins in the practical requirements of the sail age.

16. The symbolic significance of such acts was not lost on the Samoans. The Admiralty Office papers note a number of incidents when this tool of marine diplomacy was resisted because of the spatial, and thus political, dislocations and diminution of the Samoans' own powers it represented.

17. Royal Navy and class hierarchies are also registered. Only the naval ratings appear in the photographs, in the same physical space as the Samoans. The officers are out of frame, probably behind the camera with the dignitaries.

18. The nature of agency is complex, and a detailed discussion is beyond the scope of this chapter. Agency it itself historically and culturally specific. It is embedded in the intersections of beliefs and expressions of them in practice and in self–consciousness, for agency is also premised on the idea that the actors could have acted differently. Here I draw on Keane's useful discussion (1997:674–93) and references therein and also on Douglas (1999b).

19. The hair would have been a pink colour, but the orthochromatic plates of the 1880s did not register red tones well; light tones appear white and dark ones black.

20. I am grateful to Pat Kirch for discussing this with me.

21. Indeed, it has been argued that events of this nature are orientated towards the production of images. In order to be what they are, they must be multiplied or reproduced, thus the event is masked by its technical reproduction (Cadava 1997:xxiii).

22. In many ways this is not unlike what in literary texts is described as *mise enabyme*, where a fragment of text reproduces in miniature the structure of the text's entirety. See Owens (1992:17).

23. Sarah Angelina (Angie) Acland to Acland 29.10.1884: BOD.AP.Ms. dlO7.f.140. Miss Acland emerged as a distinguished photographer herself. She made excellent portraits of a number of eminent family friends, including Gladstone, Lord Salisbury and Ruskin, and was one of the first women to experiment with colour processes in the 1890s.

24. For instance, whilst Acland was in the Pacific, the ethnographer and head of the Melanesian Mission, R. H. Codrington of Wadham College, was in Oxford working on one of his many translations of the Bible into Melanesian languages. A family friend of the Aclands, it is clear from the correspondence that he saw Acland's photographs of Banks Island, Vanuatu (New Hebrides), and furthermore was able to name most of the people in the photographs.

25. Acland's photographs do not seem to have been widely disseminated outside close family and friends or later, outside museum use. Codrington used Acland's photograph of slit drums at Ambrim, Vanuatu, as the basis of a drawing in his volume *The Melanesians* (1891). However, anthropological performances accrued, for a few of Acland's photographs of New Hebrides and Banks Island are found illustrating books of popular anthropology. A photograph of a group of Malekulans and Royal Navy officers and sailors appeared in A. H. Keane *The World's People* (1908). Another Acland photograph of women from Mota Island, Banks Archipelago appeared in the same volume as Figure 17 'Women of Mota Island, Banks Archipelago: the Natives of Mota are Christians'. A

different photograph taken on the same occasion appears in *Living Races of Mankind* ([1901?]:40), as does a cropped version of 'A Group of Natives, Pentecost Island'. What the connection was between Acland and the volumes' editors is not clear; it was possibly through the Royal Geographical Society, of which Acland was a member. None of his photographs appear to survive in that collection. Probably the contact was personal.

26. I shall argue the same process in terms of photographic style in Chapter 6 in relation to T. H. Huxley's project with the Colonial Office.

27. Phillips (1890) also uses this spelling. Again, one gets a sense of orality encompassing photographs.

s i x

Professor Huxley's
'Well-considered Plan'

The Formation of the Project

In 1869 the great Darwinian biologist, Thomas Henry Huxley, initiated
a project to produce a photographic record of the races of the British
Empire. The initial impetus came from the Ethnological Society, of
which Huxley was President at the time; but the project was facilitated
through the Colonial Office in London. My concern in this chapter is
not with Huxley himself as a scientist, but with what the project reveals
of the visual rhetorics emerging within anthropology, especially the
production and consumption of anthropometric photographs, and
their entanglement in the micro-politics of colonial power.

The political and ideological discourses embedded in the conflation
of scientific naturalism and photographic naturalism in the present-
ation of observable fact has long been recognised in writing about
photography, the body and visibility, and surveillance and control. It
has resonated through some of the anthropological performances of
images that I have considered so far. Material such as that which
emerged from this project has been subjected to extensive Foucauldian
analysis (for instance Green 1984, 1985; Sekula 1989; Lalvani 1996).
While identifying a crucial overall formation of enabling power
relations, they explain little of the nuances and ambiguities of specific
encounters within colonial ideology and endeavour. Photographs such
as those that emerged from the project discussed in this chapter have
become 'signature images', constantly reproduced and standing for the
essential relations between anthropology and photography, to the
extent that their own historicity has become curiously obscured. Such
homogenising models emerge, as Brothers has argued, from a merging
of the ideological approaches to photography and disciplinary practice
in the work of critics like Tagg and Sekula and the assumptions of the

histoire de mentalité approaches, which have tended to treat attitudes as if they were equally prevalent within any given culture (1997:30). In many ways the apparent coherence of the disciplinary practice is a manifestation of a certain 'historical success' of which the historical engagement and recognition is part. However, it cannot necessarily be assumed as characteristic of all technological practices. Following de Certeau (1980:188), I shall argue here that 'there is a "polytheism" of concealed or *disseminated practices*, dominated but not obliterated' in even the most oppressively dominating of practices, the mapping of racial characteristics. Consequently, rather than being homogenised, self-evident political operations, they are 'practices perceived and enacted through fields of symbolism and meaning that are often densely conflicted and contradictory' in which the complexities and inconsistencies of human agency are active (N. Thomas 1994a:18). Thus one can argue that the way Foucauldian models have been used at one level hinders historical understanding rather than explaining. Instead, I follow Thomas's call for ethnographies of specific colonial encounters in which projects are an 'endeavour that is localised, politicised and partial, yet also engendered by longer historical developments and ways of narrating them' (1994a:105–6). These, in this case, are ideas of racial science and hierarchy and colonial power structures that made Huxley's 'well-considered plan' imaginable in the first place. I am going to consider how such photographs were made, what was expected of them, what practices they involved, the tensions emerging out of those practices and the assessment of the images that result from those practices. I shall focus on the various scientific procedures in the production of anthropological information assumed or naturalised within this process. The photograph is not peripheral but central to these discursive forms. These latter constitute essential mechanisms of truth not only in anthropological science itself but within the meta-narratives of justification and value outside science. But, most importantly, I am going to consider points of ambiguity, fracture and resistance that emerge within the project.

This project was the first in Britain to attempt centralised control of the production of anthropological photographs made on the periphery, to create immutable mobiles of 'objective' observation in order to create scientific knowledge at the interpreting centres while at the same time attempting, through photographic form, to eliminate the mediating presence of the observer. Historically constituted ideas of objectivity, as we have already seen in Chapter 3, were part of a visualising discourse that sought images uncontaminated by interpretation, aesthetic inference

or fantasy (Daston and Galison 1992:81). Controlled observation that harnessed the inscriptive qualities of the medium in a systematic fashion, the photograph was emblematic of all non-interventionist objectivity: 'The photograph had acquired a symbolic value and its fine grain and evenness of detail [had] come to imply objectivity. Photographic vision [had] become a primary metaphor for objective truth' (Rosen and Zerner quoted in Daston and Galison 1992:120). However, this was so only up to a point, for Huxley's project and its ultimate failure reveal differentiated levels in the acceptance of the evidential value of the photograph within emergent anthropological science. Within anthropology, and especially within Huxley's meticulous notion of scientific data, this was not a naive realism but an assessment of evidential possibilities premised on the nature of photography itself and cultural assumptions about the medium. The points of fracture within the project are found in these tensions between the nature of the photograph, the nature of scientific observation and the differential values ascribed to them. Thus in addition to disturbing a homogenised characterisation of colonial power, the project also disturbs the homogenised and simplified model of naive acceptance of an unproblematic realism in photography in the second half of the nineteenth century (Tucker 1997:381).

Through unravelling the ambiguities and paradoxes that emerge from this project (some of them inconclusive), I hope to open the analysis of this kind of material beyond an over-determined closure to a position from which it is possible to see how such photographs could possibly come into being – or, as I shall show, not come into being. From this one might have a more nuanced understanding of the processes involved in making and consuming scientific images within the emerging discipline of anthropology. Nevertheless, as I have suggested, the disciplinary apparatus of control and visibility as characterised by Foucault, and its institutional infrastructure, is at the same time formational and integral to the discourses of production and the assumptions on which the project was founded.

On 30 November 1869 a circular was sent from the Colonial Office in London to all colonial governors requesting that photographs be made of the races of the British Empire for the furtherment of scientific knowledge.[1] This contained instructions for the precise placing of the body in front of the camera for a somatic visual mapping. Why did this happen at this point in the emergence of anthropology, which at the time was still eclectic – comprising biologists, philologists, archaeologists, anatomists, folklorists, medical men and colonial administrators

and missionaries, all of whom came together in a joint interest in the origins and variety of the human race, in both physical and cultural terms? How was Huxley involved – for the project dates from the very end of his active involvement in anthropology?[2] He was drawn into anthropology in its biological concerns through the major debate of the 1860s on the origin and development of the human race and this work was published in one of his most famous books, *Man's Place in Nature*, in 1863 (Stepan 1982:78; Di Gregorio 1984:137–8). He was President of the Ethnological Society of London from 1869 and was instrumental in the tough negotiations on the merger between the Anthropological Society, who were, in their sensationalist behaviour and extreme racial theories, viewed with suspicion and disparagement by the much more heavyweight Ethnologicals (Stocking 1971). Further, in 1869 Huxley had been deeply immersed in ethnology, giving a substantial series of lectures on the subject as Fullerton Professor at the Royal Institution. Meanwhile there were serious concerns, and not only in Britain, to improve the quality of data in anthropology: the late 1860s saw considerable photographic activity within the broad constituency that formed the core of anthropological discourse at that date. Furthermore, Huxley himself had strong visualist interests in scientific illustration and drawing – and indeed in the very visualised rhetoric of some of his writing.[3]

Leonard Huxley, Thomas's son, biographer and editor (1900:273–5, 307), places the germ of the idea for this photographic project in Joseph Fayrer's plan of 1866 to gather specimens of the tribes of India, the Malay Peninsula, the Indian Archipelago, Persia and Arabia for anthropological purposes, including both live physical measurement and photography (Pinney 1997:46). Simultaneously, 1868 had seen the publication of the first of the eight volumes of *The People of India*, which had been initiated by Governor-General Canning as an informal request to civilian and military officers for 'souvenirs of India', but was transformed into an official project under the auspices of the political and secret Department after the Indian Rebellion of 1857 (Pinney 1990: 254–5). This project, although not systematic in scientific terms, carried sufficient scientific weight in its presentation of 'ethnological types' to attract favourable comment in both government and anthropological circles. In an opening address at a meeting of the Ethnological Society on 9 March 1869 Huxley related how the Council of the Society 'proposes to direct public attention to the desirableness of subjecting the physical characters, the languages, the civilization, the religions, in short, the ethnology, of the various peoples over whom the rule of Britain extends,

to systematic investigation. To this end there was, through the year, a series of meetings devoted to the ethnology of 'one or other of the British possessions' (Huxley 1869:89–90). The first meeting was on India, and was accompanied by a display of photographs organised by James Forbes Watson, examples from *The Peoples of India,* which he had produced under the imprint of the Indian Museum (Poignant 1992a:42).

However, there would appear to have been other formative configurations. It is likely that the image of controlled photography as an analogical scientific tool accorded with the agendas of serious systematic anthropological science. It was perhaps one of the ways in which the Ethnologicals wished to characterise themselves in opposition to the agendas of the Anthropologicals. A Committee for Classification was established by the Ethnological Society in 1869 for the purposes of examining and registering all branches of ethnological evidence. This should be seen as part of the same broad agenda as the photographic project we are considering here. Further, earlier in 1869 John Lamprey had published in the *Journal of the Ethnological Society* itself a system for anthropometric photography .[4] The surface visual language of the photographs taken for Lamprey by Henry Evans was that of anthropometric science. The figure was placed in shallow pictorial space against a regulated grid (Figure 6.1); however, the positioning of the body suggested the dialect of the academy figure. Indeed, Lamprey had anticipated his system as being of use to both ethnologists and artists. It appears that it was perhaps the initial intention for this system to be used in the scheme to photograph the races of the empire. A report in the *British Journal of Photography* in October 1869 clearly links such a project, Huxley and the description of a system that is clearly that of Lamprey (1869:513). However, if this report is correct there was clearly a change of plan. It is likely that Lamprey's system appeared considerably flawed by Huxley's standards of science, and the scheme to produce a system of measurement that removed the ambiguities of Lamprey's system seems to have been in preparation by July 1869.[5]

Thus it was possibly to these projects and considerations, severally outlined above, that Huxley referred when he wrote:

> Great numbers of ethnological photographs already exist but they lose much of their value from not being taken upon a uniform and well-considered plan. The result is that they are rarely either measurable or comparable with one another and that they fail to give that precise information respecting the proportions and the confirmation of the body which alone are of any considerable worth to the ethnologist.[6]

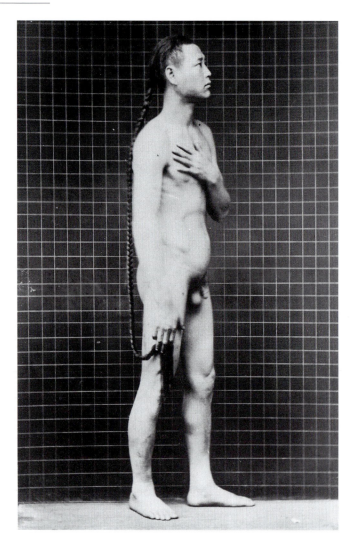

Figure 6.1 Measurement according to Lamprey's system. Albumen print, 1868. Photographer: Henry Evans. (Courtesy of Pitt Rivers Museum, University of Oxford, PRM AL.31.3.)

It was this position, in general terms, that the project initiated by the Ethnological Society through Huxley and Colonial Office was intended to remedy[7] through producing a scripto-visual 'text' of detailed and 'legible' somatic mapping. While one hesitates to attribute direct causal links on such circumstantial evidence, I would argue that certain elements in both anthropological and photographic desire and necessity

established an originating formation of imperatives in the course of the first half of 1869. The initial impetus for the project came from the Ethnological Society. In 1869 Huxley had assumed the Presidency of the Society and, as I have suggested, was anxious to establish the scientific nature of the anthropology. By this stage in his career Huxley, severely overstretched, was as much a bureaucrat as a biologist, sitting on Royal Commissions and the London School Board, as well as setting up new science teaching laboratories at South Kensington (Desmond 1997:13,22–3). It would appear that he suggested the project to Lord Granville, then Colonial Secretary, in the course of conversation some time early in 1869.[8]

The Circular went out on 30 November 1869, the day after a request of photographs of the principal buildings and locations of interest in the colony. It would appear that most Colonial Governors read the two circulars as part of the same instruction, which was intentional.[9] Although Huxley's project was concerned with the production of scientific knowledge *per se,* and the buildings might be seen to represent 'colonial' and 'economic' knowledge, the two were closely interrelated within a broad economy of knowledge. It would appear that the Colonial Office had been somewhat uncomfortable about this arrangement with Huxley and the Ethnological Society, fearing that if they facilitated this photographic survey work for ethnology and anthropology, in the words of one civil servant, 'what about all the other -ologies?'.[10] The Ethnological Society had provided no funding for the project beyond the £10.0.0 investment in the 50 sets of specimen photographs, made by Mr Pedroletti supervised by Huxley himself in the studio, which were sent out with the instruction.[11] It would appear also that the Ethnological Society had assumed that the administrative and financial power of the Colonial Office combined with absolute colonial authority in the Empire itself would be able and willing to furnish their requirements. What is equally clear from the reticence about committing themselves, and anxiety over the cost to themselves, is that the Colonial Office were not, at this period, particularly concerned with anthropological data *per se* for their own use – that anthropology was not a *direct* colonial concern in political and economic terms, although it was deeply implicated in the values that upheld colonialism (Stocking 1987:266).

According to the instructions sent out to Colonial Governors, the entire figure of the subject was to be photographed, unclothed, full face and profile, and then the same aspects of the head alone. The subject was to be placed at a precise distance from the camera. Significantly,

what is not given is more detailed photographic instruction about focal length, lighting and so forth, unlike Bertillon's later system for criminal anthropometry, which tried through such instructions to elevate the photographic itself to an exact and systematic science. A measuring rod was to be placed in a specific position alongside the body, off which measurements of that body could be read. Ideally a male, a female and an immature specimen were to be provided. And so it goes on: the positioning of the arms, the hands, the positioning of women's arms in profile so as not to obscure the profile of the breast, feet close together but the ankles barely touching. The detail is meticulous and the functional status of the photographs so produced is clear; the data represented in this precise somatic mapping were to be systematically comparable for use in the comparative method of biological analysis of human races. While this operated within a broadly evolutionary environment, the images, perhaps, were more concerned with data on racial difference than with a precise evolutionary taxonomy as such.

What Came Back

The Colonial Office request resulted in a range of images – from those that carried out the instructions precisely to the kind of commercially produced *cartes-de-visite* portraits of local 'exotica' that might be sold in any photographer's shop. At one level this project is like the French *Photographie Zoologique* of 1857–8, which collected together specimens, including human beings, to link species or the German project (which so impressed Tylor; see Chapter 2), run by the Berliner Gesellschaft für Anthropologie with the photographer Dammann, to amass, copy and disseminate photographs of the races of mankind (Rosen 1997; Theye 1994/5). As we observed in Chapter 2, such projects brought together a wide range of visual evidence in one collection, imbuing it with an equivalence of meaning that is the product of processing those images in certain spaces and in adequate forms of informational organisation (Poole 1997:119–23).

However, an exploration of the production of the photographs in the Huxley project suggests more complex contexts at work for acquiring images. It is significant that there are only about forty sets of images (i.e. 160 photos. – four images per set) where Huxley's instructions had been carried out almost to the letter. It is these I want to discuss first, as they set out how certain configurations of authority were used to produce the required images. They also set the distance of the photographic dialects and currency of the other images that were absorbed into the project.

These photographs are the most overtly and oppressively scientific, dehumanising, producing a passive object of study. Significantly, two substantial series were made precisely within that domain that Foucault identifies as a concentration of coercive and instrumental power with total visibility and power of resistance denied – the prison: at Breakwater Jail, Natal (Figure 6.2),[12] and at the Malay Straits Penal Settlement. There are in addition a further two images from Wilikadu Jail in Ceylon.[13] There are also substantial sets from Sierra Leone and Bermuda and a small set from Western Australia. Here the circumstances of making are not clear, although the Bermuda set may originate in a hospital (another space of surveillance, of course, that was identified by Foucault), for the Chief Medical Officer was in charge of implementing the project.[14]

The distress of the subjects is too often palpable, especially in the Malay Straits set, which was organised through the prison authorities.

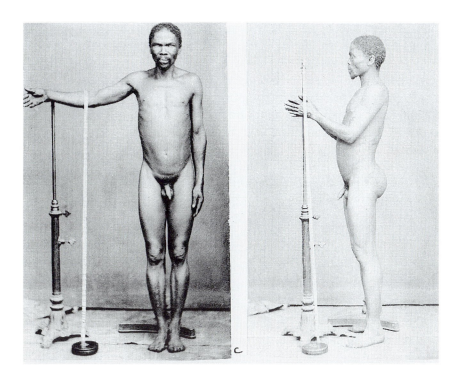

Figure 6.2 Anthropometric photographs taken according to Huxley's system at Breakwater Jail, Cape Town. Albumen prints, 1871. Photographer: Lawrence and Selkirk. (Courtesy of Pitt Rivers Museum, University of Oxford, PRM B11.1.c-d.)

The Breakwater series was organised by Wilhelm Bleek, philologist and ethnographer of the Bushmen (Khoisan) in South Africa. Here sample photographs were made by the photographers Lawrence and Selkirk in February 1871, of //Kabbo and !Gubbi, both /Xam Bushmen (Godby 1996:119–20), presumably copying Pedroletti's sample photographs made for Huxley and the Ethnological Society. These latter were used, one can surmise, for the unsuccessful attempt to elicit photographs from the states of Cape Colony. When these were not forthcoming, prisoners from the various races gathered at Breakwater Jail were used as substitutes: Khoisan, Zulu and Damara (Herero) were photographed, and, although the circular did not actual call for measurements to be appended – after all, the photographs themselves were intended to be legible – Bleek added names, ages, and measurements, as in the case of the Bushman: '. . . the race is dying out and dwelling in regions which are generally inaccessible and hardly any photographs existing represent genuine bushmen'.[15]

Yet beyond the spaces in which absolute colonial power operated, the result was rather different. Some Colonial Governors stated that they were quite unable to comply with the request because of the resistance of the indigenous communities, or of the colonial officers and missionaries directly responsible for the administration of indigenous peoples, or indeed of the photographers themselves. Governor Musgrave of British Columbia, Canada, wrote 'I am informed that no Indians here will consent to be photographed in a state of nudity, although reward has been offered. It is believed that they have a superstitious dread of some hidden purpose which they do not understand and it would impossible to explain to them the scientific object of the proceeding.'[16] While one cannot generalise reactions to either nudity or the camera cross-culturally, there does emerge a pattern of resistance, however premised. Musgrave's inability to comply with Huxley's instructions, was in fact, indicative of a pattern of resistance and substitution. For example, A. B. Fryers, Surveyor General of Ceylon, commented, 'I have met with more difficulty than anticipated in obtaining nude photographs of the native races in this island, but I hope to be more successful in the course of the present year.' One can assume he was not, because no more Ceylon photographs are forthcoming. Governor Darcy of Malta explained: 'the insuperable difficulty of persuading either men or women to stand in a condition of absolute nudity before a photographer has prevented me from complying with the directions'. Governor Chapman of Bermuda wrote, 'owing to the smallness of the community and the peculiar prejudices of the people, much difficulty

has been experienced both in inducing an artist to execute and in procuring subjects for photographs of this description'. The Office of the Central Board of Aborigines in Melbourne, Australia, explained more fully: 'In some parts of New South Wales, in Queensland and elsewhere in Australia it will be easy to procure photographs of nude aborigines but in Victoria it would be difficult. I shall be glad to collect [note *collect* not *make*] photographs of full length figures . . . but I can promise such only as have been taken with the cheerful consent of the blacks. . . . Indeed, they are careful in the matter of clothing & if I empowered a photographer to visit the stations and take photographs with Professor Huxley's instructions in his hand, he would, I am sure, offend the Aborigines and meet with little success.'[17] It was precisely similar problems, experienced in the various states of Cape Colony, that Sir Henry Barkly found to obtain when he assumed office as Governor of Cape Colony in 1871. The failure of other states to provide images placed all the emphasis and activity on Breakwater. However this general pattern of resistance within the colonial system itself was, to a degree, qualitative. Viscount Canterbury, of Victoria, Australia, passing on comments, says 'It is scarcely necessary to state that objections which apply to the Aborigines would be still more weighty in the case of half-castes and others.'[18]

What emerged in a number of cases, in an effort to comply, are photographs in a more negotiated style of what might be described as 'scientific reference' (Edwards 1990), and in particular commercially produced *cartes-de-visite* (Figure 6.3). All these photographic discourses are presented within an intellectual and disciplinary continuum. This is actually articulated by Bleek of South Africa: 'Three other Bushmen photographed by Mr Barnard [were] not in complete accordance with Professor Huxley's directions . . . [But were] sufficiently near to help in illustrating the characteristics of this remarkable race' (Bleek and Lloyd 1911:437–8).[19] While the blank backgrounds and focus on the head resonate with scientific reference, the images are presented as oval vignettes, with light gently moulding features, and significantly there is no measuring stick.

The Governor of Tasmania, stating that the Aborigines of Tasmania had died out 'except for one elderly woman',[20] substitutes Woolley's photographs taken for the 1866 Inter-Colonial Exhibition in Melbourne. Furthermore, the version submitted was the popular portrait style, a fading-out vignetted print, rather than the full frame. The Governor of the Falkland Islands, who had declared that he was 'not at all sure that they [Tierra del Fuego Indians] would consent to be photographed

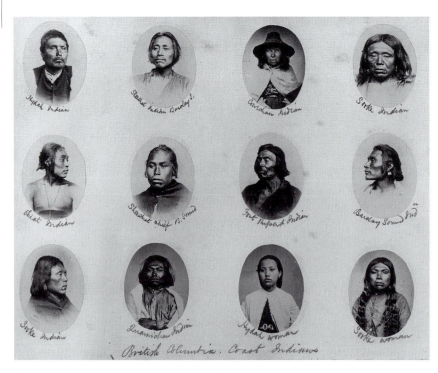

Figure 6.3 Trimmed *cartes-de-visite* by F. Dally mounted in an album. Albumen prints on cream card. (Courtesy of Foreign and Commonwealth Office Library: Canada Album 1.)

in the only manner which would be of value to you'[21] produced four *cartes-de-visite* in quasi-drawing-room style, strange hybrid images specially taken for Huxley of Tierra del Fuegians who had been on board a mission schooner; images tense with the contradiction between style and meaning.[22] The way these images operated within the visual economy of the project is significant. They were substituted and presented in terms of equivalence with the anthropometric images through the privileging of content over photographic dialect and intention. While at one level the Governors may simply have been trying to fulfil orders from their own colonial masters, nevertheless images formed a concatenation of visual forms, linked through cultural taxonomies of subject-matter.

Whatever the reasons given by the various Governors, whether they represent humanitarian sensibilities, an ill-defined sense of indecency even when such imaging was being visited upon non-Europeans, or an unwillingness to destabilise the colonial *status quo*, what emerge

are patterns of resistance within colonialism itself. Thus, whereas the project was premised on assumptions of absolute colonial authority combined with the appeal of science, the colonial administrator and photographer were, in practice, faced with a more ambiguous situation, juggling the demands of distanced metropolitan colonialism and those of the local *status quo* in the translation of power. Colonial discourse does not simply or necessarily reproduce an ideology or set of ideas to be constantly repeated. Rather, it is a way of creating and responding to a reality that is specific and infinitely adaptable in preserving the basic structures of power (Spurr 1993:11). It is precisely this relationship between power and practice that sets one of the lines of fracture for Huxley's 'well-considered plan'.

Much writing on colonial photography had concentrated on this overtly objectifying anthropometric material and presented it as an ideologically legitimated norm of science, colonial relations and indeed popular perception. While ideas of racial and cultural superiority and ordering both informed the broad shape of scientific assumption on the one hand and were legitimated by scientific racial discourse on the other in a symbiotic relationship, it would appear that such imagery was not widely disseminated, but was for scientific consumption. The only dissemination of these images that I have been able to find is through scientists and officers of HMS *Challenger*, who were given sets of the South African material by Bleek when *Challenger* put into Cape Town in December 1873.[23]

Images of a very different order are, however, the very large number of photographs of scientific reference, which absorb the visual styles of science, inflected through reports of anthropological endeavour in the popular press, the visual dialects of phrenology and physiognomy and notions of positivist quantification. What is significant here is the intellectual viability of visual slippage, in terms of function, between scientific and aesthetic photographic discourses. This position privileged content to form an ethnographic massing of peoples, rather than the mode of presentation of that content, in another manifestation of a rhetoric of substitution founded on the language of equivalence (Snyder 1998:33). In this project this operated on two axes, first the substitution of image for body and second, the substitution of image styles. These images mirror the scientific mode of representation – the isolated figure, against a plain background; even or flat lighting projecting the figure forward in the picture plane; the insistent focus of attention. Uniformity of form suggests a beguiling uniformity of function. The broad equiv-alence of pose and of composition that dominated much *cartes-de-visite*

production of this kind can thus be related back to the conceptualising groundwork of the more precisely articulated scientific modes that Huxley's plan typifies (Poole 1997:139) .

These photographs are at one level more insidious in their objectification. The mapping of the body and the cultural are conflated with tropes of the exotic, for consumption within a broad paradigm of popular science and anthropology. Scientific forms legitimated a certain representational form and a certain moral value attached to the subjects of the photograph. Racial and cultural differentiation had, as we have considered, moral valuation attached to it; even Huxley, more liberal than many and certainly more scientifically rigorous than most, talked, in his lectures and writing, of 'higher' and 'lower' races, immediately introducing a set of values that could be and were perceived in evolutionary terms and that, in the context of biology, became scientific (Di Gregorio 1984:169).

As we have seen, for reasons of colonial micro-politics it was, in some instances, impossible to instigate photography precisely to Huxley's instructions, and visual substitutions were made. However, it would appear that the analogical, iconic elements of the photographs, of surface appearances, made commercially produced *cartes-de-visite* images of 'native types' an intellectually valid response to scientific ideas of scientific quantification in that they had a representational truth value premised on a cultural expectancy of the medium's qualities – even if the photographs fell short of Huxley's definitions of evidential truth.[24] What is crucial is the way in which the analogical realism of photography and the related notion of a sort of 'virtual witnessing' through photography combined to overpower scientific and photographic aesthetics in the assessment of the suitability, the potential for meaning, of the photographs themselves.[25]

However, even in those photographs taken according to Huxley's system, the indiscriminate nature of photographic inscription inserted other discourses, cultural discourses, both on part of the photographer and the subject. Yet it was precisely these that the systematic approach envisaged by Huxley was intended to contain and control. The dehumanising nature of the photographs is accentuated through the intrusion of humanising, cultural detail and the subjectivities of the photographic act itself – elements of subjectivity that the project was attempting to remove.[26] They provide a productive dissonance that interferes with the communication of the truth value of science.

This is particularly so in the series from Ceylon and the Malay Straits penal colony. The arrangement of the hair as seen there in a Burmese

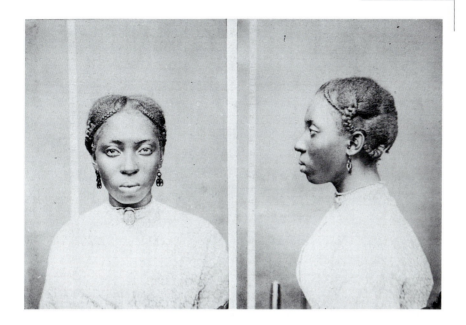

Figure 6.4 Lydia, photographed in Sierra Leone, Albumen print, *c.*1870. Photographer unknown. (Courtesy of the Royal Anthropological Institute.)

man, odd pieces of jewellery, a Hindu's lingnan, a Chinese man's queue, and likewise in the Sierra Leone series, the tense juxtaposition of the measuring rod and the young woman's pretty earrings and modest gown (Figure 6.4) point to the fracturing ambiguities inherent in the project. The intersubjective space constituted by the act of photographing leaves its mark on the images. Sometimes heaps of clothes are visible in the frame, resonating with the act of making visible, the violence of laying bare, and even more so in those photographs where the clothing is removed but the fetters remain. Further evidence emerges from the photographic object itself, however. The negative of the profile image of a 43-year-old woman from Azinghur, in the series from the Malay Straits Penal Settlement, perhaps points to the anxiety of the photographic session, although this can only be conjecture. All the plates in the series, although now with very damaged emulsions, are well coated with an even spread of collodion going right up to the edge. In the profile of the woman from Azinghur, the most visibly distressed of those photographed, large areas of the plate have remained uncoated (Figure 6.5). Was this a photographer working under pressure? A plate that could not be reshot? Or was in merely a photographer

Figure 6.5 Missing collodion, 1870 [detail of wet collodion plate negative]. Photographer unknown. (Courtesy of the Royal Anthropological Institute.)

running out of collodion in a hot climate? The deposits suggest it could have gone further. But why this plate? One can conjecture that this faulty plate possibly points to the unease of the photographic session.

While at one level the collection itself constitutes a set of meanings, through the politics of the making and their performance as anthropological images, it was the various confluences of aesthetic, political and scientific practices that, one might argue, contained the lines of fracture for scientific structures of knowledge. These cohered around the ultimate rawness and uncontainability of photographic meaning, the cultural expectancy of analogical realism, the visibility of content and the invisibility of photography as a discursive practice. Clearly Professor Huxley's 'well-considered plan' did not turn out as he anticipated. It would appear that Huxley lost interest in the project; there does not appear to be any correspondence to the Colonial Office asking what was going on, even though it took over two years for some of the material to reach London. Anthropology was, after all, only one of Huxley's many interests. Furthermore, by 1871–2 the concerns of the Ethnological Society were more focused on the identity of the newly constituted Anthropological Institute.[27]

If the responses of the Colonial Governors to the visualising desires of anthropology reveal a series of ambiguities, equally so do the responses in the Colonial Office as photographs arrived over the next two years. We can extrapolate a certain amount from the massing effect of slight evidence. It suggests a less homogenised and normalised view of these images than has been assumed. First, the production of the sample photographs does not appear to have been straightforward. The photographer Pedroletti is rather mysterious. He is not recorded as a commercial photographer anywhere or as an employee of the Royal College of Mines, Huxley's institution.[28] Second, there are the Colonial Governors unwilling, for whatever reason, to comply with the circular. In addition it would seem that the photographers were not totally happy with what was being asked of them. A couple of Colonial Governors comment on the unwillingness of photographers to do this work. Whether this was on humanitarian grounds or whether they were afraid of prosecution under obscenity laws we cannot know. Then there is a cryptic remark from Queensland that they are 'unable to further the views of Professor Huxley'. Whatever the detail of the various cases there would appear to be an unease with what was being asked, morally, politically and practically. Particularly revealing in this relation is a Civil Service minute note attached to the files for the Falkland Islands. The *cartes-de-visite* of Indians of Tierra del Fuego had arrived. They are

not, as we have seen, to Huxley's instructions. There are a few scribbled jokes about missionaries, who had felt that their charges would be morally weakened by scientific photography, and what Huxley is likely to say to them (Huxley was well-known for his anti-clerical views). There follows then a crystal-clear note that would appear to be by Sir Frank Rogers, Permanent Under-Secretary at the Colonial Office; he writes: 'But personally I am bound to confess [?] how in drafting out that circular I always felt as if I was fingering something filthy.'[29] Further, when the series from Sierra Leone, taken according to Huxley's system, arrived in the Colonial Office in April 1872 Lord Kimberley's instruction is that they be put with the photographs of the public buildings. Sir Robert Meade, Assistant Under-Secretary at the Colonial Office, objects 'I don't think these horrors should be put into the book. They might, with the others as they arrive, form a separate collection.'[30]

On the other hand, when the group of photographs from Ceylon and the Malay Straits, which has we have seen are amongst the most disturbing, are sent for the new Colonial Secretary, Lord Kimberley, to see, he scribbles in the margin 'Hideous series'. We can only conjecture whether he meant the subjects, the photographs or both; was the 'hideous' a comment on race, criminality (both categories of colonial value) or both, or on the photographic style?[31] Similarly there are derogatory comments on Woolley's portraits of Tasmanian Aboriginals premised on ideals of feminine beauty.[32] It is a difficult task to assess the few remarks that survive on photographs such as these, outside the language of scientific discourse, so that consequently one cannot give too heavy an evidential weight to them. They nonetheless suggest that whereas certain tropes suffuse images of non-European peoples operating within generalised discourses of fascination, or popularised and value-laden contemplation of difference, precise scientific desires were not necessarily normalised within the consumption of these images. The rubric of the colonial gaze has tended to obscure different-iated intention, production and consumption of images, homogenised under the notion of 'anthropological', whereas as the evidence from the Huxley project would point to a more complex and nuanced assess-ment of photographs.

Traces in the Archive

So the project slowly collapsed. But what of its social biography and its related deposits? For the early archival fragmentation is one of the indications of the project's failure. It is quite clear that, despite the

entanglement of anthropology, politics and cultural value and biologic-
ally determined ideas of culture, the Colonial Office, at this date, was
not particularly interested in the anthropological nature of the people
whom it ruled and administered beyond the related issues of the
economics of labour supply, law and order, health and infrastructure.[33]
Consequently the photographs from the buildings project were kept
in the Colonial Office,[34] but those of the races of the British Empire
have largely disappeared with little trace. Although the original request
was for triplicate sets of the photographs to be supplied, it is clear that
although the material was circulated within the senior levels of the
Colonial Office itself, it was not retained, or not for long. The Tasmanian
portraits are still in the Foreign and Commonwealth Office Library, as
is the album for British Columbia, containing 'ethnological types',
clearly because both buildings and 'types', photographs by F. Dally (see
Figure 6.3), were presented in one album at the time of deposit. The
material from British Honduras stayed in the Colonial Office, never
reaching Huxley, because, one can conjecture, of the evident unsuit-
ability of the portraits for Huxley's purpose, despite the enthusiastic
Governor Harley's accompanying ethnographic notes on the character,
moral and cultural, of the subjects. Further this submission took almost
2½ years to arrive, by which time this photographic project had, in
the mind of the Governor, become conflated with another request to
supply visual information, this time concerning industry in the
colonies, for the 1872 International Exhibition.[35] However, there are a
couple of albums where the trace of the racial series remains in the
form of a note saying that the photographs had been either sent on or
filed separately. For instance, clearly Sir Robert Meade won his argument
concerning the placing of the Sierra Leone images; they are not in the
book,[36] there is merely a note stating 'Photographs of Natives in
separate covers'.

The set of photographs at Imperial College London in Huxley's Papers
is the most complete. However, what of the other sets? In some cases
it seems that the prints were never submitted in triplicate – the entries
in the Colonial Office In-Registers are not totally consistent. Others,
notably the set from Sierra Leone and Australia and later the negatives
for the Malay Straits series eventually arrived in the collections of the
Royal Anthropological Institute (successor of the joint Ethnological and
Anthropological Societies), but evidently at different times, some time
later – perhaps from the Colonial Office/Foreign and Commonwealth
Office. The Earl of Kimberley, who was Colonial Secretary at the time,
is listed as a donor to the library and 'museum' in the Report of the

Council for 1872 (Anthropological Institute 1873:428); however, there is no indication as to whether these photographs constituted the donation. The photographs' connection with Huxley's Ethnological Society project was lost – for example, the negatives of the Malay Straits set were simply described as 'Prisoners?' 'Southeast Asia?'. Clearly material was not passed on to the Ethnological Society, as had been the original intention.

Finally, how were the images used? There is no evidence that I have found, either in Huxley's work or in any other, that the material was actually used in any analytical way, attempting to read data off the images. The material lacked precision, since 'the inability to quantify (except in some purely auxiliary aspects) stemmed from the impossibility of eliminating the qualitative, the individual' (Ginzburg 1983:100). Its function at the end of the day collapsed into the illustrative. In any case, as Spencer has argued, the system devised by Huxley contained inherent flaws in the positioning of the subject's limbs, the placement of the measuring device and the presence of the subject's hair, which all obscured crucial biological information were the photographs indeed intended to provide somatic information (1992:100–2). There appears to have been interest in the exchange potential of the photographs. H. Jagor, the German traveller and anthropologist, reported the project to a meeting of the Berliner Gesellschaft für Anthropologie as early as January 1870, when he clearly had a copy of the instructions and Pedroletti's sample photographs (presumably from Huxley himself) (1870:147–8). Huxley's photograph collection at Imperial College includes a substantial set of some 80 cabinet-size prints from Jagor's photographs from south and south-east Asia of the mid-1860s – clearly in anticipation of an exchange. But there is no evidence that anything materialised.

In addition, the nineteenth century was very concerned with the quality of vision and the limits and possibilities of observation (Green-Lewis 1996; Crary 1990); despite the cultural expectations of photographic objectivity and naturalism, the project photographs lacked accuracy in scientific terms. Writing of photography in craniometry in 1866 Wesley stated that 'It does not appear to me probable that photography will ever supersede drawing for scientific purposes . . . [The] disadvantage [is] that the photograph renders every minute detail with absolutely certain fidelity' (1866:189–94). In other words, the object of study could not be correctly represented in terms of what was perceived to have evidential validity: those features considered significant could not be privileged, nor those insignificant suppressed.

As we have seen in the photographs produced for Huxley, the visual noise of the photograph's naturalism effectively disrupted the scientific orders of significance.[37]

Further, I would argue that by 1875, despite the strong scientific reference as the notion of measurement persisted as indexical of scientific intention, one begins to get the first stirrings of divergent trajectories in terms of imaging. These reflect the emerging fields of physical anthropology and cultural anthropology, each with different visualising trajectories, but nevertheless within a relationship that was not finally disentangled until the 1920s or 1930s. The precise anatomical mapping that Huxley had hoped to delineate owed its representational strategies to a mapping of anatomical draughtsmanship that goes back to the seventeenth century translated into photographic form. It depended entirely on the mechanical and indexical nature of the photograph, rather than on the possibilities of photography as a medium. By the mid-1870s Galton was developing his composite photographic method for the delineation of type and the isolation of characteristics, which constituted a clear trajectory within physical anthropology and later eugenics (Green 1985). Importantly, in its layered inscriptions, this work pointed to very much more sophisticated applications of photography within physical anthropology that actually engaged with the technical possibilities of the medium itself as a route to scientific data. Nonetheless, the idea of centralised bodies of visual racial data re-emerged periodically in the late nineteenth century, notably in the form of the British Association for the Advancement of Science's Racial Survey of the British Isles, which initially started in 1878 as being concerned with the whole British Empire. While it was conceptually systematic, the photographic success of the BAAS project was, like Huxley's, very limited, emerging as a serendipitous collection of images.[38]

Conclusion

What Huxley's project with the Colonial Office and its ultimate failure from Huxley's perspective suggest is that beyond the discursive meta-level and enabling power structures, Foucauldian assumptions do not necessarily hold. The production, transmission and response to images of anthropological science in the mid-nineteenth century are very much more complex and nuanced in their negotiation than such a model allows for. While one must keep that meta-level in sight so that one does not diminish the impact of the broad operation of colonial power within the detail, the facts nonetheless suggest that the consideration

of images cannot rest solely on homogenised models of colonial action visited on passive and undynamic populations, nor can the consumption of images be formulated in simple causal terms – if x then y. The Huxley/Ethnological Society project contains a wide range of visual responses to anthropological scientific desire, from the totally oppressive and objectifying from the moment of photographic encounter and production on the one hand, to a refusal to co-operate on the other. In between is the currency of those images made 'scientific' through their consumption and juxtapositioning. These conflicting and disparate responses to photographic production might be seen in the explanatory context of local colonialisms and in the fluidity and mutability of photography as a discursive practice. But neither should one lose sight of the fact that where substitutions of other photographic styles and visual dialects were made by Colonial Governors, for whatever reasons, the subjects of those photographs, even if the images were made with the willing and remunerated co-operation of their subjects, first, were already irrevocably enmeshed in an exploitative and marginalising political and economic environment and second, had their images absorbed into a scientific project that generalised and deindividualised them, and ultimately appropriated them as specimens. However, within this exist different levels of domination, resistance, ambiguity, fracture and appropriation within colonial practice itself and within the populations it dominated. Within the relationship between general power structure and local conditions is enmeshed a greater complexity of photographic production within anthropology than we might imagine.

Notes

1. PRO CO.854/10.

2. He returned to anthropology towards the end of his life, when his interests involved ethics and social evolution (Desmond 1994:339–54).

3. Flower records (1996[1895]:387) Huxley's 'great facility for bold dashing sketching comes in most usefully [in dissections] . . . The notes he made being largely helped out by illustrations. . . . His power of drawing on the blackboard during lectures was of great assistance to him and to his audience.'

4. This was the first use of photographic illustration in a British anthropological journal (Poignant 1992a: 49).

5. The change of plan was clearly made on scientific grounds only. Henry Evans was prosecuted for selling obscene photographs in March 1870. But as the raid on Evans's shop was three months after Huxley's circular went out, it cannot have caused the change of plan. Lamprey wrote to the press in Evans's defence, and while the anthropometric photographs were stated not to be part of the prosecution, the mere fact of it does suggest that making such images was on the margins of photographic practice (London Metropolitan Archives MJ/5PE/1870/06, *British Journal of Photography* 14 October 1870).

6. ICL.HP.30.f.75.

7. It would appear that the Ethnological Society's input and involvement was extremely limited beyond the initial approach. All the data were reported back to Huxley, and most of the photographs passed on from the Colonial Office seemed to remain in Huxley's possession (ICL.HP MS. Box H). The images attributable to the project now in the collections of the Royal Anthropological Institute (the successor to the Ethnological Society) were probably received somewhat later and without documentation.

8. No originating letter survives in either Huxley's papers or on Colonial Office files. A letter dated 30 June 1869 from Sir Robert Meade, private secretary to Granville, reminds Huxley of a conversation with Granville and that the Colonial Office is awaiting promised instructions (ICL.HP .XX:206).

9. Governors were in regular receipt of circulars from their masters in the Colonial Office. These requests for photographs must have appeared an irritating demand on hard-pressed infrastructure. This is hinted at in the response of a number of Colonial Governors, who cite lack of funding as a reason for their inability to comply. This was a Colonial Office project: India was not included, but it is possible that it was seen as broadly complementary to *The Peoples of India*.

10. PRO CO.323/296/374.

11. On 16 November 1869 Colonel Lane Fox (Pitt Rivers) '. . . transmit[ted] 50 double photographs for distribution in the Colonies for the purpose of having photographs of the Native Races taken in a similar position & on the same scale. Transmits them at the request of Prof. Huxley" (PRO CO.378.5). Lane Fox was Honorary Secretary of the Ethnological Society.

12. For a detailed examination of the making of the Breakwater Jail images see Godby (1996).

13. The concern of these photographs appears to be entirely racial. The physical mapping of criminality, such as is described by Sekula (1989) and Duffield and Bradley (1997), does not seem to have been a consideration.

14. PRO CO.37/200/90.

15. ICL.HP. XV.I.5v.

16. PRO. CO.60/38/332.

17. ICL.HP.XV.117.

18. Ibid., 115.

19. For a description of the making of Barnard's Bushman images see Hall (1996).

20. PRO.CO.280/380/122v. This was probably Trucanini, until recently described as the 'last Tasmanian'. She died in 1876.

21. ICL HP.XV.117.

22. There is also a large series of Maori *cartes-de-visite* from New Zealand, from photographers such as Swan & Wrigglesworth, which probably falls into this category but which I have yet to be able to trace through properly.

23. The set belonging to H. Moseley, a naturalist on HMS *Challenger*, is in the collections of the Pitt Rivers Museum (PRM.PC. B10.13,25, B11.1–3, 13,16) and that given to *Challenger*'s chief scientific officer, Wyville Thompson, in the Picarini Museum, Rome.

24. There is probably, also, an element of desire and anxiety on the part of the Governors to comply with the requests/orders of their masters in the Colonial Office in London.

25. The vast number of such images that survive in anthropological archives and museums throughout Europe, North America and Australia reinforces this view.

26. Mitchell's comment in a review article on Malek Alloula's *Colonial Harem* resonates here. There is no room for 'the ecstatic wound of "punctum"' , only the 'massive trauma of degrading fantasm' (1994:308).

27. Significantly, in this context, just as the split between the Anthropologicals and the Ethnologicals in London in 1861 had come to a crisis over a visual representation (Stocking 1971: 376), the correctness of Owen's visual representations, his drawings, were key to the *hippocampus minor* debate (Di Gregorio 1984:137–8). In both cases the *representation* of scientific information was perceived as failing the moral imperatives of mid-nineteenth century objectivity (Daston and Galison 1992:82–3).

28. Possibly there were concerns about scientific photographs in relation to the obscenity laws. Newspapers reported a steady stream of prosecutions; as the Evans case was to show, these could get close to anthropology. I have tracked Pedroletti to Camden, north London. He is recorded in the 1860s as an artist and possibly photographer, but then he disappears. The house where the sample photographs appear to have been made is listed as a private house in contemporary directories and the 1871 Census.

29. PRO CO.78/58.

30. PRO CO.267/311.

31. PRO CO 273/41/240. For discussion of these issues in relation to representation see Duffield and Bradley (1997).

32. PRO CO.280/380/121v.

33. John Cell (1970: viii) has noted how the tone of strident racism, which is common in Colonial Office documents of the late nineteenth century, is missing in documents dating from the mid-decades of the nineteenth century.

34. The catalogue of the albums in the Foreign and Commonwealth Office Library in London identifies this project as the founding collection of the album series now extant there.

35. PRO CO123/147. Harley cites the circular of 30 November 1869 (Huxley's instructions) and one of January 1872 concerning the Exhibition in his reply.

36. Foreign and Commonwealth Office Library, Sierra Leone Album 1.

37. Jehel (2000) has noted a similar unease and ambiguity in relation to physical anthropology and photography at the same period in France.

38. Poignant (1992a:59–61); BAAS (1879:175–20). This was produced under the auspices of the Anthropometric Committee, which was appointed to 'undertake . . . systematic examination of heights, weights etc. of human beings in the British Empire, and the publication of the photographs of the typical races of the Empire' (1879:175), while the Committee amassed data on British racial variety between 1878 and 1883. However, by contrast with Huxley's project, textual and statistical data were included in the project, and it was from these that scientific meanings were projected on to the photographs, which fulfilled a largely illustrative and authoritating function. The resulting albums of the British 'Racial Committee' are in the collections of the Royal Anthropological Institute.

Re-enactment, Salvage Ethnography and Photography in the Torres Strait

Flawed photographs?

Anthropological truth value has been grounded in a cultural representation, extracted from real time, authenticated through real-time observation, captured and stilled through the action of the camera. Within this, images that depart from real time have been deemed as somehow epistemologically flawed in terms of the scientific morality of the discipline. However, it is a particular form of these latter images that I want to explore, those of re-enactment, constituting as they do a form of visualising science in the period of proto-modern anthropology which combines both the method and the object of observation. Re-enactment might be defined here as a performative reconstruction of social action outside normal or natural contexts and constitutive happenings. Another characteristic is that it is a citational act, referring back to social action. By looking specifically at the relationship between photography, anthropological science and re-enactment I want to explore how, while it is only part of a wider methodology with historical implications, re-enactment was a central tool in visualising anthropological, scientific data, which came out of science itself.

My concern is not to evaluate the naturalistic claims of re-enactment but to explore the methodic practices that transform an unseen or unseeable cultural past into a visual representation for 'seeing' and 'knowing'.[1] Re-enactment cannot be explained through anachronistic value judgements of 'fake' or 'untrue' in comparison with the authority claims of later fieldwork practice. It occurs in different densities and

157

intensities in much anthropological photography between about 1885 and 1925, even occasionally in the work of Malinowski, for instance, working with a method which would appear to reject intervention in observational real time. In addition, while technological constraints on the one hand and the desire to 'show how' on the other are clear determinants at a surface level, I hope to show that re-enactment was not an unconsidered mode of illustration. Rather, it was integrally linked to historically specific notions of intellectual validity, objectivity and scientific method. Simultaneously, within the context of salvage ethnography, it was premised on an assumption of absence, loss, desire and resurrection of a fractured cultural wholeness (Morris 1994:54–5), for the very performative qualities of re-enactment make it a site for multiple subjectivities.

I am going to consider this in relation to one photograph in particular, although there will be others. It was made on 21 September 1898 on Pulu island by A. W. Wilkin under the direction of A. C. Haddon, leader of the Cambridge University anthropological expedition to the Torres Strait, a group of islands scattered between Australia and New Guinea. It is an image that is 'good to think with', in that it presents that 'condense[d] a range of social forces and relations' (Daniels 1993:244–5). I shall then consider briefly some other photographs that could be termed 're-enactment' in the light of my analysis of this one photograph and the issues in which it is embedded. I shall also argue that, for the Torres Strait Islanders involved, re-enactment became a significant mechanism through which to write or control their own ethnography within the parameters of the colonial situation. This argument also has implications for the consideration of early visualisation in anthropology, especially, in this case, for the famous four minutes of film from Torres Strait. Much analysis has been premised on homogenising models of colonial anthropology and notions of veracity in visual recording that are anachronistic and fail to understand the scientific premises on which photography and film operated in the closing years of the nineteenth century and, more specifically, the place of re enactment within them.[2] Rather than ask why it failed to do it another way that accords better to our notion of truth, one should ask what kind of notion of reality and authenticity led to the possibility of representation in a certain way; not 'what their ontological status is … [but] what their import is … what is getting said' and thus how it is possible for them to be perceived as intellectually valid (Geertz 1973:10). For again we must ask, how were photographs made? What were the claims made by them and of them? What practices were involved?

Questions concerning the evidential value of photography in nineteenth-century anthropological science, as argued in the previous chapter, must reflect not only general meanings culturally attributed to photography but the different inflections in distinctive and shifting sites of scientific practice (Tucker 1997:380–1; Daston and Galison 1992). Technological advances and availability constituted a range of historically specific possibilities that could be applied within shifting epistemological and heuristic environments in anthropology and beyond. Re-enactment, and by extension the whole notion of the 'posed photograph', became problematic only when veracity and authenticity as they are now perceived became technically possible, and sources were interrogated from a different basis, so doubts concerning authenticity and authority became differently premised (Winston 1995:120–3). Such practices are rarely commented on, so naturalised were they within the discourse of objective observation; however, within the anthropological material of the late nineteenth and early twentieth centuries there is a sufficient evidential mass for us to be able to explore the matter further.[3]

In many ways the concerns of authority, inscription, veracity, aesthetics, scientific ethics, intervention and pose, articulated by Gregory Bateson (who had been a student of Haddon's) and Margaret Mead in their *tour de force* of anthropological still photography *Balinese Character* (1942), can be found embedded in the visual practices of the Torres Strait Expedition. These elements have been problematised as the dominant concerns of visual anthropology ever since. The general ambivalence towards the visual and its devaluation as an active interrogatory form in anthropology, which, as I discussed in relation to Jenness's photographs, is manifested as a move from process to product of anthropological investigation. It can be traced, perhaps, to the collapse of the scientific laboratory paradigm of anthropological practice and the shift in evidential validity from instrumentation to the unmediated scientific eye embodied in the fieldworker. As we saw in relation to the exchange systems of anthropologists in Chapter 2, photographs created within the older paradigm no longer appeared as valid evidence in the newer observational and explanatory modes.

Two registers of authenticity are at work within the photographic re-enactments considered here. First 'the authentic' was a central trope in salvage ethnography. The salvage operation might be characterised as a mediating, and arguably appropriating, gesture of Western science to 'save' the object of study from vanishing irretrievably, thus legitimating representational practice (Clifford 1986:112–14; Morris 1994).

Malinowski, as quoted in Chapter 1, lamented the way in which the object of ethnographic study disappeared at the moment of its scientific recognition (1922:xv). Such a sense is based in both personal and collective experience of what that loss might entail. Ideas of authenticity defined and selected, in terms of subject-matter, what was to be preserved. In other words, they had the power to authenticate. Thus secondly, and linked, there was an authenticity of observation that defined the authority of the scientist and anthropologist. The genuineness and authority of observation was played through the verisimiltude of the photograph. Through the latter's indexical insistence and concentration of space and time, the act of re-enactment defines the original. However, attractive as they might appear, theorists such as Baudrillard, Eco and others who have argued for the disappearance of the original in relation to the simulacrum cannot be sustained here, because slippages between reality and re-enactment, past, present and configurations of authority are too complex to be accommodated within a dichotomous model. Rather, in re-enactment photographs one is dealing with a fluid, negotiated, historically and culturally grounded perception of authenticity as a social process through which expectation, credibility, veracity and authority, working within certain parameters, constitute a re-enactment as evidentially valid (Bruner 1994).

All these considerations have implications for evidence and demonstration in late-nineteenth-century ethnographic and anthropological work. Further, the concepts that come together in re enactment have significant implications in the structuring of knowledge, relationships between observer and observed, and subjective spaces within anthropological practice of the period. For if the photograph's role in the representation of cultural reality is problematic, so is the idea of representing reality through salvage and re-enactment. However, rather than this double mimesis resulting in simply a double inauthenticity, I shall argue instead a construction of authenticity that reveals a deeply complex cross-cultural encounter and intersecting history, as re-enactment engaged, very literally, with both the construction and the theatrical possibilities of history through its inherent imaginative projections.

Science in Torres Strait 1898

The Cambridge Torres Strait Expedition, from which my case-study is drawn, is seen as a watershed event in the development of British anthropology, a nascent form of the modern school of systematic,

scientific, sociologically based fieldwork (Stocking 1983:83–4). The Expedition was under the leadership of A. C. Haddon, a Dublin- and Cambridge-based zoologist who had converted to anthropology during an earlier field trip to the Torres Strait in 1888. He had chosen this site for a study of the marine biology of coral reefs on the advice of his mentor, T. H. Huxley (see Chapter 7), who had himself visited the Torres Strait as a young ship's surgeon on HMS *Rattlesnake* in 1848 (Quiggen 1942:79–80). During his 1888 expedition Haddon had worked closely with islander assistants. He not only collected natural history specimens and artefacts and made photographs, but talked to people, visited sacred sites with the old men, collected stories and heard tales of the exploits of the totemic hero Kwoiam. The islands of the Torres Strait had undergone massive transformation through concentrated colonial activity, especially that of the missions. The experience of sitting with the old men, hearing tales of times before the LMS Mission came in 1871, engendered a sense of loss and the passing of cultural wholeness, and convinced Haddon of the necessity of anthropological work. He longed to return to Torres Strait to study and record the cultures of the islands in a salvage ethnography exercise before it was, as he saw it, too late.

By the late 1890s the second expedition was becoming a reality. Encompassing ethnology, physical anthropology, psychology, sociology, linguistics, ethnomusicology and anthropogeography, the Expedition intended a thorough systematic multidisciplinary scientific study of the cultural region (Herle and Rouse 1998:1–3). Haddon was determined to have the best team of scientists he could muster, representing a range of scientific skills. In addition to Haddon, the team comprised three medical doctors, McDougall, Seligmann and Myers. A fourth medical man, a late addition to the team, was W. H. R. Rivers, who was at the forefront of the emerging discipline of experimental psychology.[4] The team was completed by Sidney Ray, a schoolmaster and expert on Melanesian languages, and Anthony Wilkin, a young Cambridge graduate who joined the Expedition, responsible for the photography and certain aspects of material culture study.[5]

As I have explored elsewhere, visualisation was a central concern of the Torres Strait Expedition, both in their work in the islands of the Strait itself and in the Gulf of Papua, where some Expedition members, including Haddon and Wilkin, spent two months in order to collect comparative data for their regional survey. The visual recurs constantly in the methods they employed and in the foci of their study (Edwards 1998, 2000): Rivers's psychological testing, the study of material culture

and its contexts and the visualisation of the mytho-historic past through landscape constitute a focus that we might now describe as visual culture. What concerns me here is the method by which salvage ethnographic observation was constructed and made permanent through the mediation of photography, a method in which re-enactment could be embraced within contemporary constructs of the objective recording of culture.

One of the major methodological aims of the Expedition was to reconstruct (replicate) the conditions of natural science laboratory research in the anthropological field situation. The experimentation with photographic inscription and laboratory conditions attempted on Torres Strait should be seen in the context of new forms of experimental production of evidence or data and demonstration in laboratory sciences at this period. In late-nineteenth-century laboratory practices (several of which were linked to museum-based sciences such as natural history and physiology), natural phenomena selected as significant were reproduced – effectively re-enacted – in the laboratory in order to isolate and then study specific characteristics of the phenomena so imitated in controlled conditions (Galison and Assmus 1989; Schaffer 1994). For instance, the contribution of the cloud chamber (the re-enactment of atmospheric conditions) and photography (the making visible) in early particle physics in Cambridge was being worked on at precisely the same time as Torres Strait Expedition were publishing their first results (Chaloner 1997).[6] Laboratory practices transformed (indeed still do) 'invisible or unanalysed specimens into visually examined, coded, measured, graphically analyzed and publicly presentable data' (Lynch 1988:204). Cambridge natural scientists were protagonists in these developments. Haddon's teacher, Michael Foster, was developing laboratory teaching in natural sciences,[7] and both Haddon and Rivers would both have been keenly aware of these changing methods in producing evidence and the status of the data. The working through of visual ideas and the relationship between the mimetic devices of drawing and photography (and later film) in the inscription of the mimesis and citation of re-enactment should be positioned within this shifting paradigm and the status of mimetic conditions of experiment in the period (Galison and Assmus 1989; Schaffer 1994:20). Given that Haddon was trained within the culture of the natural sciences, it is not unreasonable to see the visual thinking and planning of the Expedition as akin to a repetition of experiment through photography: a replicability based on the relationship between the photograph and its referent, to verify the results of scientific observation. This, as

suggested in Chapter 3, carried a moral dimension in the production and transmission of evidence.

The systematic scientific laboratory nature of the Expedition was stressed by the 'cutting edge' technology assembled (Gathercole 1977). This technological configuration, with all the values it implied, was developed, like laboratory material culture, to be transparent. There was, for instance, the latest equipment in psychological testing, with which Rivers hoped to replicate laboratory conditions in the field. Much of it was for testing visual acuity, visualising capacities and performance, colour recognition and differentiation. However, the mimetic tools of inscription were numerous. They included the Newman and Guardia cinematograph, several cameras for still photography, including a Newman and Guardia Series B, the colour photographic process developed by Ives and Joly and two phonographs with both recording and playback facility for sound recording. Given that the proven integrity of the material technology of experimentation was vital to the perceived integrity of the knowledge the apparatus helped to produce (Shapin and Schaffer 1985:30), it is significant that the photographic equipment, from the cinematograph to chemicals and dishes, was from Newman and Guardia, a prestigious London firm, renowned for high-quality apparatus. The choice of Newman and Guardia's highly flexible and sophisticated Series B camera as the main piece of photographic apparatus is particularly significant, stressing the importance the Expedition placed on the production of visual evidence. In all the Expedition produced about 300 photographs from the Torres Strait and another 300 from their comparative area survey of British New Guinea.[8] Wilkin was responsible for the photography, but, although he technically took many of the images, Haddon had directorial control. The technical stress on visuality and visualising clearly articulates the core intellectual objectives. One can argue that a multilayered and multifaceted concern with the visual was intended as integral to the presentation, proof and transmission of evidence in the validation of the Expedition's findings. Many of these images are concerned with ritual and sacred sites, a photographic selectivity that reflects Haddon's interest in totemism and religious belief as the cohering elements of social organisation in his perception of pre-contact Torres Strait culture.

Like photography, re-enactment can also be related to other scientific practices of the Expedition, especially that of making models and replicas. As Herle has argued, replicas, such as making masks and models, were produced as part of the salvage agendas of the Expedition. If photographs restored past actions, the models and replicas restored

past objects. Such procedures played an important part in some of the sciences with which Haddon was familiar, for instance anatomy. As Herle rightly argues, distinction must be made between replication as a laboratory activity that validates specific claims and the production of mobile specimens (immutable mobiles) for post-factum analysis (Herle 1998:87–96). However, it would appear that the photographs, especially those of re-enactment, operate over both registers. Statements act as validated, mobile specimens, produced through the scientific integrity of the instrumentation and the indexical nature of photography itself. We are dealing, very literally, with Latour's 'theatre of proof' (1986:6,19).

As suggested, re-enactment and photography are strongly linked to salvage ethnography. They were clearly perceived as such by Haddon, and salvage ethnography was the rationale given by him for the use of photography in his contributions to both the 3rd (1899) and 4th (1912) editions of *Notes and Queries*. There was also a sense of moral urgency, in that the failure of the salvage project would reflect badly in the future. In the introduction to *The Study of Man* Haddon wrote 'Now is the time to record . . . The most interesting materials of study are becoming lost to us, not only by their disappearance, but by the apathy if those who should delight in recording them before they become lost to sight and memory' (1898:xxiii). Paradoxically, it is in re-enactment in the registers of the rational tradition of demonstration in the physical and biological sciences that the mytho-poetics of the past emerge. Re-enactment is figured equally by scientific objectivities and the subjective imagination through which attention is focused in a series of 'dramatised inscriptions' (Latour 1986:19; Daston and Galison 1992:82). Here moral urgency translated into intensity of scientific endeavour and subjective desire, where a sense of the loss of the whole is manifest in a romantic yearning.[9] In this register the reality effect of photography fulfils both the desire to represent and to make whole. Yet it was also an anthropology that stressed certain forms of empirical description, generating, as Gruber has argued, 'a kind of intellectual myopia' (1970:1296).

There is, of course, a strong element of objectification within the idea of both salvage and re-enactment, and as such it becomes a politics of reproduction. Objectification, in terms of representation, places the salvage of people and the salvage of objects on a visual continuum of focused vision and scientific gaze. Through photography, a perceived cultural essence, an authenticity, was reified. More broadly, objectification reproduced the distanced, visually privileged mode of separating observing subject from observed object, and in this case, the desired,

constructed object. Such methods were used to produce a huge range
of isolated photographic statements, seen as inherently valuable
through their indexical nature. It was this view that made photography
the salvage tool *par excellence*. As Fabian has argued, the ideological
effects of visualism form part of that discourse of atemporality that
embraced an objectivity, premised on cultural and temporal distance,
and an objectification that denied coevalness (1983:121–2). The
citational nature of re-enactment makes it inevitably of the past. Through
it the temporal space in which Haddon placed Torres Strait culture was
distant and past, a collapse into a dichotomous time of then (authentic)
and now. At the same time, the restoration of the lifelike, such as the
death of Kwoiam, is itself postulated as a response to a sense of loss. It
is to this I now wish to turn in detail, for it is in the images made by
the Expedition concerned with Kwoiam, especially that of his death,
that the method of re-enactment is both exemplified and played out
to full rhetorical and revelatory effect.[10]

The Death of Kwoiam

Haddon had become interested in the stories of Kwoiam during his
first visit to Torres Strait in 1888. At the end of this trip, Haddon made,
in his words 'a final pilgrimage' to the places associated with Kwoiam
at Mabuiag in the western Torres Strait.[11] Kwoiam was the totemic hero,
whose mythic cult, centred on the island of Pulu, was central to all
western Torres Strait initiation and death ceremonies. There are strong
spatial elements. The landscape was mapped and marked through
Kwoiam's social interaction with it and its contact with Kwoiam's body
and those of his victims. His footprint is in the rock, double rows of
boulders are the heads of his victims, a stream that never dries is the
place where he thrust his spear into the rock; elsewhere the grooves in
a rock where he straightened his javelins, the grassy plans studded with
pandanus where he had his gardens, his house and his water hole.
Wilkin and Haddon mapped this sacred topography photographically.
But most revealing is the photograph that visualises the mythical
moment that defined topographical and social space in western Torres
Strait – the death of Kwoiam itself (Figure 7.1).

 The stories tell of Kwoiam's exploits, which involved much slaughter,
including the death of his own mother Kwinam, and associated head-
hunting. However, eventually Kwoiam was ambushed by his enemies,
the men from Moa. He retreated to the summit of a hill, where, crouched
on the ground, he died. Haddon writes with interesting rhetorical

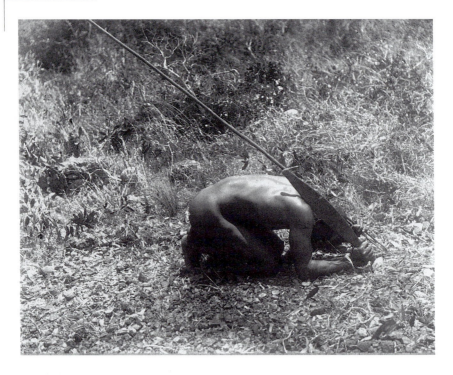

Figure 7.1 Re-enacting the death of Kwoiam, 21 September 1898. Gelatin silver print. Photographer: A. C. Haddon/A. Wilkin. (Courtesy of Cambridge University Museum of Archaeology and Anthropology T.Str.66.)

slippage: 'The bushes on the side of Kwoiam's hill have most of their leaves blotched with red, and not a few are entirely of a bright red colour. This is due to the blood that spurted from Kwoiam's neck when it was cut at his death; to this day the shrubs witness this outrage on a dead hero' (1901:147).[12] The use of present and indicative language in this description – the leaves *are* bright red – adds to a sense of presence and the reality effect stated by the photograph. Through re-enactment, the physical body is reinserted into mythical space through the realistic re-presentation, itself expressed through the realist agendas of photography. For Haddon writes immediately before the above passage: 'I wanted one of the natives who had accompanied us to put himself in the attitude of the dying Kwoiam, so that I might have a record of the position he assumed, photographed on the actual spot . . .' (1901:146). The photograph was published in the Expedition Reports, where the caption stressed the spatial particularity of the re-enactment 'The

photograph was taken on the exact spot where he [Kwoiam] died' (1901–35, V Pl. IV, fig. 2). There is an extraordinary temporal tangle as the mythic moment from a parallel time, foundational yet present, is stilled through the scientific demands of re-enactment, in the 'real time' of history.

Precisely the same intellectual validity entangled with subjectivities is at work in other, less overtly theatrical re-enactments (Figure 7.2):

> When all is ready the photograph is taken and we sit down, and I get a native to tell me the "storia" connected with it. Which I then write down, as nearly as I can in his own words – or at all events with some phrases verbatim ... It was most interesting to hear these yarns on the spot, told by natives who believed in them.[13]

> We had with us the Mamoose, Enocha, Jimmy Dei, Ulai and Kaige all of whom belonged to the *zogo*.[14] We learnt the names of the stones and

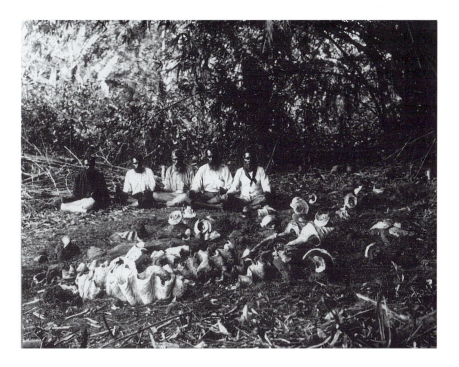

Figure 7.2 Telling 'storia': the men of the *zogo*. Gelatin silver print. Photographer: A. C. Haddon/A. Wilkin. (Courtesy of Cambridge University Museum of Archaeology and Anthropology T.Str.290.)

then at our request the *zogo* men placed themselves in the right position and attitude for consulting the *zogo*, and then they were photographed. It was very suggestive to see the reverent affection the old men had for the *zogo*, and they seemed gratified at the care with which it had been cleaned and mapped (1901:54).

There are other instances of making whole in relation to material culture. Re-enactment or reconstitution working with the precise clarity of scientific inscription vested in photography is stressed repeatedly:

> Occasionally a few stones required to be placed upright, or broken ones put together. The best view for the photograph had to be carefully chosen and further clearing of the foliage was generally necessary; sometimes branches of trees a little way off had to be lopped if they cast distracting shadows. Usually little twigs, leaves or tiny plants had to be removed from the ground or from between the stones and shells so as not to unnecessarily complicate the picture . . . Very rarely did I turn a carved stone so as to bring out its carving more effectively; occasionally I shifted shells a little, so as to make them show up better, but only when these had no definite position. Attentions to small details such as these are necessary to produce intelligible photographs but care must be exercised not to over do it or in anyway to modify the object or shrine' (1901:66).

Similarly when photographing the *Au Kosker zogo* in their cave: 'I replaced the head, but could not do so to the other which I placed by the side of the body – after a lot of trouble we focused the camera and left it for half an hour or so for exposure. We found to our surprise that we had a fairly good negative when it was developed in the evening.'[15] In all these instances Haddon was directing performances. Through the act of making visible and reconstituting 'as if it were' whole, re-enactment moves into the subjunctive mood, 'as if' – which Dening has identified with re-enactment and the theatrical mode of history (Dening 1996:117–18). It is significant that all the sites of re-enactment in Torres Strait, whatever the density, are related to sites of sacred and ritual significance. In this register re-enactment photographs become articulations of Haddon's own desires, assumptions and perceptions, again validated through the reality effects of photographs. Haddon is realising himself in his subjective desires through the process of simulating of historical and mythical worlds (Bruner 1994:408).

However, crucially, while salvage collects the still extant, in re-enactment the no-longer extant or invisible becomes reconstructed and

reinstated, indeed sometimes carrying an element of resurrection. In Lynch's model of methodic practice of re-enactment, the unseeable is transformed into visual representation, first through 'theatre' and then through the photograph. While couched in terms of the disappearing authentic, salvage ethnography opened the space for metaphor, allegory and the possibility of theatre: '[a]n appreciation of the transience of things and the concern to rescue them for eternity is one of the strongest impulses to allegory' (Owens 1992:56). It is perhaps useful in this context to position re-enactment in terms of performance. The argument outlined in Chapter 1 becomes central here. Peacock's definition of performance (1990:208) as a condensed, distilled and concentrated life, an occasion when energies are intensely focused, is useful here. For the photograph, its subject-matter contained and heightened within the frame, assumes a performative quality. Like performance or theatre, photographs focus seeing and attention in a certain way. Performances are set apart; photographs are also apart; being of other times and other places. The Kwoiam photograph is 'good to think with' here because it encapsulates the performative qualities of the photographic frame, which constructs and concentrates the performance in terms of both the containment and the projection of the subject-matter within the frame. Performances, like photographs, embody meaning through signifying properties, and are deliberate, conscious efforts to represent, to say something about something. The ethnographer here becomes, through re-enactment, facilitator, envisioner or director of continuity, active in the performance of culture.

The images related to the death of Kwoiam open a much deeper reading of the agendas of salvage ethnography, not only in Torres Strait, but in terms of the whole notion of re-enactment and historical truth, the fluidity between past and present and its inscriptions. They can, also, be linked to much broader paradigms that embrace anthropology, and that admitted the intellectual possibilities of re-enactment. Many of the photographs produced within this broad frame of intellectual possibility were prompted, like the Torres Strait photographs, by the disappearance of the desired subject.

Re-enactment and Pose

Once identified, a wide range of photographic material in anthropology during this period, and indeed beyond, can be seen to draw its authority, and later its uncertainties, from the constituting paradigms outlined above. This material might equally be interrogated through the concepts

of re-enactment and the merging of scientific validity and subjectivity. I can only point to a few examples here, but they are worth flagging as representative of a highly complex paradigm. Amongst the best known are Franz Boas's reconstructions or re-enactments for the camera of Kwakiutl technologies and cultural activities, to 'show how', such as cedar bark technologies or the *Hamatsa* dancers. Significantly, Boas was originally a physicist by training and, like Haddon and Rivers, stressed the value of scientific training for effective fieldwork with rigorous objectives (Schaffer 1994:28-33; Morris 1994:64). Even if it was not identical to that of the Torres Strait Expedition, he framed his anthropological interrogation in scientific terms and through the values of scientific instrumentation. Such techniques were integral to Boas's methodology of museum anthropology and collecting.[16] However many of his images point to their demonstrational quality. For instance, in a photograph of a Kwakiutl woman spinning,[17] the edges of the background cloth, held up by Boas's Kwakiutl assistant and collaborator, George Hunt, and the picket fence behind are clearly visible, documenting the texting of its own scientific documentation, even if such signs were subsequently edited out. A contemporary parallel with the Torres Strait Expedition's use of re-enactment is that of the Jesup North Pacific Expedition (1897–1902). Like the Torres Strait Expedition, it was a broad survey ethnography of a cultural region, under the direction of Boas, bringing a number of specific disciplinary skills to a salvage ethnography of the hunting and gathering peoples of the Russian tundra and the American north-west Pacific coast. Drawing on Boas's museum methodologies, indigenous peoples were enlisted to dramatise earlier cultures, while, at the same time, there was a deliberate suppression of objects and behaviours perceived as hybrid and inauthentic (Kendall, Mathé and Ross Miller 1997:29–30, 37).[18]

Even Malinowski, within the context of participant observation, used re-enactment to demonstrate past cultural action: for instance, in his photographs of war magic (Young 1998:123). Although posed or re-enacted photographs are relatively inconspicuous in Malinowski's overall photographic corpus, he did not necessarily see them as incompatible with his notion of observation: 'If you know a subject matter well and can control native actors, posed photographs are almost as good as those taken *in flagrante*' (quoted in Young 1998:17). Nevertheless, he is careful to make the distinction, and it becomes a powerful statement of the authority of observation. For instance in the caption of Plate 100 in *Coral Gardens*, 'Bwaideda making garden magic', Malinowski assiduously stresses the immediacy and the unposed nature

of the photograph in question: 'This picture is not posed, it was taken during the actual performance of the *gibuviyaka* rite and shows the concentration of expression of the magician at work . . .' (1935:461–2; Young 1998:17).[19] This concern over direct observation and unmediated inscription is part of the shifting paradigm of authority and authenticity. In other words, doubts had been raised over re-enactment as evidentially valid.

Re-enactment photographs proper are related to, but must be distinguished from, those prompted by the limited technology available for inscribing the desired images. However, this itself had a scientific counterpart, in that experimenters' tactics were obviously dictated by instrumental capacity. These technologically determined demonstrations often took the form of asking people to go through activities in daylight so that they might be photographed. In Central Australia, Spencer and Gillen appear to have had *corroborree* performed in daylight (Spencer and Gillen 1927:xiii). Malinowski's photograph of the corpse of a man decorated with valuables was reconstructed outside the hut in order to photograph it (Young 1998: 213). Jenness had the children of Bwaidoga perform their games for his camera, and games were performed for Malinowski's camera during daylight (Young 1998:197). Some years later Bateson articulated clearly the conceptual distinction between the re-enactment, the posed photograph, and creating 'the context then allowing the action to take its natural course during which notes and photographs were taken'. He argued that the latter, for example paying for the dance or asking a mother to delay the bathing of her child until the sun was high, was very different from posing photographs. It did not intervene in the behaviour itself, merely triggered it. However, unmediated spontaneity was the dominant truth value: 'We tried to shoot what happened normally and spontaneously, rather than decide upon the norms and then get Balinese to go through these behaviours in suitable lighting'(Bateson and Mead 1942:49–50). Not only does this suggest differential notions of 'posed' but that certain forms of intervention had become naturalised within the embodied field relations of the scientific observer.[20]

The documentary validity of re-enactment, originating in scientific practice, was perhaps responsible for the ambiguous scientific identity of some more popular projects. For instance, Edward Sheriff Curtis's great photographic work on Native American cultures relied heavily on reconstruction, re-enactment and construction of a historical past, informed by a sense of nostalgia and salvage desire. Oddly, as these things happen, Haddon landed up in a Blackfoot sweathouse with

Curtis in Montana in 1909 and wrote a memoir, which resonates with the poetics of salvage, of the occasion and their experiences with Blackfoot people.[21] Curtis's film *In the Land of the Headhunters* (1914) also employed detailed re-enactments, as did Robert Flaherty's film of Inuit life, *Nanook of the North* (1922). Both operated a form of ethnographic allegory through the narrative treatment of their subject, which consisted of the interventionist use of native peoples as actors in directed sequences of detailed reconstructions of cultures.[22]

This is not to argue that such re-enactments were seen as 'real' in naive terms, nor that they all necessarily carried the same truth value. Neither were all performative events of re enactment alike; they vary from those produced by the actors to those that the ethnographer seeks and instigates. Although naturalised and given equivalence by photography, as argued by Bruner (1994) in relation to authenticity, each should be seen as within the shifting matrix of the historically specific, historically determined and historically entangled. Nevertheless, as I have argued, the intellectual pre-conditions for expressions of culture allowed for the demonstrational validity of re-enactment, and, through photography, the subjunctive 'as if it were' moving into the active voice, the present. Re-enactment fulfilled both scientific demands and a judgement of the credible and convincing within certain cultural parameters. This is surely the affective key to the relations between salvage and photography.

Counter-narratives

However, there are hints of another perspective on re-enactment; that of the people of Torres Strait, which cuts through both the scientific and allegorical practices discussed so far. Further, it is one that cannot be reduced to the mimetic faculties of alterity used in encounter in the way argued by Taussig (1993). It would be a mistake, certainly in the case of Torres Strait, to characterise the re-enactors or actors necessarily as demoralised or passive objects, coerced by implicit colonial authority, into performing for the camera. This is not to say that the action did not resonate with the colonial, but rather that the relations were more ambiguous, complex and nuanced. Agency, as I argued in relation to Acland's photographs of Samoans, is premised on the idea that the actors could have acted differently. Here re-enactment becomes instead a site of negotiated ethnography, imprinted with the various subjectivities of all the parties – performers, directors and audience. In this register, re-enactment forms part of the 'indigenous countersigns in

colonial texts, the oblique stamp of indigenous actions, desires and agency on imperial imaginings' (Douglas 1999a:68). What emerges is the potential for recognising different levels of ethnographic inscription, ethnographic authority and directorship in operation in the late-nineteenth-century anthropological record, both visual and textual. It is paradoxical that points of fracture become more apparent through re-enactment, which, to late twentieth- and early twenty-first-century eyes, is the most interventionist form of anthropological inscription.

Re-enactment and performance are powerful social tools in many cultures, and mimesis is deeply embedded in the cognitive processes of the preservation of cultural elements and forms the basis of the incorporation of collective experience.[23] Commemorative re-enactments of myth were, as in many other places, central to Torres Strait belief systems. Rituals such as the Malu Bomai dances likewise translate mythic time parallel to the present through performance, a performance that, like photography, constantly cited the past. The re-enactments constituted a conscious expression of elements that had been suppressed by the Missions in the last quarter of the nineteenth century. Further, re-enactment or citational performance was an expression of the past familiar to the men of Torres Strait. It released the subjectivities of the Islanders' own histories, for the act of telling stories in an oral history tradition is an act of performative restatement – verbal re-enactment.

Indeed resonating through this, as through so many photographs, is a sense of orality.[24] Photographs are, as many commentators have argued, enmeshed in language (for example Poignant 1996a, Binney and Chaplin 1991; Niessen 1991). One gets a strong sense of the Torres Strait re-enactment photographs, and perhaps Boas's photographs, as emerging from storytelling. Haddon, like Boas, stressed the importance of oral 'texts', and the reports of the Expedition are full of the voices of named islanders. It was Papi, Ailumai, Nomoa, the former chief, and Waria, the chief in 1898, who told Haddon the story of the death of Kwoiam (Haddon 1901–35, V:67).[25] Haddon also links orality and photography in the *zogo* photographs 'When all is ready the photograph is taken and we sit down, and I get a native to tell me the "storia" . . .'[26] and throughout both portraits and storytellers are named, stressing the strong links between oral and visual. It is part of the process through which fragments and 'storia' are translated into 'history', again merging the imaginative and the evidential (see Ginzburg 1991). A sketch of the death of Kwoiam, which survives as a loose sheet from Haddon's field notes,[27] is almost identical to the photograph (Figure 7.3). Was it the result of a storytelling, a translation that is finally fixed through

Figure 7.3 Sketched in storytelling? The death of Kwoiam. Ink drawing in Haddon's notebook (Courtesy of Cambridge University Museum of Archaeology and Anthropology, Haddon Papers Env. 1053.)

photography? Whatever the status of this particular document, the relationship between orality and photography reaches beyond the frame, through the theatricality, gesture and performance of story-telling. Listening attentively to what Islanders had to say was one of the hallmarks of the Torres Strait Expedition, even if they got some of it wrong. Indeed, it is the Expedition's strong base in orality and who was speaking that has made their records so valued as a resource and a tool in cultural renewal for the people of the Torres Straits today (see Sharp 1999:543; Beckett 1998).

Conversely, the subjective experiences of power relations inherent in the production of re enactments are also brought to the surface in the death of Kwoiam. Haddon's request for the re-enactment brings the asymmetry into focus. He records that the actor needed a great deal of persuasion to remove his clothes and adopt the pose of the dying Kwoiam. There are a number of readings of this event, which are not mutually exclusive. Haddon attributes it to a somewhat unreasonable coyness (1901:146) – Islander values concerning naked-ness were both particular and strong; however, one can conjecture that this was not the only reason. It is perhaps significant that whereas Haddon names all the men taking part in the various re-enactments and demonstrations in Torres Strait, the actor here remains anonymous and unidentifiable, his face hidden.[28] Possibly from Haddon's perspect-ive the naming of the actor was unnecessary: it was not part of the discourse of authority and authenticity in this particular instance, because the actor *was* Kwoiam, whereas the authenticity of the *zogo* re-enactments was premised precisely on the identities of the actors and by implication their genealogies. Further, maybe the actor did not want to be identified – perhaps he himself had no right, in terms of Torres Strait religious organisation, to be identified with Kwoiam. Given the power of the Kwoiam story and the importance of the divisions of knowledge in western Torres Strait society, one can fully appreciate the actor's concern over multiple transgressions. Yet Haddon was able to persuade him. This throws us back on explanations grounded in the asymmetries of colonial power relations, recalling Bruner's suggest-ion that the authority to authenticate is a matter of power.

Although the death of Kwoiam itself is perhaps a more problematic working out of cross-cultural relationships because of its complex subject-matter and the meanings attributed to it, in broader terms it is clear that Torres Strait Islanders were active in, and to an extent authorial of, the re-enactments, inserting themselves into the ethno-graphy through the version of culture given to the ethnographer. For

instance, Pasi and other men from Mer in eastern Torres Strait initiated re-enactments such as the dog and pigeon dances at Las or the death dances, which were extensively photographed by Haddon, Wilkin and Myers, as they were in the filmed Malu Bomai. As Herle has argued, these re-enactments were not simply 'a desperate attempt to salvage ethnography but a shifting, a repositioning, which places the emphasis on performance and experience'. Haddon's description of the event as a 'fantasy in red and green lit up by spots of sunshine' points to the poetics of the situation (Herle 1998:92). It is clear that men from Mer were active and enthusiastic participants. One wonders what role re-enactment, with its insistent focus on the past, might have played in the 'unrest' reported by the Queensland Home Secretary's Department in 1899, despite the limited number of actors.[29] The excitement around these other re-enactments throws the unease over the death of Kwoiam into sharp focus. There was great excitement about making the replica cardboard masks for Haddon, and the men involved, Wano and Enocha, were extremely pleased with their productions. They were shown secretly to senior men, in whom they evoked an emotional response;[30] indeed, there was alarm when Haddon indiscreetly showed the masks to the women.[31] Thus, while Haddon may have been a catalyst, initiating the action through his requests and having broad directorial control, the specific 'evidence' to be inscribed was dictated by the Islanders, who 'performed' social actions and myths on their terms.[32] Schechner has described this directorial role of the fieldworker as theatrical in itself: 'He exists in a liminal state, a situation in transition. He is not the performer and certainly is not a spectator. He's in the middle ... between two spheres of actuality' (Schechner 1981:43). Although Haddon perceived re-enactment and photography as within the boundaries of scientific investigation, his situation thus remains ambivalent.

These acts of re-enactment and reconstruction would appear, through their links with both the subjectivities and allegorical elements of salvage ethnography and with the agency of Torres Strait men, to reinvest past social actions with meaning through the subjective and sensory embodiment of re-enactment. This position is echoed by Haddon's visualising comments at the beginning of the first volume (actually published last) of the Expedition reports: 'Since 1888 I have constantly tried to recover the past life of the islanders, not merely in order to give a picture of their former condition of existence and their social and religious activities but also to serve as a basis for an appreciation of the changes that have since taken place' (Haddon 1901–35, I:

xiv). The interplay of re-enactment and photographic reality is suggestive of deep ethnographic layers in the Expedition's work, those relations between science, allegory and imagination in the creation of an authenticity, both in subjective and scientific terms. As Dening (1996) has suggested, it is in the theatre of history that we 'get the plot', see the meaning of things. The original meaning of *fictiones* – fictions – is 'something fashioned' as an imaginative act; however, they are not necessarily false, unfactual or merely 'as if' experiments, but different routes to expressing historical realities (Geertz 1973:15; Ginzburg 1991:87–8). Performance blurs the distinction between appearance and fact, surface and depth, illusion and substance (Schechner 1981). Through the projection, heightening and concentration, the scientific and the poetic come together; through its mutability the photographic image is able to perform in two registers.

Conclusion

The death of Kwoiam pushes beyond the salvage ethnography of the still extant. As I have suggested, it moves into the subjunctive mood 'as if' – 'as if it were so', which Dening has identified with both re-enactment and the theatrical mode of history (1996). Especially pertinent here is de Certeau's suggestion of the 'as if' as the belief in the intelligibility of the things that resist it most, such as myth perhaps. Through it, scientific models are reconnected with what is missing from them, the subjective discourses that inform them, moving inscriptive and interpretative possibilities into another realm (1980:219). In re-enactment the no-longer extant or invisible becomes reconstructed and reinstated, even with an element of resurrection. Meanwhile, the disjunctures of photography and its reality effect give the *appearance* of the extant: mytho-poetic history becomes real, visible, tangible. Yet at the same time it blurs the distinction between history and poetry, and thus the nature of evidence, the study of events that actually occurred, as distinguished from the imagining of events that might have occurred. Further, re-enactment is itself theatrical not only in terms of replication: it is a *heightening* of reality through the bounded intensity of the photographic moment, both as action and image. The cultural expectation of photographic veracity, the tensions between temporal and spatial ambiguities and the mimetic certainties of photography, naturalise the theatrical qualities of re-enactment in the creation of reality effects. The photograph here confronts the Platonic idealism that mistrusts re-presentations of reality and thus performance. To me

this is an extraordinary image, if we think through the content in terms of the ontological rhetorics of the medium. It encapsulates the relationships between photography, the social agency of scientific inscription, performance and history and the claim that 'it is in the theatre that we know the truth', for here we are persuaded of the actuality and reality of Kwoiam. This is why the Kwoiam photograph is so useful to think with. It is doubly mimetic through re-enactment and photography, and on the cusp of intersecting histories.

If this exploration of re-enactment and photography has lurched between science and theatre, this is intentional, for there is no certain way to separate the scientific from the allegorical in such photographs. Stafford's argument seems to summarise the issues: 'Making art is like conducting an experiment in so far as each yielded artificial phenomena . . . situations are contrived to force culturally invisible behaviour and unseen events to manifest themselves. Cogent pictorial exemplification then could claim to be "historically [or culturally/ anthropologically] accurate"' (1994:293). As has been argued, shifting truth values away from laboratory science towards embodied observation in anthropological field situations also shifts the boundaries of methodological and evidential acceptability and its associated scientific morality. Whereas re-enactment, within the laboratory paradigm of controlled demonstration of isolated phenomena, was in accord with accepted norms of scientific morality, within the new paradigms of unmediated field observation such intervention failed the test of scientific morality in the production of evidence. I hope to have suggested the way in which re-enactment has an ambiguous identity: while its intellectual rationale emerged from the techniques of laboratory science and the desire for the controlled and objective, it was also capable of articulating the opposite, the articulation of subjective desires and the site of intersecting histories: 'Pasts are both past *and* present: They are gone, knowable only as histories, through their variously "texted" debris, written, visual, spoken, remembered; but histories are always present acts of conception and representation.' All these strands of complex history, identified by Douglas (1999a:65,73), meet in the photograph of the death of Kwoiam. Thus this also constitutes a scientific document as a revelatory object, the nexus of scientific intent, the nature of evidence and the structure of feeling and romantic compulsion inherent in the salvage paradigm. The photograph, through its mutability and its 'performative' capacities 'fulfils contemporary expectations of . . . informational value, not because they were objective or mimetically true but because [of] their particularity and capacity to condense complex sensations . . .'.

Notes

1. Here I am following the model outlined by Lynch (1988: 203).

2. A notable exception is Griffiths (1996/7).

3. However, the position was not clear-cut. Within documentary film the idea of sincere and justifiable reconstruction of events that had taken place, or that were normal practice, was distinguished from the reconstruction of events that had never taken place. While the latter was unacceptable, the former was acceptable, as was the reconstruction of events that *could* have taken place (Winston 1995:120–3).

4. Rivers was perhaps the most important member of the Expedition in terms of his future achievements as a scientist and the intellectual energy he both brought to the Expedition and gained from his experience in Torres Strait. See Slobodin (1978); Langham (1981). Recently Rivers has been made famous more widely through Pat Barker's *Ghost Road* trilogy and the subsequent film *Regeneration*.

5. For a detailed account of the recruitment of the Expedition members see Stocking (1995:98–126); Quiggen (1942:95–9). The Expedition's own monument are the six volumes of Expedition reports 1901–1935. For a detailed assessment of the achievement of the Torres Strait Expedition and its place in British anthropology see Urry (1993:61–82). See also Rouse (1998:56–7).

6. One could also extend this photographically: for instance, the scientific isolation of movement in front of the verifying camera in the work of Marey and Muybridge in the 1870s, 1880s and 1890s.

7. With Huxley, Foster transformed the teaching of the biological sciences in the 1870s with his insistence on practical work.

8. Now in the collections of the Cambridge University Museum of Archaeology and Anthropology.

9. I have discussed the relationship between romantic salvage ethnography and photographic intensity elsewhere (Edwards 1998, 2000). See also Tobing Rony (1996: Chapter 4).

10. As my concern is with Haddon's interpretation of the event, I am retaining Haddon's spelling 'Kwoiam', rather than the current 'Kuiam'.

11. CUL. HP Journal 1888–89:67.

12. For a full account of the Kwoiam story and his death see Haddon (1901–35, V:67–83)

13. CUL. HP Diary 1898:190.

14. *Zogo* is a sacred site that may take several forms, possessing, for instance, special powers, an oracle or a potent object.

15. CUL.HP Box 10/1030 Diary 1898:85.

16. For a discussion of Boas's photography see Jacknis (1984:14, 50–1). Boas was re-enacting culture for film as late as the 1930s: see Morris (1994:63–4).

17. Taken for Boas by Oregon C. Hastings at Fort Rupert, 1894.

18. For instance, the Sakha *ys akh* festival was held out of season in order to accommodate the schedule of Jochelson, the Russian ethnographer working in Kamchatka with the Jesup Expedition.

19. Malinowski also made a series of six re-enactments of the sex act, which he describes in detail in *The Sexual Life of Savages*. Understandably, these were never published; and given that the actors were young boys, they were open to misinterpretation. See Young (1998: 21–2).

20. Significantly a recent commentator has homogenised and glossed these nuances of intervention as 'staged' (Sullivan 1999:30).

21. An uncertain Haddon wrote to Clark Wissler 'Who is Mr. E. S. Curtis? . . . He has offered to take me on some Expedtn. & I don't know who the devil he is and what the devil he is doing.' Quoted in Gidley (1982).

22. For a discussion of *Nanook* see Tobing Rony (1996:99–115); also Ruby 1979.

23. In this connection, Poignant (1996b) has analysed an interesting series of photographs (produced as postcards) of the re-enactment of a historical event, the Fort Dundas Riot of 1824, made by Ryko (Edward Reichenbach) in about 1916. The story of the riot was itself re-enacted in Tiwi dance, establishing chains of connection between the postcards and Tiwi readings of the story, both transmitted through intersecting re-enactments.

24. I thank my colleague Laura Peers for raising this issue and for her subsequent stimulating discussion.

25. For a modern telling of the story see Mosby (1998: 22–3).

26. CUL. HP Diary 1898:90.

27. CUL. HP Env.1053.

28. I am grateful to Jude Philp for drawing my attention to this and for her discussion of the issues it raises.

29. CUL.HP. Envelope 1022.

30. For an extended analysis of the making of the cardboard masks and their effects see Herle (1998:90–5).

31. Although photographs were part of the Expedition's reciprocal relationships with Island people (see Edwards 1998:121–5) there is no evidence that the Kwoiam photograph or any of those of the related sacred sites were shown locally. Although lantern slides exist, it would appear that these were made later for 'scientific' use.

32. For instance they never told Haddon the meaning of the sacred Bomai. Sharp reports (1999:542–3) that senior people from Mer today believe that their great-grandparents were preserving important parts of their culture in the only ways available to them at the time.

Part IIII

Reworkings

eighte i g h t

Rethinking Photography in the Ethnographic Museum

Museums and Genre

Much has been written on photography and anthropology, on art curatorship and ethnographic curatorship and the politics and poetics of their productions in terms of the Western museum's representation of post-colonial and minority cultures. However, few have addressed the nexus of these various practices or, more specifically, the role of photography in contemporary museum practice beyond the fine art canon or wide sweeps on 'representation'. This has become especially urgent as post-colonial nations and communities attempt to define and redefine their identities within broader cultural discourse. In this chapter I explore how shifts in assumptions about the role of photography, especially in ethnographic museums, can function as an interpretative strategy or as a site of translation within the public space of the museum. The photograph's transparency and analogical insistence, through which it has almost unnoticed contributed to the dominant discourses, makes it an especially pertinent constituent part of both reflexive critiques and alternative strategies. I am starting from the premise that if statements of authority are now problematic in anthropological writing and museum displays, then the authority of photography as a realist didactic tool *par excellence* must be similarly brought into question. The ambiguities that characterise photographs are in tune, not only with the uncertain identity of anthropology, but also with that of museum practice. Consequently, one can perhaps consider alternative strategies that have their basis in the nexus of photographic theory, visual anthropology and museum discourse and practice,[1] and explore how photography might function as a critical voice within the space of the ethnographic museum, blurring and transgressing the traditional boundaries in which photographs are active players.

183

The concepts of oral history, outlined in Chapter 1, become pertinent here. I want to frame my ideas in terms of genre, expectancy and performance, because departing from the didactic transparency of photographs in the museum context implies orchestrating different expectations about the visual translation of culture in museum display. I shall also consider photographs in the ethnographic space in terms of 'performativity', their agency in shifting the shape of discourse within institutions. While genre, in photography, is often used in the sense of formalist categories and approaches to subject-matter, it is more usefully conceptualised here as a social contract for expressing appropriate forms for different kinds of statement. These invite certain shapes of expectation. 'In every act of looking there is an expectation of meaning . . . Prior to any explanation an expectation of what appearances themselves may be about to reveal' (Berger and Mohr 1989:117). To express it in terms of oral history, 'the social context of delivery . . . may be definitive not the content' (Tonkin 1992:8–9). Genre here constitutes different 'plot types' that are themselves interpretations. A number of writers have characterised genres as meeting places, intermediaries that can help interrogate relations between, for instance, poetics, history, ethnography, and museum discourse (Todorov 1990:20; Baxter and Farndon 1991: 3–4). What happens to facts and 'narratives' when they are interpreted in the exhibitionary space through different genres? While we may concentrate on genres of photographs, these do not exist independently, but are linked to other genres. Museums themselves have their own genre. Museums of ethnography (and indeed social and cultural history) have used functional realist images as a 'window on the world', without problematising either photographic agendas themselves, the way in which photography operates as an institutional practice within museums, or the nature of photography itself (Porter 1989; Borne 1998). Yet the nature of photographs threatens disruption of the museological discourse at many points. The fragmenting and heightening nature of the medium, the temporal and spatial ambiguities, the semiotic undecidability and almost infinite recodability, destabilises images at the very moment when their meaning must be contained in response to the dominant demands of objects.

As I have suggested, the expectancy of photographic performance in ethnography museums and exhibitions has long been grounded in the tacit collaboration between curators and audience to maintain an expectancy, informed by transparent realism, applied uncritically to illustrate and explain in ways that confirm the status quo of cultural visioning, rather than challenging it. The certainty of the referent and

the transparency of the medium is reflected in the way labels for photo-graphs use a classic indexical style – 'A Batak House', 'Market Day' – rather than 'Photograph of a Batak House' and so on. While rationally there are few curators and few audiences too that would hold such a naive view of photographs – after all they decode advertising for what it is every day of their lives – nonetheless, in the museum space, the 'invisible role' of photographs in relation to object-led narratives has tended towards a privileging of certain photographic styles or genres that are deemed to be unproblematic routes into the agendas of exhibitions. Such a position persists in many curators' minds, and certainly in those of museum visitors, despite the fact that the political and ethical issues of representation, which have dominated the debate on ethnographic museums over the last couple of decades, have made such a position untenable.

Despite the tidal wave of deconstructionist and post-structuralist critique that has engulfed anthropology and the debate over the politics of representation (see, for example, Vergo 1989; Bennett 1995; Coombes 1994; Simpson 1996; Bal 1996; Clifford 1997, museum curators are caught between theory and pragmatics – the pressures for exhibitions to be merely 'informative', not 'formative' (Shelton 1990:89) on the one hand, and the nature of photography and assumptions about its cultural function on the other. However, as Ames has argued (1992:139), museum-based anthropologists are well placed to play an active role in anthropological reconstruction, with immediate and practical solutions on issues of epistemology and representation that have resonated through the rest of the anthropological discipline, and to use anthropological thinking to script more discursive narratives (Bouquet 2000). This position is well accepted within museums in relation to policies on consultation, accountability, multivocality, access and so forth, and sophisticated forms of reflexivity permeate exhibitions at all levels. In this the signifying properties of photographs in museum contexts in exhibitions are fully recognised (Lidchi 1997b). Yet in many ways photography seems to have been remarkably untouched, beyond debates of 'positive' and 'negative' imaging, despite the centrality of visual anthropology in debates on representation. Further, in photo-graphic terms, while the tropes have been recognised, little has been done to displace them or to explore other ways of using photographs. Even where stereotypes are 'challenged', the use of photographs has worked within a consensus of didactic certainty. However, I would suggest rather, that instead of attempting a ready recognition of photographs as 'positive' or 'negative', it is necessary to engage with

their effectivity (Bhabha 1994:67), in an attempt to make visible the photographic assumptions naturalised within the epistemological base of museum practice.

Lidchi (1997a:15) has rightly argued that curators are fully aware of the limits and discourses that institutions impose upon them and that they seek to work creatively within them, a point to which I shall return. Nevertheless, the didactic functions of photographs, at whatever level, are integral to the construction of the political economy of meaning. They directly fix meaning to be constructed and maintained (Greenberg 1996:2; Porter 1989), explaining and re-presenting it to visitors whose expectation is the creation of cognitive distance for the absorption of objective information (Riegel 1996:87). Further, the use of photographs 'contextually' is also part of an institutional statement of intention. Their presence signals the statement of a 'cultural' message rather than formal, aesthetic messages about objects where 'contextualising' photographs are excluded or kept to the minimum (Clifford 1997:159).[2] In the ethnographic museum, in which one should include their refigured post-colonial successors, galleries of world culture and world art, the photograph as cultural statement is paramount. Photographs are used in a didactic way, to show how this or that 'works', 'is used', 'made', they are seen as providing context, they explain, authenticate and, on occasion, substitute for the real object. Alternatively, they are used as establishing mechanisms, to create the total environment in the re-presentation of a people or place, establishing a social reality, denoting the environment, and the 'look' of a place – for instance, the large photographs of landscape that were placed behind many of the 'functional' sections of the *Maori* exhibition at the British Museum in 1998.[3] Thus photographs extend the object[s], rectifying 'the poetics of detachment', the very process that constitutes the collected museum object in the first place (Kirshenblatt-Gimblett 1991: 338). Paradoxically, meanwhile, they replicate and naturalise detachment through the fragmenting nature of photography.

In relation to objects, Kirshenblatt-Gimblett has distinguished *in situ* and *in context* exhibition strategies. *In situ* entails metonymy and mimesis, recreating environments for objects in a relentlessly realist, or positivist discourse. Photographic murals in exhibitions, such as that at the *Maori* exhibition, function in this way, expanding the boundaries of objects by including more of what was left behind. Such strategies are not, of course, neutral; however, I would argue that the expectation of the function of photographs within such a performance naturalises, and indeed neutralises, the construction of *in situ* approaches and is

integral to their didactic strategies. An *in context* exhibition strategy, on the other hand, is more clearly interpretative. I have already suggested in Chapter 5, in relation to Acland's Samoa photographs, the construct-edness of the idea of context. In a museum environment *in context* approaches 'exert strong cognitive control over objects' and suggest the constructedness of knowledge (Kirshenblatt-Gimblett 1991:389–91).[4] However, the transparency of the generic functions of photographs within the exhibition space blurs the distinction between *in situ* and *in context* strategies. This is seen in Clifford's analysis of the photographs in the *Paradise* exhibition at the Museum of Mankind in 1993. Here the performance of the photographs challenges the distinction between object and context, where photographs are used to 'collect' and 'display' objects that become more real and explicable only in relation to the photographs (1997:160). Has the object become the photograph or the photograph the object?

There is certainly a place for such explanatory strategies – it would be churlish to suggest otherwise, for this is why photographs exist in the first place. Nonetheless, there has been an over-emphasis on the indexical – Barthes's 'having-been-there' – which has had considerable responsibility for generating the myth of photographic truth (Brothers 1997:5). This results in a levelling of images, a homogenising of function based on the acceptance of the realist transparency of photo-graphy: photograph as instant gratification and total explanation at the nexus of vision, perception and knowledge (Porter 1989:23–4). These constitute the economy of truth in which photographs operate – as Tagg asks, under what circumstances would a photograph of the Loch Ness monster be 'truthful' (1988:5)? One is tempted to respond 'in a didactic display in the Natural History Museum'. This nexus of genre, expectancy and performance is used within the exhibition context to generate a preferred reading of the exhibition or specific objects within it (Lidchi 1997b). For instance, in the exhibition *The Maldive Islands: Thriving on a Reef* at the British Museum (Museum of Mankind) in 1994, small photographs, on exhibition panels, established the reading of objects as fine craftwork through a concentration on the makers' hands and the use of objects (Lidchi 1997a:21). This narrative itself was determined by the limited range of Maldive material culture held in the Museum's collections. Lidchi describes a finely nuanced process of selection of images that shifted the preferred reading of the exhibition and set the affective tone. However, the fact remains that the photographs still constituted a form of authoritative statement, which demanded to be read in realistic modes.

These traditional functions of photographs suppress both the nature of the medium in theoretical terms, and the historical specifics and asymmetrical relational dynamics of their making. This is especially so of historical images, where traditional uses of photographs have also elided the historical specifics of images in their various performances. For instance, in the South Asian gallery of the Tropenmuseum in Amsterdam photographs are used extensively and uncaptioned to give a 'feel' of period and place to the displays of objects, without any recognition of the photographs' own historicity. Yet they are active in setting the interpretative environment of the objects, for the object-dominated discourses of the museum require an order that elevates object and subjugates photograph to the extent that the latter can be lifted promiscuously to make an object 'mean' in contexts delineated by the object, not the photograph (Porter 1989:24). The increasing number of photographic exhibitions in ethnographic museum (as opposed to the direct placement of photographs with objects) are often merely extensions of object-based discourses of realism in making factual 'window on the world' statements. Such exhibitions effectively extend the rhetoric of substitution that I discussed in Chapter 3. They form part of the museum discourse based in a natural-realist model of ethnographic construction of Western logical frames of making connections between objects (Shelton 1990:99). This naturalises the meanings it makes and presents a holistic vision of culture. While at an informational level such exhibitions are perfectly legitimate, in that it is possible to give access to historically and ethnographically important material under those terms, this happens only at the cost of eliding the representational base.

There are, of course, important exceptions to my argument. There may be very strategically different uses of photography where the trace of the real is unambiguously central to the museum's and exhibition's purpose. In an exhibition 'Captive Lives', which toured Australia from the National Library of Australia, imagery, including photographs, constituted both the discourse and the metaphorical narration of the history of a group of Palm Island Aboriginal people who were taken, dispossessed and turned into a spectacle of savagery in the shows of Europe and North America (Poignant 1993). Photographs, the indexical trace of the people, are an important means through which to reach their histories. What one might term memorial museums, such as those commemorating and educating on the Holocaust, also have very clear photographic strategies that are linked to very specific historical experiences, and where the cultural and technical certainty of the

photographic trace is fundamental to the museum's purpose. For instance, at the Museum of Genocidal Crimes at Tuol Sleng, Cambodia, rooms are covered with photographs of prisoners under torture or impending death. At thirty-six people per block, comprising thirty-six 6″ × 6″ squares, ten blocks each of thirty-six people – 360 squares: the massing of indexical traces of victims literally and metaphorically performs the scale of the atrocities (Ledgerwood 1997:84).[5]

Mismatches

Uses of photographs in the museum are premised on an implicated belief that context is capable of controlling the polysemic unpredictability of the image. But political and cultural discourses subscribed to by different constituencies of museum visitor also define the appropriateness and affective limits of 'context', as a number of curators have found to their cost. It was no coincidence that photographs formed the centre of major rows over 'Into the Heart of Africa' at the Royal Ontario Museum, Toronto, in 1989–90 and 'Hidden Peoples of the Amazon' at the Museum of Mankind, in 1985.[6] In Toronto, despite the reflexive curatorial intention and the historically specific nature of the material, in particular an image of a missionary's wife 'showing women how to wash' overrode attempts to control its semiotic energy. As such it became a powerful reminder of a history of oppression (Ames 1992:157) and a symbol of the racism and suppression of African and African-Canadian experience with which, some constituencies argued, the exhibition colluded. The cognitive distance required to see the 'irony' of the exhibition was not available to those who felt a political or emotional affinity with the subject-matter (Riegel 1996:94), especially when expressed through the indexical insistence of photographs. In the case of the 'Amazon' exhibition, the timeless representation of culture was criticised for failing to address the contemporary crises faced by Indian peoples of the Amazon. At the centre of the criticism was a small photographic section at the end of the exhibition, 'The Amazon Today', which hinted at contemporary problems. Not only was there a performative imbalance of presentation and affective tone between small, bland, factual photographs of this section and the dramatic and impressive representation of 'tradition'. The main photograph, which featured a young Panare man astride a motorbike belonging to Paul Henley, the British anthropologist who took the photograph, was interpreted as trivialising and symbolic of the exhibition's lack of engagement with the fight for cultural survival in the Amazon region.

This was seen as especially so in relation to that photograph, as Panare people had been more successful than others at cultural survival in the face of centuries of murderous encounter (Simpson 1996:36). The movement from the specific indexical trace of a young Panare man to a generalising icon of the contemporary Amazon was an inadequate representation, leaving the viewer, as one critic said, with the trivial, the bland and the pretty (Bourne 1985). In both these cases the realist evidential power of the photograph could not contain the ambiguity of the complex sets of signifiers in generating meanings: 'In the image – the object yields itself wholly and our vision of it is *certain*' (Barthes 1984:106 original emphasis).

I now want to consider an instance where different genres were intentionally introduced into the gallery space, yet the preferred reading of the exhibition overall submerged potential photographic perfomances. This is not simply a matter of unstable signifiers, although signifiers are indeed destabilised further through ambiguous performances in relation to genre; but rather it illustrates the need to shift the conceptual base on which photographs are used. The Life Cycle Gallery at Glasgow Museum's St Mungo Museum of Religious Life and Art explores, as its name suggests, the different ways in which people mark the shape of their lives through religious or spiritual observance and experience in the broadest sense. It is a largely conventional, tightly designed and integrated cross-cultural display of objects and supporting photographs and audiovisuals. But into the middle of this are introduced different photographic genres. While this was intended to suggest the subjectivities of religious experience and to make the displays 'more alive or peopled' (Lovelace, Carnegie and Dunlop 1995:68) it is the content of the photographs that dominates within the didactic space. Despite the recognition that these were photographs of a different order, the historicities of the different genres themselves, their conceptual base, their narrative contexts and subjectivities were not allowed sufficient interpretative space to realise their potential. This is interesting because one is able to see how genre, expectancy and performance enmesh the images within the ethnographic space. One photograph is from a series about novitiate nuns, *Brides of Christ*, by the distinguished Magnum photographer, Eve Arnold. The photograph is not only documentary, in the traditional sense, in that it is intended both to record and to communicate an interpretation of the world: specific formal elements of the photograph, such as the energising framing, construct meaning through tensions between form and content, pointing to its mediation. Similarly, Sebastião Salgado's photograph of an open-eyed burial of a

child in Peru, from the project *Other Americas,* is heavily dependent for its effects on the active geometry within the frame and the action of light on the contrasting textures of the dead skin and woollen clothing. These photographs are presented differently within the gallery, signalling their different discourses. They are matted and framed in an art gallery-style, whereas the other photographs are dry mounted, unframed and placed in cases or on walls as insignificant oblong bits of paper amongst objects. Yet, despite intentions, there is a sense in which the documentary images sit uncomfortably, both formally and technically, with the didactic and functional images that surround them, most of which are photographically naive, merely photographs 'of' things, in a 'no-style' style where mediation is suppressed. The latter suggest immediate observation and ethnographic authenticity translated into photograph, whereas documentary has long been premised on the mediating vision of the interpreter to reveal the truth. We are dealing with very different registers of images; while this was recognised by the curators, the photographs fail to realise their communicative potential, even at the level of coherent content, because precisely what makes them successful photographs becomes suppressed in the dominant noise of didacticism.[7]

On the other hand Stanley Matchett's photograph of Father Daly clearing safe passage for one of the dying on Bloody Sunday in Northern Ireland 1972, which is used in the section on religion and power, fulfils admirably the curators' intention to offset the 'very confirmatory adjoining case'.[8] As an image it is less tightly and self-consciously structured than the Arnold or Salgado photographs: it is a photograph of yet another order. As a successful piece of photo-journalism, it belongs to a genre of photographs intended to communicate succinctly in a wide range of different contexts. It has the visual incision of a spot-picture, with a tight closure of meaning, a density of signifiers within the frame merging with the signified in the act of translation: what has been referred to as 'nouns and verbs' of photography in a single frame (Stryker quoted in Retman 1996:54). While it is arguably more didactic in intention than the other photographs discussed here (after all, photo-jounralism exists to 'report'), it is an image of another order in terms of the expectations of the ethnographic gallery. Interestingly, it raised objections from the public. As with the semiotic energy of the photographs in 'Into the Heart of Africa' and 'Amazonia', the photograph could not be 'contained' and was seen by some as 'supporting terrorism'. It was an image that could not be depoliticised in its performance, for its indexical insistence, the presence of the referent,

could not be contained within the frame of either the photograph or the contexts of its use – the performance was deemed inappropriate.[9] Form and content come together to create a meaning that extends our understanding of the experience of strife. Very few images used in ethnographic exhibitions can make such a claim.

Thus one can argue that in some ways the use of the Arnold and Salgado in Glasgow collapsed into mere illustration, and failed in their incisive qualities where genre did not equate with expectation. While the Bloody Sunday photograph was more successful in this context, all might be said to be trapped in a discourse of museologically traditional use of images, in which the grounds upon which meanings articulate themselves remain unquestioned or at least unproblematised (Bal 1996:8). The tensions and disjunctions produced by these contesting genres in the space seem to be to be constituted precisely through the 'distinction between factual statements (considered to be the product of object-language) and interpretations of them (considered the product of one or more meta-languages)'; and 'modes of emplotment [genre] are used to represent facts as displaying the form and meaning of different *kinds* of stories' (White 1992:39 [added emphasis]). While the Glasgow gallery represents an attempt to broaden photographic discourse, it nonetheless highlights the problems of applying different genres, without shifting adequately the epistemological or interrogatory base from which they function. It is an instructive example of where the 'categories of seeing' represented through photographic genre, expectancy and performance might signal confusion through being allowed insufficient space to function as they were intended. The attendant semiotic confusion, the premising of meaning primarily on the content of the image at the expense of genre, actually fractured their potential to engage the viewer both ethnographically and photographically.

Alternative Genres – Different Expectations?

So if the hope of tightening the closures of photographic meaning ever further is a flawed project, if the inherent polysemic and fragmented nature of photography itself, its place-specific performances and its subjective interaction with the viewer is problematic – what next? Perhaps one might explore what could be achieved by privileging these very characteristics that militated against the photograph. As I have suggested elsewhere (Edwards 1997), fragmentation, ambiguity, dislocation and uncertainty might be turned around to open a space

that positions the creator, the institution and the viewer in the co-construction of knowledge. Martinez has explored such strategies, in relation to ethnographic film, and found that films that use 'open' textual strategies, rather than attempting precise closures of meaning, actually engendered more elaborated, interrogatory and reflexive responses. Conversely, the strongest patterns of aberrant readings and simple lack of interest and alienation corresponded to more closed meanings of factual and distanced representations. He suggests that experimental or reflexive styles empower viewers, by allowing them space to negotiate meanings in a more dialogic and interactive way, generally resulting in more complex and engaged interpretations (1992:135–6). Thus through the agency of what is precisely photographic, an inconclusive narrative might be used in the museum space to open up a closed authority and position the subject-viewer in the co-construction of knowledge.[10] Perhaps in engaging with the expressiveness of photography 'the problematic limitation or fragmentation of scopic knowledge is overt, a result of sharpened focus upon its subject's status as an observer' (Green-Lewis 1996:34).

Alternative strategies are intriguing because anthropology's own contribution to the contemplation of photography, especially historical photography absorbed and used within anthropology, has been precisely to collapse those very boundaries and ways of representing peoples and places to which, in the past, it had contributed so forcefully. The collapse of traditional representational paradigms, the decentring of authority, the ambiguous status of authorship and the multi-vocality of responses, whether in text, film or photography, have opened up a subjective space for thinking about photographs and thinking with photographs. While my concern here is with the epistemological base on which photographs operate in the ethnographic museum, the strategies I am discussing connect with those of multivocality, cross-cultural translations, indigenous voices and decentred authorities that are increasingly filling the space created through critical counterpoints. At the same time the boundaries of what constitutes valid cultural commentary have shifted. As Clifford has argued (1988:118–21) 'serious fictions', such as novels, short stories, diaries and autobiography, have become absorbed into the new canon of anthropological text as having some representational validity. I am arguing the same for photography:[11] that we investigate different modes of visual narrative through different dialects, genres and emplotments. These might depend not on realist photographic syntax, but on quotation, metaphor and expressive nuance. One can premise perhaps that, used in an intelligent, enquiring

and informed way, where photographic structuring disrupts and fractures realist assumption, such strategies might decentre stereotype, institutional intransigence and audience expectation more forcefully than a realist language. I am arguing here that if we think in terms of visual dialects, genres of photographs differentiated in intention, content and form, through drawing attention to the mediation of the image – 'denaturalising' it – one might work towards decentring expectancy and thus open up a critical space '"Between" places [given] a tactical centrality to undermine the very notion of a centre' (Clifford 1997:213). In this register photographs can be used as a tool to reveal the epistemological base of museum discourse rather than merely to make authoritative statements.

To achieve this we should consider consequently how other genres of photographs, such as the documentary, photo-journalism and arts practices, and different display strategies, which invite different responses, might work within the ethnographic space. Such an approach immediately decentres ethnographic photography as a category. In blurring the boundaries one moves from the vertical axis of disciplinary practice to a horizontal axis where photography is positioned on a whole continuum of photographic practice of many interwoven intellectual strands, realised through one technology. In this, cultural representation is constituted over a range of related and sometimes contested practices. From such a space, cleared between the image itself and didactic assumption, it becomes possible to investigate the ethnographic use of photography and its authority, challenging the confirming nature of mainstream imagery and both the viewer's and institution's position in that representation. One might premise an alternative, one that might decentre expectancy perhaps through the suggestion of not knowing – of uncertainty – opening a subjective space where visitors become aware of the photographic act of mediating vision and their own part in the co-construction of knowledge. This requires museums to reconceptualise photography as no longer only a realistic statement of content but as a process of translation, of a continuous dialogue between image and culture, not only the culture of the content of the photograph but the culture of use (Brothers 1997:12).

Such strategies might be used to open up discursive spaces in the viewer's mind. 'What is this image doing here – it is not what I expected – how? why?' Even if, as Heumann Gurian has argued, 'the visitor receives an impressionistic, sometimes indelible, sense of the topic . . . [to] which all subsequent exposures will be referenced' (1991:181) one might argue that such disruptive photographic strategies consequently

embody a power of resonance beyond the images themselves. Extending it to other classes of object in the museum moves the viewer towards interrogation of, and perhaps a dialectical understanding of, the processes in making statements about culture and history and their own subject position in this relationship, rather than a more passive consumption of a didactic narrative. Reclassification always entails making new meanings. Museums are, of course, actively involved in selection, classification and reclassification as essential mechanisms of truth production. Shifting the conceptual base of photography, how it performs in an institution, is to make radical shift in the discourse. However, such strategies have to be articulated fully. To ignore the role of photographic genre or to employ photographic irony is, as Riegel (1996) has pointed out in relation to *Into the Heart of Africa*, a dangerous strategy. In order for representations to work they have to comply broadly to the expectancy patterns of certain socially constituted photographic realities that the exhibition visitor holds to be generally true or appropriate (Lidchi 1997a:18). So, in line with the critical and reflexive agendas of contemporary museum practice, it is essential to open up the 'horizons of expectation' that determined the questions asked and the answers given. All hinge on a conceptual shift in photography in the museum from a privileged realist role to a complex voice of many genres, which can exist on its own terms, defined neither by the objects it supports nor its presentation of surface appearances. Visibility in the museum thus becomes differently premised, a shift from 'overseeing' to a clarity and openness of epistemological basis.

Confronting Materiality

I want to consider briefly forms of display and materiality. The materiality of photographs is, as was suggested in Chapter 1, central to their social meaning. There are ways in which this can be used within the museum space. Presenting photographs in terms of their social practice, I would argue, is a strategy for the visibility of photographs as social objects in time and space.

This is especially pertinent in relation to historical material. As the responses to *Into the Heart of Africa* demonstrated, the temporal slippage, whereby the 'there-then' becomes the 'here-now' in the signifying processes of the photograph, confirms stereotype, rather than confronting it, and legitimises the reproduction of, for instance, colonial visual tropes. Even critical engagements with colonial material in terms of image content can be very problematic. Bal has argued (1996:195–6)

in relation to an exhibition held in the Netherlands in 1989, *The Colonial Imagination: Africa in Postcards*,[12] critiquing colonial images, that such exercises are in danger of effectively reproducing precisely what the exhibition intends to critique. The insistence of the image and its signification, in this case the sexualised, colonialised female African body, can simply collapse into restatement. In other words, do viewers actually see their act of viewing or does the context of viewing, the didactic museum space, merely legitimise repeated viewing? Is it possible to argue that a focus on the photograph as material object, rather than only on the image, might disrupt the reproduction of viewing that concerns Bal? Of course, objects signify as well; but what I am suggesting is that materiality goes some way to positioning the subject-viewers and making them aware of the act of viewing. Exhibitions following such strategies constitute ethnographies of seeing rather than ethnographies of content. The stress on materiality positions the photographs as a series of mediated objects grounded in social practices of viewing. Display techniques play a major role here, moving away from framing and matting toward the display of the whole object. Materiality has the potential to insert itself between the image and the viewer, pointing to the act of viewing.

A number of exhibitions have used materiality to convey a critical sense of the impact of visual images. *Pirating the Pacific* in Sydney in 1993 (Stephen 1993) explored a wide range of images and photographic objects that were in circulation, especially in popular discourse, constructing an imagined Pacific of tourist appropriation through photographs, postcards, tour brochures and the like. An important exhibition that functioned as an ethnography of colonial and ethnographic photographs was *Picturing Paradise: Colonial Photography in Samoa 1875–1925* (Engelhard and Mesenhöller 1995).[13] The way in which photographs were consumed was, as with *Pirating the Pacific,* central to this exhibition. Here was a chaos of photographic formats; many images were shown in more than one format (Figure 8.1) as an albumen print, a platinum print, as a half-tone or even, in the case of a portrait of a young woman by Thomas Andrew, transformed into an oil painting by G. Pieri Nerli (Nordström 1995:16–17). This device moved the photograph away from the unmediated window on the world on the one hand, and away from the art-historical model of the singularity of the great work on the other. Rather, photographs became not just images, but socially salient objects that moved through different spaces accruing different meanings while they were consumed in different contexts as people interacted in time and space. While there

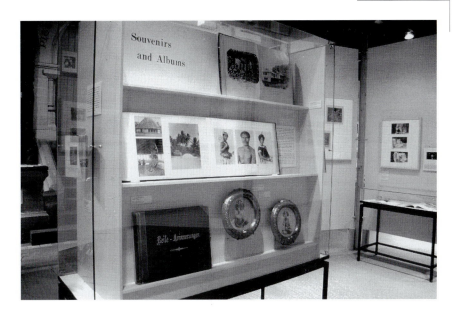

Figure 8.1 *Picturing Paradise,* installation. Photographer: Malcolm Osman. (Courtesy of Pitt Rivers Museum, University of Oxford.)

were sections on the key tropes, such as the 'colonial Venus' and key sites of instrumentality, such as missions, the photographs were presented in terms of consumption inflected through these grids. The museum visitor was put firmly in the position of the viewer, and the act of viewing was mediated through the material forms, of albums, magazines, cigarette cards, stereocards, posters, postcards and souvenirs. The exhibition was merely the latest context in an ongoing history of consumption. Such exhibitions are strongly reflexive, positioning viewers and exploring the processes of subjectification in which they are implicated.

A different focus on materiality has been taken in displays at the Museum of the Romanian Peasant in Bucharest. It has used photographs in its galleries in especially imaginative ways that allow them to function simultaneously as documents, as extending objects, and as affective tone, but without losing a sense of photography's mediation. The director of this interesting institution of internal ethnography, operating within the discourses of post-communist national identity, is an artist rather than an ethnographer, although the curatorial staff are ethnographers. In some galleries the informative photographs that 'add' to the display in illustrative, authenticating or authoritating

modes, are actually displayed as objects themselves. Rather than being displayed as unproblematic informative oblongs of paper, they are framed as if in the domestic space with which the displays are concerned. The viewer is forced to engage with the photographs as objects; knowledge is literally being presented framed, indexical yet mediated. This is not knowledge literally at a glance in the museum space; the material forms and scale of the framed photographs require closer attention. Further, there is a disjunction, for the photographs in the frames are not always the kind of photographs that might be expected to be in such frames, displayed in such social conditions (Figure 8.2).

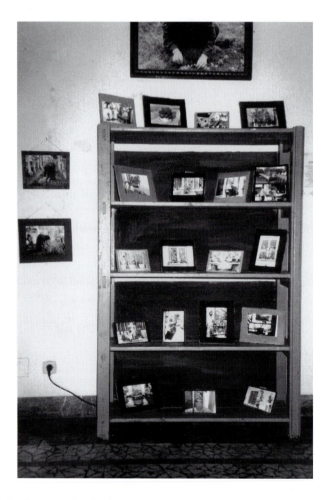

Figure 8.2 Photographs displayed. Museum of the Romanian Peasant, Bucharest, 1997. (Author's photograph.)

However, in mixing contents and presenting them in a continuum of material form, the displays point to the mediation attendant on very different social uses of photography, in the historical community and in the museum.

Radical Strategies

I now want to consider a very different strategy. As different voices within anthropology's traditional territory have challenged the conception of the museum, anthropological engagement with contemporary art actually challenges anthropology's authoritative and appropriating modes of representing other cultures (Schneider 1996:184–5; Edwards 1997). I am going to look at photography in this intersection as a site of critique of museum practice. Further, such work makes acts of representation visible through taking them to excess, performing consciously inappropriate genres in the museum space as a form of contamination, 'displaying representation upon representation upon representation' (Riegel 1996:99). One is reminded here of Benjamin's comments on translation: that in order to represent and translate the original faithfully the translator must depart from it, seeking realisation of his task in something other than that original (1973:78). Meaning resides in the space between the original and its translation.

It is precisely in this spirit that museums of many kinds have been working with contemporary artists, to explore the edges of collecting and collection. Through it, the critiques of museum practice in particular, and of anthropology more generally, are translated into demonstrable and tangible public experiences within institutions, where the epistemological base of collecting and the museum is made clear through counter-narrative: 'There is more to the mixing of artists and museums than the regeneration of wonder and curiosity. The multicultural epoch has forced curators to embrace the issues of representation as well as the post-modern fusion of fact with fiction and history with myth' (Dorsett 1998:11). While artists' interventions are becoming almost commonplace in museums – for instance the work of the American installation artist Fred Wilson, who has made a major impact on the politics of representation and identity in museums, Mark Dion at the Tate Gallery, Richard Wentworth's *Question of Taste* at the British Museum, which mixed archaeological objects with contemporary 'rubbish', and Chris Dorsett's *Deep Storage* at Cheltenham and *Divers Memories* at Oxford, Manchester, Stockholm and elsewhere[14] – the experimental use of these forms in ethnographic museums has not

been widely extended to photographs as such, beyond their function within the mixed media available to contemporary artists. If museums are to act as 'contact zones, spaces of cultural confrontation, negotiation and brokerage', the role of photographs, as a dominating currency of contemporary experience, is surely central.

I want to look briefly at two projects in which I have been involved at the Pitt Rivers Museum and which were curated with precisely those issues in mind. They were both developed as conscious dialogic translations between anthropological theory and exhibition strategy (Bouquet 2000:210–20). The first is a series of the photographs made by the photographer and artist, Elizabeth Williams, in the northern Sinai desert in 1993–4 and the second the work of the Scottish photographer, Owen Logan. I have discussed the making of Williams's project *Strange Territory* elsewhere (Edwards 1997:63–70); my concern here is how it performed in the context of the ethnographic museum in 1994. Particularly related to my argument here is a series of photographs made at a deserted Bedouin camp: the objects were surface archaeology, the detritus of culture. The narrative was imposed by the photographer, creating an ethnography of found materials – textiles, ropes, shoes – a narrative that moved from the traditional to the imported. Rather than proclaiming 'this is how it is', the distance from the transparent and descriptive image communicated, through its metaphors, an incisive truth about the relationship of the Bedouin with their desert in the late-twentieth-century. Despite their indexicality, the photographs rejected the realist privileging of visual truth. Through their use of painterly quotation and metaphor, they become a translation where the sense is rendered, rather than seeking a precise fidelity to the original (Benjamin 1973:78), and the act of translation was clearly visible. Their subjective interventions are unmistakable – these are photographs of another order.[15]

The work was shown in a cascade of linked enlargements, mounted on a great calico sail, tumbling down into the museum space. The overall effect was spectacular, especially when viewed from across the main court of the museum. Its presence was unavoidable and it resonated through the whole institution. It functioned as a series of questions about other objects. Were they, too, abandoned? What were their histories? It set up a strong sense of the presence of absence, pointing to the partial nature (in both senses of the word) of the museum as a site of cultural translation. What emerged was a questioning of the territory of the 'cultural image', raising questions about the performance of culture through images. Another series, fragments of

objects created by close-ups, suggested the slippage between image and object in the museum. Made like postcards, they are strongly formalist detailed photographs of textiles taken at the Northern Sinai Heritage Centre. In these terms they referred to the kinds of descriptive photographs that are made in museums every day and are part of the control of objects, whether in conservation, documentation or classification. However, the surface of the image was disrupted by the addition of objects to the picture plane. Press-studs were sewn on to photographs of jackets (Figure 8.3), shells on to photographs of women's clothing, the objects being placed precisely over their indexical traces in the photographs. They became ambiguous statements: were they images or objects? Formalist or documentary in their meaning? Do they record objects or make objects? They were photographs that appeared to describe objects; but intervention had destabilised and thwarted expectancy; the viewer was forced to question the categories object and photograph. Consequently, the image/objects resisted institutional categorisations and thus an appropriation that threatened to neutralise them. Through these devices, the project explored both alternative ways of communicating cultural experience and the ways in which museums are implicated in the modes of translation.

Figure 8.3 Objects, from *Strange Territory*. Photographer: Elizabeth Williams. (Courtesy of the photographer.)

The other project, *A Home of Signs and Wonders*, challenged the very basis of didactic assumption – the relationship between image and referent that has been the source of authority for photography in the ethnographic museum. Owen Logan worked in Calabar in southern Nigeria for two years, initially with an anthropologist, in a project that started as a piece of anthropological fieldwork. It explored the syncretic religious traditions of Calabar, the legacy of the Scottish Missions and the newer forces of fundamentalist religion in a culturally diverse region that is dominated by an externally controlled oil industry. At first sight the photographs appear in the genre of documentary, and somewhat post-modern in conceptualisation in their ambiguity, disruptive subject-matter and fracturing in their overt mediation between observer and observed. They attempt visual incision in cultural terms through anthropologically framed questions concerning continuity, change, cohesion, process and difference in the negotiation of complex identities in the modern nation-state of Nigeria. While far from unproblematic, the genres of documentary photography have been premised on the possibility that resonance fosters empathy or identification that enables an appreciation, or even imagination, unifying and underlying the moment of shared experience. In Logan's case, the photographer's wonder and occasionally uncertain comprehension of the scene allow the artifice of conscious manipulation and negotiation to be echoed through the conscious artifice of the photographs. In the case of both photographer and subject, there is a visual articulation of ambiguous and discordant religious experiences, where things that were once foreign and unknown have become local and vice versa. The photographs were exhibited at various venues in southern Nigeria, which Logan saw as his primary audience.[16] Responses to the work were an essential part of it, and the complex, and often metaphoric, responses opened up a new layer of visualist expressions of contemporary experience.

Looking for means to translate this deep-level cultural identity led Logan to extend the constructedness of his photographs. He was concerned with producing a photographic space that might act as the focus of a dialogue that goes beyond the norms of anthropological photo-elicitation. Working with re-enactment and then with digitally produced negatives that merged 'straight' photographs, he moved consciously away from a realist genre to articulate more coherently the cultural worlds that people expressed to him.[17] The digital work consciously moves away from the certainties of indexicality and away from the idea of the 'decisive moment' that has dominated the concept of documentary truth at so many levels. Digital construction enables

the photographer to move beyond the fragmentations of time and space, and to pile up inferences, constructing narratives within the photographic frame (Figure 8.4).[18] None of the elements is 'fake'; rather, they are inscriptions put together with coherence and integrity (like any other historical or ethnographic statement), constituting a narrative over time and space within the frame. It is impossible to make a 'this is' statement; yet arguably this is expressive, imaginative and ethnographic in the deepest sense, moving through different genres, each increasingly transgressive, constituting 'thick ethnography' to reach unarticulated forms.

A Home of Signs and Wonders was conceived as an exhibition that consciously worked to shift patterns of expectancy. It was about neither Nigeria nor photography in any definitive way. It was an ethnography of seeing: the key question, presented in the introductory headline caption, made this very clear. In other words, the exhibition's epistemological base was articulated through a series of questions about the status of photography, culture and representation and the subjectivities of viewing, for instance: 'If no representation can articulate the complete nature of experience, whose view are we seeing?' The museum thus 'became a field-site for the visitor-as-anthropologist during the show' (Cornwall-Jones 2000:168).

The audience was consequently conceived of as a witness involved in the subjectivities of the encounter in a shared space, rather than a cognitive distant recipient of a didactic statement. Something was demanded of both the author and the audience – a willingness to engage with the possibilities of another world and the possibilities of not knowing through photography. In using that rawness that permeates photographs, the exhibition confronts the didactic, unproblematised regimes of photographic truth. But at the same time it makes a clear link between two experiencing subjects, creating a shared space, which admits the possibility of not fully understanding. It shatters the assumption of a mere vicarious knowledge from a photographic genre that states 'this is how it is'. Rather, the subjects are imaginable to one another, in Logan's own words, shifting the grounding premises of both ethnographic photography and documentary: 'I'm not trying to install a message in my representation of southern Nigeria, but rather to negotiate a new vocabulary in which viewers might examine their own versions' (Logan 1997:[3]).

Such work is, as I have suggested, about the processes of seeing and translating rather than the content of the image as such. The photographic alterity, mediation and metaphor is unmistakable. They are

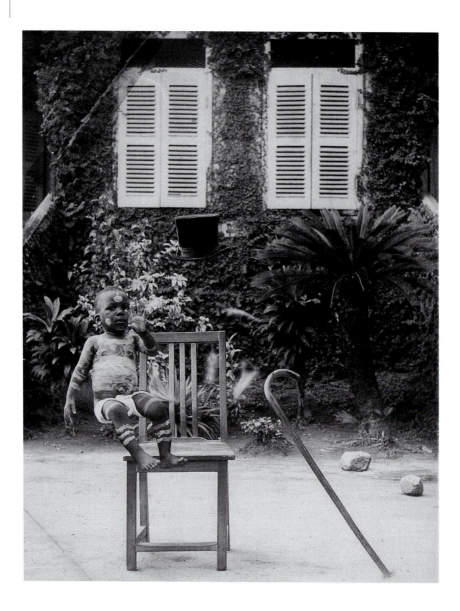

Figure 8.4 'Ete Ete sits on his grandfather's knee: the "invisible chief" who wouldn't pay tax and couldn't be arrested', Calabar, Nigeria, 1996/1997. From *A Home of Signs and Wonders*. Digital composite photograph from a triptych by Owen Logan. (Courtesy of the photographer.)

unsettling, they present no certainties, they play the counterrule to differently negotiated discourses. Ultimately, what is interesting about this work is that it brings together theoretically grounded photographic, historical and anthropological concerns. They become part of the trans-formative discourse of the institution itself, destabilising those sets of semiotic and epistemological habits that enable and prescribe ways of communicating and thinking (Bal 1996:3). They refigure expectations of what ethnographic photography *is* and might be. Both these bodies of work I have discussed make statements about the conditions of their making and engage a conscious subject viewer in the co-construction of knowledge, through raising questions, and purposely not offering a closure of meaning. Nor do they claim to 'speak about' in any direct way, rather they speak about 'speaking about'. Like the materiality of the photographs in the Samoa exhibition, such work reinserts the site of social production through interventions that consciously move away from the dominant authority in museums (Shelton 1990:80). This critical distance is projected into the museum space through photo-graphic genres that intentionally disturb the epistemological base.

Conclusion

Museum practice is not, of course, homogeneous. All such strategies will have local or community-specific appropriateness. What is suitable for a tribal museum will, of course, not necessarily be suitable in a major metropolitan institution and vice versa. They do not occupy the same interpretative spaces of genre and expectancy. I have discussed a number of ways in which photography might contribute to the critical debate in museums. There are, of course, others. One obvious area is the work of artists from many cultural backgrounds, including indigenous and diaspora artists, whose work constitutes a critique of the archive and museum, both in terms of the photographs within them and as spaces in which meanings are made. One thinks here, for instance, of Maud Sulter's series *Syracus* (1994), which involved a critical photographic re-presentation of African objects in Manchester Museum, or Dave Lewis's work with the Royal Anthropological Institute for *The Impossible Science of Being* (1995–6), which explored the spaces of museums and learned institutions where anthropological meanings were made. Or on a different cultural register one might cite the work of Native American artists, such as George Longfish, Hulleah Tsinhnahjinnie or Pam Shields, all of whom, from their own particular cultural perspective, have made work refiguring the images of anthropology's history. My

concern here has been with photography itself and how it is expected to perform with critical potential in the museum space, whoever the originator of the images, and contribute to 'provide[ing] the framework, actual, ethical, historical, cultural and aesthetic, through which such work may be seen' (Elliot 1993:33).

As Jenks has argued (1995:13–14), theorised sight will always be problematic in its relations to the real world; transformed objects of knowledge compete with everyday empirical experience. The problem in a museum context is when one masquerades as the other through genre confusions caused by a failure to think beyond content. By introducing different genres, pointing at the constructedness of vision, photographs are allowed to participate in the 'in context' strategies of exhibitions argued for by Kirshenblatt-Gimblett (1991:381), which 'invite audiences to recognise the arbitrary nature of all representations' and indeed point to the museum as a form of genre in itself. Such concerns can, I have argued here, be explored through counterpositioning genres. Such strategies can offer many entry points, offering visitors a range of fluid learning experiences (Heumann Gurian 1991: 184). They are transformative because they stress subjectivity in ethnographic space and therefore point to a shifting environment of consumption, while pulling to the fore intellectual, critical or incisive elements in images.

What emerges from thinking through photographic strategies in terms of genre, expectancy and performance is a differentiation of the multiple strands and practices of photography in the museum that must be disentangled in order for photography to have both a problematised and a critical role. I have purposely positioned my argument in terms of photographic practices in order to make the processes more visible. In addition, addressing the tensions between genre and expectancy is surely crucial to any attempt to rethink the role of photography in the ethnographic museum, or indeed other forms of social and cultural historical institutions. Rather, I have outlined a theoretical position inflected through an idea of differentiated photographic voices or genre, where photography might make a positive contribution in contemporary museum practice. Issues of representational practice remain cogent, for exposing forms of discourse is in part itself expository (Bal 1996:165). My argument consequently does not present answers as such, but puts in place a critical propensity, where assumptions about cultural representations can be reconfigured through the use of differently negotiated images. Perhaps, then, through setting up an overt discourse within the museum space of different voices,

different genres, photographs/photography might be instrumental in pointing to the limits of ordering systems and in destabilising those dominant regimes of 'truth production' to which it has contributed so forcefully in the past. As Riegel has argued, at one level it is a dangerous strategy, 'but it can be an inordinately productive one for museums who want to create shared spaces of communications with their publics' (1996:100). Photographs cannot, of course, operate in isolation – they are inevitably enmeshed in the broader discourses of the institution; however, I have suggested a strategy by which photographs can have active, open and transgressive potential in the reflexive agendas of contemporary museums.

Notes

1. My concern here is photographs in museum spaces where they operate alongside objects in the cross-cultural translation of socially coherent objects, rather than art gallery spaces, which have a different sets of aestheticising agendas and representational rhetorics.

2. The latter strategy is exemplified by the Rockefeller Wing of the Metropolitan Museum of Art, New York, or at the Sainsbury Centre for Visual Arts, University of East Anglia, where photographs support objects only in catalogues and in the broader discourse around the objects, not in the gallery space itself.

3. Indeed a critique of the 'Hidden Peoples of the Amazon' exhibition (1985) at the Museum of Mankind complained that there was not a single photograph of the river from which the exhibition took its name (quoted in Bourne 1985:380).

4. Here it suggests the use of the object as a document to counter some of the effects of detachment and triviality in terms of context. However, it would seem, in the context of the present discussion on the use of photographs, merely to shift the problem of 'context', not to circumvent it.

5. This is not to suggest that there is not plurality of experience and narratives within genocide histories; merely that in museum terms the preferred reading of those institutions is unified around the enormity of the crimes against humanity. Holocaust representation has been widely discussed, see for instance Friedlander (1992) and van Alphen (1997) and references therein.

6. A full consideration of the complex issues that engulfed both exhibitions is tangential to my particular purpose here. The Canadian exhibition, in

particular, has spawned a substantial literature as its implications rippled through the museum world. See for example Ottenburg 1991; Schildkrout 1991; Cannizzo 1991; Clifford 1997:206–8; Riegel 1996. For briefer considerations of the Amazon exhibition see Bourne 1985; Simpson 1996:35 and Coombes 1994:219.

7. Significantly these photographs were accessioned in the Fine Art Department of Glasgow Museums before use (Antonia Lovelace, personal communication. I am grateful to her for discussing the gallery with me at length). The others were not accorded the status of objects and remained unaccessioned ephemeral and ultimately expendable illustration. This echoes Porter's contention that 'order in the Museum requires the elevation of the object and the subjugation of the photographic image . . . [a] hierarchy which exists in storage and display' (1989: 24).

8. Lovelace, personal communication.

9. Lovelace, personal communication. The photograph attracted as many generalised objections as the controversial use, in the *rite de passage* section, of a photograph of the face of a young girl, contorted with terror and pain as she underwent female circumcision. This latter photograph was read by some as condoning the practice by not doing enough to condemn it: the image was recaptioned to position it more strongly in terms of the controversy.

10. This after all has been central to post-modern documentary photography.

11. Such ideas are not new, see for instance Becker (1981), but they not been explored in terms of museum spaces nor have their implications been pursued with any great effect. See also Edwards 1997.

12. Curated by Raymond Corbey at the African Museum, Beng en Dal, Netherlands.

13. Curated jointly by Peter Mesenhöller (Rautenstrauch-Joest Museum, Cologne) and Alison Devine Nordström (Southeast Museum of Photography, Florida), the exhibition was shown in different forms in Cologne, Oxford, Daytona Beach and New York. Each had a different stress, producing different sets of meanings from the same body of material, the narrative shifting through differing spatial configurations, captioning style and lighting, articulating different preferred readings.

14. In Lieska, Northern Karelia (Finland) *Divers Memories* included some of the work of Jorma Puranen discussed in Chapter 9.

15. Elizabeth Williams was a Leverhulme Fellow and British Council photographer-in-residence at the Northern Sinai Heritage Centre in Egypt.

16. The audience outside Calabar was not Logan's primary concern The exhibition, developed for a Nigerian audience, was shown at three venues in Calabar and southern Nigeria.

17. I am indebted to Owen Logan for discussing his work with me at length.

18. Captions, except text panels, were kept to a minimum. Double dates, giving the date of the indexical inscription and the date of image construction, indicated digitally produced work.

Jorma Puranen – *Imaginary Homecoming* – A Study in Re-engagement

One of the defining characteristics of both contemporary anthropology and contemporary arts practice has been the use of quotation and metaphor. To engage with the complexities, instabilities, constructedness and contingency of meanings, there has been a severe disruption in the traditional relations between the subject of anthropology and the ethnographic museum on the one hand, and arts practices on the other. These ideas are grounded in part in the subversions and problematics of post-modernism, which have fostered a profound scepticism and blurred boundaries in relation to disciplinary authority and in relation to visual practices that depart from traditional forms of anthropological and historical representation (Marcus and Myres 1995; Schneider 1996). In other ways the post-modern practice of 'defamiliarising the past [can] also serve as a prelude to renewing contact in unforeseen ways' (Holly 1996:5), opening new spaces of engagement and interpretation.

It is in this context that I want to discuss *Imaginary Homecoming*, the work of the contemporary Finnish photographer Jorma Puranen. It exemplifies the exploration of an intersection of those histories of peoples, anthropology, the archive and the material image that have threaded their way through these chapters. The primary vehicle for this exploration, both literally and metaphorically, is a series of historical anthropological photographs of Sami people from northern Scandinavia. These were translated into compellingly beautiful and elegiac installation pieces in the landscape of the far north, which were then rephotographed and contained within the frame of the black and white print (Figure 9.1). Re-engagement here is complex, embracing the images

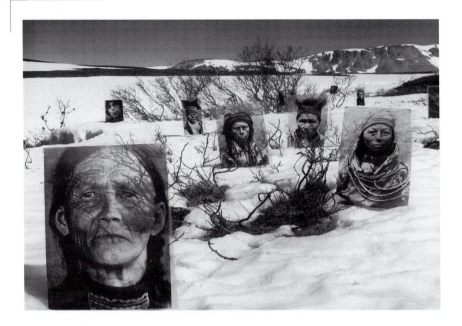

Figure 9.1 From *Imaginary Homecoming*. Photographer: Jorma Puranen. (Courtesy of the photographer.)

themselves, Puranen's relationship with them, their referents and their potential in the modern context of social identities. Such an approach is reminiscent of Walter Benjamin's suggestion that the truth of history does not involve the representation of an eternal past, but rather the production of an image, in relation to an agent (here the artist) and a present moment – 'The truth of history is performed when we take the risk of making history rather than assuming it to belong only to the past' – awakening becomes a condition of writing history. This opens up a space for exchange that is part of that continuum of dialogue between image and the culture of use, where photographic objects enliven rather than entrap meanings (Cadava 1997:72–3; Brothers 1997:12). Such projects are not unproblematic, of course; however, as I hope to suggest, by acknowledging its own contingent nature and engaging critically with the character and meanings of certain historical images, *Imaginary Homecoming* does something to liberate the photographs from the interpretative grids in which they were enmeshed (Kerr 1999).

The histories explored in this re-engagement with photographs and their projection into new spaces and new forms of articulation are

concerned with the intersecting histories of the minority Sami people of northern Norway, Sweden, Finland and Russia, of other European peoples, and of science and of photographic practice as they came together through the demands of nineteenth-century anthropology. I have chosen this particular body of work because it encapsulates the various intersections, tensions and biographical processes that have formed the foci of these essays. As I argued in Chapter 8, expressive photographic practice that stresses the subjective and poetic as a mode of exploration has the capacity to penetrate and articulate contra-dictions and nuances that might be lost in textual forms. Through constructive engagement with elements of ethnographic practice and the history of photography, especially anthropological photography, Puranen has experimented with modes of visual elaboration that open up variations on the imagery of ethnographic and documentary photography. Because *Imaginary Homecoming* demonstrates a great trust in the constructive opening of the creative act, it also possesses undeniable heuristic potential (Maresca 1996:195–6).

Imaginary Homecoming is thus an expressive re-engagement, reposit-ioning and renegotiation of such historical images. It represents a dynamic articulation of history as a continuing dialogue between past and present concerns. The entangled histories of these images are worth reflection. To understand the significance of *Imaginary Homecoming* the images must be situated in the history and consumption of nineteenth-century photographs of Sami people as 'anthropological documents', and the 'texting' that accrues through their preservation in archives devoted to that area of Western classification and intellectual endeavour. Yet at the same time, through the social being of the subjects of the photographs, the photographs embody a form of 'retention' that represents the sedimentation of past experience as an active starting-point for the present.

It was an encounter with nineteenth-century images of Sami people, both as engravings in travel literature and photographs in ethnographic and folklore archives, that first suggested to Puranen the possibility of exploring visually the imaginative historical projections that had gathered around the peoples of the north of Scandinavia. Although not Sami himself, Puranen comes from northern Finland and has had a long association with the region. He had been working there since 1975 when he met an elderly woman, Martta Orttonen, who introduced him to the local community and through whom he learnt of the rich oral history of the region. Her death was like the 'death of a book'.[1] He worked photographing everyday life, organising exhibitions, teaching

photography and contributing to Sami publications, such as *Sápmelas*. However, the starting-point of the *Imaginary Homecoming* project was in 1988 when Nils-Aslak Valkeapää of Pättikä, near Enontekiö, Finnish Lapland, showed Puranen a book he was working on, *Beaivi Áhcázan* (The Sun My Father), which was published later that year. In it were reproduced portraits of Sami people that he had found in the Musée de l'Homme in Paris (Puranen 1999:11). These photographs had been taken under the direction of Prince Roland Bonaparte on his visit to northern Scandinavia in 1884, and numbered some 400 negatives, 250 of which were portraits. They became the basis for Puranen's visual investigation of Sami history and its intersections and encounters. The Bonaparte photographs consist of pairs of portraits in the style of scientific reference (see Figure 9.2); although there is no measuring rod in the image, a number, held on a metal clamp, is inserted into the space of the sitter. This number itemises the subject of the photo-graph and refers back to an accompanying list of data that gives basic anthropometric information as well as details of name and age.

To this corpus Puranen added other photographs of Sami people found in scientific archives in Finland, France and Britain. Many had

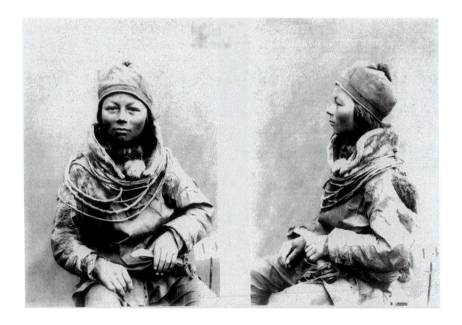

Figure 9.2 Sami boy. Photographed for Prince Roland Bonaparte. Albumen prints, 1884. (Courtesy of the Royal Anthropological Institute.)

been produced intentionally as anthropological documents. Others, for instance, those of traveller Lotten von Düben taken in 1868 and 1871, had been absorbed into anthropological discourse, as their content was deemed to have anthropological interest. This mode of representation, which, as we have seen, constituted a major represent-ational trope in photographing colonialised peoples over a wide range of interlinked photographic practices, became one of the predominant ways in which Sami people, as Europe's own marginal people, were portrayed. Such images functioned as vehicles of communication inside the scientific community, as part of the homogenisation expressed through a scientifically universal visual language (Dias 1997:97). From the mid-nineteenth century Sami people became increasingly 'anthro-pologicised' – described, measured and contained within a scientific discourse. As late as the 1930s substantial data-collecting projects were undertaken in the north of Scandinavia, Sami people being offered medical treatment in return for submitting to the camera and measur-ing tape. The dissemination and consumption of generalised 'types' reached beyond the boundaries of science. The aesthetic of 'scientific reference' and the de-individualising language associated with it became more widely absorbed in popular representations, to the extent that the broader manifestations of these controlling and distancing tropes came to dominate the representation and consumption of both non-European peoples and marginal 'anthropologised' groups within Europe. Consequently, anthropological and anthropometric photographs constituted a major element in making Sami people visible. The links made between biology and culture in the nineteenth century meant that this visualisation assumed a moral dimension, as indicators of value cohered around the notions of 'primitive' and 'civilised' – tropes of particular significance in relation to Europe's definition of its 'internal other'.[2] I am going to concentrate here in particular on the Bonaparte photographs, because we can see them operating clearly within a visual economy that connects with the production of anthropological meaning on a number of levels and that forms the focus of *Imaginary Homecoming*.

Bonaparte's Photographs

In 1884 Prince Roland Bonaparte, the son of Napoleon Bonaparte's nephew, undertook a three-month scientific expedition to Lapland in the course of which he 'endeavoured to study the Lapps from two points of view – anthropometrically and ethnographically'. His agendas were grounded strongly not only on the objective, positivist links between

photography and the emerging discipline of anthropology in general, but more specifically in the French school of physical anthropology. Throughout this work Bonaparte used Broca's method of anthropometry, measuring about 150 individuals (Bonaparte 1886:210–11). In the 1870s Bonaparte had studied with the polygenist Paul Broca, generally acknowledged as the founder of modern physical anthropology and the major influence in the field well into the 1880s. Much of the methodology was drawn from medical or biological science and was premised on precise observation and measurement within comparative anatomy. A biologically determined model of culture was premised on the resulting classificatory and representational methodologies.[3] As Dias has argued, the visual was integral to the production of such models. The desirable photographic manifestation of these ideas was articulated by Broca in his *Instructions generales pour les recherches anthropologiques* (1865).[4] Like the project that Huxley and the Ethnological Society attempted with the Colonial Office (see Chapter 6), it emphasised the requirement of clear, systematic photography of the subject, in full face and profile, capable of yielding raw data in the delineation of 'racial types' for comparative study. However, Bonaparte was also influenced by La Play, a liberal economist and social theorist, who advocated a detailed study of the conditions of family, religion and social integration in the interests of moral progress and the remedy of the ills of the human condition. These ideas were especially present in the person of François Escard, Bonaparte's librarian, who had been closely involved with La Play, and whose influence permeates the ethnographic notes and accounts of the expedition (Delaporte 1988:7–8).

Bonaparte's Sami photographs, taken by his secretary M. G. Roche, are in many ways different from other sets of anthropological images that he had made, in that they were the result of travelling and working in the region. Many of Bonaparte's other photographs were taken without that cultural dimension of place. Rather, he photographed groups re-enacting culture as spectacle in the shows and exhibitions of Western Europe, for instance the 'indigenous and mixed race groups' from Surinam at the Amsterdam Colonial Exhibition of 1883 (Bonaparte 1884), the Omaha group at the Jardin d'Acclimitation, Paris in 1884 ('Peaux-Rouges' 1992) or Australian Aborigines from Queensland, toured by R. Cunningham, and photographed by Bonaparte in Paris in 1885 (Poignant 1993). Yet despite the expedition locus of their making, the resulting images appropriate the Sami subjects into the normalised visual conventions of nineteenth-century science, for they were products of the same intention, to provide objects of study and

of classification within the visual agendas of late-nineteenth-century French science. With a tension between aesthetic forms of presentation and content that was not uncommon, many of Bonaparte's photographs were disseminated in portfolios, red half morocco and buckram, embossed with gold lettering. Each contained mounted albumen prints, stamped with Bonaparte's impressive blind stamp of a double-headed eagle and accompanied by a printed booklet containing anthropometric and other descriptive detail.

The contexts of the making of all these images emphasise the scientific spectacle of classifiable bodies. But they also point to the mutually sustaining relationship by which scientifically legitimated notions of race and culture, the primitive and the exotic, informed popular culture, enhancing the popularity of the shows and legitimating the exotic spectacle in which photography, including Bonaparte's portfolios, both set and maintained the agendas of visibility. This convergence is illustrated by a 'performance' of the Sami images at a meeting of the Anthropological Institute in London on 9 June 1885. Such a performance establishes the photographs in a number of trajectories that form the focus of Puranen's exploration in *Imaginary Homecoming*. At the meeting, Prince Roland Bonaparte exhibited a 'very large collection of photographs of Lapps'.[5] There followed a short lecture by Bonaparte on the physical anthropology investigations of his expedition: 'Note on the Lapps of Finmark (in Norway) illustrated by photographs' (1886). The paper linked strongly to the display of photographs and stated that 'Each Lapp was photographed in full face and in profile, the two positions being rigorously exact, whence it follows that all these photographs are comparable among themselves' (1886:211). This was followed by a substantial paper on the ethnography of the Sami by anthropologist Professor Keane, who brought along a Sami group, then performing at the Alexandra Palace, as living exhibits (1886).[6] They were listed in the minutes of the meeting alongside the photographs.

> To members of this Institute, devoted as they are to the special study of mankind, an intellectual treat of the Alexandra Palace, which without inconvenience to ourselves, offers us a rare opportunity of observing on the living subject the physical qualities, social usages and domestic life of perhaps the most interesting group of aborigines still surviving in Europe. A section, as it were, of the Arctic region of Lapland has been brought to our very doors ... They are here in our very midst ... a compact family group, affording with their 'furniture and fixings' objects

and implements of daily use, some even of their domestic animals [there was a dog present], a picture in miniature of the whole life of the people drawn directly from nature (Keane 1886:213).

Finally, there was a paper on the 'Physical Characteristics of the Lapps' by Dr J. G. Garson who, with Professor Keane, had examined the Sami at Alexandra Palace (1886:235–8).

This little history of the meeting on 9 June 1885 has been outlined because it serves to encapsulate not only the interplay of the scientific and the popular, but more importantly the visual, textual and physical appropriation of Sami people into the discourses of Western science in the nineteenth century, their 'typification' for consumption, and the way in which the physical reality of people, object and photograph assumed a contiguous evidential quality. The anthropological object had been created from disparate forms of evidence, the truth value of which was mutually sustained in a symbiotic relationship.

Within a specifically Finnish local agenda, which especially informs Puranen's work, the visual rhetoric of scientific objectification that delineated Sami as 'distanced' and 'outsideness' was manifest in two ways. Visualisations played, first, on the marginal status of Sami people in socio-economic and political terms in the emergence of the modern nation-states of Scandinavia and, secondly, in racio-cultural terms as Europe's 'aboriginals'.[7] In Finland the years 1924–1928, in particular, were a period of intense anthropological fieldwork under the auspices of the Finnish Academy of Sciences. It built on a substantial tradition of internal ethnography and anthropology of both Sami and non-Sami populations that had been undertaken since the mid-nineteenth century.[8] The Academy of Sciences had established an anthropological committee in 1924, under the directorship of Yrjö Kajava, which was directly linked to the political and historical sensitivities of the newly independent state of Finland. This provided a measure against which Finnish Nationalist agendas could be placed in the 1920s, when Finnish notions of identity needed to define, amongst other things, 'civilised' Finns against 'natural' Sami. Thus, like so many constructions of 'otherness', such categorisation was as much an exercise in self-definition as a scientific endeavour. This history of national self-definition constitutes a reflexive undercurrent in Puranen's exploration of the intersecting histories of Sami and non-Sami.

In drawing heavily on these various anthropological and historical images and their implications, *Imaginary Homecoming* subjects them to an expressive repositioning and renegotiation. As such it represents a

dynamic articulation of history as a continuing dialogue between past and present concerns, while at the same time forming a broad critique of the 'cultures of imaging and imagining'. As Thomas has recently argued, while there are differences between the ways in which artists and historians or anthropologists re-use and represent the past for the present, nevertheless, art works are interpretations, in their own right, of the issues that preoccupy historians and anthropologists, and they invite comparison with texts of various kinds. They are co-interpreters of the issues that preoccupy scholars and artists alike. They present different ways of expressing, exploring and stating the relationship between the past and the present, and translating culture from one space to another, yet each is partial (N. Thomas 1999; Edwards 1997). It is the result of this cultural appropriation, visual fracture and historical intersection, the cultural stage on which the performance of the images was played out, that Jorma Puranen's photographs confront.

In making *Imaginary Homecoming* Puranen rephotographed anthropological photographs. Significantly, this was done in both positive and negative forms. These copies were enlarged, printed on large plexiglass panels, and inserted in the landscape of northern Scandinavia, the land of the Sami. Alternatively they were printed, as positives or negatives, on polyester sheets and wrapped around trees or hung in bushes. As such, the subjects of the photographs reconnect, literally, with the land. The installations were then rephotographed (see Figure 9.1.). These pieces constitute an imaginary, metaphorical homecoming that plays on both the iconic and the indexical qualities of the photography (Puranen 1993:96). First, there is an iconic merging of historical human form and contemporary natural forms. Second, at an indexical level, the displacements of Sami people become manifested through the relationship of the photograph to its absent referent. Something of Barthes's indexical romanticism is at work here 'The Photograph is literally an emanation of the referent. From a real body, which was there, proceed radiations which ultimately touch me, who am here; the duration of the transmission is insignificant; the photograph of the missing being . . . will touch me like the delayed rays of the star' (1984:80).

Mirroring contemporary anthropological concerns with the form of voice and authority in cultural representation, *Imaginary Homecoming* presents a clear articulation of the paradox of photography itself as identified by Sekula: 'The hidden imperatives of photographic culture drag us in two contradictory directions, toward "science" and the myth of objective truth . . . and toward "art" and the cult of the "subjective

experience" ... In its own erratic way photographic discourse has attempted to bridge the gap between the extreme philosophical and institutional separation of scientific and artistic practice' (1987:124–5). Thus *Imaginary Homecoming* juxtaposes two historically specific notions of photography, the positivist and the mutable. The positivist realist images of the nineteenth century operate within a metonymic rhetoric of substitution – here the objectified body. Yet they are transformed, becoming part of a reflexive visual exploration in the late twentieth century, where self is positioned historically in that very set of dynamic and ongoing relationships that *Imaginary Homecoming* explores.

Puranen's photographs thus assume a metaphorical character as the photographs move from the symbolic space of appropriation, the archive, subsumed in other people's writing of history, to the symbolic space of belonging, being in and of the land. *Imaginary Homecoming* resonates with quotation and metaphor. It creates at one level a redemptive statement in relation to cultural marginalisation and inequality. At another level a mytho-poetic history emerges from the spiritual engagement with the land and the people of the far north, as the theatricality of the performance of these historical photographs moves them from the informational, through the representational, to the contemplative.

The context of the original making of the anthropological images, used so lyrically by Puranen, emphasises, as I have suggested, the scientific spectacle of classifiable bodies. Some of Puranen's images in *Imaginary Homecoming* specifically address the processes of scientific objectification through the deliberate, formal repetition of precisely those forms that characterised it in the nineteenth and early twentieth centuries. The blankets or plain wooden walls, which isolated the subject for scientific scrutiny and provided powerful tropes, are repeated. However, as Maresca has argued, the background cloth – rendered invisible in anthropological photographs through cropping – despatialised the subject and reduced the body to a formal mapping. *Imaginary Homecoming* deliberately repeats this trope, but shows the edges of the cloth, and thus the containment and the constructedness of framing (Figure 9.3). The clips on the securing cords, the way the wind lifts the corner of the cloth, deliberately point to the provisionality and construction of the original images. As we saw with the Huxley project photographs, intrusion into the constructed anthropological space provides a point of fracture – only in Puranen's case it deliberately articulates the conditions of making. Further, the whiteness of the snow in the landscape,

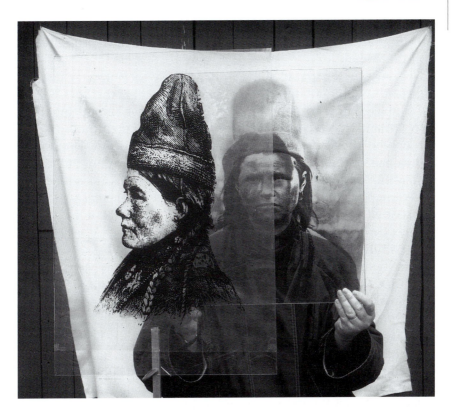

Figure 9.3 From *Imaginary Homecoming*. Photographer: Jorma Puranen. (Courtesy of the photographer.)

one of the defining features of the geographical and historical imagin-ation in the north, has a visual resonance with the whiteness of the blanket or sheet in front of which Sami people were arranged for the mapping of their bodies (Maresca 1996:219–20, 224). However, in the stylistic re-enactment of historical ways of photographing, the dead and the living are brought together. The plexiglass panels of historical images, placed (or is it re-placed?) in front of the scientific sheet, are held by living hands and reveal the presence of the living behind them. Yet the layering of the images is sometimes ambiguous and the visual correlations destabilised. The viewer cannot always distinguish the precise layers as temporal relationships, the dead from the living, the past from the present. Like so many other photographs in *Imaginary Homecoming,* the boundaries between past and present are intentionally blurred. Consequently, the work not only reuses and juxtaposes

historical representations of Sami but refers, through its own formal structures and devices, to the way in which Sami have been imaged over the years.

Not only are the 'quoted' images historically specific; they become present through quotation within the work itself. Sometimes images are doubled. Either by light shining through images, imprinting them into the land or on to trees, or through repetition, their multiple uses throughout the work reflect the multiplicity of historical meaning. Individuals of the past appear in different photographs of Puranen's, as they move into different spaces with different emphases – sometimes cohesion, sometimes dispossession. Identities shift, transposed and transported, connecting past and present, person and community or culture, through repeated presence.

The return is saved from a mere cultural atonement of post-colonial romanticism by the way in which the work confronts viewers with their own history and the nature of photographic appropriation. As the viewers look through the images into the landscape beyond, they are confronted by the faces of the past in the earth, on trees, staring straight into the camera, almost through the camera: '. . . The historical portraits, as it were, block our path when we might be tempted simply to admire the beauty of the landscape. The eyes of the past, so to speak, scrutinize the immense changes that have befallen the northern landscape during this dying century' (Puranen 1999:12). The temporal intersection that photography allows comes together in a spatial intersection, rearranging and reconstituting the spatial dimension of historical experience. The gaze is arrested at the picture plane. The Sami in Bonaparte's photographs look back at us through Puranen's, the viewer is held in the tension of mutual knowledge of what has passed, the gaze – so often problematised – is mutually acknowledged. One is reminded here perhaps of Trachtenberg's comments, following Nodelman, on the dehumanising Zealy slave daguerreotypes made for Agassiz: 'The subject's awareness of being in the presence of a spectator who shares his space and "narrative time" opens a wedge between the mask and the self, the persona and the person – between self-presentation and self-awareness. This acutely strained double awareness signals back to us our own presence as spectators, the pressure of our own gaze upon the portrait subject' (Trachtenberg 1989:53–6). Yet what discussions of gaze have taught us is that perception and indeed cultural understanding always involves a circulation of oppositions, a process of movement back and forth that undermines the fixity of the two poles, inside and outside. The artist working with quotation and

metaphor has to attempt to make what will, forever, be a provisional metaphorical construction, resonate in a way that will remain visible through the circulation of positions (Holly 1996:83). While the viewer is acutely aware of the historical nature of that gaze, re-viewing is placed inescapably in the continuing discourse. Viewing is no longer innocent. We are returned, for instance, to a reality of the experience of encounter and of intensive anthropological fieldwork around Petsamo, north-east Finland, in 1926. From the shape of Bonaparte's camera reflected in the eyes of his subjects to the reflection of Puranen's installations in the land, the encounter and the manifold histories projected from it become encapsulated, stilled; yet that very stillness heightens the historical moment as only photography can: 'Stillness is the moment when the buried, discarded, and the forgotten escape to the social surface of awareness like life-supporting oxygen. It is the moment of exit from historical dust' (Seremetakis 1994:12).

Some Representational Dilemmas

If the seductive, melancholic beauty of the work evokes an aesthetic or emotional response, it could be argued that this is in danger of subverting the work, of overpowering not only more complex meanings, but also masking important ethical issues. Does it heighten awareness of the issues facing Sami people in the twenty-first century?[9] Through the very return of the images in these formal terms, are they merely being reappropriated into yet another Western discourse? Is the work, which results from a form of anthropological fieldwork, just another kind of 'text', with the problems of politics and of ethics and authorship to which traditional ethnography is subject (Schneider 1996:196)? Does it, or can it, articulate intersecting and contested histories? There are certainly other ways of telling the stories that Puranen attempts to articulate. As Said has argued, the 'Native' point of view is not merely an ethnographic fact or a hermeneutical construct: it is a continuing, protracted, sustained resistance to cultural forms of anthropology and political policy and dominance (1989:220). Further, through rephotographing, is Puranen reasserting the technology of dominance and appropriation, despite his careful self-positioning, conscious of the way in which he, as a photographer, is implicated in this tradition? 'From the very beginning, when I made the first picture, I was conscious of my own role as an offspring of the same tradition. I put there among the Sami my own pictures made in a similar vein in the early 1970s, to show that I didn't consider myself innocent' (Ripatti

1993:10–15). Does the success of this work – it has been shown to date in France, Canada, Britain, Spain, Germany and the Netherlands – become exploitative through absorption and performance within international, institutional structures of contemporary art, the photographer's intentions notwithstanding? For issues of the ethics of fieldwork remain, the production of texts and acknowledgement and access given to indigenous groups in the final execution, presentation and interpretation of works (Schneider 1996:196–7). It would appear significant that the press release for the first major exhibition of *Imaginary Homecoming* in the far north of Finland at the Samimuseum, Siida, in the summer of 2000 speaks of the 'awakening' being in Barcelona and London but the 'homecoming' only truly happening at Siida.[10]

These are key issues of translation, authority, legitimacy and multi-vocality, which have been as forceful in anthropology as they have in arts practice. Detailed comment on them, important as they are,[11] is beyond the scope of my particular concerns here, namely photographs as sites of intersecting histories and their potential in the articulation of those histories. However, in response to the questions I have just posed in relationship to Puranen's work, one might cite Foster's contention, in his essay 'The Artist as Ethnographer', of the problems inherent in the assumption that an artist not perceived as culturally and/or socially 'other' has only limited access to the 'transformative alterity' of radical or politicised practice in a given context, while artists perceived as 'other' are assumed to have automatic access to it. He goes on to argue that such a productivist position, which enabled the cultural politics of marginality, has at the same time disabled the cultural politics of immanence relevant to the post-colonial global situation, where models of centre and periphery are destabilised (1995:303–5). It would appear that the intersections in Puranen's work are attempting to address that immanence, although, conversely, its strong romantic impulse, in formal terms, threatens to restate the purely oppositional role of marginality.

Foster's position, and its concern for the structural effects of assumptions about alterity, is broadly echoed by Thomas and others, arguing that the rhetorics of 'decolonisation' replace one set of privileged authorities with another, both of which run the risk of being premised on an essentialism that threatens to romanticise or normalise the 'other' voice (N. Thomas 1997:230; Coombes 1994:218–21). There is a danger that concern with who is speaking is such, that one fails to hear what is being said.[12] The deterministic polarisation of historical authority neglects the fluidity and ambiguity of identity, the intersections and

the shifting and various encounters that constitute past experience, the constituent nature of 'the content of particular renderings' and the role of contested and overlapping agencies within them (Pujade 1994). In many ways it is the discursive formations that both constitute and are constituted by Bonaparte's photographs and the later material from the Finnish Academy of Sciences that, as examples of 'particular renderings', give *Imaginary Homecoming* much of its power.

It is perhaps interesting to consider Puranen's photographs alongside those of the Australian photographer of Aboriginal descent, Leah King-Smith. Although coming from a radically different cultural space as an indigenous artist re-engaging with the 'anthropological archive', her series *Patterns of Connection* (1991) has certain points in common with *Imaginary Homecoming*. Both are making critical interventions in the anthropological archive as key strategies of the work. Like *Imaginary Homecoming, Patterns of Connection* has become extremely successful internationally, being shown in Europe, North America and Japan as well as exhibited widely in Australia. In it, King-Smith replaces and refigures historical photographs of Koori (Aboriginal) people from the La Trobe Collection of the State Library of Victoria. They are the kind of photographs found in anthropological archives the world over. Massively enlarged and manipulated in fine cibachrome prints, ghostly figures move through a contemporary painted and photographed landscape of King-Smith's own making. Like Puranen's imaginary homecoming, the source photographs 'show subjects inscribed in history, within a nexus of power and knowledge. These figures are positioned within a particular narrative of the past then recontextualized in the present. This reconstructed past . . . draws on memory, narrative and myth, positioning the subject within identity politics' (Marsh 1999:117).[13] As with all such projects, there is a danger of collapsing into an essentialism in the attempt to repossess and articulate Aboriginal cultural identities.[14] Yet repossession and re-engagement with such images is an essential step towards redetermining people's self-esteem (Croft quoted in Williamson 1999:219). Both these works use the quotation to convey meanings that, at one level, are diametrically opposed to their source. However, they differ in that King-Smith's images largely obliterate the originating contexts of the original photographs by remaking them, whereas Puranen's, through their referencing of historical tropes, such as the plain backdrop of scientific photography, constitute a re-reading of and engagement with the historical ambiguities inherent in such an exercise and an acknowledgement of what Bhabha has termed 'the process of subjectification' (1994:67).

Quotation itself is, however, not unproblematic. Joan Kerr's discussion (1999:236) of similar dilemmas of legitimacy and the pitfalls of romantic paternalism, in relation to Australian artists quoting from the early European artists of colonial Australia, would seem to resonate with the problems I outlined earlier. Not only is there, as I have suggested, a risk of essentialising complex historical values, but also a danger that the artists replicate rather than dislodge the curatorial and/ or scientific authorities that a work was intended to critique. However, as Kerr goes on to argue, there is a crucial difference between quotation and appropriation. The former comes from within. Owens has argued that images appropriated into contemporary arts practice are emptied of their resonance, their significance and their authoritative claim to meaning (1992:54). While highlighting the borderline between appropriation and quotation, such a claim would seem to go too far for work such as that of Puranen and King-Smith, and indeed equally powerful work of re-engagement such as Carrie Mae Weems's interventions in Zealy's slave daguerreotypes which were made for Agassiz. In this work, *From Here I Saw What Happened and I Cried,* daguerreotypes, enlarged in black and red, are placed in oval vignettes and overprinted with linked statements: 'You Became a Scientific Profile', 'A Negroid Type', 'An Anthropological Debate', '& a Photographic Subject'. Rather, I would argue that in such quotation the historical images are not emptied but engaged with, challenged. Their claims are still present, but they are powerless in relation to the changed meanings with which the images have become newly imbued. It is precisely the articulation of multiple meanings and contested histories *within* the photographs, an awareness of their original meanings and possible meanings in between, that is integral to the efficacy of the artistic intervention. The international success of the work might constitute an institutional form of appropriation; but the intentions of the work, its roots and its realisation at a local level constitute quotation to critical effect, for they open another space for the subjective contemplation of histories.

Counterpoints

Imaginary Homecoming faces complex and ambiguous dilemmas of this kind. Yet, as Robert Pujade has argued (1994:48), the aesthetic quality itself also works towards the destruction of ethnocentrism. The ghostly figures, shimmering in the landscape, emerging from (or is it into?) trees, transform the space into something ineffably bound to the people themselves, belonging in terms of human spirit. At one level it is intensely

romantic, and as Marsh has argued in relation to King-Smith's work, appeals to a contemporary nostalgia for spiritual roots. But at the same time it is also potentially powerful and reaffirming as '. . . a "strategic" essentialism [that] can trigger a dynamic discourse' (Marsh 1999:114, 117). The ambiguities of the work are essentially those of photography itself, with its rawness, mutability and indeterminacy. The work attempts to resist essentialising discourses by making clear its own limitations in terms of representation. Rather than pondering the relation with what might have been lost, this re-engagement with images of anthropology's history tries to suggest what we might perhaps still find (Puranen 1999:12). In the same way as I suggested with the very different photographs of Jenness and Acland, *Imaginary Homecoming* attempts to clear a space from which alternative histories might emerge.

This reading is also positioned through counterpoint. It is here one senses the possibility of Foster's cultural politics of immanence, for Puranen does not present us with an unmediated, restated arcadia but a complex set of relations in which the land is central. It is a cultural landscape in which, Puranen asserts, we are implicated as the battle for the northern environment takes a new shape, with the land being investigated as a potential mineral resource.[15] These are histories that cannot be tied only to questions of ownership of the past, but must address ownership of the future through a repositioned relationship between centre and periphery. This becomes clear in some of the works that confront the fragile homecoming in the face of actual fracture. These images explore the complex set of contemporary relations concerning land. The formal and actual dislocations of railways, barriers, surfaced roads and opencast mineral extraction intervene in the 'homecoming' as harsh interjections. The stress is on the communications that tie old Sami lands to global networks. The photographic frame is full of power lines and telecommunications, railway tracks and fences to contain snow, all enabling a different land use from that of the traditional economies. Details of contemporary economic exploitation of the land, such as cars, camper-vans and hotels, further puncture arcadian impulses.

Overlaid on opencast mines and railway tracks leading to industrial plants are images of Sami people (the same images that peopled the landscape) arranged in rows of stark frontality, in a way that recalls the anthropological intention of many of the photographs (Figure 9.4). It is a new deindividualising appropriation, of the individual entangled in a web of globalisation. From this resonate two further appropriations:

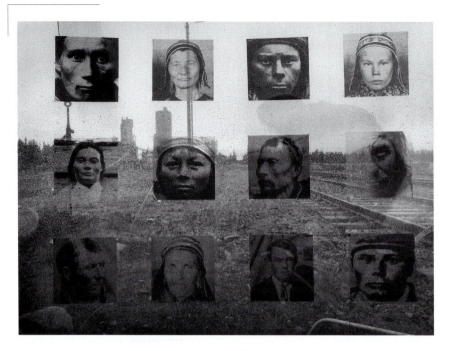

Figure 9.4 From *Imaginary Homecoming*. Photographer: Jorma Puranen.
(Courtesy of the photographer.)

first, land and body, and by implication culture; and second, the threat
to landscape, which is a threat to memory and history, the very being
of social existence. The formal language of the photographs is that of
fracture. No light passes through the images, whereas in the landscape
images there is a more embracing 'homecoming' as the rays of the
Arctic sun project images into the land – like the 'sun pictures' of early
photography, rays of light inscribe the image.

 The formal arrangement of some of the photographs within the frame
of Puranen's work also suggests, conversely, the format of the family
album. Rows of faces, arranged in a narrative of juxtaposition, look out
at the viewer. In this reading, the portrait mode also points to disquiet.
The traditional dimensions of existence represented in the humble
family photographic portrait sit uneasily in a consciously disjointed
relationship with the background space. In this space, change is
represented as a violent penetration and intervention with the land-
scape forms. The same formal language of fracture is at work. This is a
social reality in which the dislocation of the northern lands makes it
increasingly difficult to sustain traditional economic patterns, and
people are drawn increasingly into the institutional systems of the

nation-state and dependency culture. Furthermore, the contemporary interventions anchor Puranen's photographs to a precise temporal moment measured against the 'atemporal' metaphor of homecoming, with its tranquillity and timelessness of snow and birch trees, a place of refuge and a place of coherence. It is perhaps in these images that the tensions I have already suggested become visible; the fragility and disquiet deep within some of the photographs that make up *Imaginary Homecoming* are brought to the fore through the juxtapositions in a way that articulates their haunting quality. Yet conversely it is in these images that one might argue that *Imaginary Homecoming* becomes a form of ethnographic commentary, making incisive statements about the cultural realities and experience of the people of the far north at the end of the twentieth century.

The juxtaposition of contradictory ideas resonates through the series. The redemptive qualities of homecoming and the spatial dimension of landscape are counterbalanced in the confrontations and imbalances of intersecting histories. Perhaps the key to evaluating such a project is the recognition that 'histories are cultural projects embodying interests and narrative styles, the preoccupation with the transcendent reality of archives and documents should give way to dispute about forms of argument and interpretation' (N. Thomas 1997:34). Such a view allows space for the multiple elements of *Imaginary Homecoming* to co-exist. The viewers (and by implication, the 'archive', the residence of images) are drawn into their/its own place in these histories. They can never be free of each other, each pointing to the possibilities of other histories within the other.

This in itself poses some problems. Since it is impossible to return every archival image, literally, to the place of its inscription, the process becomes selective. To this extent *Imaginary Homecoming* might be seen as engaging in a problematically generalising discourse based on an undifferentiated Sami.[16] The merging of the portraits spatially and the compression of time suggest the collective vision. Nevertheless, through its very title the work removes itself from the possibility of realist statements. The possibility of completeness or closure of narrative is precluded, stressing the way in which the significance of the photographs is symbolic within the homecoming. Importantly, however, Puranen's re-engagement with the images goes beyond merely returning photographs at the metaphorical level. Indeed, following Valkeapää's *Beaivi Áhcázan,* it was the recognition of people and names in relation to the documentation of anthropological photographs that formed the original impetus for the work: 'I was in Paris, among millions and

millions of people, sitting in a dark museum and going through photographs of the Sami. I recognised some names, knew they had to be the grandmothers and great grandfathers of people I knew in Kautokeino. There they were, they had been waiting in those boxes for a hundred years. I thought that I maybe should do something about it' (Ripatti 1993:12). Although Bonaparte's photographs are 'types', they are meticulously documented, with the names and ages of the subjects given. This is paradoxical information, in that it functions both to label the scientific specimen, and, through Escard's sociological interests, to individualise and socialise the subject. It is precisely this kind of documentation, collected to enhance the various scientific meanings of the photographs, that opens the space for re engagement and a 'homecoming'. The documentation moves photographs into a totally differently constituted informational space and enabled them, as active socially salient objects, to move back from the public collective anthropological space of the archive to a private space of consumption as the photographs circulated in the local community and in schools. It is a return with both an individual and a collective level. The new dynamics of viewing translate the 'type' into the individual, restoring autonomous personhood. Berger's comment, so pertinent in the case of Jenness's D'Entrecasteaux photographs, is equally so here: 'If the living take that past upon themselves, if the past becomes an integral part of the process of people making their own history, then all photographs would reacquire a living context, they would continue to exist in time, instead of being arrested moments' (1980:57).

Again, such a position cannot be dismissed as mere romanticism, for it reinserts the possibility of individual experience in the historical record and alternative histories. A lack of written history, especially for the elderly of the communities, in conjunction with the displacements and deprivations of forced removals and volatile political boundaries, gives visual histories particular potential. They are complementary sources to oral histories. As Maresca has argued, images here 'speak', they are interlocutors. From this perspective photographs become, as I suggested in earlier chapters, a form of orality that would not exist independently of the photographs. The photographer here, in terms of memory, reunites material form (in the photographs as objects) with language form, rendering words visible (1996:203–4, 210). Added to this is Puranen's own return, and perhaps that of anthropology, for, as I have suggested, *Imaginary Homecoming* has strong elements of reflexivity and auto-critique, which position the relationship between the photographer and the subject.

Conclusion

Finally, one must consider briefly these photographs as physical objects, for this has been central to Puranen's photographic 'performance' of these images. Further, the materiality of the photographs in the archive impressed itself upon Puranen '. . . these material objects – faded, ripped and worn-out photographs of people long deceased – become vivid and strongly present' (1999:11). The photographs move from image to object to image, reflecting the materiality of the photograph as object and the people it re-presents, moving in different spaces, all of which contribute to the biography of the *object,* integral to which is re-engagement with the *image.* Although I have been discussing *Imaginary Homecoming* as a series of photographs, the work has also been shown in installation form. Becoming almost theatre or re-enactment of the social biography of the original images themselves, the photographic objects move from their making in the lands of the north in 1884, to the archive, to return to the north of Norway and Sweden as fleeting installations made to create the images, to the local communities, and then to spaces of the global contemporary art world, for instance the 1992 Rotterdam Photography Biennale or the Photographers Gallery in London in 1994, where the plexiglass panels were shown as free-standing installations in front of a photo-mural of birch trees in a landscape. In these installation 'performances' of *Imaginary Homecoming* the photographs themselves are actually enclosed in space, an inversion of photography's usual spatial relationship, the images refiguring in each space. The sheer physical power of the photographs in installation forced a response, which was grounded as much in the power of the object as in the power of the image.

In many ways *Imaginary Homecoming* might be seen as an 'entangled object' (N. Thomas 1991:125), changing as a socially and culturally salient object, in defiance of its maker's intentions and their material stability and appearance, as they perform, projecting new meanings, in different spaces and at different times. Thus the photograph becomes the site of the fluid renegotiation of the past. It is not merely evidence in terms of pure document – what people wore, how they lived. It is ineffably of the past and of the present, as it moves through different spaces. Historical photographs here become explicable through re-engagement and the creation of new visual material. Puranen's work represents an exploration of the space between the historical document as such and the expressive investigation of that document, including the assumptions, classifications and significances in which it is enmeshed.

At a metalevel it constitutes precisely an instance of criticism consciously disrupting the 'naturalisation of the cultural', which, Barthes argued, is repeated and reinforced at almost every level of cultural apparatus, of which 'the archive' is held paradigmatic (Sekula 1987:119; Barthes 1977). In the course of this process, the authority of the photographic text is recentred to suggest new meanings and new relevances.

Notes

1. Jorma Puranen, personal communication.

2. For a summary of the history of anthropologies of Europe, see Schippers (1995).

3. For a summary see Stocking (1968:56–8).

4. Similar systems were published by Quatrefages in his *Instructions générales aux voyageurs* (1875) and later by Topinard, 'Instructions anthropométriques pour les voyageurs' (1885). Whatever their individual differences they stressed the non-verbal in racial description and point to the centrality of images in constructing knowledge within medicine and comparative anatomy. See Dias (1994:89–90, 1997).

5. This portfolio of pairs of photographs of scientific reference, still in the collection of the Royal Anthropological Institute, London, partially duplicates the 250 portraits in the Musée de l'Homme.

6. There is a large and growing literature on ethnographic spectacles of the nineteenth century: see for example Thode-Aurua (1989) and Kirshenblatt-Gimblett (1991). Lapp (Sami) groups had been exhibited as human spectacles, performing their own culture on a number of occasions in the nineteenth century. For instance there was a group at Bullock's Museum in London in 1822. Accounts would suggest that they were viewed as a form of stoic 'noble savage' surviving against all the odds in a very difficult terrain and climate on the edges of 'civilised' Europe (Altick 1978:273–5). Sami people were amongst the first groups at Hagenbeck's 'anthropological-zoological' exhibition at the Tierpark in Hamburg in 1874, and re-enacted their daily life to large and enthusiastic audiences.

7. An imagery still perpetuated in tourist literature, travel documentaries and so forth.

8. Finland was a Grand Duchy of the Russian Tsar throughout the nineteenth century, becoming an independent nation-state in 1917. I. K. Inha's photographs

of the peasant life of Karelia, for instance, made in the 1890s, were integrally connected to a Finnish sense of national identity. The series included re-enactments, somewhat erroneously posed, of the chanting of oral poetry, the roots of the *Kalevala*, the Finnish national epic. Some of the photographs were published as *Suomi Kuvissa* (1896) and presented the divided borderlands of Karelia as a unified Finnish entity in terms of national consciousness.

9. For up-to-date information on a wide range of Sami issues see http://www/yle.fi/samiradio/enlink.html.

10. Press release for *Imaginary Homecoming* Samimuseum, Siida, June – November 2000. I am grateful to Arja Hartikainen for this information. The Sami word *siida* means 'home' or 'village'.

11. There is a massive and growing literature. See, for example, Araeen (1991); Jahnke (1999) ; Livingston and Beardsley (1991); Marcus (1995); Tsinhnahjinnie (1998:41–56); N. Thomas (1998).

12. 'On the issue of authorship, it may indeed be a good thing if Bengali history is written by Bengalis rather than Americans or Australians, but it is certainly a bad thing if the identity of the writer is reduced to his or her membership of a national, minority, or subaltern group and taken to be more important than what is actually written' (N. Thomas 1997:29).

13. For two excellent discussions of the issues in relation to *Patterns of Connection* see Marsh (1999:113–17); Williamson (1999).

14. There is a massive literature on post-colonial identities, hybridity and arts practice, beyond the scope of this essay: see for instance Bhabha (1994), S. Hall (1996) and Spivak (1990).

15. Puranen, personal communication.

16. Indeed, the nomenclature 'Sami' was resisted by some of its constituent people: for example, Skolt Lapp people, who saw their own specific identity, the name they called themselves, subsumed within a wider politicised cultural description (Ingold 1976: 232–4).

ten

Epilogue

I was talking to a colleague visiting unexpectedly from an African country. Still pinned on my wall was a reproduction of a photograph that I had been discussing with students. It was a difficult image, conflating the scientific and the exotic voyeurism of colonial desire. Two very beautiful young women, from my visitor's country, posed for the camera in the style of scientific reference, one facing the camera, the other with her back to the camera. The photographer focused, both photographically and in terms of his desire, on the star-like cicatrices covering the women's bodies. To stress the cicatrices, the photographer had overpainted their negative inscription so that they printed white. White stars hovered almost surreally over the women's black bodies. It appeared to me a classic image of colonial desire, and it made me uneasy. Seeing my visitor's eyes stray often to the photograph, in the end I said 'What do you think of that photograph?', 'It's wonderful' said my visitor 'my grandmother had cicatrices like that, so beautiful – seeing that I remember the smell of her.'

As Bakhtin (1981:152–3) suggested, it is always possible to reach to the human voice, and thus human experience, because the text is never dead. Hulleah Tsinhnahjinnie has positioned such moments of recognition, and the shift from observed to observer: 'That was a beautiful day when the scales fell from my eyes and I first encountered photographic sovereignty. A beautiful day when I decided that I would take responsibility to reinterpret images of Native peoples' (1998:42). The rawness of photographs, their infinite recodability, their inclusiveness and randomness of inscription, hold the seeds for recognition. The increasing sense of visual sovereignty empowers one not only to make images, as contemporary practitioners are doing, but to re-engage with and re-interpret historical images from radically different perspectives, to give 'voice' to images and through them to insert the human voice, breaking through the containing contexts of photographs, to articulate the submerged. This is the site of their historical potential.

235

The starting-point for these essays, as I said at the very beginning, was at the coal-face – a theoretically informed engagement with photographs themselves as socially salient visual objects that operate in social space and in real time, and not simply the undifferentiated products of a practice conceived only in abstract terms. I have argued throughout the necessity of a different conceptualisation of the historical potential for photographs as they operate at the intersection of different historical trajectories. In photographs there meet for a moment histories of the colonial, of the colonialised, and of anthropology as a discipline represented through its instruments of fieldwork, the archive and the museum. I have found this visualising concept of intersecting traject-ories important because it encompasses registers of both common ground and difference within the photographic inscription. Rather than attempt a unified perspective, I have tried, where possible, to bring the fluid, partial, ambiguous and contradictory nuances inherent in photographs into focus and to explore them as potential points of fracture in the surface inscriptions of photographs.

While photographs may have different densities in the way that they bring together those field forces of social relations and present their contents, they nonetheless all carry with them the characteristics of photography as a medium of inscription. As such, all photographs are touched in some way, to a greater or lesser extent – official photographs, family photographs, portraits, the complex residues of cross-cultural encounter. They have the potential to perform history in ways in which we perhaps least expect, when they are used not simply as evidential tools but as tools with which to think through the nature of historical experience. The positioned subjectivities in looking at photographs leave a space to articulate other histories outside the dominant historical methods. As I have suggested, even the most heavily connotative photographs, saturated with the asymmetries of power relations and objectifying rhetorics, can be made to reveal the moments of human experience, the little narratives that are constituted by and are constit-utive of the larger.

Alternative histories in relation to photographs can only be carried forward 'on the basis of the conception of the historical record as being not a window through which the past "as it really was" can be appre-hended but rather a wall that must be broken through if the "terror of history" is to be directly contested and the fear it induces dispelled' (H. White 1983:143). This is especially so of photographs, with their indexical certainty, analogical insistence, and beguiling realism. With photographs in cross-cultural relations that terror and fear is not only

of the making of the inscription but of the appropriation and disen-franchisement of histories into institutional practices of interpretation and control.

What I have tried to do is point to ways in which the wall can be broken through and 'The Archive' can be opened up conceptually. This implies an opening up of photographs themselves to explore other explanatory models. Such a strategy means letting go of categories, as photographs enter another stage of their social biography. The histories I have recounted in the course of my case-studies are only some of the possible histories embedded in the photographs. I can only tell those that I, as a late-twentieth-century/early-twenty-first century viewer, a product of my own particular cultural background, can extrapolate. There are other histories that have not been my focus here, but which are actively engaged with images; histories belonging to other peoples and places. What I have wanted to do is to disturb the surface of the photograph and the archive, to hint at the possibilities that photo-graphs hold. As yet many of them are raw histories, to be articulated, digested and made active.

Bibliography

Archival Sources (abbreviations used)

Acland Papers, Bodleian Library, University of Oxford (BOD.AP)
Haddon Papers, Cambridge University Library (CUL.HP)
Huxley Papers, Imperial College, University of London. (ICL.HP)
Oxford University Archives, Bodleian Library, University of Oxford (OUA)
Tylor Papers, Pitt Rivers Museum, University of Oxford (PRM.TP)
Spencer Papers, Pitt Rivers Museum, University of Oxford (PRM.SP)
Photograph Collection, Cambridge University Museum of Archaeology and Anthropology (CUMAA.PC)
Photograph Collection, Pitt Rivers Museum, University of Oxford (PRM.PC)
Photograph Collection, Royal Anthropological Institute (RAI.PC)
Public Record Office, Kew, (PRO)

Other archival references are given in full in the endnotes.

Published Sources

Alpers, Svetlana 1989
The Art of Describing: Dutch Art in the Seventeenth Century, Harmondsworth: Pelican.
Altick, R. 1978
The Shows of London, Cambridge, MA: Belknap.
Ames, Michael 1992
Cannibal Tours and Glass Boxes: The Anthropology of Museums, Vancouver: University of British Columbia Press.
Anthropological Institute 1873
Report of the Council for 1872, *Journal of the Anthropological Institute,* ii: 428.

—— 1878

Report of Meeting, *Journal of the Anthropological Institute,* vii:2.

—— 1882

Report of Meeting, *Journal of the Anthropological Institute,* xi: 74.

—— 1887

Report of Meeting, *Journal of the Anthropological Institute,* xvi: 23.

—— 1889

Report of Meeting, *Journal of the Anthropological Institute,* xviii: 241.

Appadurai, A. (ed.) 1986

The Social Life of Things: Commodities in Cultural Perspective, Cambridge: Cambridge University Press.

Araeen, Rasheed 1991

'From primitivism to ethnic arts', in Susan Hiller (ed.), *Myths of the Primitive,* London: Routledge.

Athenaeum 1872

'A series of photographs from the collections in the British Museum', 7 Sept. , No.2341: 309–11.

BAAS, (British Association for the Advancement of Science) 1879

'Report of the Anthropometric Committee'. *Reports of the British Association for the Advancement of Science* 49: 175–20.

—— 1899

Notes and Queries on Anthropology, 3rd edn. London: BAAS.

—— 1912

Notes and Queries on Anthropology, 4th edn. London: BAAS.

Bakhtin, M. 1981

The Dialogic Imagination: Four Essays, Austin, TX: University of Texas Press.

Bal, Meike 1996

Double Exposure: The Subject of Cultural Analysis, London: Routledge.

Barnouw, D. 1994

Critical Realism: History, Photography and the Work of Siegfried Kracauer, Baltimore, MD: Johns Hopkins University Press.

Barringer, Tim 1998

'The South Kensington Museum and the colonial project,' in Tim Barringer and Tom Flynn (eds), *Colonialism and The Object: Empire, Material Culture and the Museum,* London: Routledge.

Barringer, Tim and Tom Flynn (eds) 1998

Colonialism and The Object: Empire, Material Culture and the Museum, London: Routledge.

Barthes, Roland 1977

Image Music Text (trans. S. Heath), London: Fontana.

—— 1984 [1980]
Camera Lucida, (trans. Richard Howard) London: Fontana.
Bateson, Gregory and Margaret Mead 1942
Balinese Character: A Photographic Analysis, New York: New York Academy of Sciences (Special publications Vol. II).
Bather, F. A. 1894
'Some Colonial Museums', *Report of the Proceedings of the 5th Annual General Meeting of the Museums Association*: 193–239.
Baxter, T. W. and R. Farndon 1991
'Genre as a middle term', *Bulletin of the John Rylands University Library of Manchester* 73 (3):3–10.
Becker, Howard 1981
Exploring Society Photographically, Evanston, IL: Northwestern University Press.
Beckett, Jeremy 1998
'Haddon attends a funeral', in A. Herle and S. Rouse (eds) *Cambridge and the Torres Strait: Centenary Essays on the 1898 Anthropological Expedition*, Cambridge: Cambridge University Press.
Bender, John and D. E. Wellbery (eds) 1991
Chronotypes: The Construction of Time, Stanford, CA: Stanford University Press.
Benjamin, Walter 1973
'The task of the translator', in *Illuminations* (ed. H. Arendt), London: Fontana.
Bennett, Tony 1995
The Birth of the Museum: History, Theory, Politics, London: Routledge.
Berger, J. 1980
Uses of Photography, London: Writers Cooperative.
—— and J. Mohr 1989 [1982]
Another Way of Telling, London: Granta.
Bhabha, Homi 1994
The Location of Culture, London: Routledge.
Binney, Judith and G. Chaplin 1991
'Taking the photographs home: the recovery of a Maori history', *Visual Anthropology* 4(3–4): 431–42.
Bleek, Wilhelm and Lucy Lloyd 1911
Specimens of Bushmen Folklore, London: George Allen.
Bloch, Marc 1954
The Historian's Craft, Manchester: Manchester University Press.
Blum, Ann S. 1993
Picturing Nature: American Nineteenth Century Zoological Illustration, Princeton, NJ: Princeton University Press.

Bonaparte, Prince Roland 1884
Les Inhabitants de Suriname à Amsterdam, Paris: D. A. Quantin.
—— 1886
'Notes on the Lapps of Finmark (in Norway)', *Journal of the Anthropological Institute* xv: 210–13.
Borne, G. 1998
'Public museums, museum photography and the limits of reflexivity', *Journal of Material Culture* 3(2):223–54.
Bouquet, Mary 2000
'Thinking and doing otherwise: anthropological theory in exhibitionary practice', *Ethnos,* 65(2):217–36.
Bourne, R. 1985
'Are Amazon Indians museum pieces?', *New Society* 29 November ,74 (no.1196):380–1.
Brigham, W. T. 1898
'Director's Report,' *Occasional Papers of the Bernice Pauahi Bishop Museum* 1(1).
—— 1913
'Report of a journey around the world to study matters relating to museums,' *Occasional Papers of the Bernice Pauahi Bishop Museum* 5.
British Journal of Photography 1869
'Ethnological Photographs', XVI No.494, 22 October 1869: 513.
Bronner, Simon 1989
'Object lessons', in S. Bronner (ed.), *Consuming Visions: Accumulation and Display of Goods in America 1880–1920,* New York: W.W. Norton & Co.
Brothers, Caroline 1997
War and Photography: A Cultural History, London: Routledge.
Bruner, Edward M. 1994
'Abraham Lincoln as authentic reproduction: a critique of postmodernism', *American Anthropologist* 96 (2): 397–415.
Bryson, Norman 1990
Looking at the Overlooked: Four Essays on Still-Life Painting, London: Reaktion.
—— 1992
'Art in context', in R. Cohen (ed.), *Studies in Historical Change,* Charlottesville, VA: University of Virginia Press.
Cadava, Eduardo 1997
Words of Light: Thesis on the Photography of History, Princeton, NJ: Princeton University Press.
Cannadine, David 1987

Rituals of Royalty: Power and Ceremonial in Traditional Societies, Cambridge: Cambridge University Press.

Caygill, Marjorie and J. Cherry (eds) 1997
A. W. Franks: Nineteenth-Century Collecting and the British Museum, London: British Museum Press.

Cell, John 1970
British Colonial Administration in the Nineteenth Century, New Haven, CT: Yale University Press.

Chaloner, C. 1997
'The most wonderful experiment in the world: a history of the cloud chamber', *British Journal of History of Science* 30: 357–74.

Churchward, W. 1887
My Consulate in Samoa, London: R. Bentley & Son.

Clifford, James 1986
'On ethnographic allegory', in James Clifford and George Marcus (eds), *Writing Culture: the Poetics and Politics of Ethnography*, Berkeley, CA: University of California Press.

—— 1988
'On collecting', in James Clifford, *The Predicament of Culture*, Cambridge, MA: Harvard University Press.

—— 1997
Routes: Travel and Translation in the Late Twentieth Century, Cambridge, MA: Harvard University Press.

Collier, John 1967
Visual Anthropology, New York: Holt Winston and Rinehart.

Connerton, Paul 1989
How Societies Remember, Cambridge: Cambridge University Press.

Coombes, Annie 1994
Reinventing Africa: Museums, Material Culture and Popular Imagination, London: Yale University Press.

Cornwall-Jones, H. 2000
'A Home of Signs and Wonders', Review, *Journal of Museum Ethnography* 12:165–8.

Crary, J. 1990
The Techniques of the Observer: On Vision and Modernity in the Nineteenth Century, Cambridge, MA: MIT Press.

Crimp, Douglas 1993
On the Ruins of the Museum, Cambridge, MA: MIT Press.

Cruikshank, J. 1995
'Imperfect translations: rethinking objects of ethnographic collection', *Museum Anthropology* 19 (1):25–38.

Daniels, Stephen 1993
Fields of Vision: Landscape, Imagery and National Identity in England and the United States, Cambridge: Cambridge University Press.
Daston L. and P. Galison 1992
'Images of objectivity', *Representations* 40:81–128.
de Certeau, Michel 1980
Heterologies: Discourse on the Other, Manchester: Manchester University Press.
Delaporte, Yves 1988
'Le Prince Roland Bonaparte en Lapoine', *L'Ethnographie* 84(2):7–20.
Dening, Greg 1988
History's Anthropology: The Death of William Gooch (Association for Social Anthropology in Oceania, Special Publication 2), Lanham, MD: University Press of America.
—— 1994
'The theatricality of observing and being observed: eighteenth century Europe "discovers" the ? century "Pacific"', in S. B. Schwartz (ed.), *Implicit Understandings: Observing, Reporting and Reflecting on the Encounters between Europeans and Other Peoples in the Early Modern Era,* Cambridge: Cambridge University Press.
—— 1996
Performances, Melbourne: Melbourne Unversity Press.
Derrida, Jacques 1987
'Parergon', in *The Truth About Painting,* trans. G. Bennington and I. McLeod, Chicago: Chicago University Press.
Desmond, Adrian 1994
Huxley: Darwin's Disciple, London: Michael Joseph.
—— 1997
Huxley: Evolution's High Priest. London: Michael Joseph.
Dias, Nelia 1991
Le musée d'ethnographie de Trocadero (1878–1908), Paris: CNRS.
—— 1994
' Photographier et mesurer: les portraits anthropologiques', *Romantisme,* 84:37–49.
—— 1997
'Images et savoir anthropologique au XIXe siècle', *Gradhiva* 22:87–97.
Di Gregorio, M. 1984
T. H. Huxley's Place in the Natural Sciences, New Haven, CT/London: Yale University Press.
Dorsett, Chris 1998
Freighted with Wonders, Exhibition catalogue, Ipswich: Ipswich Museum.

Douglas, Bronwen 1998
'Inventing natives/negotiating local identities: postcolonial readings of colonial texts on island Melanesia', in J. Wassmann (ed.), *Pacific Answers to Western Hegemony,* Oxford: Berg.
—— 1999a
'Art as ethno-historical text', in N. Thomas and D. Losche (eds), *Double Vision: Art Histories and Colonial Histories in the Pacific,* Cambridge: Cambridge University Press.
—— 1999b
Across the Great Divide: Journeys in History and Anthropology, Amsterdam: Harwood Academic Press.
Duffield, I. and J. Bradley (eds) 1997
Representing Convicts, Leicester: Leicester University Press.
Edwards, Elizabeth 1990
'Photographic "types": in pursuit of method', *Visual Anthropology* 3(2–3):235–58.
—— 1992
'Wamo: D'Entrecasteaux Islands, New Guinea 1911–1912: photographs by Diamond Jenness', *Pacific Arts* 5:53–6.
—— 1997
'Beyond the boundary: a consideration of the expressive in photography and anthropology', in M. Banks and H. Morphy (eds), *Rethinking Visual Anthropology,* London: Yale University Press.
—— 1998
'Performing science: still photography and the Torres Strait', in A. Herle and S. Rouse (eds), *Cambridge and the Torres Strait: Centenary Essays on the 1898 Anthropological Expedition,* Cambridge: Cambridge University Press.
—— 2000
'Surveying culture: photography and the collection of culture, British New Guinea, 1898,' in M. O'Hanlon and R. Welsch (eds), *Hunting the Gatherers: Collectors and Agency in Melanesia,* Oxford: Berghahn.
Egmond, Florike and Peter Mason 1999
' A horse called Belisarius', *History Workshop Journal* 47: 243–52.
Elliot, David 1993
'Framing the "frontiers". Definitions of modern and modernist art', in H. Leyton and Bibi Damen (eds), *Art, Anthropology and Modes of Representation: Museums and Contemporary Non-Western Art,* Amsterdam: Royal Tropical Institute.
Engelhard, J. and P. Mesenhöller (eds) 1995
Bilder aus dem Paradies: Koloniale Fotographie aus Samoa 1875–1925, Marburg: Jonas Verlag.

Engelhard, J. and W. Wolf 1991
'Licht und Schatten. Zur Photosammlung des Rautenstrauch-Joest-Museums für Völkerkunde', *Kölner Museums-Bulletin* 4:4–17.

Fabian, Johannes 1983
Time and the Other: How Anthropology Makes its Object, New York: Columbia University Press.

Fanon, Frantz 1990 [1967]
The Wretched of the Earth, Harmondsworth: Penguin.

Fawcett, Terry 1986
'Graphic versus photographic in nineteenth century reproduction', *Art History* 9(2):185–212.

Flower, W. H. [1996]
Essays on Museums, reprinted, London: Routledge/Thoemmes Press.

Foster, Hal 1995
'The artist as ethnographer', in G. Marcus and F. Myers (eds), *Traffic in Culture*: *Refiguring Art and Anthropology,* Berkeley, CA: University of California Press.

Foucault, Michel 1989 [1972]
The Archaeology of Knowledge, London: Routledge.

Freitag, W. M. 1979/80
'Early uses of photography in History of Art', *Art Journal* 39:117–23.

Friedman, Jonathan 1998
'Knowing Oceania or Oceanian knowing: identifying actors and activating identities in turbulent times', in J. Wassman (ed.), *Pacific Answers to Western Hegemony,* Oxford: Berg.

Fried, M. 1980
Theatricality and Absorption: Painting and the Beholder in the Age of Diderot, Berkeley, CA: University of California Press.

Friedlander, Saul (ed.) 1992
Probing the Limits of Representation: Nazism and the Final Solution, Cambridge, MA: Harvard University Press.

Galison, P. and A. Assmus, 1989
'Artificial clouds, real particles', in D. Gooding, T. J. Pinch and S. Schaffer (eds), *The Uses of Experiment*, Cambridge: Cambridge University Press.

Garson, J. G. 1886
'On the physical characteristics of the Lapps', *Journal of the Anthropological Institute* xv: 235–8.

Gathercole, Peter 1977
'Cambridge and the Torres Strait 1888–1920,' *Cambridge Anthropology* 3(3):22–31.

Geertz, Clifford 1973
The Interpretation of Cultures, London: Fontana.
Gell, A. 1998
Art as Agency: An Anthropological Theory, Oxford: Clarendon Press.
Gidley, M. 1982
'A. C. Haddon joins Edward S. Curtis: an English anthropologist among
 the Blackfoot, 1909', *Montana: The Magazine of Western History,*
 Autumn: 21–33.
Gilson, R. P. 1970
Samoa 1830–1900: The Politics of a Multicultural Community, Melbourne:
 Oxford University Press.
Ginzburg, Carlo 1983
'Clues: Morelli, Freud and Sherlock Holmes', in U. Eco and T. Sebeok
 (eds), *The Sign of the Three: Dupion, Holmes, Pierce,* Bloomington, IN:
 Indiana University Press.
—— 1991
'Checking the evidence: the judge and the historian', *Critical Inquiry*
 18(1):79–92.
—— 1993
'Microhistory: two or three things that I know about it', *Critical Inquiry*
 20(1):10–35.
Godby, Michael 1996
'Images of //Kabbo', in Pippa Skotnes (ed.), *Miscast: Negotiating the
 Presence of the Bushmen,* Cape Town: University of Cape Town Press.
Goody, Jack 1987
The Interface between the Written and the Oral, Cambridge: Cambridge
 University Press.
Gosden, Christopher 1994
Social Being and Time, Oxford: Blackwell.
—— and Y. Marshall 1999
'The cultural biography of objects', *World Archaeology* 31(2):169–78.
Green, David 1984
'Classified subjects,' *Ten-8,* 14:3–37.
—— 1985
'Veins of resemblance: photography and eugenics', *Oxford Art Journal*
 7(2):3–16.
Greenberg, Reesa 1996
'Introduction', in R. Greenberg, B. W. Ferguson and S. Nairne (eds),
 Thinking about Exhibitions, London: Routledge.
Green-Lewis, J. 1996
Framing the Victorians: Photography and the Culture of Realism, Ithaca,
 NY: Cornell University Press.

Griffiths, Alison 1996/7
'Knowledge and visuality in turn of the century anthropology: the early ethnographic cinema of Alfred Cort Haddon and Walter Baldwin Spencer', *Visual Anthropology Review* 12(2):18–43.
Gruber, J.W. 1970
'Ethnography, salvage and the shaping of anthropology', *American Anthropologist* 72:1289–99.
Haddon, A. C. 1894
Decorative Art of British New Guinea: A Study in Papuan Ethnography (Cunningham Memoir 10), Dublin: Royal Irish Academy.
—— 1895
'Photography and Folklore' [summary], *Folklore* vi:222–4.
—— 1898
The Study of Man, London: Murray.
—— 1901
Headhunters: Black, White and Brown, London: Methuen.
—— (ed.) 1901–1935
Reports of the Cambridge Anthropological Expedition to the Torres Straits, 6 vols, Cambridge: Cambridge University Press.
Hall, Martin 1996
'The proximity of Dr. Bleek's Bushman', in Pippa Skotnes (ed.), *Miscast: Negotiating the Presence of the Bushmen,* Cape Town: University of Cape Town Press.
Hall, Stuart 1996
Critical Dialogues in Cultural Studies, London: Routledge.
Hamber, Anthony 1996
A Higher Branch of the Art: Photographing the Fine Arts in England 1839–1880, Amsterdam: Gordon and Breach.
Harlan, Teresa 1995
'Creating a visual history: a question of ownership', in *Strong Hearts: Native American Visions and Voices,* New York: Aperture.
Harraway, D. 1989
Primate Visions: Gender, Race and Nature in the Natural Sciences, London: Verso.
Harrison, Charles 1872
'Introduction', *Catalogue of a Series of Photographs from the Collections of the British Museum,* London: W. A. Mansell.
Hartmann, W., P. Hayes and J. Silvester (eds) 1998
The Colonialising Camera: Photographs in the Making of Namibian History, Cape Town: University of Cape Town Press.

Haworth-Booth, Mark and Elizabeth Anne McCauley 1998
Photographs at the Victoria and Albert Museum 1853–1900, Williamstown, MA: Clark Institute of Art.

Henderson, J. 1868
'Photography as an aid to archaeology', *Journal of the Photographic Society* 18 April , No.192:37–40.

Herle, Anita 1998
'The life-histories of objects', in A. Herle and Sandra Rouse (eds), *Cambridge and the Torres Strait*: *Centenary Essays on the 1898 Anthropological Expedition,* Cambridge: Cambridge University Press.

—— and Sandra Rouse (eds) 1998
Cambridge and the Torres Strait: *Centenary Essays on the 1898 Anthropological Expedition,* Cambridge: Cambridge University Press.

Heumann Gurian, Elaine 1991
'Noodling about with exhibition opportunities' , in I. Karp and S. Levine (eds), *Exhibiting Cultures: The Poetics and Politics of Museum Display,* Washington, DC: Smithsonian Institution Press.

Holly, Michael Ann 1996
Past Looking: Historical Imagination and the Rhetoric of the Image, Ithaca, NY: Cornell University Press.

Holman, Nigel 1996
'Curating and controlling Zuni photographic images', *Curator* 39 (2): 108–22.

Holmes, L. D. 1974
Samoan Village, New York: Holt, Winston and Rinehart.

Hoskins, J. 1998
Biographical Objects: How Things Tell Stories about People's Lives, London: Routledge.

Huffman, Kirk 1996
'Histoire des documents audio-visuels du Vanuatu', in J. Bonnemaison *et al.* (eds), *Vanuatu Océanie: arts des îles de cendre et de corail,* Paris: Réunion des musées nationale.

Hughes-Freeland, F. (ed.) 1998
Ritual, Performance, Media, London: Routledge.

Huxley, Leonard 1900
The Life and Letters of T. H. Huxley, 2 vols, London: Macmillan.

Huxley, T. H. 1869
Presidential Address to the Ethnological Society ['On the Ethnology and Archaeology of India'], *Journal of the Ethnological Society.* N.S. 1:89–93.

im Thurn, E. 1893
'Anthropological uses of the camera', *Journal of the Anthropological Institute* xxii:184–203.

Ingold, Tim 1976
The Skolt Lapps Today, Cambridge: Cambridge University Press.

Inha, I. K. 1896
Suomi Kuvissa, Helsingfors: Hagelstam.

Isaac, Gwyneira 1997
'Louis Agassiz's photographs in Brazil: separate creations,' *History of Photography* 21(1):3–11.

Ivins, William 1953
Prints and Visual Communication, London: Routledge Kegan Paul.

Jacknis, Ira 1984
'Franz Boas and photography', *Studies in Visual Communication* 10(1): 2–60.

Jagor, H. 1870
[note on photographic series and types] 15.1.1870, *Zeitschrift für Ethnologie* 2:147–48.

Jahnke, Robert 1999
'Voices beyond the *Pae'*, in N. Thomas and D. Losche (eds), *Double Vision: Art Histories and Colonial Histories in the Pacific,* Cambridge: Cambridge University Press.

Jehel, P.-J. 2000
Une illusion photographique. Esquisse des relations entre la photographie', *Journal des Anthropologues* 80(1):47–70.

Jenkins, David 1994
'Object lessons and ethnographic displays: museum exhibitions and the making of American anthropology', *Comparative Studies in Society and History* 36:242–70.

Jenks, Chris (ed.) 1995
Visual Culture, London: Routledge.

Jenness, D. 1919
'Along old cannibal trails', *Travel* 33:34–7, 41.

Jenness, D. and A. Ballantyne 1920
The Northern D'Entrecasteaux, Oxford: Clarendon Press.

Karp, Ivan and S. Levine (eds) 1991
Exhibiting Cultures: The Poetics and Politics of Museum Display, Washington, DC: Smithsonian Institution Press.

Keane, A. 1886
'The Lapps: their origin, ethnical affinities, physical and mental characteristics, usages, present status and future prospects', *Journal of the Anthropological Institute* xv:213–35.

Keane, Webb 1997
'From fetishism to sincerity: on agency, the speaking subject and their historicity in the context of religious conversion', *Comparative Studies in Society and History* 39:674–93.

Kech, V. (ed.) 1998
Common Worlds and Single Lives, Oxford: Berg.

Keesing, Roger 1989
'Creating the past: custom and identity in the contemporary Pacific', *The Contemporary Pacific* 1(1–2):19–42.

Kendall, L., B. Mathé and T. Ross Miller 1997
Drawing Shadows in Stone: The Photography of the Jesup North Pacific Expedition, 1897–1902, Seattle, WA: University of Washington Press.

Kern, Stephen 1983
The Culture of Space and Time 1880–1918, Cambridge, MA: Harvard University Press.

Kerr, Joan 1999
'Past present: the local art of colonial quotation', in N. Thomas and D. Losche (eds), *Double Vision: Art Histories and Colonial Histories in the Pacific*, Cambridge: Cambridge University Press.

King, J. C. H. 1997
'Franks and ethnography', in M. Caygill and J. Cherry (eds), *A. W. Franks: Nineteenth-Century Collecting and the British Museum*, London: British Museum Press.

Kirshenblatt-Gimblett, B. 1991
'Objects of ethnography,' in I. Karp and S. Levine (eds), *Exhibiting Cultures: The Poetics and Politics of Museum Display*, Washington, DC: Smithsonian Institution Press.

Kopytoff, I. 1986
'The cultural biography of things', in A. Appadurai (ed.), *The Social Life of Things*, Cambridge: Cambridge University Press.

Kracauer, Siegfried 1980
'Photography', in A. Trachtenberg, *Classic Essays on Photography*, New Haven, CT: Leetes Island Books.

—— 1995a [1969]
History: the Last Thing before the Last, (completed and ed. P. O. Kristeller), Princeton, NJ: Marcus Wiener Publications.

—— 1995b
'Photography', in *The Mass Ornament: Weimar Essays* (trans. and ed. T. Levin), Cambridge, MA: Harvard University Press.

Kuklick, Henrika 1991
The Savage Within: The Social History of British Anthropology, Cambridge: Cambridge University Press.

Lalvani, Suren 1996
Photography, Vision and the Production of Modern Bodies, New York: State
 University of New York Press.
Lamprey, J. 1869
'On a method of measuring the human form for students of ethnology',
 Journal of the Ethnological Society of London, 1:84–5.
Langham, Ian 1981
*The Building of British Social Anthropology: W. H. R. Rivers and his
 Cambridge Disciples in the Development of Kinship Studies 1898–1931,*
 Dordrecht: D. Reidel.
Latour, Bruno 1986
'Visualization and cognition: thinking with eyes and hands', *Knowledge
 and Society* 6:1–40.
Lederbogen, Jan 1995
'Frühe Fotographie auf Samoa zwischen Wissenschaftsanspruch und
 kolonialem Denken,' in J. Engelhard and P. Mesenhöller (eds), *Bilder
 aus dem Paradies: Koloniale Fotographie aus Samoa 1875–1925,*
 Marburg: Jonas Verlag.
Ledgerwood, Julia 1997
'The Cambodia Tuol Sleng Museum of Genocidal Crimes: national
 narratives', *Museum Anthropology* 21(1):82–98.
Lefebvre, Henri 1991 [1974]
The Production of Space, trans. D. Nicholson-Smith, Oxford: Blackwell.
Leslie, E. 1999
'Souvenirs and forgetting: Walter Benjamin's memory-work', in M.
 Kwint, J. C. Breward and J. Aynesley (eds), *Material Memories.* Oxford:
 Berg.
Levi, G. 1991
'On microhistory', in P. Burke (ed.), *New Perspectives on Historical Writing,*
 Cambridge: Polity Press.
Lidchi, Henrietta 1997a
'Exposing "others"? Photography in the exhibition context', *Boletín de
 Antropología Visual* 1(1):15–39.
—— 1997b
'The poetics and politics of exhibiting other cultures', in Stuart Hall
 (ed.), *Representations: Cultural Representations and Signifying Practices,*
 London: Sage/Open University.
Lindt, J. W. 1887
Picturesque New Guinea, London: Longmans, Green & Co.
Lippard, Lucy (ed.) 1992
Partial Recall: Photography and Native North Americans, New York: The
 New Press.

Livingston, Jane and John Beardsley 1991
'The Poetics and Politics of Hispanic Art: A New Perspective', in I. Karp and S. Levine (eds), *Exhibiting Cultures: The Poetics and Politics of Museum Display*, Washington, DC: Smithsonian Institution Press.

Lloyd, Valerie 1988
Roger Fenton: Photographer of the 1850s, London: Hayward Gallery.

Logan, Owen 1997
A Home of Signs and Wonders, London: British Council.

Lotz, P. and J. Lotz (eds) 1971
'Pilot not Commander: essays in memory of Diamond Jenness', *Anthropologica* xiii. Special issue.

Lovelace, Antonia, E. Carnegie and H. Dunlop 1995
'St. Mungo's Museum of Religious Life and Art: a new development in Glasgow', *Journal of Museum Ethnography* 7:63–78.

Lury, Celia 1998
Prosthetic Culture: Photography, Memory and Identity, London: Routledge.

Lynch, Michael 1988
'The externalized retina: selection and mathematiziation in the visual documentation of objects in the life sciences', *Human Studies* 11:201–34.

McCauley, Elizabeth Anne 1994
Industrial Madness: Commercial Photography in Paris 1848–1871, New Haven, CT: Yale University Press.

MacGregor, W. 1897
British New Guinea: Country and People, London: John Murray.

Macintyre, M. and M. MacKenzie 1992
'Focal length as an analogue of cultural distance', in E. Edwards (ed.), *Anthropology and Photography 1860–1920*, London/New Haven, CT: Yale University Press.

McQuire, S. 1998
Visions of Modernity: Representation, Memory, Time and Space in the Age of the Camera, London: Sage.

Malinowski, B. 1922
Argonauts of the Western Pacific, London: Routledge and Kegan Paul.
—— 1935
Coral Gardens and their Magic, London: Routledge and Kegan Paul.

Malraux, André 1949
The Psychology of Art: Museum Without Walls, London: Zwemmer.

Marcus, George E. 1995
'The power of contemporary work in an American tradition to illuminate its own power relations', in G. Marcus and F. Myers (eds), *Traffic*

in Culture: Refiguring Art and Anthropology, Berkeley, CA: University of California Press.

Marcus, George and Fred Myers (eds) 1995

The Traffic in Culture: Refiguring Art and Anthropology, Berkeley, CA: University of California Press.

Maresca, Sylvain 1996

La photographie: Un miroir des sciences sociales, Paris: Edition L'Harmattan.

Marsh, Ann 1999

'Leah King-Smith and the nineteenth-century archive', *History of Photography* 23(2):114–17.

Martinez, W. 1992

'Who constructs anthropological knowledge?', in Peter I. Crawford and David Turton (eds), *Film as Ethnography,* Manchester: Manchester University Press.

Maynard, Peter 1997

The Engine of Visualization, Ithaca, NY: Cornell University Press.

Meleisea, Malama 1987

The Making of Modern Samoa, Suva: University of the South Pacific.

Miller, D. 1998

Material Culture: Why Some Things Matter, London: UCL Press.

Mitchell, W. J. T. 1994

Picture Theory, Chicago: Chicago University Press.

—— 1996

'What do pictures really want?', *October* 77:71–82.

Morris, Rosalind 1994

New Worlds from Fragments: Film, Ethnography and the Representation of Northwest Coast Cultures, Boulder, CO: Westview Press.

Mosby, Tom 1998

'Torres Strait Ira Mer Pe Ike', in *Ilan Pasin (this is our way) Torres Strait Art,* Cairns: Cairns Regional Gallery.

Mulvaney J., A. Petch and H. Morphy (eds) 1997

My Dear Spencer: The Letters of F. J. Gillen to Baldwin Spencer, Melbourne: Hyland House.

Munro, D. 1994

'Who owns 'Pacific History'? Reflections on the insider/outsider dichotomy', *Journal of Pacific History* 29:232–7.

Niessen, Sandra 1991

'More to it than meets the eye: photo-elicitation amongst the Batak of Sumatra', *Visual Anthropology* 4:415–30.

Neumann, Klaus 1992

Not the Way It Really Was: Constructing the Tolai Past, Honolulu: University of Hawaii Press.

Nordström, Alison 1991
'Early photography in Samoa: marketing stereotypes of Paradise', *History of Photography* 15(4):272–84.
—— 1995
'Photography of Samoa: production, dissemination and use', in C. Blanton (ed.), *Picturing Paradise: Colonial Photography of Samoa 1875–1925*, Daytona Beach, FL: Southeast Museum of Photography.
Ottenburg, Simon 1991
'Into the heart of Africa', *African Arts* 24(3):79–82.
Otto, T. and N. Thomas 1997
Narratives of Nation in the South Pacific, Amsterdam: Harwood Academic.
Owens, Craig 1992
Beyond Recognition: Representation, Power and Culture, Berkeley, CA: University of California Press.
Parnell, Geoffrey 1993
The Tower of London, London: English Heritage.
Peacock, James 1990
'An ethnography of the sacred and profane in performance', in R. Schechner and W. Appel (eds), *By Means of Performance*, Cambridge: Cambridge University Press.
'Peaux-Rouges' 1992
Autour de la collection anthropologique du Prince Roland Bonaparte, Thonon-les-Bains: L'Albaron/Photothèque du Musée de l'Homme.
Pearce, Susan 1995
On Collecting, London: Routledge.
Phillips, C. 1890
Samoa Past and Present, London: John Snow.
Phillips, Ruth and Christopher Steiner (eds) 1999
Unpacking Culture: Art and Commodity in Colonial and Postcolonial Worlds, Berkeley, CA: University of California Press.
Piggott, Stuart 1978
Depicting Antiquity: Aspects of Archaeological Illustration, London: Thames and Hudson.
Pinney, Christopher 1990
'Colonial anthropology and "The Laboratory of Mankind"', in C. Bayley (ed.), *The Raj: India and the British 1600–1942*, London: National Portrait Gallery.
—— 1992
'The lexical spaces of eye-spy', in Peter I. Crawford and David Turton (eds), *Film as Ethnography*, Manchester: Manchester University Press.
—— 1997
Camera Indica: The Social Life of Indian Photographs, London: Reaktion.

Poignant, Roslyn 1992a
'Surveying the field of view: the making of the RAI collection', in E.
 Edwards (ed.), *Anthropology and Photography 1860–1920,* London/New
 Haven, CT: Yale University Press.
—— 1992b
'Wurdayak/Baman (Life History) Photo Collection', *Australian Aboriginal
 Studies* 2:71–7.
—— 1993
'Captive Aboriginal lives: Billy, Jenny, Little Toby and their compan-
 ions', in K. Darian-Smith (ed.), *Captured Lives: Australian Captivity
 Narratives,* London: Sir Robert Menzies Centre for Australian Studies,
 University of London.
—— 1996a
Encounter at Nagalarramba, Canberra: National Library of Australia.
—— 1996b
'Ryko's photographs of the "Fort Dundas Riot": the story so far',
 Australian Aboriginal Studies 2:24–41.
Poole, Deborah 1997
Vision, Race and Modernity: A Visual Economy of the Andean Image World,
 Princeton, NJ: Princeton University Press.
Porter, Gaby 1989
'Economy of truth: photography in the museum', *Ten-8* 34:20–33.
Pujade, R. 1994
La Photographie comme Science Fabuleuse Jorma Puranen, Paris: Institut
 Finlandais.
Puranen, Jorma 1993
'Imaginary Homecoming', in Sunil Gupta (ed.), *Disrupted Borders,*
 London: Rivers Oram.
—— 1999
Imaginary Homecoming, Oulu: Kustantaja Pohjoinen.
Quiggen, A. Hingston 1942
Haddon the Headhunter, Cambridge: Cambridge University Press.
Read, C. H. 1899
'Prefatory note: ethnography', *Notes and Queries on Anthropology,*
 London: BAAS.
Retman, S. 1996
'Stryker's FSA collection: "Something more than a catalogue of celluloid
 rectangles in a government store"', *Museum Anthropology* 20 (2):49–
 66.
Richards, Thomas 1991
*Commodity Culture in Victorian Britain: Advertising and Spectacle 1851–
 1914,* London: Verso.

—— 1993

The Imperial Archive: Knowledge and the Fantasy of Empire, London: Verso.

Richling, B. 1989

'An anthropologist's apprenticeship: Diamond Jenness's Papuan and Arctic fieldwork', *Culture* 9(1):771–85.

Riegel, Henrietta 1996

'Into the heart of irony', in S. Macdonald and Gordon Fyfe (eds), *Theorizing Museums,* Oxford: Blackwell.

Ripatti, M. 1993

'The stations of the gaze: crossroads of absolution – on the works of Jorma Puranen', *Index,* 1:10–15.

Rohde, Rick 1998

'How we see each other: subjectivity, photography and ethnographic re/vision', in W. Hartmann, P. Hayes and J. Silvester (eds), *Colonialising Camera,* Cape Town: University of Cape Town Press.

Rosen, Jeff 1997

'Naming and framing nature in *Photographie Zoologique*', *Word and Image* 13(4):377–91.

Rouse, S. 1998

'Expedition and institution: A. C. Haddon and anthropology at Cambridge', in A. Herle and S. Rouse (eds), *Cambridge and the Torres Strait: Centenary Essays on the 1898 Anthropological Expedition,* Cambridge: Cambridge University Press.

Rowell, Margit 1997

Objects of Desire: The Modern Still Life, London: Hayward Gallery.

Ruby, Jay 1979

'The Aggie will come first: The demystication of Robert Flaherty', in *Robert Flaherty Photographer/Filmmaker: The Inuit 1910–1922,* Vancouver: Vancouver Art Gallery.

Rudler, F. 1897

'On the arrangement of ethnographical collections', *Report of the Procedings of the 8th Annual General Meeting of the Museums Association:* 55–62.

Rudwick, Martin 1996

'Minerals, strata and fossils', in N. Jardine, J. A. Secord and E. C. Spary (eds), *Cultures of Natural History,* Cambridge: Cambridge University Press.

Ryan, James 1997

Picturing Empire: Photography and the Visualization of the British Empire, London: Reaktion.

Sahlins, Marshall 1981

Historical Metaphors and Mythical Realities: Structure in the Early History of the Sandwich Islands Kingdom, (Association for the Study of Anthropology in Oceania, Special Publication 1), Ann Arbor, MI: University of Michigan Press.

Said, Edward 1989

'Representing the colonialised: anthropology's interlocutors', *Critical Inquiry* 15(2):205–25.

Sassoon, Joanna 1998

'Photographic meaning in the age of digital reproduction', *LASIE* December: 5–15.

Schaaf, Larry J. 1998

'Invention and discovery: first images', in A. Thomas (ed.), *Beauty of Another Order: Photography in Science,* New Haven, CT: Yale University Press in association with National Gallery of Canada, Ottawa.

Schaffer, Simon 1994

From Physics to Anthropology and Back Again, Cambridge: Prickly Pear (Pamphlet No 3).

Schechner, Richard 1981

'Restoration of behaviour', *Studies in Visual Communication* 7 (3):2–45.

—— 1990

'Magnitudes of performance', in R. Schechner and W. Appel (eds), *By Means of Performance* Cambridge: Cambridge University Press.

Schildkrout, E. 1991

'Ambiguous messages and ironic twists', *Museum Anthropology* 15(2):16–23.

Schippers, Thomas K. 1995

'A history of paradoxes, anthropologies of Europe', in Hans F. Vermeulen and Arturo Alvarez Rodsán (eds), *Fieldwork and Footnotes: Studies in the History of European Anthropology,* London: Routledge.

Schneider, Arnd 1996

'Uneasy relations: contemporary artists and anthropology', *Journal of Material Culture* 1(2):183–210.

Schwartz, Joan M. 1995

'We make our tools and our tools make us', *Archivaria* 40:40–74.

Sekula, Alan 1987

'Reading the archive', in *Blasted Allegories: An Anthology of Writings by Contemporary Artists* (Documentary Sources in Contemporary Art 2), Cambridge, MA: MIT Press.

—— 1989

The body and the archive', in R. Bolton (ed.), *The Contest of Meaning: Critical Histories of Photography,* Cambridge, MA: MIT Press.

Seremetakis, C. Nadia (ed.) 1994
'Introduction', in *The Senses Still: Perception and Memory as Material Culture in Modernity,* Chicago: Chicago University Press.
Shapin, Steve and Simon Schaffer 1985
Leviathan and the Air Pump: Hobbes, Boyle and the Experimental Life, Princeton, NJ: Princeton University Press.
Sharp, Nonie 1999
'Review: *Cambridge and the Torres Strait'*, *Historical Records of Australian Science* 12(4):541–3.
Shawcross, Nancy 1997
Roland Barthes on Photography, Gainsville, FL: University of Florida Press.
Shelton, A. 1990
'In the lair of the monkey: notes towards a post-modern museology', in S. Pearce (ed.), *Objects of Knowledge,* London: Athlone Press.
Sieberling, Grace and Caroline Blore 1986
Amateurs, Photography and the mid-Victorian Imagination, Chicago: Chicago University Press.
Simpson, Moira 1996
Representing Ourselves: Museums in the Post-Colonial Era, London: Routledge.
Slobodin, R. 1978
W. H. R. Rivers, New York: Columbia University Press.
Snyder, Joel 1998
'Nineteenth century photography and the rhetoric of substitution', in G. Johnson (ed.), *Sculpture and Photography: Envisioning the Third Dimension,* Cambridge: Cambridge University Press.
Soja, Edward 1989
Postmodern Geographies: The Reassertion of Space in Critical Theory, London: Verso.
Sontag, Susan 1979
On Photography, Harmondsworth: Penguin.
Spencer, Frank 1992
'Some notes on attempting to apply photography to anthropometry during the second half of the nineteenth century', in E. Edwards (ed.), *Anthropology and Photography 1860–1920,* London/New Haven, CT: Yale University Press.
Spencer, W. B. and F. Gillen 1927
The Arunta, 2 vols, London: Macmillan.
Spivak, G. 1990
The Post-Colonial Critique: Interviews, Strategies, Dialogues, London: Routledge.

Spurr, David 1993
The Rhetoric of Empire, Durham, NC: Duke University Press.
Stafford, Barbara 1994
Artful Science: Enlightenment, Entertainment and the Eclipse of Visual Education, Cambridge, MA: MIT Press.
Steinberg, M. (ed.) 1996
Walter Benjamin and the Demands of History, Ithaca, NY: Cornell University Press.
Stepan, Nancy 1982
The Idea of Race in Science: Great Britain 1800–1960, London: Macmillan.
Stephen, A. (ed.) 1993
Pirating the Pacific, Sydney: Powerhouse Museum
Stocking, George 1968
Race Culture and Evolution, New York : Free Press.
—— 1971
'What's in a name? The origins of the Royal Anthropological Institute 1837–1871', *Man* N.S. 6:369–90.
—— (ed.) 1983
'The ethnographer's magic: fieldwork in British anthropology from Tylor to Malinowski', in *Observers Observed: Essays on Ethnographic Fieldwork (History of Anthropology* 1), Madison, WI: University of Wisconsin Press.
—— 1987
Victorian Anthropology, Madison, WI: University of Wisconsin Press.
—— 1995
After Tylor: British Social Anthropology 1888–1951, Madison, WI: University of Wisconsin Press.
Sullivan, Gerald 1999
Margaret Mead, Gregory Bateson, and Highland Bali: Fieldwork Photographs of Bayung Gedé, 1936–1939, Chicago: Chicago University Press.
Szarkowski, J. 1966
The Photographer's Eye, New York: Museum of Modern Art.
Tagg, John 1988
The Burden of Representation, London: Macmillan.
Taussig, Michael 1993
Mimesis and Alterity: A Particular History of the Senses, New York: Routledge.
Theye, Thomas 1994/5
'Einige Neuigkeiten zu Leben und Werk der Brüder Carl Victor und Friedrich Dammann', *Mitteilungen aus dem Museum für Völkerkunde Hamburg* Band 24.25:247–84.

Thode-Aurua, H. 1989
Für Funfzig Pfennig um dies Welt: Die Hagenbeckschen Volkerschauen, Frankfurt: Campus.

Thomas, Ann 1997
'The search for pattern', in A. Thomas (ed.), *Beauty of Another Order: Photography in Science*, New Haven, CT: Yale University Press in association with the National Gallery of Canada, Ottawa.

Thomas, Nicholas 1991
Entangled Objects: Exchange, Material Culture and Colonialism in the Pacific, Cambridge, MA: Harvard University Press.

—— 1994a
Colonialism's Culture: Anthropology, Travel and Government, Cambridge: Polity Press.

—— 1994b
'Licensed curiosity: Cook's Pacific voyages', in J. Elsner and R. Cardinal (eds), *The Culture of Collecting,* London: Reaktion.

—— 1997
'Partial texts: representation, colonialism and agency in Pacific History', in *In Oceania: Visions, Artifacts, Histories*, Durham, NC, Duke University Press.

—— 1998
Possessions: Indigenous Art/Colonial Culture, Durham, NC: Duke University Press.

—— 1999
'Introduction', in N. Thomas and D. Loche (eds), *Double Vision: Art Histories and Colonial Histories in the Pacific,* Cambridge: Cambridge University Press.

Tobing Rony, F. 1996
The Third Eye: Race, Cinema and Ethnographic Spectacle, Durham, NC: Duke University Press.

Tomas, David 1993
'Transcultural space', *Visual Anthroplogy Review* 9(2):60–78.

Tonkin, Elizabeth 1992
Narrating Our Pasts: The Social Construction of Oral History, Cambridge: Cambridge University Press.

Torodov, T. 1990 [1978]
'The origins of genre', in *Genres of Discourse* (trans. C. Porter), Cambridge: Cambridge University Press.

Trachtenberg, Alan 1989
Reading American Photographs: Images as History, Mathew Brady to Walker Evans, New York: Hill and Wang.

Tsinhnahjinnie, Hulleah 1998
'When is a photograph worth a thousand words', in *Native Nations: Journeys in American Photography*, London: Barbican Art Gallery.
Tucker, Jennifer 1997
'Photography as witness, detective and impostor: visual representation in Victorian science', in B. Lightman (ed.), *Victorian Science in Context*, Chicago: Chicago University Press.
Turner, Victor 1974
Dramas, Field and Metaphors, Ithaca, NY: Cornell University Press.
Turner, W. 1878
'The ethnology of Motu', *Journal of the Anthropological Institute* vii: 470–97.
Tylor, E. B. 1876
'Dammann's race photographs', *Nature* xiii 6 January:184.
—— 1879
'Remarks on the geographical distribution of games', *Journal of the Anthropological Institute* ix:23–9.
Urry, James 1993
Before Anthropology: Essays on the History of British Anthropology, Camberwell: Harwood Academic.
van Alphen, Ernst 1997
Caught by History: Holocaust Effects in Contemporary Art, Literature and Theory, Stanford, CA: Stanford University Press.
Vansina, Jan 1985
Oral Tradition as History, London: James Currey.
Vergo, P. (ed.) 1989
The New Museology, London: Reaktion.
Von Luschan, F. 1896
Beiträge zur Völkerkunde, Berlin: Dietrich Reimer.
Wassmann, J. (ed.) 1998
Pacific Answers to Western Hegemony, Oxford: Berg.
Webb, Virginia-Lee 1997
'Missionary photographers in the Pacific: Divine Light', *History of Photography* 21(1):12–22.
—— 2000
Perfect Documents: Walker Evans and African Art, 1935, New York: Metropolitan Museum of Art.
Wesley, H. 1866
'On the iconography of the skull', *Memoirs of the Anthropological Society of London*. 2:189–94.

White, Geoffrey 1991

Identity through History: Living Stories in a Solomon Islands Society, Cambridge: Cambridge University Press.

White, Hayden 1980

'The value of narrativity in the representation of reality', *Critical Inquiry,* 7(1):5–27.

—— 1983

'The politics of historical interpretation: discipline and de-sublimation', in W. J. T. Mitchell (ed.), *The Politics of Interpretation,* Chicago, IL: Chicago University Press.

—— 1992

'Historical emplotment and the problem of truth', in S. Friedlander (ed.), *Probing the Limits of Representation: Nazism and the Final Solution,* Cambridge, MA: Harvard University Press.

Williamson, Clare 1999

'Patterns of Connection: Leah King-Smith', in Blair French (ed.), *Photo Files: An Australian Photography Reader,* Sydney: Power Publications & Australian Centre for Photography.

Winston, Brian 1995

Claiming the Real: Documentary Film Revisited, London: British Film Institute.

Wolf, Eric 1982

Europe and the People Without History, Berkeley, CA: University of California.

Wolfe, Patrick 1999

Settler Colonialism and the Transformation of Anthropology, London: Cassell.

Wollen, Peter 1995

'Introduction', in L. Cooke and P. Wollen (eds), *Visual Display: Culture Beyond Appearances,* Seattle, WA: Bay Press.

Wright, Terence 1992

'The fieldwork photographs of Jenness and Malinowski and the beginning of modern anthropology', *Journal of the Anthropological Society of Oxford* 23(1):41–58.

Young, Michael 1971

Fighting with Food: Leadership, Values and Social Control in a Massim Society, Cambridge: Cambridge, University Press.

—— 1977

'Dr. Bromilow and the Bwaidoka Wars', *Journal of Pacific History* 12: 130–53.

—— 1983

Magicians of Manumanua, Berkeley, CA: University of California Press.
—— 1998

Malinowski's Kiriwana : Fieldwork Photographs 1915–1918, Chicago: Chicago University Press.

Index